MONSTER BOOK OF MANGA DRAWING

150 Step-by-Step Projects for Beginners

David Okum

IMPACT
CINCINNATI, OHIO
www.impact-books.com

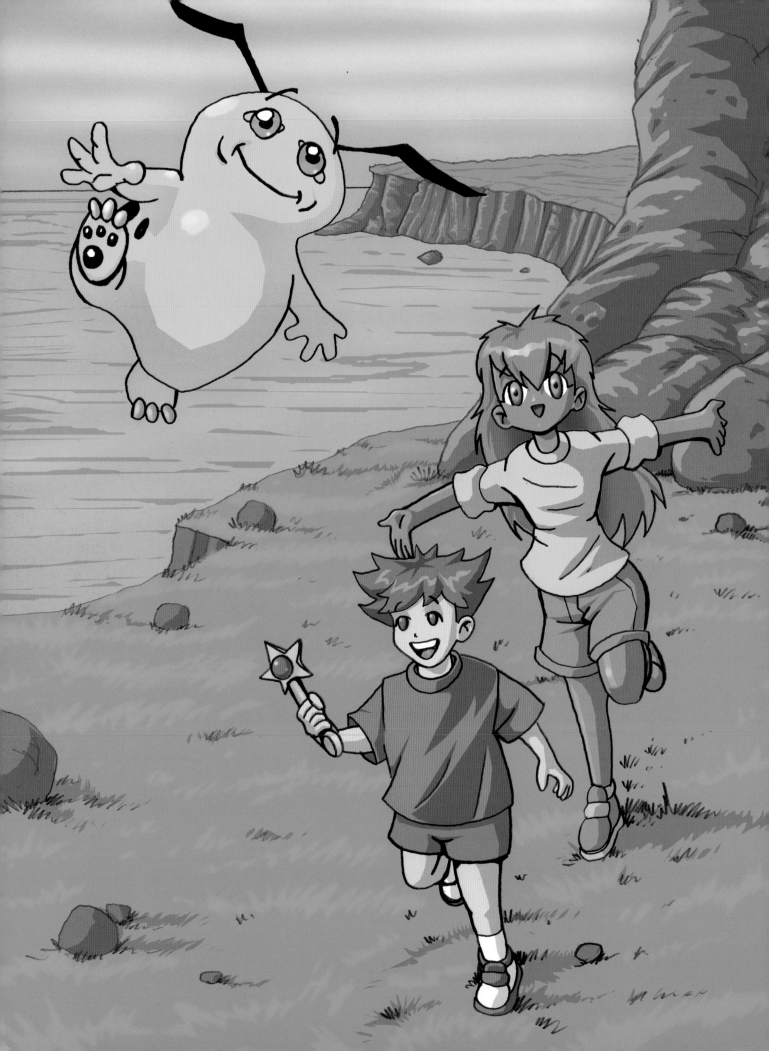

Table of Contents

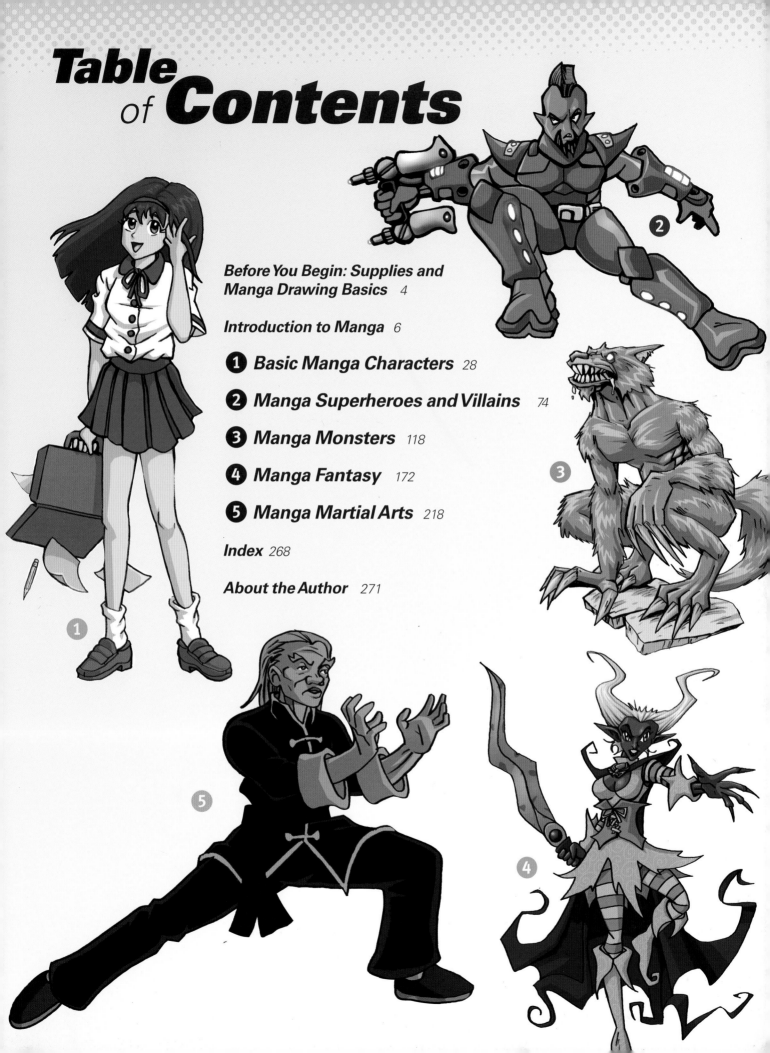

Before You Begin

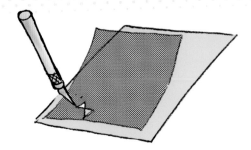

You don't need a fully equipped art studio to make manga. Here are some basic tools of the trade you *will* need.

A clean, flat, well-lit drawing surface. A drawing table, desk, kitchen table or even a coffee table will do.

Paper or board to draw on. Professional comic and manga artists use 2- or 4-ply bristol board sheets cut to 11" x 17" (28cm x 43cm). Most of the images in this book were drawn on 8½" x 11" (22cm x 28cm) sheets of bond printer paper. You can find reams of 500 sheets at any office supply store.

Try different types of paper and use what you are comfortable with. You might start out with only a half-used notebook or pieces of scrap paper. No matter what you draw on, keep a sketchbook and draw in it every day.

Pencils. Pencils come in a wide range of hard (H) and soft (B) varieties. Soft pencils (such as 2B or 4B) make nice dark marks, but are hard to erase and tend to smudge easily. Hard pencils

(such as 2H or 4H) make fine light lines, but can scratch into the paper or board, leaving unwanted indentations that can make inking and coloring difficult. Some artists prefer HB pencils because they are the most flexible and readily available.

Technical pencils are favored by many artists because of the precise and consistent lines they make. Almost all the line art in this book was done with a technical pencil.

A good pencil sharpener. Keep your pencils sharp. Sharp pencils allow the artist total control over what he or she draws. An electric pencil sharpener speeds up the process, but don't forget to replace the blade when it gets too dull. Hand-held sharpeners work well, too; just watch out for those pencil shavings.

Erasers. Erasers are very important for cleaning up any unwanted lines. White plastic erasers are preferred over pink erasers because they don't grind into

the paper or smudge. Clean your plastic erasers occasionally by erasing on a piece of scrap paper until they look white again.

Inking pens. Keep on hand a variety of thick and thin markers. Be careful with inking. The wrong marker can ruin your hard work. Test your inking pens on scrap paper first. Some markers can really bleed into the paper or board. If possible, try to use India ink or permanent pigment technical pens. The ink shouldn't fade or turn brown like some felt-tip pens.

Traditional nib and holder pens that are dipped into India ink are used by most professional manga inkers. The variety and control of line that is available with these pens in the hands of an expert is amazing. Purists insist on using these pens, claiming that the lines are much more expressive and polished.

The ultimate test of inking control is inking with a fine brush. The warm, calligraphic touch of the brush adds a level of craftsmanship and humanity to the artwork that technical pens cannot duplicate.

Screen tone. Traditional manga uses dry transfer tone patterns for shading. Screen tone can be found at larger art supply stores and comic book conventions, or online. The painstaking process of applying screen tone requires the artist to carefully cut

out the chosen area of tone with a sharp blade and then place the transfer neatly on top of the inked artwork. Some artists use computers to simulate screen tone effects. Screen tone is not essential to create your own manga, but it is often used by professionals because the tiny dots are easy to reproduce in printing.

Colored pencils. Soft colored pencils allow for a wide range of shading and blending. They are relatively inexpensive and easy to use and come in a variety of colors. Try blending and shading using little circles and moving the pencil along the natural shapes and forms of the object you are drawing.

Colored markers and paints (optional). Colored markers and paints add a whole new dimension to manga work, but can be difficult to master. Markers are expensive and may give off hazardous fumes. Water-based

markers are washable and nontoxic, but smudge easily and don't blend well. Various coloring methods such as markers, paint and computers are discussed later in this section.

A ruler or straightedge. Rulers are most important for drawing perspective lines properly and creating comic panels in manga.

Flat storage for your drawings. Don't let your drawings get folded or crumpled, ruined by a water mark (oops!) or accidentally tossed in the trash. Keep them flat and protected by storing them in a simple, labeled folder or art portfolio.

How Did Manga Begin?

The comic book is a relatively recent invention, but Japanese artists have been producing illustrated books for centuries. The famous Japanese artist Hokusai (1760–1849) coined the term *manga* in 1815 when he referred to some of his comic sketches as "man" (whimsical or careless) "ga" (drawings).

Japanese manga developed a strong following after World War II. The themes and stories reflect popular culture and national tastes. People unfamiliar with manga are sometimes surprised by how violent and racy some Japanese comics can be. There is a wide audience of women, men, boys and girls that accepts comics and animation as just another medium for storytelling. Manga is produced for every possible group and interest.

Manga produced in Japan is published weekly as part of huge 300+ page anthologies of comic stories. They are regarded as cheap entertainment for commuters, read and then discarded. They usually aren't preserved as precious artifacts like American comic books. They are consumed, not collected. High demand creates crazy schedules for manga artists, who often pump out sixteen or more pages a week.

The Japanese fan base is truly amazing, with tens of thousands of people attending conventions in an attempt to catch a glimpse of their favorite artists. Fans also create elaborate costumes and dress up as popular manga charac-ters. Artistic fans can try their hands at *doujinshi*, amateur comics about their favorite manga and anime characters.

The demand for manga has increased as the rest of the world discovers the medium. Translation of manga is difficult because most Asian books are read from right to left, opposite from most European and North American books.

Purists generally do not call non-Japanese comics "manga," even if they are drawn in the appropriate style. Non-Japanese manga is called "American manga" or "Western manga." The North American comics market has different economics and expectations. American manga are often produced in glossy color and include traditional Western storytelling and cultural elements such as superheroes.

The future of manga looks bright. Many mainstream comic companies are adopting a manga "look" for their books. Even comics like *X-Men* and *Batman* have been drawn in manga style by Japanese manga artists. Anime has become wildly popular on television and in the movies. Manga books as well as anime shows, movies and video games are winning more mainstream awards and becoming accessible to a whole new legion of followers.

Common Manga Terms to Know

Anime (AH-nee-may)—French term for "animation" adopted by the Japanese to describe all of Japanese animation.

Bishoujo (bee-SHO-jo)—"beautiful girl."

Bishounen (bee-SHO-nen)—"beautiful boy."

Chibi (CHEE-bee)—"small"; refers to a child-proportioned version of a manga character, often used for comic relief. Also referred to as SD (super-deformed).

Doujinshi (doh-JEEN-shee)—fan-produced manga involving favorite manga, game and anime characters in original stories.

Kawaii (kah-WAH-ee)—"super cute."

Manga (MAHN-gah)—"whimsical or careless drawings," meaning Japanese comic books.

Otaku (oh-TAH-ku)—nickname given to someone obsessed with being a fan, often referring to anime and manga fans.

RPG—a video role-playing game, often with complex settings and characters. Many manga and anime artists help design popular video games.

Shoujo (SHO-jo)—"young girl"; refers to comics aimed at young girls.

Shounen (SHO-nen)—"young male"; refers to comics aimed at young males.

How the
Pros Do It

Ever wonder how your favorite comic book was put together? Usually a whole team of different people—writers, editors, pencillers, letterers, inkers, colorists and a publisher—is required to produce just one story.

❶ Brainstorming

Come up with a really cool idea or character. Write down lots of ideas and draw up a model sheet (at least three or four views of the character) and an expressions reference sheet to keep everything consistent as you draw.

❷ Writing the Script and Drawing a Rough Layout

A script provides a written breakdown of the story, and a layout shows the page and panel breakdown. The layout is often drawn just with rough stick figures. Care is taken to balance the dialogue so that it doesn't overwhelm the artwork. The script and layout might be completed by two or more different people.

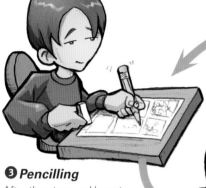

❸ Pencilling

After the story and layout have been finalized, the final pages are begun. Heavier paper is often chosen so that the pages will survive the lettering, inking, erasing and coloring to come. Lines are drawn sparingly and lightly, and instead of filling in areas of black, X's are placed for the inker to fill in later.

❹ Lettering

Most of the lettering in professional comics is done last on the computer, over the existing artwork. Any lettering done by hand is completed at this stage. Each word is carefully printed out in uppercase.

❺ Inking

All images are inked so that they are permanent. Great care is taken at this stage, since you can't erase ink. Minor errors can be covered with white paint or correction fluid.

❻ Erasing

Once the ink is completely dry, all original pencil lines are removed for a clean look.

❽ Publishing

Not every comic is a full-color glossy. Many beginning artists publish small, photocopied, folded and stapled mini-comics. The rise of the Internet has seen an explosion of online comics and manga.

❼ Coloring

Most manga are colored with a computer, but there is still a huge market for well-done hand coloring.

The **Basic Elements** of **Manga Style**

Individual manga can vary wildly in style and technique. Each manga is as unique as the individual who created it. There is no stereotypical manga style, but there are some standard conventions that have developed over the years.

Hair is wild and flowing, reflecting popular styles and revealing the nature of the character.

Noses are often less prominent and simply drawn as a small checkmark.

Mouths are small when closed and very large when open. Avoid details like lips—keep it simple!

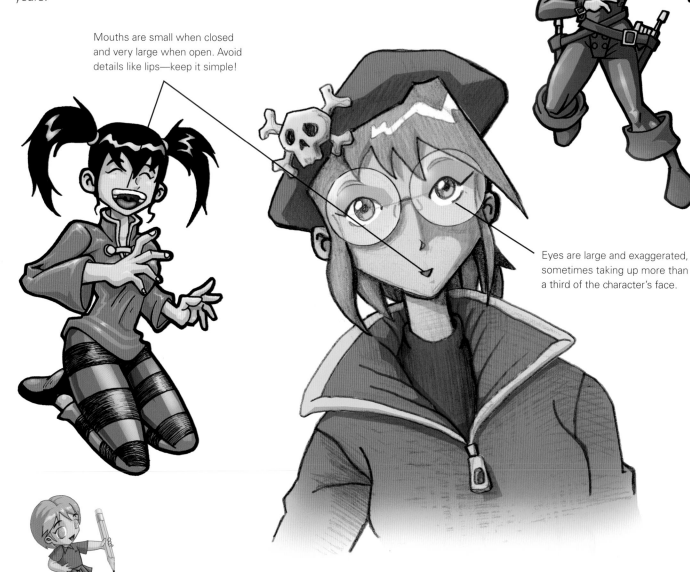

Eyes are large and exaggerated, sometimes taking up more than a third of the character's face.

The Eyes Have It

The first thing people notice about manga characters is the size of the eyes. Huge eyes make the characters appear young and innocent, and provide a dynamic means of expression. Another reason for characters with large eyes has its origin in Japanese theatrical makeup. To depict ideal beauty, actors often shave their eyebrows and paint them higher on the forehead. The eyes then look huge from the audience's perspective.

Manga Categories: Shounen and Shoujo

Shounen (boys' manga)

Shounen can trace its origins to the work of Tezuka Osamu, creator of *Astro Boy*. *Astro Boy* was a robot boy comic created by Osamu in 1951, and in 1963 was one of the first manga characters animated in his own cartoon. *Astro Boy* was translated into English and broadcast on American television in the 1960s. Osamu revolutionized the art and craft of manga in the late 1940s when he started using cinematic techniques such as dynamic angles and closeups. His stories were exciting

and intense, and more importantly, they did not always have happy endings.

Many shounen manga comics are about Japanese history, combat, action, science fiction, giant robots, and sports such as soccer and tennis. The standard theme is conflict. A single hero and his friends must somehow overcome overwhelming threats. In the course of the story, the heroes usually learn something about friendship, loyalty and the power of spirit. The villains are vile and the heroes always seem close to despair and defeat, but friendship and inner strength usually win the day. There is often a lot of posturing and showing off of fancy martial arts moves or high-tech weaponry.

Shoujo (girls' manga)

Shoujo manga developed in Japan during the 1950s and 60s. Many female artists and writers created stories of character, relationships and depth aimed at middle-school girls. As manga readers aged, manga matured with them, focusing on age-appropriate stories of high school or soap-opera stories of adults in complex relationships.

Shoujo manga tends to focus on slice-of-life stories,

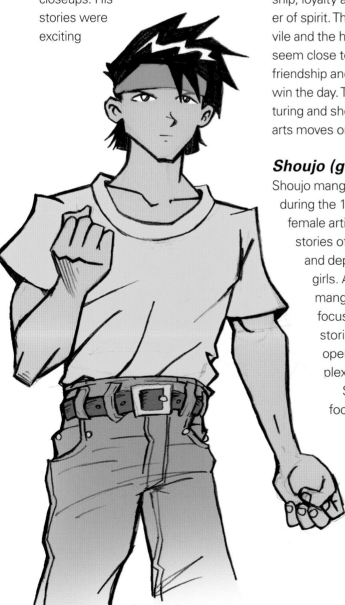

and the fantasy or science-fiction elements all but disappear in manga aimed at older readers. At its heart, shoujo manga is about relationships, friendship, romance and family. Shoujo manga also has a history of wacky humor and over-the-top cuteness at almost toxic levels.

The Basics of Construction

The key to drawing realistically is in observation. If you look closely at the world around you, you'll notice that objects are made up of basic shapes: circles, squares, rectangles and triangles. If you take into account that the objects are really three-dimensional and not flat, you are actually seeing collections of spheres, cubes, cylinders and cones. By combining these basic 3-D forms, you can create an infinite number of new objects.

Every Drawing Begins With Basic Shapes

Don't be intimidated by the complexity of figures or high technology when you set out to draw. You can probably handle drawing spheres, cones, cylinders and cubes. Try drawing these basic forms first. Keep them loose. It only takes a few minutes to fill a page with 3-D forms.

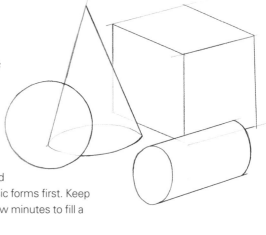

Even a complex object like this delta wing shuttle can be broken down into basic forms.

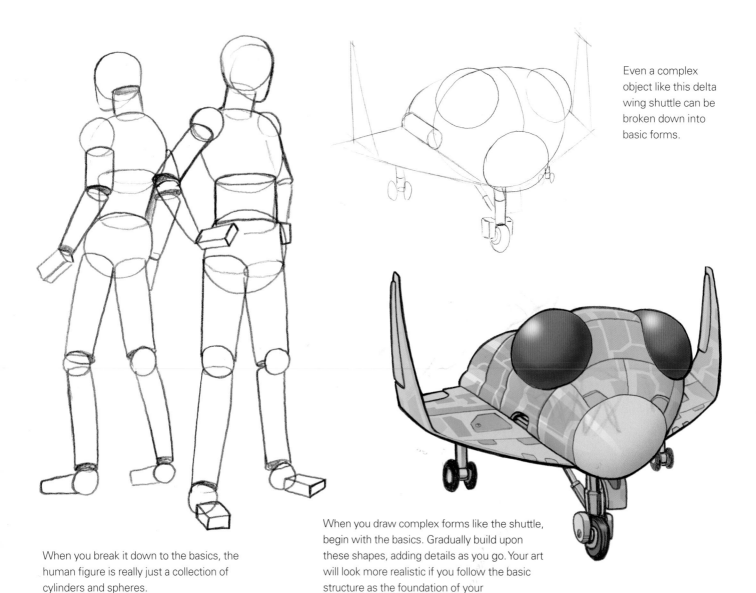

When you break it down to the basics, the human figure is really just a collection of cylinders and spheres.

When you draw complex forms like the shuttle, begin with the basics. Gradually build upon these shapes, adding details as you go. Your art will look more realistic if you follow the basic structure as the foundation of your drawings.

Download FREE bonus demos at impact-books.com/monster-manga-book

Shading and 3-D Effects

To make drawn forms appear realistic, you need to consider the way light falls on them and how they cast shadows. Your shading should have four to six levels (or values) of gray, from lightest to darkest.

The first thing you need to establish is where your light source is located before you begin shading your drawing. To make the drawing more 3-D, follow the form of the object you're shading as you drag the pencil or paintbrush across the paper. Imagine you are wrapping the forms in string and each pencil or brushstroke is a strand. Your pencil lines should literally wrap around the form.

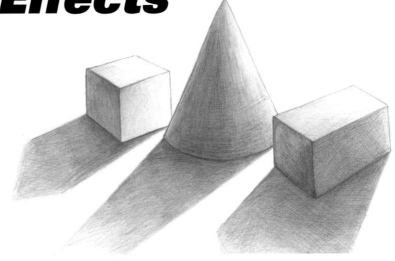

Shade a Few Simple Forms

Know where your light source is before you start shading. Keep the direction of that light the same for all objects in your drawing. The change from light to dark is gradual on round objects and more abrupt on angular ones. When you master shading simple forms, combine them for something more complex. Keep in mind how each form relates to another. The forms will cast shadows and highlights onto each other.

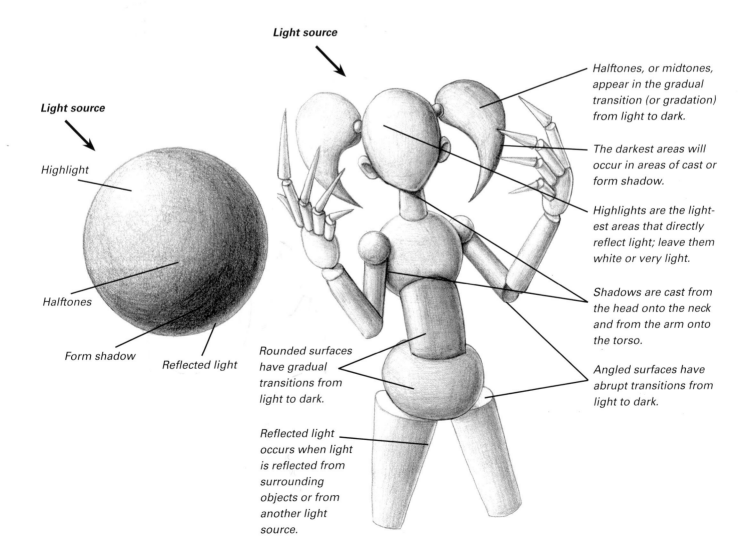

Light source

Light source

Highlight

Halftones

Form shadow

Reflected light

Rounded surfaces have gradual transitions from light to dark.

Reflected light occurs when light is reflected from surrounding objects or from another light source.

Halftones, or midtones, appear in the gradual transition (or gradation) from light to dark.

The darkest areas will occur in areas of cast or form shadow.

Highlights are the lightest areas that directly reflect light; leave them white or very light.

Shadows are cast from the head onto the neck and from the arm onto the torso.

Angled surfaces have abrupt transitions from light to dark.

Drawing Eyes

One of the most striking and recognizable features of manga is the way eyes are drawn. The eyes are large for expression and innocence. Villains and less innocent characters have narrow, more realistic eyes. Innocents have large, expressive eyes. In some manga, the eyes can take up to one-third of the face.

Take a look at how realistic eyes can be exaggerated and distorted to become manga eyes.

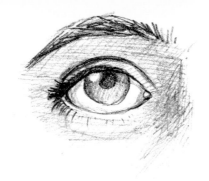

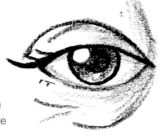

The first eye looks pretty realistic. By simplifying the basic shapes into lines, we can create a more stylized "cartoony" eye.

The eye can be stylized even further. Widening the eye will make the character appear young and innocent. The character's personality should dictate the size of the eye.

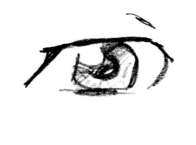

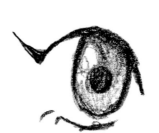

Manga eyes may be stylized in many ways. Don't add too much detail. It's better to draw the eyelashes as a solid mass or add one or two long lashes instead of every single eyelash. Eyebrows should also be drawn solid.

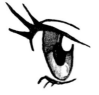
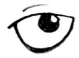
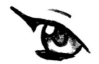
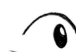

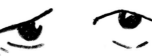
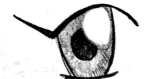

Closed eyes are often drawn as simple curves, usually with some eyelid and eyelash details. Draw tears playfully. When manga characters cry really hard, their eyes shoot large jets of water.

Download FREE bonus demos at impact-books.com/monster-manga-book

Eyes

1 Begin with a simple circle within a circle, or an oval within an oval. Make sure the pupil is in the center of the eyeball.

2 Cover at least one-third of the eyeball with the top eyelid. Keep the details of the eyelashes to a minimum.

3 Add the highlight on the eyeball. This will make the eye appear glassy and reflective. Make sure the light source is the same for all of your shading. Block in the areas of light and dark on the iris.

4 Finish the shading and clean up any extra lines with an eraser.

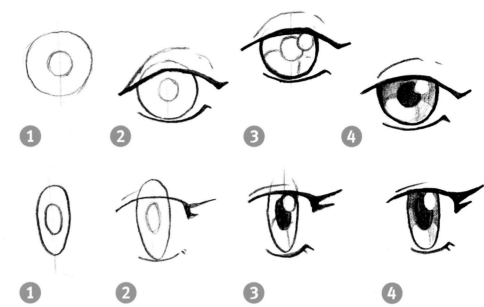

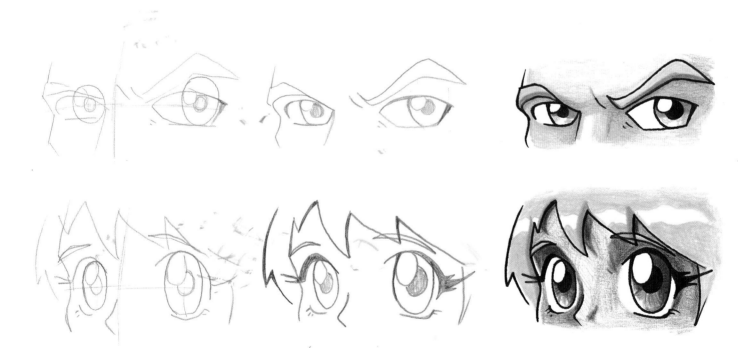

Now try drawing pairs of eyes. Keep each eye lined up on the eye line of the head. Realistic eyes generally have the space of one eye-width separating them. Less realistic ones may have a smaller space or even no space at all between them.

Face
Front View

Manga characters come in all different shapes and sizes. Different artists have unique approaches to drawing faces. Some draw faces round and graceful, while others draw them long and lean. This lesson and those that follow provide a basic framework that should be modified depending on individual characters and your unique style. Use these guidelines to get a sense of proportion and anatomy and then use your imagination to create something original.

1 Lightly draw a circle, then draw a vertical guideline down the middle of it. Sketch the jaw—which can be long and pointed or rounded and soft, depending on the character—placing the point of the chin in the center. Use your ruler to find the halfway point between the chin and the top of the head. Draw a horizontal guideline on a right angle with the vertical line. This will be the line on which you will draw the eyes.

2 Set the pupils of the eyes on the horizontal line, equally distant from the center line. Fill in the rest of the eye details, leaving almost enough room between the eyes for another eye. Leave some room on either side (about half an eye from the side of the head). Draw the eyebrows as solid shapes.

The base of the nose is located halfway between the eye line and the point of the chin. Draw the nose as a simple checkmark

Start Light
Always draw lightly with pencil when you block out the main shapes of your drawings. The lighter lines erase more easily when you make mistakes. Prevent smudges by placing a scrap of clean paper on the artwork under your hand.

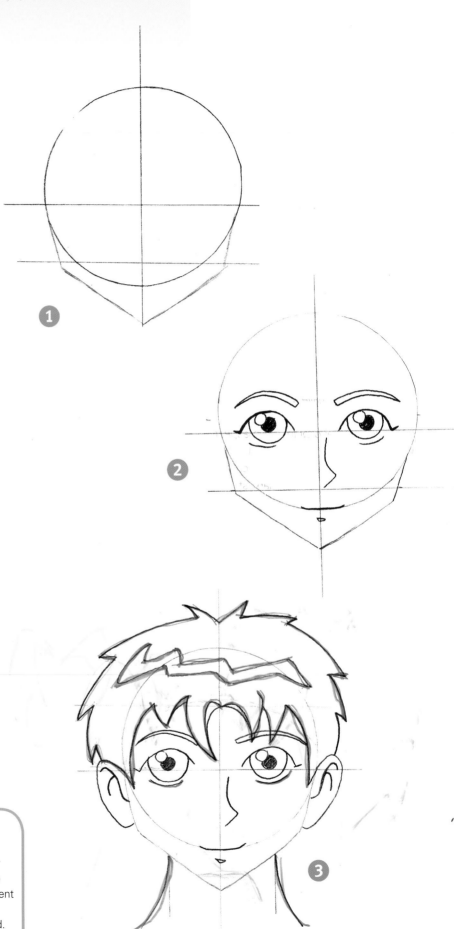

pointing in the direction that the shadows will fall across the face. The mouth is drawn simply and is usually no wider than one eye when closed. When open, the mouth can take up over half the face.

3 Hair should rise off the head with some volume. If hair overlaps the eyebrow or eyes, it is traditional in manga to let the details underneath show through. This allows the artist to use the eyes for expression without changing the hairstyle.

Place the ears between the top of the eyes and the base of the nose. Draw the neck from the point where the ear rises off the skull. This point is usually as wide as the far corners of the eyes, but this can be exaggerated in manga. Usually only very powerful characters have thick necks.

4 Shade the final color image to appear 3-D. Carefully place highlights to show the points that rise off the head and catch the light. Areas of shadow are darkest in the eye sockets under the eyebrows and below the chin.

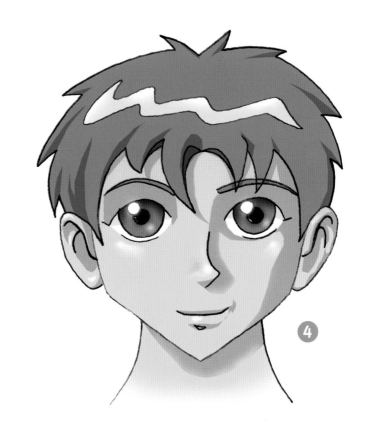

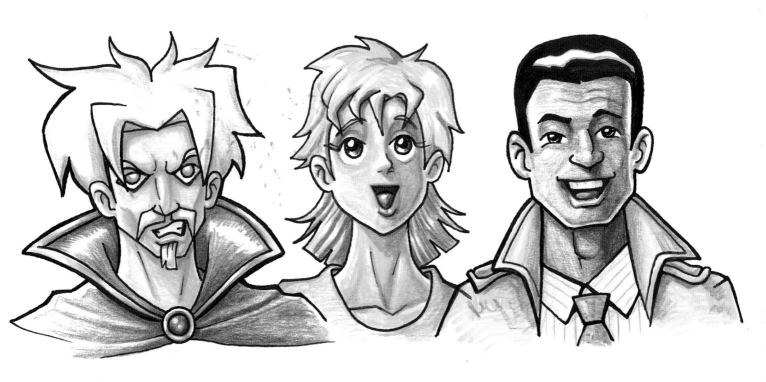

Face
Profile

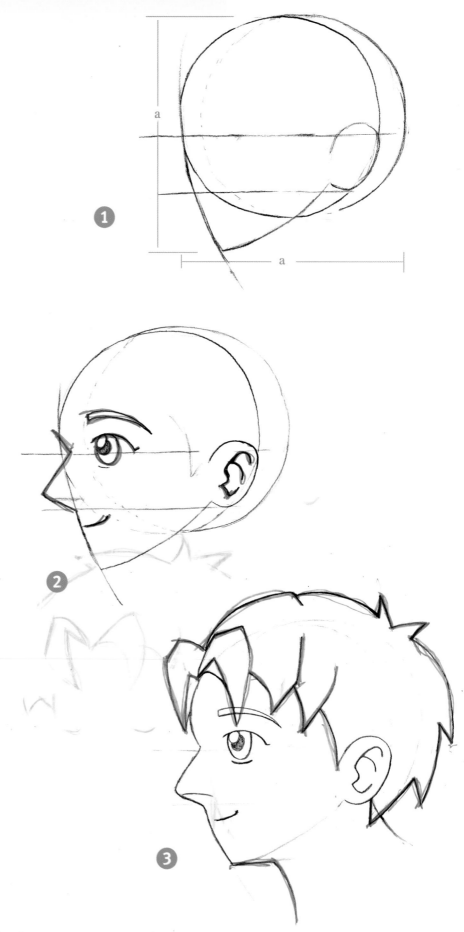

Now that you've mastered the front view, try your hand at the profile, or side view.

1 This gets a little tricky, so pay attention. Start by drawing a single circle, and draw the jaw with two sweeping curves. When you know how long the face will be, measure it (**a**). Use that distance to show where the back of the head should go. Draw a second circle the same size as the first, but move it over slightly to form the back of the skull.

Sketch the eye line halfway down the head, and then the nose line halfway down from the eye line to the chin. Place the ear at the back of the first circle.

2 Draw the eye with the pupil resting on the eye line. The eye shape is different from the way the eye appears from the front. The eye should be set almost one eye distance in from the front of the face. The nose should rise up from the nose line and extend from the face. Don't make the nose too large. The mouth is drawn off to one side, or sometimes not drawn at all. The jaw should slope up to the ear. The jaw of a male character is often drawn in a more' dramatic and exaggerated way than a female character. The ear is seen from the side.

3 Clean up the underdrawing and define the final lines. Be careful not to make the nose too pointy or too squat. The nostril is hinted at with a single line. Have the hair rise above the skull and spring onto the face as manageable chunks of hair.

The neck should drop down from the chin at the back corner of the eye. It should slope back and not drop straight down. The back of the neck begins at the base of the skull behind the ear, sloping back down at an angle.

4 The final color image helps define the shapes and planes of the face using light and shadow. Don't forget to shade the details of the ear and nose. Other details such as the lips may be hinted at as well.

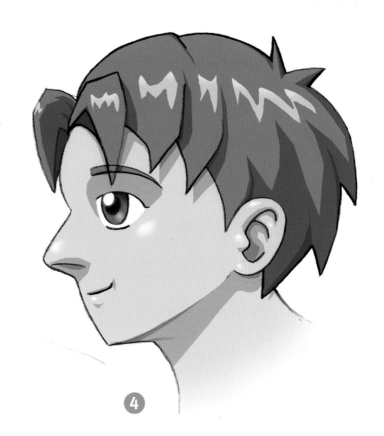

Face
Three-Quarters View

This is one of the most common views of manga characters, but is also the most challenging. Try to think of the face as a three-dimensional object as you draw it. The curved surface will distort some details such as the eyes and nose, as you'll see here.

1 Draw a circle and extend the shape of the jaw down from the circle. Notice how the jaw is off to one side and uneven. The point of the chin is placed about a third of the way across the shape. Draw a curved vertical axis line to show the center of the face. Halfway down the axis is the eye line and halfway between that and the chin is the nose line.

2 Each eye has a distinct shape in this three-quarters view. The eye closest to you is similar to the basic manga eye shape, while the eye on the other side of the nose is shaped more like a teardrop. (Don't forget the highlights!) Indicate the indentation of the cheekbone and the brow ridge by drawing a small arrow pointing at the eyeball into the basic head shape. Block in the nose, mouth and ear with just a few simple lines.

3 The hair rises above the skull, and the nose should appear to rise from the face. Avoid drawing huge nostrils; indicate them with only a simple line. Characters who are bald or have very short hair may need smaller or narrower eyes to avoid distortion. Here, the eyebrows have been adjusted to appear square and more masculine.

The mouth should not have any lip details. Keep the mouth small when closed and really big when open. The neck drops down from the middle of the chin to the area below the ear lobe. Curve the edges out as it drops down.

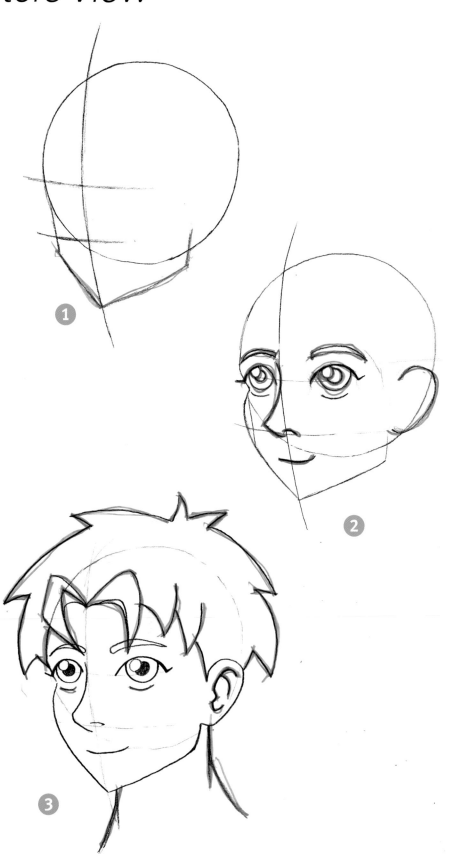

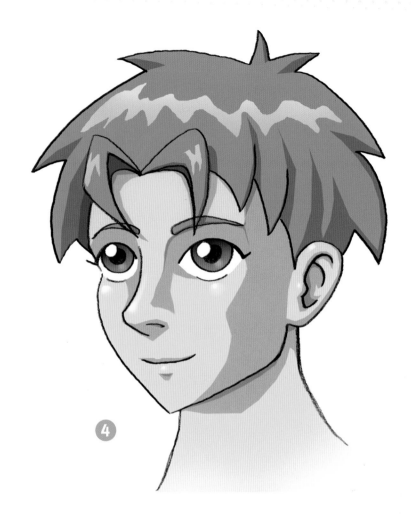

4 The degree of realism you choose for coloring the drawing should be consistent throughout the image. Use shadows to define facial details such as the cheekbones and nose. Highlights add to the realism and provide further structural details such as the bridge of the nose and the purse of the lips.

Human
Anatomical Proportions

Although your manga character drawings don't necessarily have to follow any particular anatomy rules, it's always a good idea to know the rules before you break them.

"Classic" human proportions are surprisingly consistent. Half the figure should be made up of legs and feet. These proportions vary, depending on the age of the character and the level of simplification and stylization of the character.

Adults

- Adult human "classic" proportions range from 8 to 8½ heads tall.
- The neck is about ¼ of the head's height.
- Shoulder width is roughly the height of two heads.
- Wrists begin at the halfway mark of the figure.

Teens

- Teens and the average-size human range from 7 to 7½ heads tall.
- Teen shoulders are often narrower and rounder than adult shoulders.

Super-Deformed

Proportions of super-deformed characters are 2 to 3 heads tall. The difference in size between the chibi (3 to 3½ heads) and the SD (2 to 3 heads) is obvious in this illustration. The eyes are much larger and expressive on the SD head and the face and figure have less detail. Avoid any muscle definition or realistic anatomy.

Children

- Older children range from 4½ to 5 heads tall.
- Children's hands and feet seem larger because the rest of the body is less developed.

Toddlers or Chibis

- Toddler or chibi proportions are often 3 to 3½ heads tall.
- The head appears much larger in relation to the rest of the body.
- Keep the eyes large and expressive.

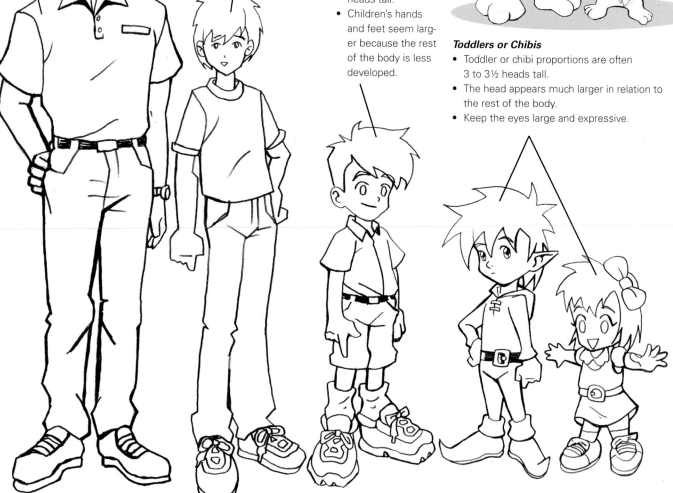

Drawing
Hands and Feet

Drawing hands realistically can be an extremely frustrating chore. This is where many drawings break down. You can only draw your characters with their hands hidden so many times. Many artists also avoid drawing feet. Approach hands and feet like any other part of the figure: Reduce the forms to simple shapes and then add details.

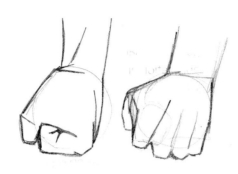

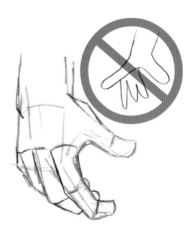

A Fist With Punch
When drawing a fist, keep the thumb up over the fingers. If your superhero punched the villain with his thumb tucked under the fingers, the thumb would break.

No Banana Hands!
Many artists create shortcuts and symbols to get around drawing hands. This is fine for a while, but it doesn't really solve the problem.

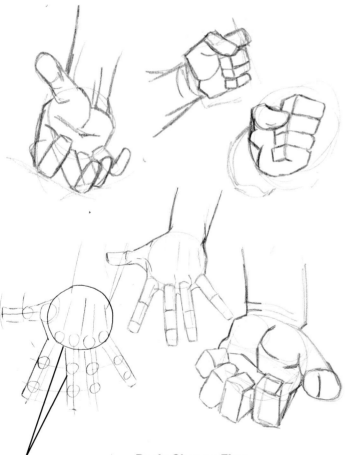

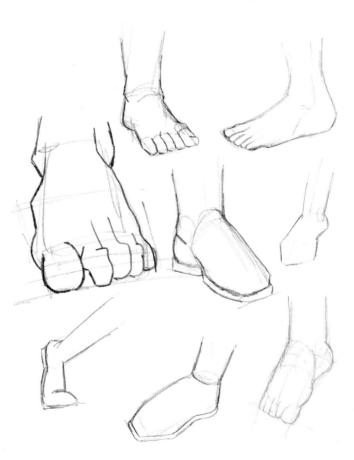

The length of the longest finger is roughly the same size as the palm.

Basic Shapes First
Hands are made up of basic shapes. Once you understand the basic building blocks of the hand, you can draw it in a variety of poses.

Make Sure the Shoe Fits
Draw footwear with the basic shape of the foot in mind. The shoe should follow the form of the foot. Keep references handy so you can add realistic details such as soles and laces.

Pencilling Techniques

Professional comics are produced in stages by several creators: the writer, the penciller, the inker, the letterer and the colorist. Few professional pencillers ink and color their own work. Production deadlines are just too tight to do it all. Consequently, most professional pencillers must create very tight images that appear very much as they will appear in the finished product. This makes the inker's job easier and avoids possible delays and continuity errors.

You will probably be inking and coloring your own artwork, so your pencils can be looser since you will be able to clean them up with ink later. Pencils come in a wide variety of hard (or light) graphite (H) and soft (or dark) graphite (B). The higher the number before the letter, the harder (8H) or softer (8B) the pencil. HB pencils provide a tonal balance between hard and soft graphite.

Pencilling art is often done in three stages: (1) loose gesture and construction drawing, (2) tighter drawing, and (3) detailed rendering.

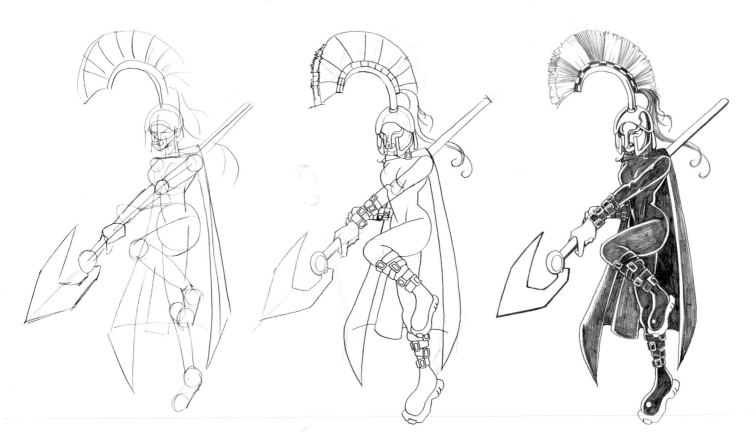

1 Most artists choose a 2B or HB pencil for this sketchy, exploratory stage because softer graphite is difficult to erase cleanly since it smudges easily. Don't press too hard—the harder pencils may create indentations in the paper that could make inking and coloring difficult.

2 Using a softer lead (such as an H or HB), clean up the artwork and tighten the pencil lines. Erase confusing lines and simplify existing lines. Your own style will dictate how you use line in your drawings, but if you keep the number of lines to a minimum, you will produce a much clearer image.

3 The rendering stage adds a 3-D quality to the finished drawing. Carefully vary the thickness of the lines to help define form, value and weight. Indicate areas of shadow and highlights. Instead of filling in areas of solid black with pencil, you may mark these areas with a small "X" to be inked later. This saves quite a bit of time and avoids possible smudging problems.

Inking Basics

More than just "tracing" a penciled image, inking allows the artwork to be developed further. Ink lines are also easier to reproduce, and they will not smudge or fade like pencil. Inked lines are darker and more consistent than pencilled line.

Everyone has individual tastes when it comes to inking. Some people love thin, uniform lines that economically describe the form. Others prefer thicker, more expressive lines. Avoid lines that are too similar in thickness. Try to change the pen size from time to time. Objects that are closer to the viewer or in shadow should have a thicker line.

Ink other people's work to develop your inking skills. Every artist will have a different pencilling style to interpret.

Inking Gear

There are many kinds of reusable and disposable technical pens. Collect a variety of sizes from .005 (thin) to .08 (thick). Use ink that is permanent and waterproof.

Felt-tip brush pens are also available, but they take some getting used to. Ink and crow quill pens have been the most widely used inking tools in comics. They can be somewhat difficult to master but provide more flexibility than technical pens. Brush and ink can create very expressive lines but can be tricky to use competently without lots of practice.

Have some correction fluid or white paint on hand to cover any mistakes.

Inking Don't
Be careful not to make the lines all the same weight as in this image. See how the image looks flat and expressionless?

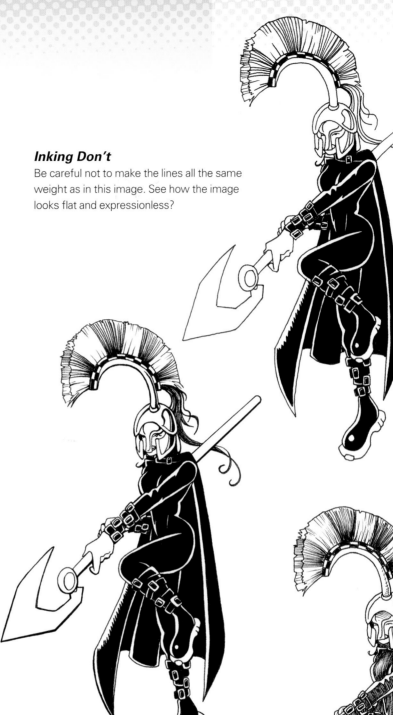

Inking Do
This is better. The lines are crisp and vary from thick to thin.

Inking Overdo!
The extra lines are terribly confusing and do not help the drawing at all. Each line you draw should help define the form and nature of the character, not just fill space.

More Than One Way to Add Color

You can color your drawings in a couple of different ways. No matter what coloring media you choose to use, try to create the illusion that your image is three-dimensional. You want your characters to look real, not flat and lifeless.

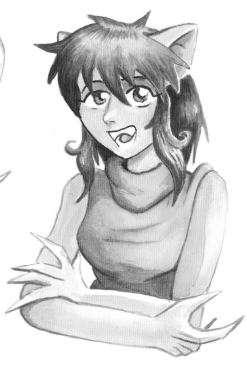

Colored Pencils

Because they are convenient and relatively cheap, this is a good medium for beginners. Both the texture and quality of the paper is a very important factor when drawing with colored pencil. Paper that is too bumpy can be difficult to control. Vary the pressure of the pencils to make the color soft or solid.

Markers

Markers are one of the toughest mediums to use properly because they bleed into paper in almost uncontrollable ways, and they are difficult to change once they are down. Artists enjoy their bright colors and the fact that they look very much like cels used in animation, where color is painted on a plastic transparent sheet (or cel) that is layered with a separate cel of the drawing to make a complete image. Some marker errors can be touched up using a pencil crayon at the end. Shading with markers is usually done to appear as if it were cel shading, with sharp-edged highlights and shadows, mainly because it is difficult to blend softly with markers.

Watercolors

Watercolors are traditionally used in shoujo manga. The results are softer and more personal than the outcome of marker or computer coloring. When painting with watercolors, start with light colors and end with darker colors. It is almost impossible to paint a light color on top of a dark color because the water makes the paint so transparent that you can see through the lighter layer to the darker layer underneath.

Colorless Manga

Most manga from Japan is printed totally in black and white. Printing costs and production time make full-color comics very rare in Japan. Color is usually reserved for covers and promotional art. Often, it isn't until manga is turned into anime that fans see the characters in full color.

Colored Pencil Tips

If you're like most beginners you'll probably start out with colored pencils. Some tips:

- Make your first graphite pencil marks light. Erased lines can show up as "ghost lines" when you draw over them with colored pencil.

- For even coloring instead of streaks, build up areas of color slowly using regularly spaced crisscrossing lines. Pressing too heavily will build up areas of wax that will be difficult to draw on top of.

- Know where the darkest and lightest areas of your drawing are before you start shading. Draw lightly first, then shade in the darker areas. Shade in small circles, applying pressure slowly.

- To darken an area of color, add the color's complement instead of black. For example, add green to red, blue to orange or purple to yellow. This will make your darks vibrant instead of harsh.

- Keep colored pencils sharp for more control.

- Use a white pencil crayon as a neutral medium to blend colors together and to flatten streaky areas.

Acrylic on Acetate

This method really allows you a glimpse at the tremendous effort that goes into traditional animation, where multiple cels may result in only one second of screen time. Simply transfer a drawn image onto an acetate sheet using a photocopier, then apply thick acrylic paints on the back of the sheet to color the image. The shadowed areas are usually blocked in first and appear cel-shaded. If you try this method, use thick craft paint, which covers the plastic better than some acrylics and comes in a wider range of colors.

Computer Coloring

Most manga and comic book coloring is done on computers with programs such as Photoshop and Paint Shop Pro. Shading with the computer can be done smoothly (soft shading) or sharply (cel shading). The program that you use for coloring on the computer will make that decision for you. Coloring with computers requires a good deal of practice and technical ability. Many online artist groups provide excellent tutorials to help you get the hang of it.

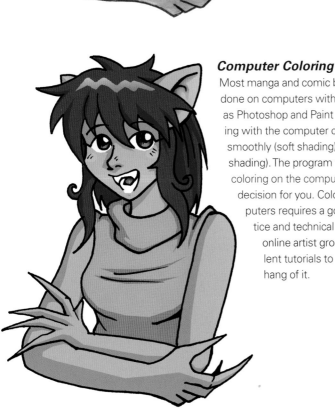

Colored Pencil Techniques

Colored pencils are readily available and produce very professional results with a minimum of cost and hassle. Here are a few techniques that will enhance your hand-coloring.

Shading and Blending

Using layers of similar colors for shading and blending adds depth and richness to a drawing. Change the pressure for dark and light areas. Blend colors evenly by layering color on color.

Shading and Lessening a Color's Intensity

Apply shading to or lessen the intensity of a color by adding its complement. Avoid shading with black, which can look dull and lifeless.

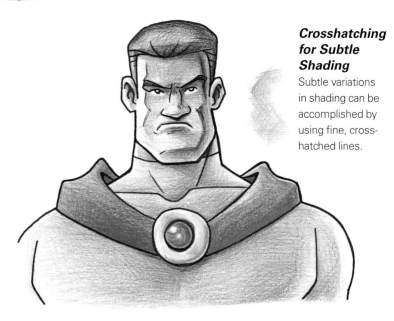

Crosshatching for Subtle Shading

Subtle variations in shading can be accomplished by using fine, crosshatched lines.

Lifting Color

Lift color with an eraser to create highlights and reflections and to lighten areas that are too dark. Erasers can create soft, blended areas of faded color.

Burnishing

Burnishing the surface blends and lightens the colors beneath. To do this, use a white colored pencil over an existing layer of color. The result is smoother, softer blending.

Rubbing

Rubbing existing surfaces can produce interesting textures. Place the paper over the surface and rub with the side of a colored pencil to transfer lettering, shapes and realistic textures.

Creating Patterns

Create a pattern of impressions on the surface of the paper using any dull, pointed object. Then lightly shade over the area with colored pencil. White lines will appear where the impressions were made.

Masking

Use masking tape or pieces of paper to cover areas of the drawing, saving defined edges. This technique is very effective for highlights.

Colored Pencil Don'ts

Ouch! Colored pencils can be trickier to work with than you think. Watch out for smudging; rest your hand on a scrap piece of paper to avoid direct contact with your drawing, keep waxy or powdery buildup off the paper and have an eraser handy. Don't just scribble color into an area; follow the 3-D form of your subject.

Another common problem is ghost lines. These unwanted white lines show up when the surface of the paper has been unintentionally scratched or impressed in any way. It is possible to make some ghost lines disappear by pushing hard when coloring, or burnishing and blending with a white colored pencil.

1 BASIC MANGA CHARACTERS

Manga is full of dynamic images and unique stories. Start creating your own! First, we'll look at the basics of Japanese comics—including the culture and style references that set it apart from other ways of drawing—then practice building characters step by step, from pencil sketch to full color. Hero or villain, chibi or giant, mecha or mega-cute, your manga cast is ready to be drawn to life.

Expressing Emotions

Manga characters can express a wide range of emotions. Is your character happy-go-lucky? Out for revenge? About to be obliterated by a giant raging robot? Then his or her face should show it. Here are some of the more common and manga-specific emotions. Try using a mirror to see your own face to get the expressions you want.

Pleased
Eyes closed in delight, high eyebrows and a smirking lop-sided grin.

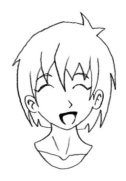

Laughing
Closed eyes, high eyebrows and an open mouth.

Happy
Bigger eyes with large high-lights, high eyebrows and a triangle-shaped open mouth.

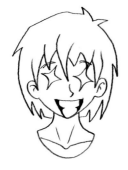

Joyous
Sparkling eyes and a huge smile. If the sparkles were replaced with dollar (or yen) signs, then the entire mean-ing of the expression would change.

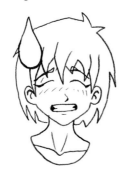

Embarrassed
Slanted eyes and eyebrows, teeth clenched apologetically and blush lines. A sweat drop is a dead giveaway that a character is embarrassed or stressed. The larger the drop, the more intense the emotion.

Confused
Tilted, limp head, raised eye-brows, mouth hanging open and blush lines. Add a stream of drool and spiral eyes for extremely confused characters.

Sleepy
Slanted eyes and eyebrows (showing the effort of keep-ing the eyes open), blush lines and undereye bags. A noseless face brings atten-tion to the tiny mouth and exhausted eyes.

Pearly Whites
Showing teeth in Japanese culture is considered impolite and even ugly. Historically in Japan, teeth were often cov-ered with a black paste to make them invisible. It is still con-sidered polite to hide your mouth when you laugh or giggle. Young manga characters often show teeth to express their youthful ignorance or crassness. Show teeth in a smile only to reveal the tactless and careless nature of the character.

Sly
A lopsided grin, narrow eyes and scowling eyebrows.

Pouting
Even narrower eyes; tight eyebrows with a single wrin-kle between them, and a raised lower lip (a frown, of course!) that almost touches the nose.

Download FREE bonus demos at impact-books.com/monster-manga-book

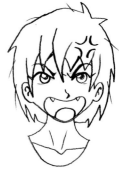

Bored
Intense (but not angry) eyes and mouth turned slightly downward. The eyelids grow heavier as the character becomes more and more bored.

Annoyed
Extremely narrow eyes, arched eyebrows and a small, pursed mouth.

Angry
Small, intense eyes and mouth open on one side, muttering a complaint or rant. The eyes might stare at the offender in an almost dis-believing way.

Enraged
Wild eyes, highly arched eye-brows and loose hairs. Char-acters who are really at their wit's end may sprout fangs or have a raised vein (indicat-ed by the star shape above the eye).

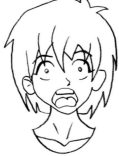

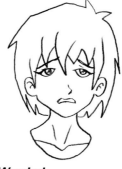

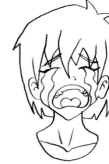

Shocked
Wide-open eyes with small pupils, arched eyebrows and an O-shaped mouth with an indication of a lower lip.

Terrified
Even wider eyes with small pupils and a mouth open wide with the top teeth showing. The character appears to be gasping or screaming.

Worried
Eyes and eyebrows that rise in the middle, an open mouth wavy with uncertain-ty, and a worry line or two on the forehead.

Crying
Slanted eyebrows, streams of tears and a wide-open mouth with the bottoms of the top teeth exposed as the head is thrown back in agony or despair.

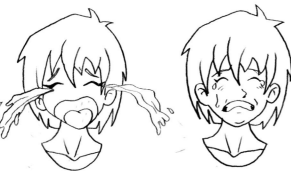

Bawling
Mouth open wider, eye-brows slanted even more and fountains of tears leap-ing from the eyes.

Blubbering
Eyes squeezing out tears, a flushed face and an open, frowning mouth revealing clenched teeth. The charac-ter is trying very hard not to cry, but she can't help it.

Yawning
An O-shaped mouth reveal-ing the tongue and both sets of teeth; blush lines, very high eyebrows and tiny tears escaping from heavy eyelids.

Smug
Wide and challenging eyes topped with angry eye-brows, and a haughty smirk dimpled to one side.

Mischievous **Chibi**

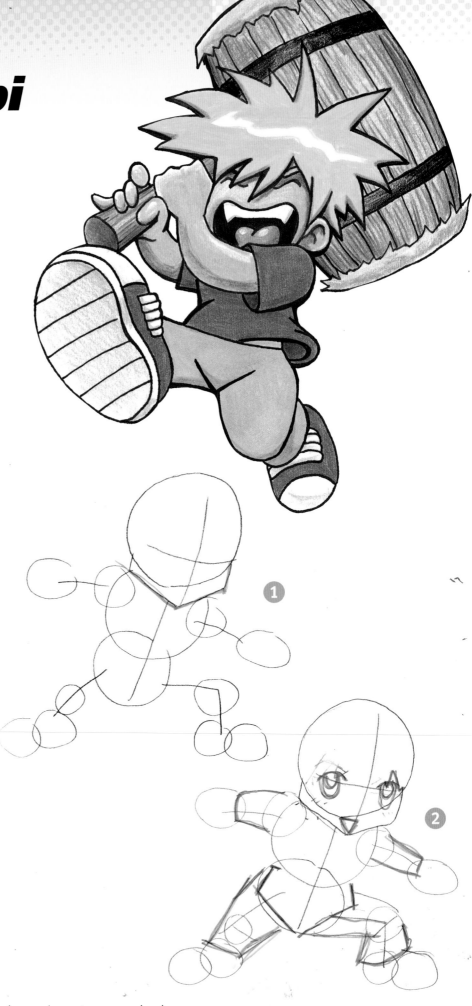

Chibis are used for comic relief, balancing the action and drama with a wacky, super-deformed (SD) version of a character running around in a youthful, carefree way. Chibis often cause all kinds of mischief, violence and property damage, which usually disappears when the characters return to normal from their SD forms.

Use chibis to break up tense situations or when the story is taking itself too seriously. They should be silly and off-the-wall, doing ridiculous things. Let them run up the sides of buildings, heave tanks and haul giant hammers out of the air to flatten their opponents. Just remember, nothing that happens in chibi form should really alter or change the course of the story.

1 Roughly place the main body segments plus the shoulders, hands, knees and feet. Use the chibi proportions of 3 heads tall. Some chibis are pudgy and babylike; others are long and lean. Make the proportions suit the character. Draw the eye line and vertical axis on the face, turned slightly right.

2 This chibi is happy (wide eyes) but ready to cause some mayhem (arched brows and blush lines). The eye on the left is just a bit larger than the other, since his head is only slightly turned. If turned more, the difference in size would be bigger. Lightly flesh out the arms, position the hips and give him some pants. This little guy looks like he's surfing. If his body language isn't working, change it now before moving on.

3 Start using heavier lines. Wild, unruly hair gives him some personality. Make sure the hair rises off the skull, but don't forget that gravity has some effect on man-

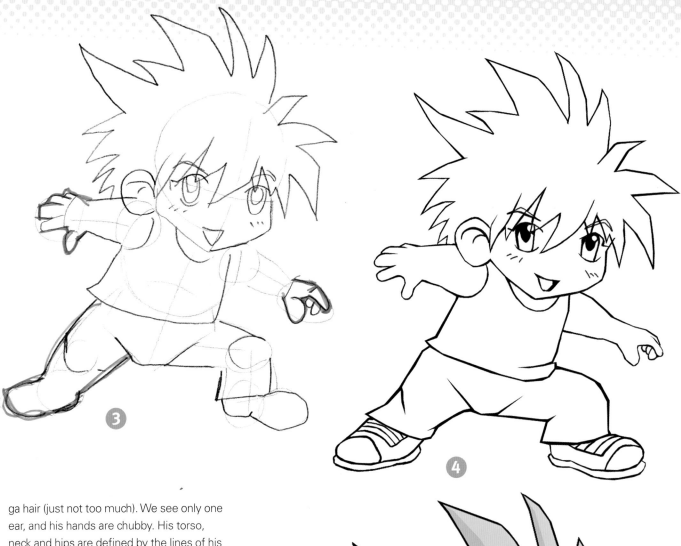

ga hair (just not too much). We see only one ear, and his hands are chubby. His torso, neck and hips are defined by the lines of his clothing. Avoid an amateurish, pasted-on look by drawing his clothes to fit around his basic form.

4 Erase the light guidelines and clean up the drawing. Your final lines should be solid and confident, not sketchy and timid. Trace over your rough drawing with a clean sheet if you want to. Flesh out the arms and leave highlights for the eyes. Make sure his clothing has folds and creases, so he's truly wearing it. Add a pair of sneakers and he's ready to run from anyone who tries to stop his fun.

5 With some shading and color, this guy's ready to go. I changed his tank top to a sleeved T-shirt because I wanted his head to contrast or stand out against the red sleeves. You decide how far to take the details. Don't forget the highlights on his hair.

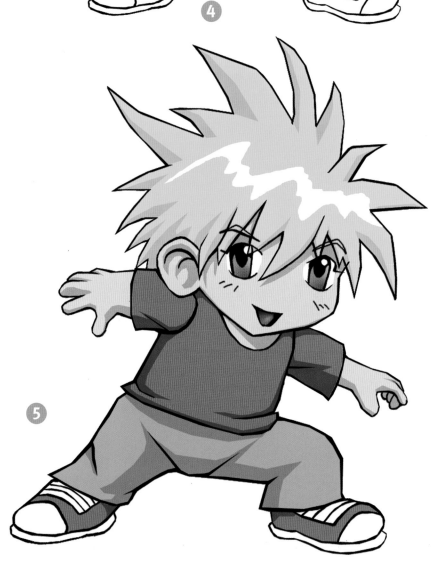

| Dashing
Hero

The Dashing Hero is young, confident and looking to take revenge on the Big Bad (his archrival) or to right some wrong. He is usually on his very first adventure and almost always falls in love with a woman from the "dark side." Their love could be tragic, or it might be exactly what's needed to stop the two sides from fighting each other.

1 This hero will have a strong stance: feet firmly planted, posture strong, one fist clenched. Make sure the feet are balancing his weight well and that his proportions are correct (8 heads tall). Draw the jaw, eye line and vertical axis on the face so that he's looking at you head-on.

2 Add some muscle mass to his arms and legs. Don't draw him bulky; our hero is fit and trim. His hips should be narrower than his chest. Add a neck and nose line and he's starting to look human. Adjust the position of his left foot so it doesn't jut out to the side so much. The hand at his side starts to take shape.

3 Start erasing the skeletal lines and strengthening the basic outlines. A dramatically raised eyebrow hints that this guy is on a mission. His messy hair is held up off of his head (and out of his way!) with a headband.

Take It Easy!
Make the main character in your story easy and fun to draw. You will be drawing that character on nearly every page and panel of your comic.

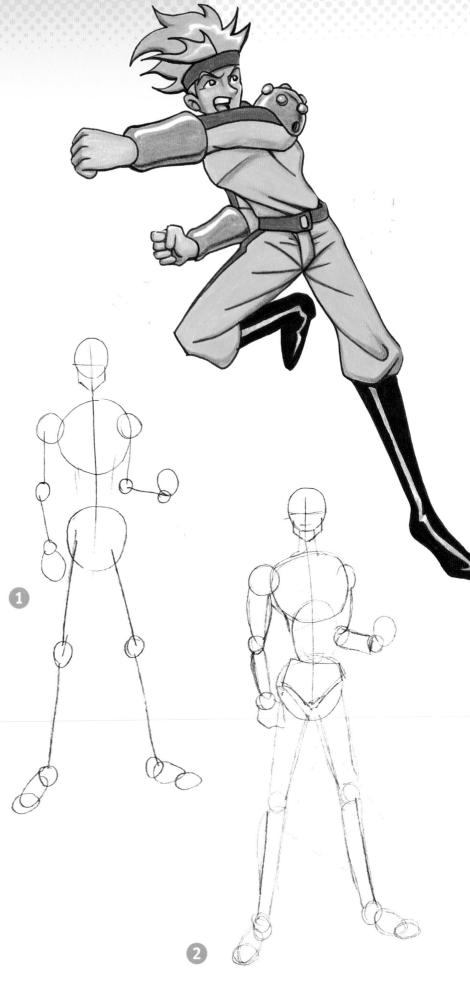

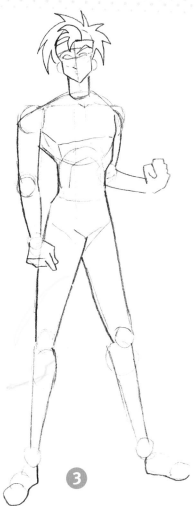

3

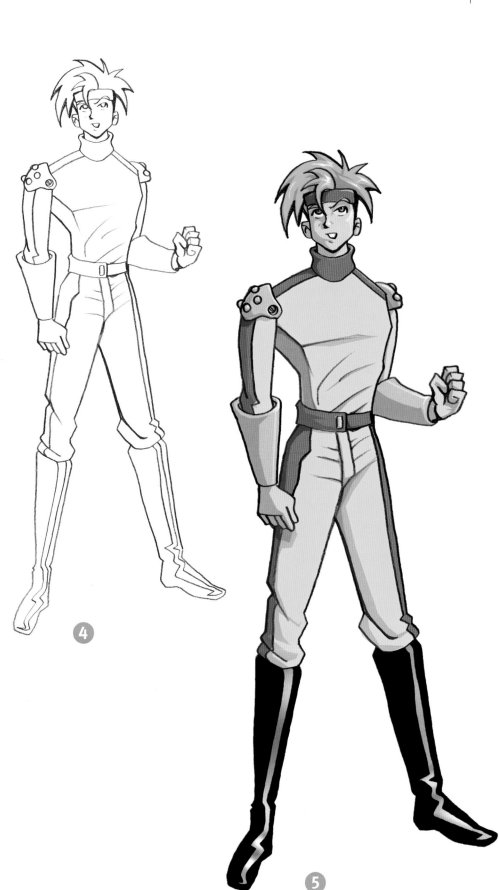

4

5

4 Finish erasing the light guidelines and dress him in a costume. I've drawn him wearing his giant-robot pilot jumpsuit. He has big, shiny boots (highlights down the center) and protection for his forearms and shoulders. Lines and creases show not only how his clothing fits but how buff his physique is. Refer to your own fists to draw his.

5 A jumpsuit in bright yellow and red makes this character really stand out from the crowd. Blue hair and green eyes give him an exotic, cool look. Pay attention to where the light source is located (here, the front right) when you are shading and placing highlights to give him 3-D form. Shadows should follow folds and creases on clothing; the hand at his left side casts a shadow on his leg; the deep shadow down the left of his torso defines his muscular form.

Magical Girl

The Magical Girl is usually a popular but somewhat ditzy girl in middle school or high school who has lots of embarrassing problems. Somehow she is the heir of special powers and abilities that are triggered through a magical item.

Costume details are very important for Magical Girls. The costume should be elaborate and unusual, but have a playful, feminine appeal. Some Magical Girls get a makeover every time they transform to their heroic selves. The details of the costume can be an interesting sidebar to the main story.

1 This preteen is about 6 heads tall and tilts her head in a three-quarters view. Make sure her skull is bigger in the back or she'll look like the back of her head was cut off. Try a strong stance: legs and feet together, head centered over the base of her feet for balance. Her raised hands are positioned to cradle her scepter, the source of her magical powers. The arm closer to us will look slightly bigger.

2 The arm on our right covers her torso, but lightly draw the covered part anyway; you can erase it later. If you don't know what's going on beneath the arm, you might get unwanted figure distortions. Sketch her costume details. Her power of flight will come from magic mechanical wings. Clunky shoes give her a sense of gawkiness, as if she hasn't quite grown into her role. She's young and innocent, so make her eyes huge. Her fingers gesture playfully, making the scepter seem light-weight.

3 Start cleaning up the details. Her short hair reflects her perky personality. If a Magical Girl's hair is longer, it's usually in ponytails or braids. Her dress mirrors her wings, and her winged headband tops off her aerodynamic look.

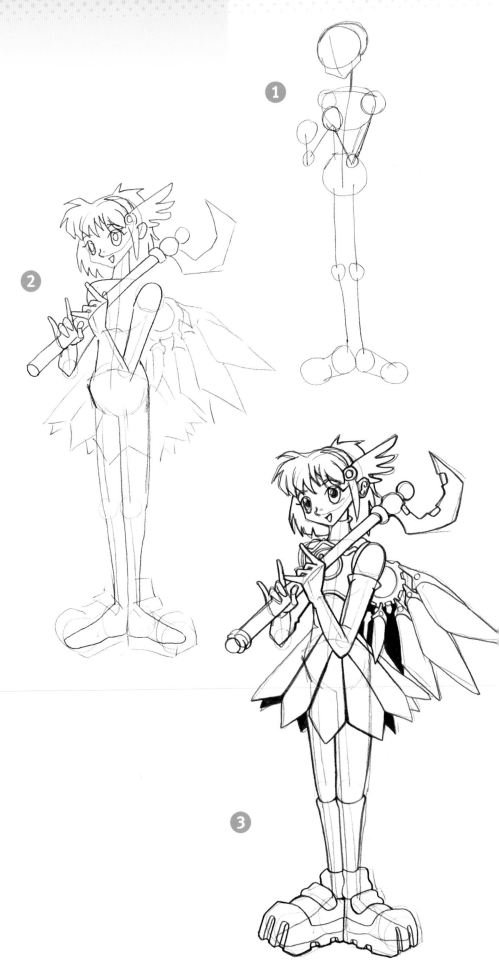

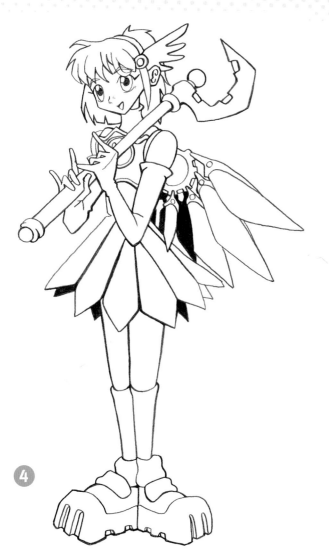

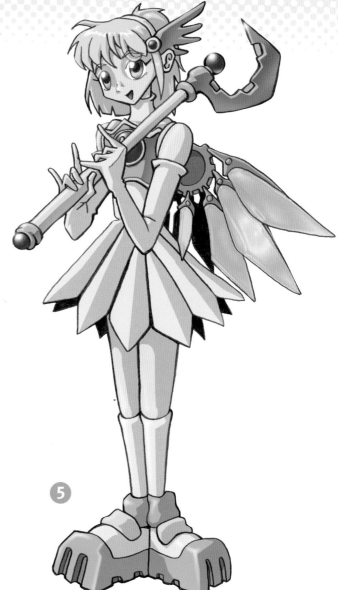

4 Erase the remaining guidelines or trace the figure on a clean sheet. Alternately, you may ink the figure with a pen at this stage. Be sure that the ink is totally dry before you erase the pencil lines or else you will have a smudge on your hands.

5 Color choices are very important and symbolic for the Magical Girl. In this case, she is blonde and blue-eyed to show innocence and purity. Her costume is predominantly blue, a color representing spirituality and the otherworldly. Her scythe-like scepter is decorated with two rubies and she has similar gems on her chest and headdress. She's ready to fly!

What Every Magical Girl Needs

- A cute animal mentor or sidekick who can identify the bad guys.

- A team of friends who assist her in the battle against evil.

- Mysterious allies who help, then melt into the shadows.

- The ability to transform from a mild-mannered girl into a magical warrior. To transform, she needs to utter special words or use special items.

- Magical powers triggered by catchy names like "Gold wing feather blast!" or "Cosmic love power strike!"

- Elaborate, ever-changing costumes.

- An unattainable love interest who doesn't notice the normal girl, but is interested in the Magical Girl.

- A long history that links her to a mythical past that has been hidden or forgotten. She often has a royal connection; she may be the princess of a forgotten kingdom.

- A familiar setting such as a school where the character's innocent past conflicts with the new responsibilities of magical power.

Rebellious Hero

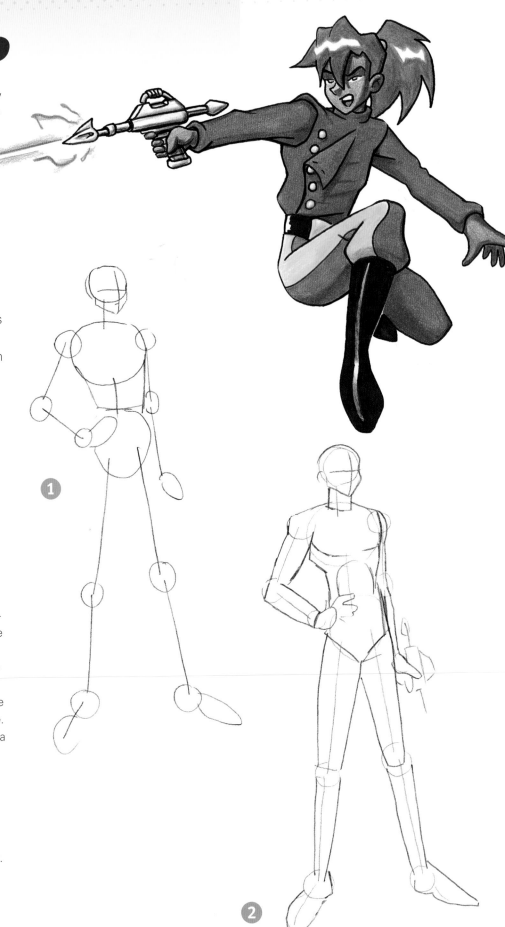

The Rebellious Hero is the shadow side of the Dashing Hero. Usually just as strong and capable, the Rebellious Hero lacks the discipline and control of the Dashing Hero. Strong and powerful emotions cloud his judgment and cause him to act rashly, putting everyone at risk.

Often the most powerful character in the group, the Rebellious Hero lacks the cool-headed charisma to be a leader. He is constantly frustrated with his role in the group and is prone to royal temper tantrums if his brilliant ideas are shot down by the Dashing Hero. He often makes a deal with the dark side that threatens the whole group, but provides valuable insider information about the bad guys. This betrayal must be repaid with his life or some form of redemption, such as admitting he's wrong or rescuing the Dashing Hero during the climactic struggle.

1 Notice how the weight of this character is placed on his left leg. At first the character seems ready to react, but is distant or withdrawn, standing apart from the action. The character is somewhat off balance. When standing slightly off center, the character appears sleeker and more catlike. The hand on the hip suggests attitude and a slight superiority complex.

2 Avoid making the character overly muscular. He should appear somewhat stronger than the Dashing Hero, but more sophisticated. Even his gear and weaponry should appear refined and sleek.

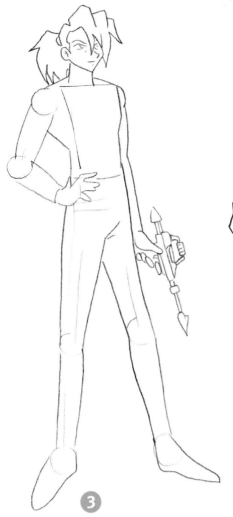

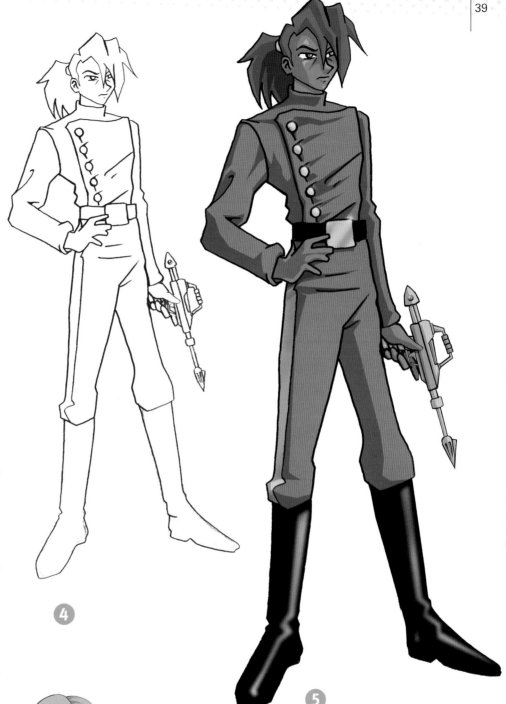

3 Both the character's attitude and personality are revealed in the pointy chin (a sly, foxlike feature) and narrow eyes (less innocent). The weapon design echoes the sleek lines of its owner.

4 Fix the anatomy to maintain both proper proportions and the sleek look, and develop his old-fashioned uniform. The personality of the character is totally developed by this stage. His stance is impractical, but adds to the smug air of superiority his sneering face seems to express.

5 I chose to make his costume red with gold accents because it is the opposite of the Dashing Hero's yellow color scheme. In Asia, red signifies luck and celebration while yellow is the color of imperial sacredness. The color choice makes the Dashing Hero seem purer than the Rebellious Hero.

Rebel, Rebel...

Many online shrines have been dedicated to these lovable, yet doomed antiheroes. The Rebel's appeal lies in his world-weary confidence and street sense as well as his refined, elegant appearance and fashion sense. The Rebel is free to act outside of the rules and that makes him more dangerous and interesting. The dark side of the Rebellious Hero creates more conflict and inner turmoil than the Dashing Hero, who is often a victim of fate. The sacrifices of the Rebellious Hero create unforgettable drama and add an unpredictable reality to the manga.

The **Kid**
(Shounen)

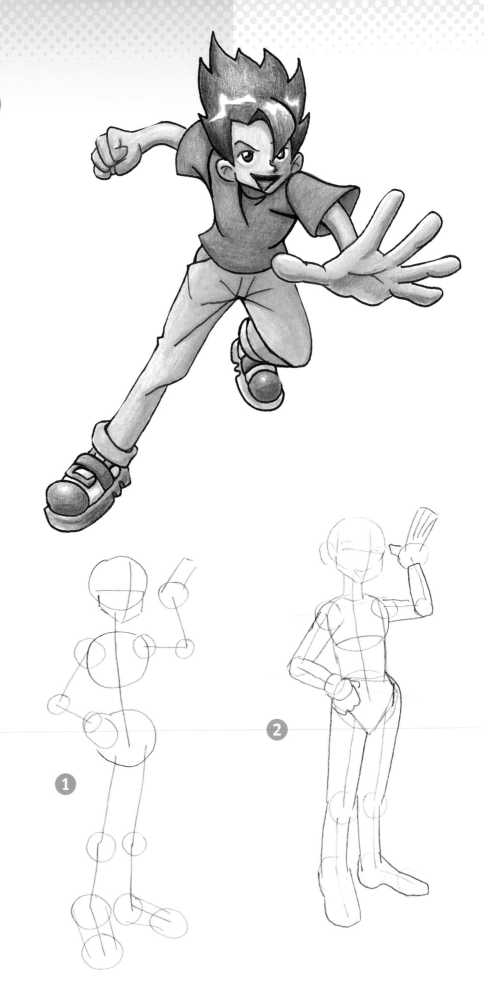

Hundreds of manga stories have been devoted to the courageous boy who befriends the giant monster, pilots the robot armor or sets off on a heroic quest to save the kingdom. Shounen comics are all about overcoming obstacles and achieving personal bests. Even older readers respond to manga about children because they once had to go through the same things as the characters. Nostalgia for times past and the innocence of youth is a common theme in anime and manga.

The kid can be a younger brother to the hero or simply a tagalong for the adventure. Often the kid operates in a group where he's treated like a mascot and must constantly try to prove himself worthy of adventuring with the older characters.

1 Children are normally 4½ heads tall and have slightly larger heads than adults. Keep the neck thin and no more than one-fourth of the head's height. Don't forget to draw the back of the skull when drawing a three-quarters view. Notice how the feet point out like a "V" in a three-quarters view. Keep one foot higher than the other, grounding the character in the picture plane.

2 Keep the body cylindrical and avoid drawing obvious muscle details. The character should still have some baby fat on him. Keep things fairly soft and rounded. The body language is positive and sort of silly at the same time. The gestures are awkward and exaggerated.

3 Manga kids have wild hair with lots of cowlicks and spikes. Pay attention to the folds and wrinkles of the clothing. Think 3-D by drawing arm holes, the neck hole and jeans cuffs. Lines indicating his pockets

Download FREE bonus demos at impact-books.com/monster-manga-book

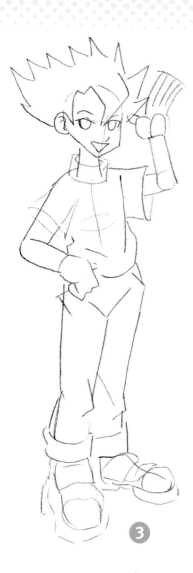

3

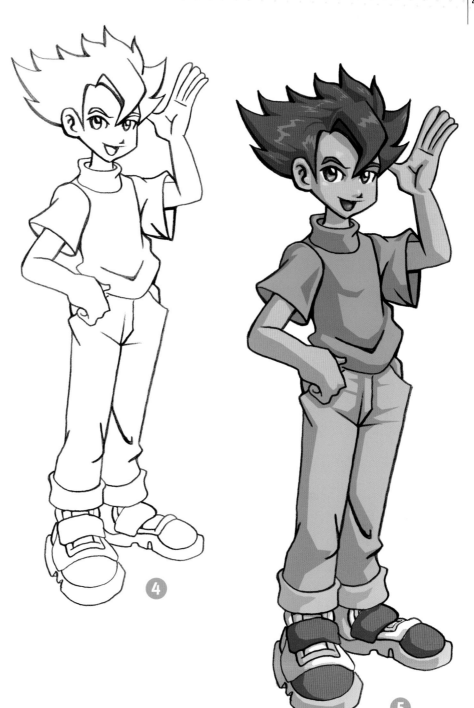

4

5

and knees should jut outside the main lines of the pants. Erase some of the rough construction lines as you work.

4 Control the weight and pressure of your lines. Darker, thicker lines appear weightier; use them for areas of shadow or emphasis. Outlining the figure with only heavy lines flattens the image. Alternating thick and thin lines give the drawing a stronger sense of 3-D form.

5 When you begin shading, the most obvious clue about where the light is coming from is found in the eyes. Look for where you put the highlight. That will be the side of the figure that the light falls on. Add a few more details such as wrinkles and hair texture as you add color.

Boy's Day!

May 5 is Children's Day in Japan, but the main focus of the day is a festival celebrating boys. Carp windsocks decorate rooftops, one for each boy in the family. The carp is a symbol of power and resourcefulness in Japan because it battles the rivers and streams to travel upriver. May 5 reminds Japanese boys that they can overcome any obstacle they encounter to become successful and capable men.

Girls
(Shoujo)

Girls are the lead characters in most shoujo manga, but they play an important part in many shounen manga, too. The girl is often a younger sibling of an older lead character. If the girl is the focus of the story, she may even have a younger sibling who provides comic relief and who might need rescuing from time to time. Girl characters usually develop from mundane surroundings and become strong, capable adventurers.

1 This kneeling position is a very difficult pose. Many details are hidden by the overlapping arms and legs. At this stage you should know where everything goes. Don't be afraid to draw what is hidden by other body parts. Keep the lines light and darken the proper outlines that are not hidden by other body parts.

2 Don't make her too lean. Children still have some baby fat, so think of their arms and legs as plump sausages. Keep things rounded and avoid sharp angles. Think of the figure as a series of interconnected cylinders and spheres. Note that the hand closer to you is lower than the other, and fanned out like a pie slice so that all the fingers won't look the same size. Things that are closer to you overlap and hide things that are farther away.

3 Work on details of the anatomy, face and hair. This is the stage where you should dig through your resources or imagination to come up with some ideas for hair styles and clothing. A bouncy ponytail is perfect for this little lady. Clean up any extra lines that might be cluttering up your drawing.

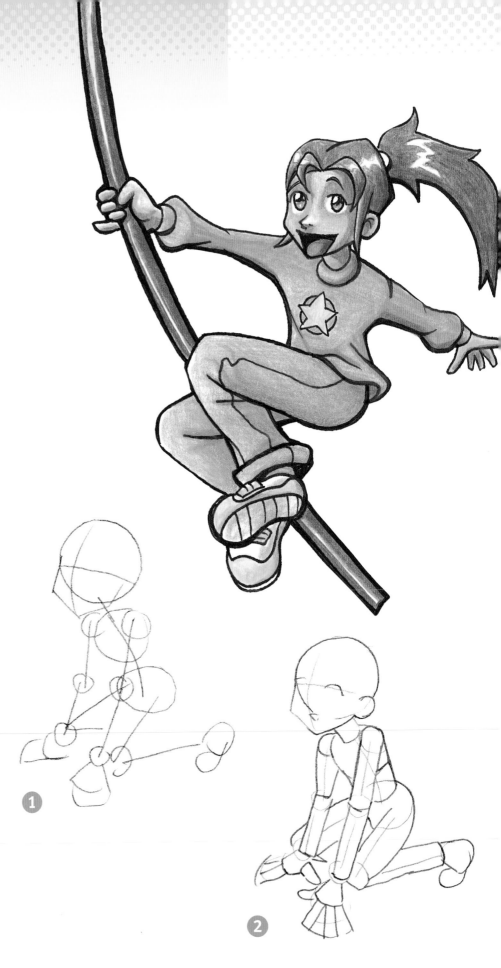

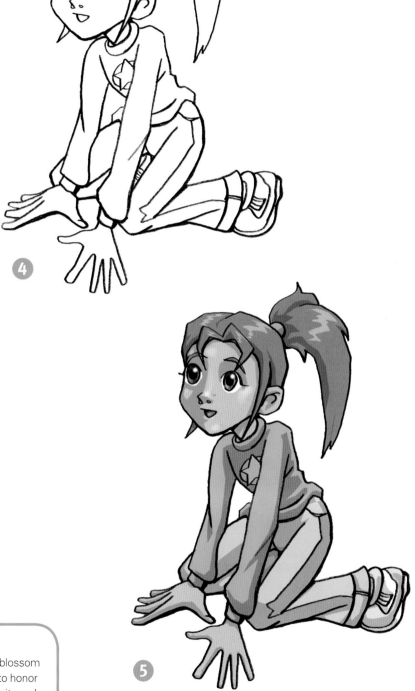

3

4 This outfit is both realistic and contemporary without being too specific. Make sure that the folds give the impression of a rounded form existing in 3-D space. Consider the folds as lines that wrap around the arms, legs and torso. Revealing the bends and shapes with wrinkles and folds makes the drawing more convincing. Two tiny nostrils and a small check are enough to indicate the upward tilt of her nose.

5 Keep the colors fun and light. Details such as the star shirt may provide symbolic clues about the role of the character in the story or could simply be for decoration and fashion.

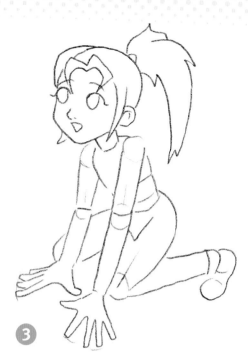

Girl's Day!

March 3 is a doll festival and a peach blossom festival in Japan. It is a day set aside to honor the feminine traits of refinement, serenity and self-control. Houses are decorated with elaborate doll displays and peach blossoms.

| # The **Big Guy**

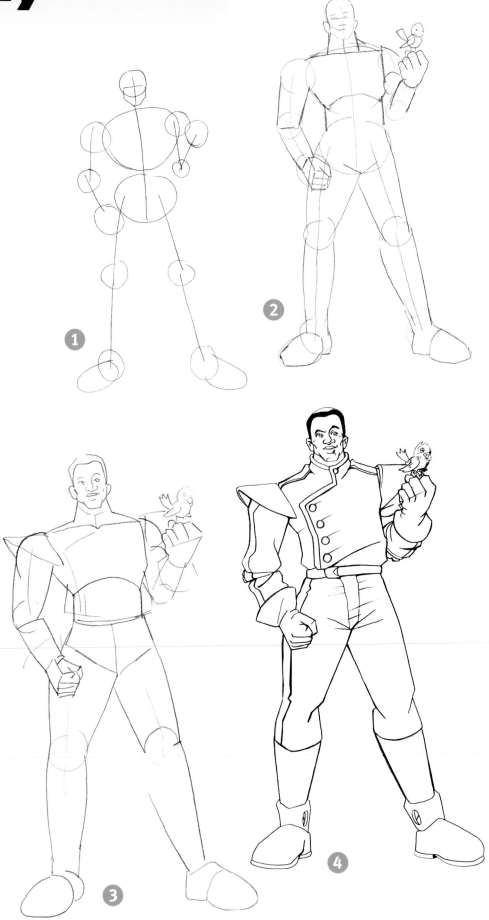

The Big Guy is a lovable lug, a two-fisted bruiser with a heart of gold. At first glance he appears fierce and powerful, but he has a weakness for food, cute animals or pretty ladies. He's often a simple peasant with superhuman strength. He is usually the largest of the group and, being an obvious target, is often the first to fall. He is a loyal friend to the Dashing Hero and often takes care to nurture the Kid when he can. He may primp and preen when the Magical Girl passes by, but blushes and stutters when she confronts him.

The Big Guy is the heart and soul of the team, not just the mindless muscle. He might be the computer expert or chemist of the group. You can't always judge a book by its cover.

1 You can really go nuts with the proportions when you want to. The chest circle in this gesture study is huge. Everything has been supersized except the head. Keeping the head smaller gives a sense of bulk and power to the figure. Notice the slight twist of the hips and shoulder. Most of the figure's weight is placed on his right leg.

2 Make the neck huge. Be aware how it arcs out from below the ears and slopes down to the shoulders. The figure should be big and strong, but not a muscular powerhouse. The tiny bird was added with simple shapes. Adding details like this makes the character more sympathetic.

3 Block in basic costume features. Elements such as the details of the nose, cheekbone and jaw help define his character. He's larger and physically stronger than the others. To draw his fists, just treat them like boxes at the end of his wrists. I usually start by drawing the back of the hand as a rectangle in perspective, then add the thumb and fingers.

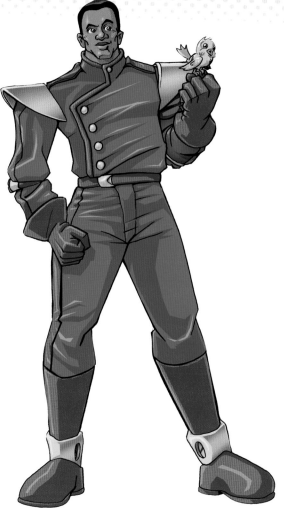

5

4 This costume gives him a very militaristic or policelike appearance. The shoulder pads make him look even bigger. The clothing folds and creases help define the figure and the points of tension in the costume. The buttons, for example, seem to be pulling on the front of his shirt. Wrinkles appear where clothing is overlapping or responding to being pulled. Draw the bird as cute as possible to take the edge off the clenched fist.

5 The final shading and coloring should add detail and information about the clothing. Don't just color in your drawing like a picture in a coloring book; reveal the 3-D form of the character and make it come to life. Instead of straight lines, the wrinkles should be curved to define the figure underneath.

A Five-Star Lineup

The Big Guy rounds out the classic structure of the "five warrior team", which is found in many manga, anime and live-action sentai shows. Even the popular *Star Wars* films have used this team structure with much success. The Dashing Hero often joins with the Big Guy, the Princess and the Kid to fight evil. The Rebellious Hero joins the fight reluctantly, arguing with the Dashing Hero. Sometimes the Big Guy and the Rebellious Hero are a team, with the Big Guy providing a sentimental balance to the hard-hearted rebel. There is usually a strong connection between the Kid and the Big Guy.

The *Mascot*

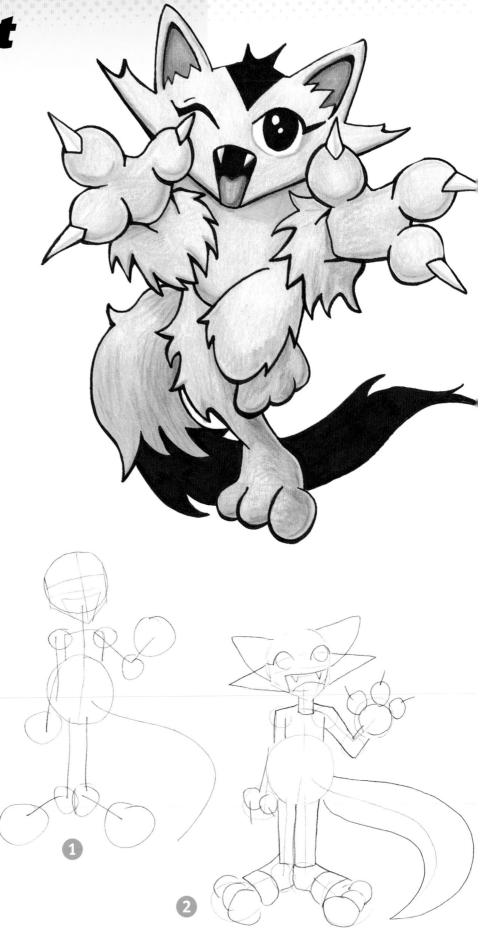

Where would the mighty hero be without the lovable Mascot? The Mascot can be a pet or alien creature, or even a mechanical being. Either way, the Mascot should provide endless amusement and trouble for the heroes. It is the Mascot who reveals their hiding place by sneezing, breaks the computer or embarrasses the team at the most untimely moments.

The most common form of the Mascot is a strange hybrid of cat and rabbit known as the "cabbit." Any other animal features are fair game to throw into the mix, such as fox tails, bat wings and antennae. The Mascot usually has one standard catchphrase or sound that it repeats over and over again. It's a good thing it's cute!

1 Keep things loose and round at this stage. The Mascot should be simple and cute. Use the chibi or child proportions if the figure walks around on two legs like this one. The Mascot can do anything you want it to do; just keep the figure 3 to 4 heads tall.

2 Add some paws with claws, a large tail, fangs, pointy ears and the start of a hairy face, and your Mascot becomes a cat. Make the toes closest to you biggest and the rest smaller. Even though the Mascot is a little more cartoony and simplified, it should still look 3-D. Its huge feet are perfect for pouncing.

3 Develop a catlike character with details like fur and claws. The tail is big and fluffy like a fox's. This Mascot has been drawn without a nose because it distracted attention from the large mouth and expressive eyes. In a story, details can change as the character changes gestures or attitudes. The potbelly can all but disappear in the next drawing if it suits the situation.

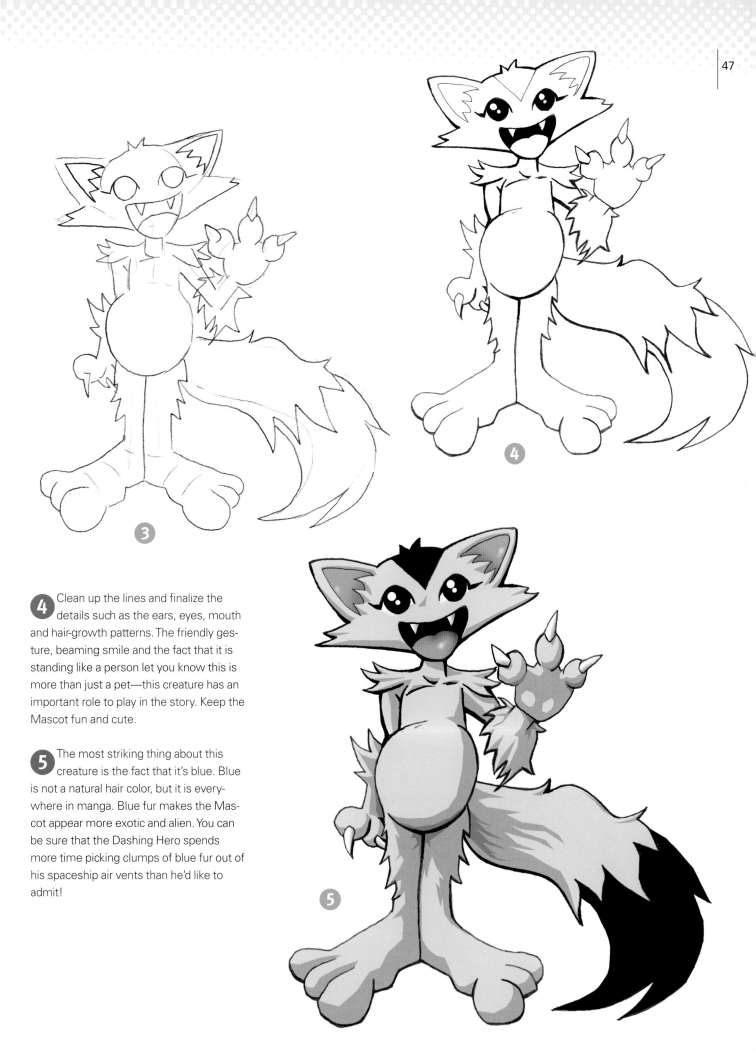

4 Clean up the lines and finalize the details such as the ears, eyes, mouth and hair-growth patterns. The friendly gesture, beaming smile and the fact that it is standing like a person let you know this is more than just a pet—this creature has an important role to play in the story. Keep the Mascot fun and cute.

5 The most striking thing about this creature is the fact that it's blue. Blue is not a natural hair color, but it is everywhere in manga. Blue fur makes the Mascot appear more exotic and alien. You can be sure that the Dashing Hero spends more time picking clumps of blue fur out of his spaceship air vents than he'd like to admit!

| *Fallen **Hero***

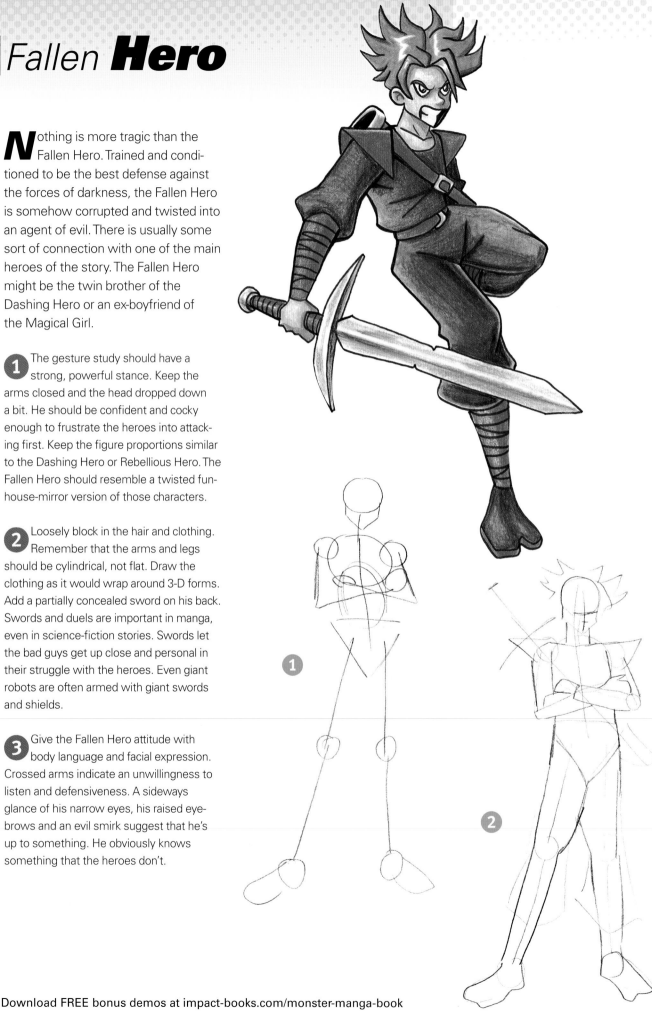

Nothing is more tragic than the Fallen Hero. Trained and conditioned to be the best defense against the forces of darkness, the Fallen Hero is somehow corrupted and twisted into an agent of evil. There is usually some sort of connection with one of the main heroes of the story. The Fallen Hero might be the twin brother of the Dashing Hero or an ex-boyfriend of the Magical Girl.

1 The gesture study should have a strong, powerful stance. Keep the arms closed and the head dropped down a bit. He should be confident and cocky enough to frustrate the heroes into attacking first. Keep the figure proportions similar to the Dashing Hero or Rebellious Hero. The Fallen Hero should resemble a twisted funhouse-mirror version of those characters.

2 Loosely block in the hair and clothing. Remember that the arms and legs should be cylindrical, not flat. Draw the clothing as it would wrap around 3-D forms. Add a partially concealed sword on his back. Swords and duels are important in manga, even in science-fiction stories. Swords let the bad guys get up close and personal in their struggle with the heroes. Even giant robots are often armed with giant swords and shields.

3 Give the Fallen Hero attitude with body language and facial expression. Crossed arms indicate an unwillingness to listen and defensiveness. A sideways glance of his narrow eyes, his raised eyebrows and an evil smirk suggest that he's up to something. He obviously knows something that the heroes don't.

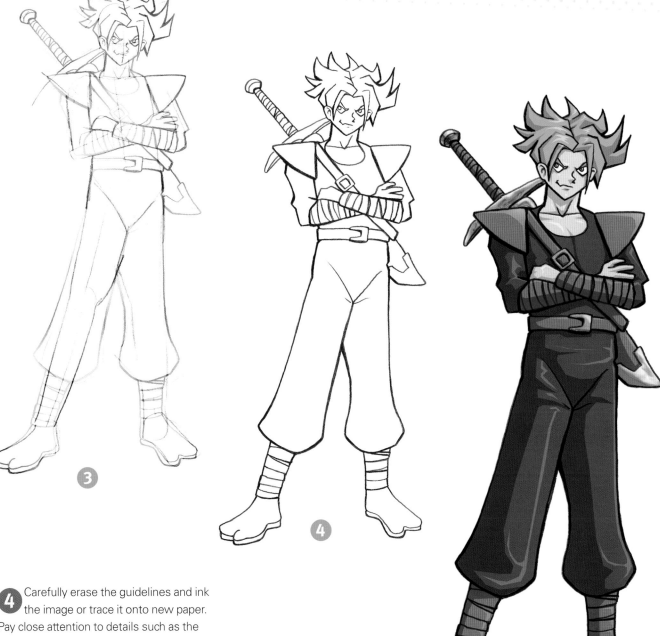

3

4

5

4 Carefully erase the guidelines and ink the image or trace it onto new paper. Pay close attention to details such as the tabi boots (used by ninja), buckles and weapons. A strap across his torso holds the sword to his back. Attention to details helps convince viewers that what they are seeing is real.

5 Unless the Fallen Hero has a totally showy personality, dress him in fairly dark colors. This dark gray-and-red combination makes the character seem more sinister and emphasizes his gloomy nature. Highlights are especially important on darker clothing to make it look 3-D. Remember to keep your light source the same over the entire figure, and use the eye highlight as your guide to light direction.

The Guys You Love to Hate

The basic plot of any work of fiction involves some sort of conflict. A good villain makes a story memorable, even if it's just a strict teacher in a shoujo manga. Don't make your bad guys snarling stereotypes; get into their heads and make them interesting. Give them quirks and flaws to make them human. Above all, avoid making them look stupid. Nothing adds to the drama more than a smart enemy. Keep the villains one step ahead of the heroes and the readers will be caught up in the suspense. The race to the end to see who will win should be unforgettable.

| *Evil* **Queen**

The Evil Queen appears in many shoujo manga. She barks orders to her unlucky servants who scramble desperately to satisfy her every whim, including destroying the heroes. Fortunately for the heroes, they always fail and have to face her wrath.

Often times the Evil Queen is after an item of magical power possessed by one of the heroes. This item would give her the power she needs to take over the universe. She is usually unable to directly affect the world; that's why she relies on her followers to do her dirty work. She possesses powerful magical skills and can foretell future events. Despite her power and grand plans, the heroes always save the day, often in a symbolic victory of love over hate and sacrifice over selfishness.

1 Our queen should appear strong, confident and sneaky all at once. Even though you will eventually hide the legs with a long dress, sketch them now so you know what they're doing and to avoid making the figure too squat.

2 The dress should drape down off of her body. Long strips of material make her appear more octopus-like. Wild, flowing hair echoes the movement of the dress, and razor-sharp claws complete her otherworldly nature. The shape of her crown suggests horns.

3 Make some of the looser lines clean and crisp, and carefully erase the lighter gesture lines of her basic structure. Costume details such as the belt, necklace and headdress should echo each other, creating unity. Make it clear that she puts some thought into her wardrobe before she sets off to conquer the universe.

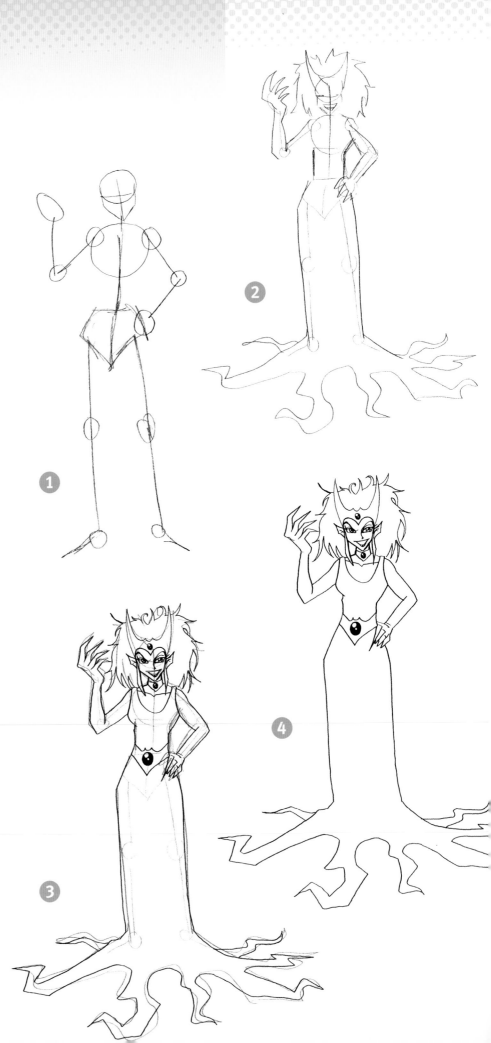

Out of Character

As you are discovering, manga has a wide range of character types. The Evil Queen may show up in the form of the wicked stepmother, the bad fairy or the scary witch. We expect these characters to play their roles as they have countless times. If the Dashing Hero always behaves in one way and the Magical Girl in another, the story is easy to follow, but predictable.

Recognizing these character patterns is an important step to creating original, dynamic stories. By manipulating these patterns and changing the expectations of the reader, we can shock them into seeing old ideas in new and unusual ways. Use character patterns to help develop your story idea. Then, as soon as you've hooked the readers, throw them a curve ball.

4 When cleaning up or making the final drawing, alternate soft, curving, feminine lines with sharp, dangerous angles. The ends of her dress should look like they are writhing like snakes or tentacles, and her hair should be big and wild. Details such as claws and fingerlike ears reinforce the fact that the Evil Queen is not human. Her narrow eyes and one raised eyebrow suggest that she toys with her enemies before she destroys them.

5 The most striking thing about the final image is the solid, dramatic black of her dress and her green skin and hair. The unusual skin color adds to her alien nature without making her totally inhuman. Her gemstones are black and blood red. She appears proud and noble, with a hand raised and ready to strike down her enemies.

The *Big Bad*

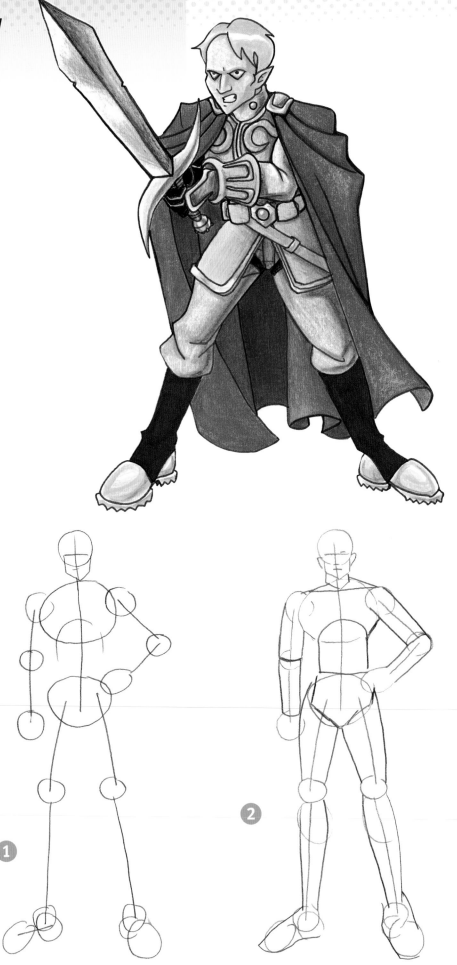

The Big Bad is the main opponent of the good guys, but he is rarely confronted until the last climactic battle. He is usually a leader who sends his underlings out to do his dirty work. He sometimes takes orders from a larger, more ominous force such as the Evil Queen or a mysterious creature of darkness.

The Big Bad usually has a very good reason for what he does. He doesn't believe he's evil; he's doing what he can to protect his interests or what he believes in. Make sure the Big Bad has a good motivation for his actions.

1 The Big Bad can be large and bulky or thin and lanky. The concept behind this Big Bad is "the general," so he'll have the best weapons and the best armor. Give him a solid, even-footed stance. He should be big enough to stand up to the combined force of the good guys if he must.

2 Block in the muscle mass. He should look solid, but not like a weightlifter (unless he is a weightlifter). The Dashing Hero should look rather scrawny compared to the Big Bad.

3 The Big Bad should have refined, aristocratic features. He is rarely a slobbering beast. His hair is neat, his eyes beady, and his hand grips the largest of swords. The pattern on his armor is not too difficult. Try to make the pattern the same on both sides and don't get too elaborate or you'll never want to draw him again.

4 Details such as the armor pattern and the pointy treads on his boots reinforce the power, status and cruelty of the Big Bad. Details of the cape should be based on observation of real cloth and how it reacts to gravity and wind.

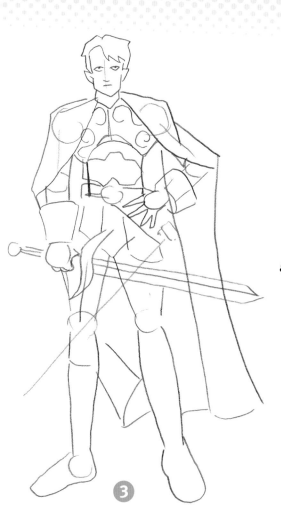

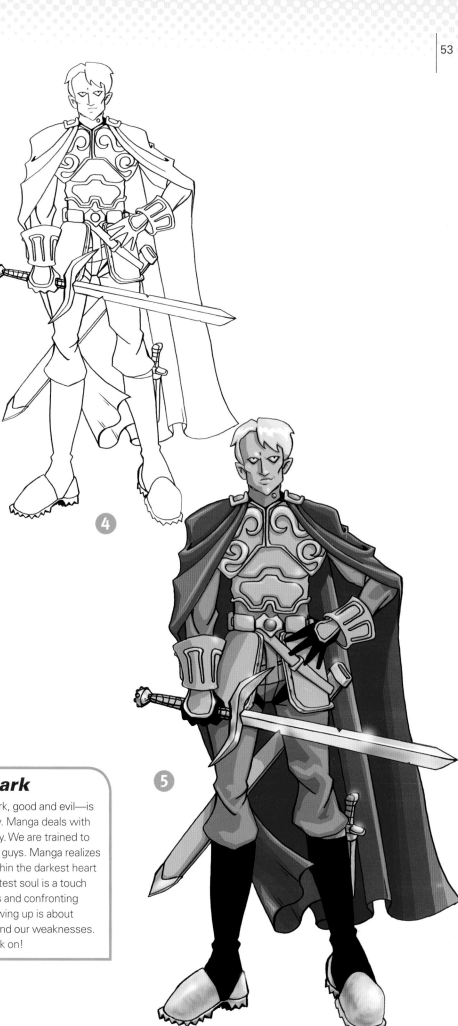

5 An unusual skin color makes the character appear somewhat alien. Notice his eyes are very different from standard manga eyes. He appears to be squinting or creasing his brow. Each iris and pupil is a tiny dot, and his eyes have an evil glow. The cape gives him a sense of majesty and great power. Coloring it red and making the details gold makes this Big Bad appear very regal indeed.

The Light in the Dark

The duality of all things—light and dark, good and evil—is an ever-present concept for humanity. Manga deals with the struggle of good and evil constantly. We are trained to cheer on the good guys and boo the bad guys. Manga realizes that all characters have a motivation. Within the darkest heart is a balance of light, and within the brightest soul is a touch of the dark side. Overcoming our frailties and confronting our shadows is a lifelong challenge. Growing up is about recognizing who we are, our strengths and our weaknesses. What a great thing to base a comic book on!

Mecha

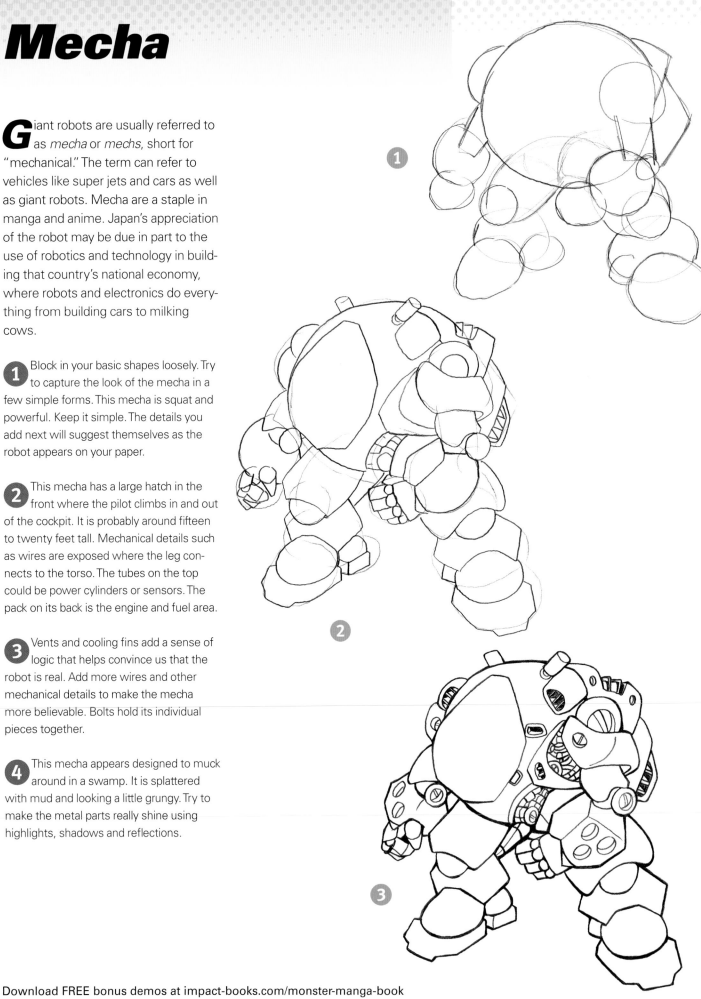

Giant robots are usually referred to as *mecha* or *mechs*, short for "mechanical." The term can refer to vehicles like super jets and cars as well as giant robots. Mecha are a staple in manga and anime. Japan's appreciation of the robot may be due in part to the use of robotics and technology in building that country's national economy, where robots and electronics do everything from building cars to milking cows.

1 Block in your basic shapes loosely. Try to capture the look of the mecha in a few simple forms. This mecha is squat and powerful. Keep it simple. The details you add next will suggest themselves as the robot appears on your paper.

2 This mecha has a large hatch in the front where the pilot climbs in and out of the cockpit. It is probably around fifteen to twenty feet tall. Mechanical details such as wires are exposed where the leg connects to the torso. The tubes on the top could be power cylinders or sensors. The pack on its back is the engine and fuel area.

3 Vents and cooling fins add a sense of logic that helps convince us that the robot is real. Add more wires and other mechanical details to make the mecha more believable. Bolts hold its individual pieces together.

4 This mecha appears designed to muck around in a swamp. It is splattered with mud and looking a little grungy. Try to make the metal parts really shine using highlights, shadows and reflections.

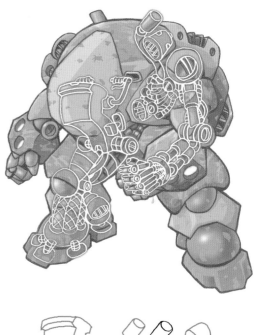

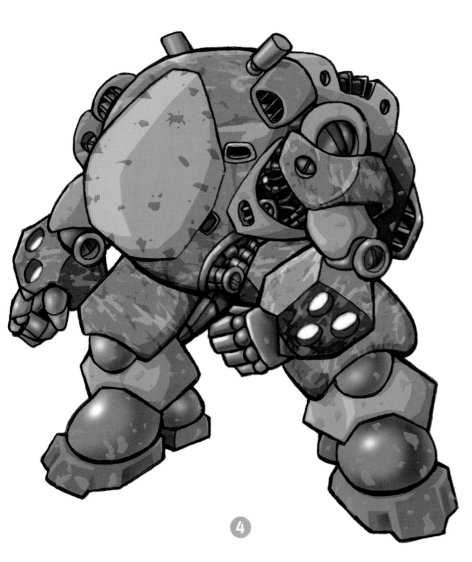

④

Pilot or Remote Control?

Mecha may be either piloted or run by remote control. Either way, the shape and form of a mecha may be more or less humanoid as the artist sees fit. A mecha without a head, for example, would not seem too bizarre if there was some indication of where the operator sat or received information.

When designing the look of the mecha, try to avoid the "tanks with feet" effect. You don't want it to look too clunky and vehicle like. Mecha may have practical technical considerations, but they should also have some life or character. Readers should worry about the mecha as well as the characters. Manga mecha are sometimes even more popular than the characters who pilot them.

What's Underneath?

A closer inspection of the mecha will reveal possible technology under all that armor. It can be very rewarding (and fun!) trying to understand what makes your mecha tick. Take it apart and try to account for each part. Where does it get its power? Where does the pilot sit? Don't be intimidated by drawing all that technology. Have fun with it.

Mindless Goons

Every Big Bad needs an army of Mindless Goons to boss around. They could be goblins, demons or clones. Mindless goons are usually heavily armed, armored and quite scary-looking. They are often dressed in a manner that conceals their individuality and makes them appear less human. They have impressive weapons but are horrible shots, and when they are hit they almost always fall down and stay down even though they may be wearing full combat armor.

1 Mindless Goons should be bulky and impressive. Keep the shapes loose at this stage and focus on the solid, massive forms of the armor. Notice that this workhorse has no neck, and it carries a big weapon.

2 This Goon is covered with protective armor from head to toe. Try to give costume details a purpose. You never know when you may need to know that information in a story. The tubes that rise out of the shoulder might hold coolant fluid, batteries, medicine or food supplies. You may want to try drawing the figure from several angles so that you can keep the details consistent as you draw the character.

3 Make sure that you keep your light source the same for every part of the figure as you are shading. Shadow should wrap around the figure. Highlights and texture add realism to the costume. The armor is scuffed and battle-scarred. The colors are muted so that the Goon does not draw the reader's attention from the Big Bad or the Dashing Hero.

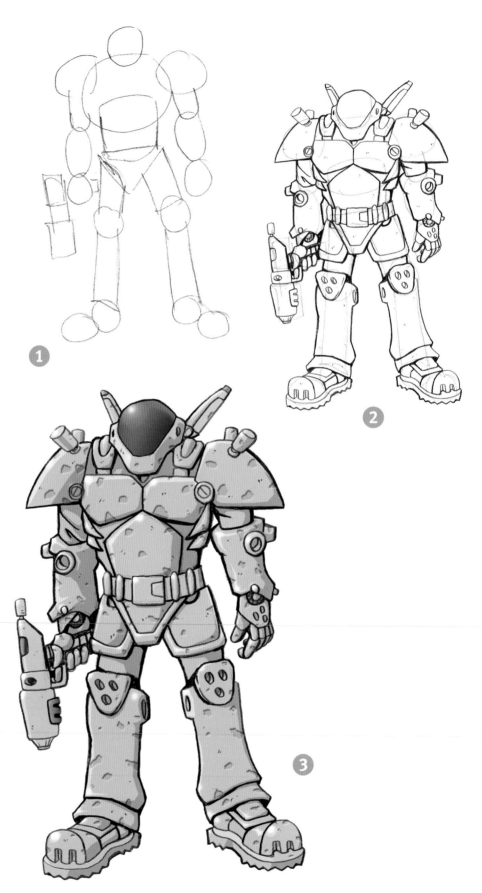

Unstoppable **Fiend**

The Unstoppable Fiend is the secret weapon unleashed on the heroes by the Big Bad. Tougher than the Mindless Goons, the Unstoppable Fiend is a challenge for the entire team of heroes to defeat. The individual hero cannot defeat it on his own; it can be defeated only with teamwork and intelligence. In other genres it might be an ogre or a giant, or even the captain of the football team. The Unstoppable Fiend is a worthy opponent for the heroes to overcome.

1 Don't worry about sticking to proportions. This is a monster! Exaggerate the physical features that make him appear big and scary. Make the shoulders and claws huge. Make the neck as thick as its small head. Hunching the shoulders makes the Unstoppable Fiend look more animal-like and dangerous.

2 The heavy-duty armor and mechanical claws and feet make this character appear threatening and inhuman. The wires and tubes add to the robotic appearance. Look at mechanical and technological devices around you for ideas.

3 As you color your image, keep in mind the textures you are re-creating. Metal will reflect light and appear, well, metallic. Notice how the circular highlights make the character appear shiny. Don't forget to add highlights and shadows to areas that are set into the figure.

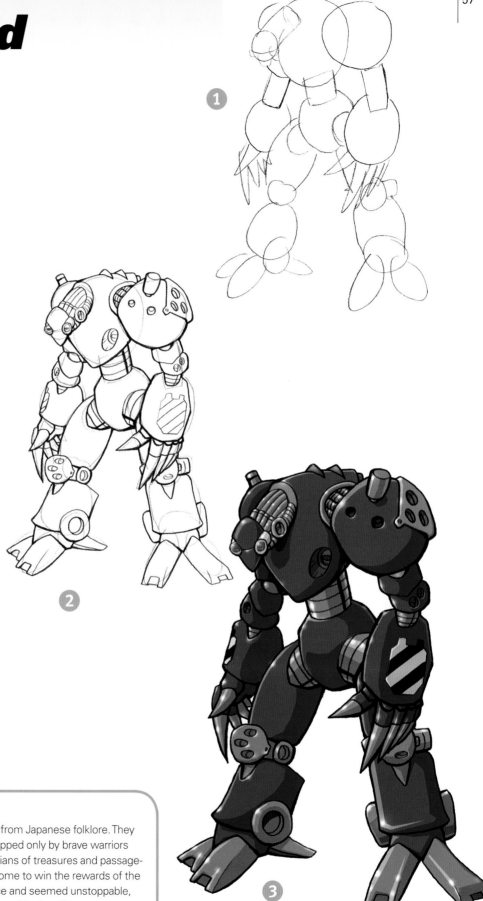

Word Break

Oni (OH-nee)—mythical demons from Japanese folklore. They ravaged the land and could be stopped only by brave warriors and holy men. Oni were also guardians of treasures and passageways, obstacles that had to be overcome to win the rewards of the adventure. Oni always appeared fierce and seemed unstoppable, but were not very smart and could be tricked easily.

Cat Girl

Many, many manga have Cat Girl characters. Some stories just show characters dressed up in cat costumes. Sometimes the Cat Girl is an alien, other times she is a magical creature. Japanese folklore has a tradition of shape-shifting cats and foxes who can take human form and cause all kinds of mischief.

1 Keep your shapes bold for this pose. Review the proportions of the figure before you start, even if you are going to break the rules. Keep the shapes soft and rounded for a more feminine look. Some Cat Girls have big cat tails for balance.

2 What else would Cat Girl wear if not a cat suit? A few lines are enough to indicate her chest, torso and collarbone. Remember to make clothing details such as sleeves and belts wrap around the objects you draw. Think of each limb as a three-dimensional cylinder and wrap the clothing details around it. Her fur should move with her.

3 Keep the clothing colors bright and fun. Circular highlights make her cat suit look shiny. You may want to look at patterns that appear on real cats like house-cats, leopards or tigers to get ideas on how to shade the fur.

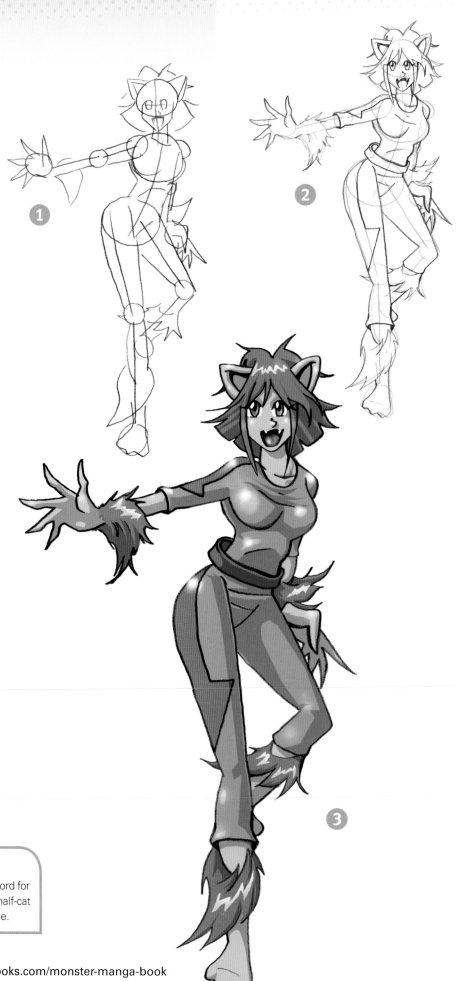

Word Break

Neko (NEH-koh)—the Japanese word for cat, but also refers to half-human, half-cat characters found in manga and anime.

Download FREE bonus demos at impact-books.com/monster-manga-book

Android Boy

*L*ike Pinocchio, the Android Boy likes to think of himself as a human, but he is so much more. He is a super-android created by a brilliant scientist. Using his robotic abilities as superpowers, he is a help to police, the military and the scientific community.

Manga has dealt with robots and androids for decades. Many heroic androids have been young or inexperienced personalities such as children or teenagers. Manga writers and artists have dealt with the concept of artificial people in a very sensitive and creative manner. They aren't afraid to confront the issue of what being human is all about.

1 Since this character isn't human, don't be afraid to experiment with the anatomy. Feel free to add another eye or two or really exaggerate the "bunny ear" sensors. Use technological details to further express the character's emotions and tell his story.

2 The bunny ear sensors are a traditional reference to some androids and mecha in manga. They can be quite expressive and even cute. The shoulders have small bolts that can be structural or maybe canisters of coolant or hydraulic fluid. The tube or wire on the back could distribute the fluid to other systems. The fingers are some sort of weapons system. The large bubbles on the forearms and lower legs might be access hatches or even energy batteries.

3 Make Android Boy dynamic and colorful. He's one of the good guys and this will also distinguish him from the enemy robots. Use highlights and sharp contrasts to make his metallic "skin" appear glowing and reflective. A trail of smoke rising from one finger reinforces that his fingers are some form of weapon.

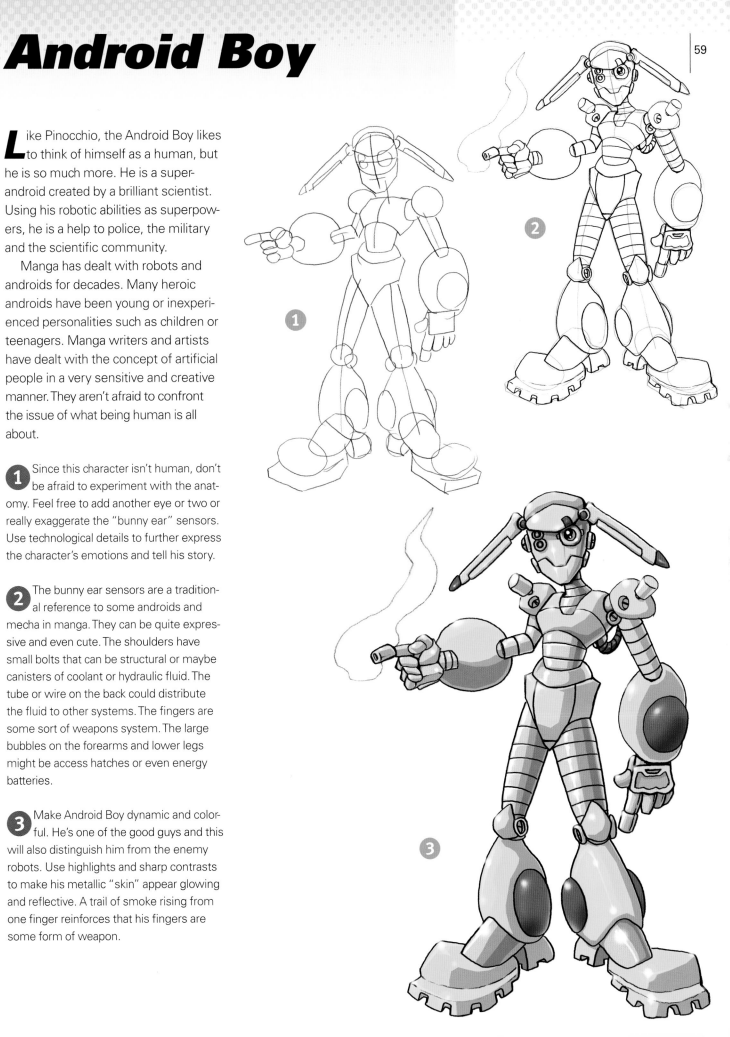

Victorian Rose
(Bishoujo)

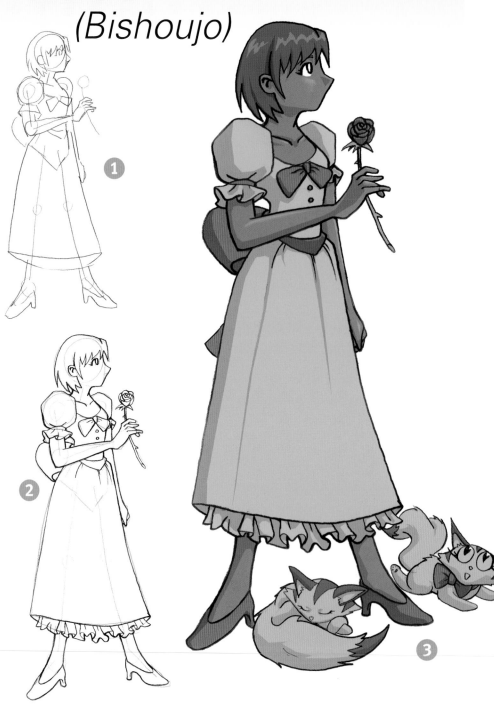

Bishoujo characters are often dressed in fancy gowns with big bows and puffed sleeves. They are often the object of affection for two rivals and must make a choice, often with dramatic consequences. Despite their fairytale-princess appearances, bishoujo characters often can take care of themselves, and they wield plenty of their own power. They are usually more than just pretty faces.

1 Use the gesture study of the stick figure to develop a wistful, romantic pose. Even though her legs will be hidden by the dress, lightly draw the basic structure of the legs so that you get the proportions and the position of her upper body and feet correct.

2 Develop the costume details: puffed and ruffled sleeves, a frilly underskirt and bows on her neckline and lower back, topped with a delicate rose. Bishoujo characters should be gentle and rounded and have dreamy, graceful mannerisms. Tame hair and a mouthless face allow her innocent eyes to steal the show.

3 Shade and color the figure simply but don't forget to show the puffiness and folds of the cloth as you draw them. It's no wonder that cute little critters gather at the feet of this lovely lady!

The Bishoujo Mascot

Don't get too complicated with the forms of Mascots. Stick to simple geometric shapes. Make the Mascots cute and cuddly. Mix and match details to create unique animals. In this case, the Mascots appear to be a combination of a cat, a squirrel and a fox. Details such as bows that match the bishoujo make a visual connection for the reader.

School Girl
(Bishoujo)

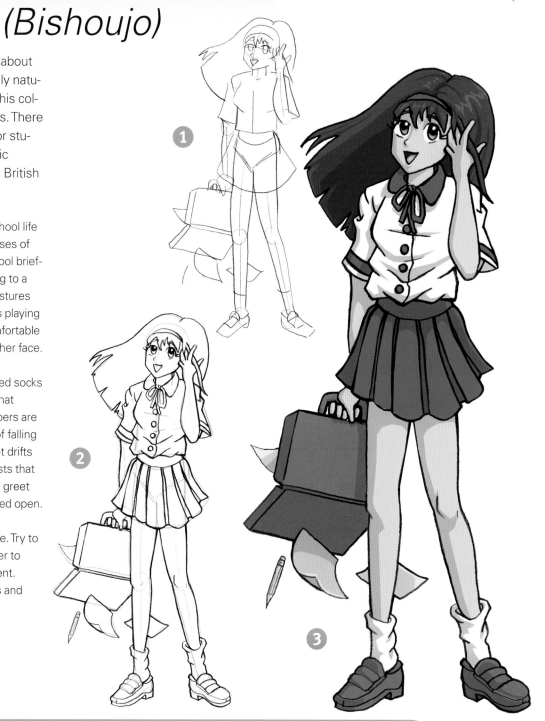

So many shoujo comics are about school life that it seems only natural to include the School Girl in this collection of manga character types. There is no standard school uniform for students in Japan, but the two basic styles are the sailor suit and the British school blazer.

1 Many manga stories about school life focus on the embarrassing crises of teenage years (like having your school briefcase burst open when you're talking to a cute boy). Pay attention to small gestures and body language clues. This girl is playing with her hair and looks fairly uncomfortable and awkward despite the smile on her face.

2 The folds in her loose, oversized socks really reinforce the cylinders that make up the legs. The fluttering papers are curved and drawn in three stages of falling to show the process of how a sheet drifts to the floor. Her moving hair suggests that she may have just turned around to greet her crush when her briefcase popped open.

3 Keep your color choices simple. Try to limit the colors you use in order to make the character appear consistent. Reinforce the forms of the wrinkles and folds with shading.

What's Your Blood Type?

You may notice that descriptions of manga characters from Japan often include the character's blood type. This information is included because of the Japanese superstition that a person's blood type can play a role in determining personality. So what's *your* blood type?

Type A people are said to be cool, collected, sensible, methodical and intelligent, but hide their true feelings.

Type B people are inquisitive about the world, but have the attention span of a ferret, often abandoning projects they were once excited about. They frequently appear cheery and eager, but really want to be left alone.

Type O people tend to get along with everyone. They seem competent and capable, but often make big mistakes.

Type AB people are believed to be very thoughtful and emotional, but are too critical of themselves and what they are capable of doing.

Victorian Gentleman
(Bishounen)

Bishounen are often better classified as bad boys rather than tough guys. They are usually the mysterious helpers in shoujo comics, unattainable love interests who constantly distract and occupy the thoughts of the heroine. They often have a wild and dangerous nature that makes them even more mysterious and attractive.

Bishounen characters are usually long and lanky and have wild, uncontrollable hair. Dressing them up in tuxedos or formal wear reinforces the "beautiful boy" stereotype.

1 Much of what will be drawn in the end has been sketched out here. Try to break down every complicated object to its basic shapes and forms. The fact that his top hat is a cylinder is very obvious in this sketch. Notice that he is slightly off balance, leaning forward with almost all his weight on his left leg. Putting a character off balance creates tension and movement.

2 Use references to get the specifics of his tuxedo right. Leave white lines for the details on black (his coat buttons, lapel and arm lines and the highlights on his shiny shoes). Carefully observe folds and creases in the clothing to help show tension and 3-D form—for example, where his buttons tug at his vest.

3 His tuxedo is a conservative color, but his red eyes pierce out from behind his tangled mess of hair. Odd-colored eyes could reveal an alien or magical aspect of the character. He might be a vampire, a type of goblin, an alien or even a robot. Or, the eyes could mean nothing at all, but simply make the character appear more interesting or whimsical.

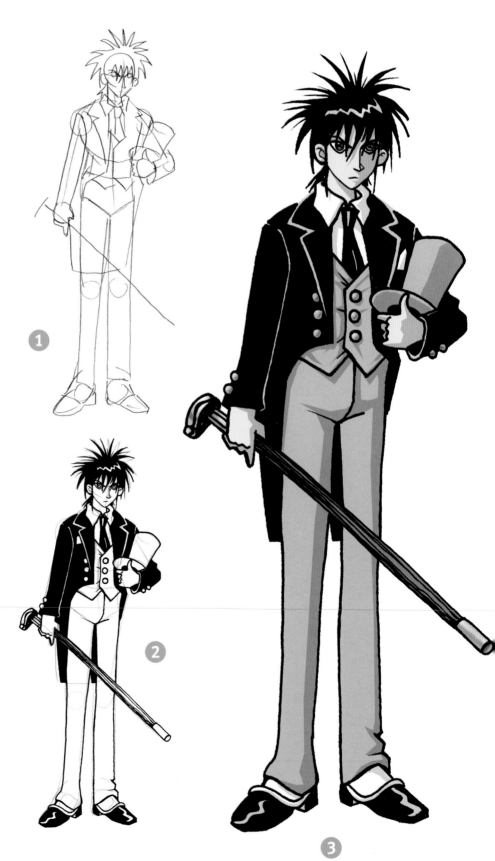

Hipster Student

The details of this school uniform are not accurate for modern Japan, but it would work in a story of another place and another time. Bishounen characters like this one are often filled with angst and brood over even the smallest decision.

1 Observe costume details such as the cut of the jacket, the curves of the pant legs and the jacket sleeves. Wrap the clothes around the basic body structure.

2 The clothing folds and creases on his lower legs, elbows and waist give the figure a strong sense of 3-D form. Use your references to draw details like the jacket lapels and the briefcase. He's turned slightly to the side, so the shoulder and lapel farthest from us will look narrower, and we'll see only a hint of the buttons on that side.

3 Keep the color choices simple. Too many colors can make a drawing difficult to follow. The most striking thing about this character is his blue hair, which symbolizes his exotic nature.

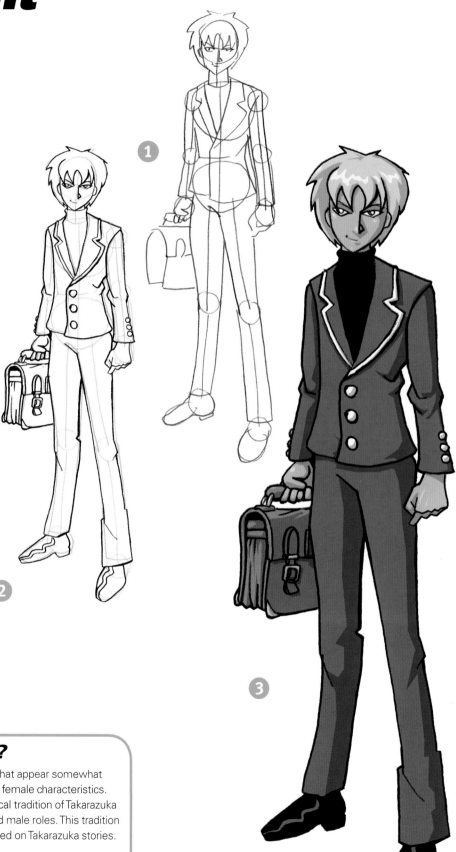

Male or Female?

In manga you'll find characters that appear somewhat androgynous—having male and female characteristics. This might be a nod to the historical tradition of Takarazuka theater, where female actors played male roles. This tradition lived on in the comics originally based on Takarazuka stories.

Skate Girl
(Shounen Youth)

Youth and popular culture are very influential in Japanese media. Shounen manga does not always focus on young male heroes. There are many strong female characters in shounen manga who are quite capable, like the spunky Skate Girl.

1 Block out the forms as usual. Review the proportions for teenage characters. Remember to avoid cutting off the back of the skull when you draw the head from a three-quarters view.

2 Her inline skates give her movement and agility and may explain the tear on her sleeve (perhaps an unexpected spill?). Her pouty, realistically drawn lips emphasize her attitude. Her buckles and multiple belts add a fun sense of style. On her shirt are the Japanese Kanji characters for mirai, meaning "the future."

3 Try very hard to keep the light source consistent. Again, use the eye highlights to keep track of the light direction. Use light and dark to make the figure appear three-dimensional. Use gray to shade areas of white. Shading the legs gives them form. Round highlights on her cheekbones, nose, chin and eyebrow bring form to her face.

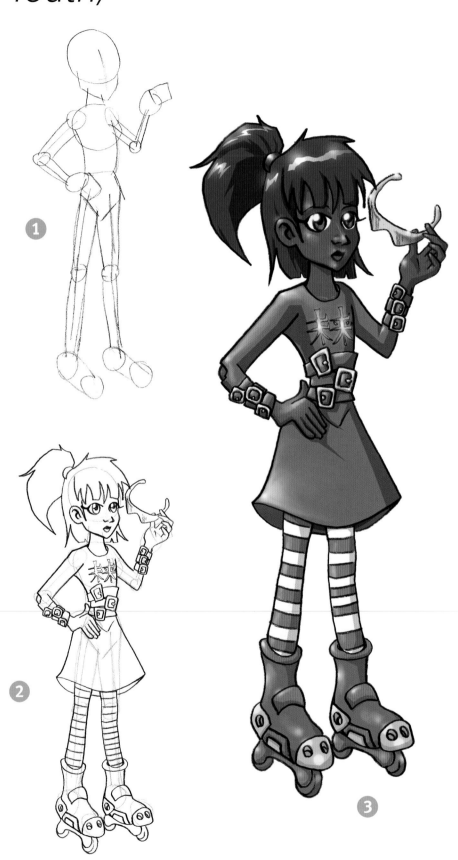

Cyberpunk Kid
(Shounen Youth)

Cyberpunk heroes often use lots of advanced technology or are partially or fully mechanical. Countless manga are about technology and how humans relate to it: what it means to be human in an age of rapid technological change. No matter how pretty the technology, don't forget the humanity behind it all. Try to make the cool robots and gadgets secondary to the people who populate the world of your story.

1 Block in the anatomy and stance. I wanted this character to have a strong, open stance, as though he is summoning great power and getting ready to use it. Make sure you give his head enough room for the back of the skull.

2 His gloves and headphones are attached to his backpack, which may hold a power source or even a portable computer. The gloves may increase his strength or possibly allow him to fire blasts of energy. Flame-edged jeans, a pair of sneakers and spiky hair are perfect for this wild child.

3 After adding color, use shading to show the wear and tear on his jeans, the creases of his white shirt and the highlights on the metal glove and his hair.

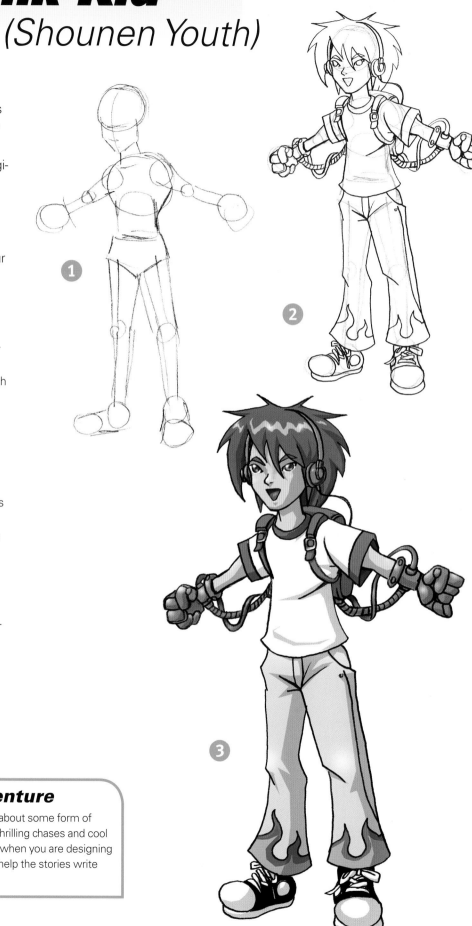

Shounen Adventure

Shounen manga are usually about some form of conflict. They are filled with thrilling chases and cool technology. Keep this in mind when you are designing characters. Planning ahead can help the stories write themselves.

Space Hero

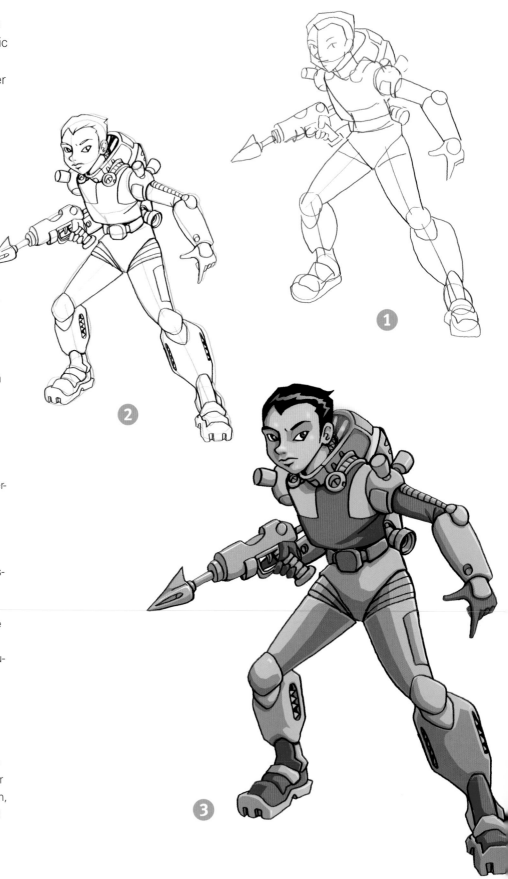

Countless shounen manga stories are set in the future, with fantastic spaceships and giant robots. There is usually an aging captain or commander of the heroic forces who sends his team, his "children," off to battle a threat from space. The Space Hero is usually young and optimistic, and is often too reckless for his own good. His Mascot is usually a robot or furry alien, but can even be the spaceship the heroes travel on.

The sides of good and evil are not always clearly defined. The "villains" usually have a reasonable motive, but they are too aggressive or deceptive in their actions. There is often an honorable duel or showdown between the hero and the enemy, where a mutual respect reveals that in other circumstances the opponents could have been the best of friends.

1 Make sure your drawing has consistent proportions and indicates the action or movement of the hero. Think interlocking 3-D shapes when drawing the figure; this will make it easier when you add details like clothing or equipment.

2 Make the specifics of your hero's costume fit in with the other characters' outfits. Starting with one basic space suit and adjusting the details depending on the character is easier than coming up with a completely unique design for each individual. Let some of the costume details have a purpose. The thrusters on this hero's backpack may allow him to jet from place to place.

3 This hero's color scheme is similar to what is used for the spaceships (later in this section) that battle the pirates. Again, try to keep the look of the story integrated with everything else.

Space Pirate

One thing that manga does very well is mix time periods and categories. Combining pirates with spaceships blends the swashbuckling thrills of a pirate story with the adventure and technology of science fiction. Giant robots often wield large energy swords like giant knights or samurai.

1 There is more information in this drawing than most of the first steps in this book, but at this stage you should have more confidence in your basic figure drawing. The collar, cuffs, hat, puffy pant legs and props such as the pistols are all blocked in at this stage.

2 The skull and crossbones identifies her "side" quickly. You may want to add other pirate trappings such as the sleeve cuffs. Details such as the glasses give us more information about this character and may set her apart from other characters in the story.

3 The costume is colored to make it appear loose and comfortable while maintaining a militaristic appearance. Her blue hair reveals her wild nature. This character seems ready for pirate adventure.

Futuristic Manga

Though some of the galaxy-spanning sagas that appear in manga are far-fetched, many manga stories have been on the cutting edge of the science fiction and scientific movements. Manga is respected by fans for dealing with hard sci-fi issues such as robotics, semi-realistic space travel and the social impact of new technologies.

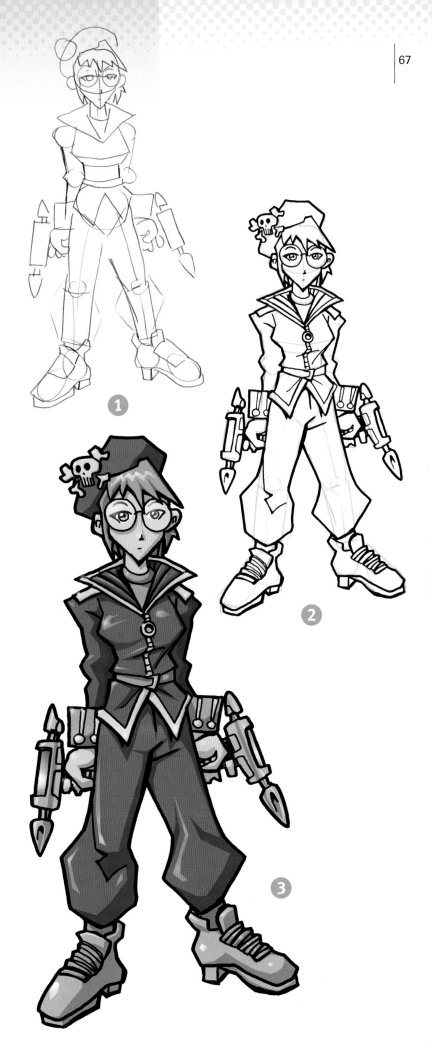

Humanoid Robot

If you are going to draw lots of different kinds of robots, you need to have a clear idea of how they work. Some giant robots are powered by crystals and magic energy. Most are powered armor suits that are operated by a pilot seated in the head or the torso. Some mecha are hundreds of feet tall, while others are designed to be outfits that protect the wearer and increase his or her strength and abilities. Your design options are limitless.

1 Block out the shapes and think about the details that you want to add. What head shape will the robot have? What kind of sensors? Shoulder pads? Move from body part to body part and make decisions. Try to keep the design unified with similar arm and leg treatments. Repeat shapes and details for even more unity.

2 Try to give thickness and form to the details you've sketched. Make sure that all the parts look like they belong to the same robot. Your giant robot isn't human, so you can have fun modifying proportions and changing anatomy. Expose some mechanical details such as hydraulic pistons and wires. You may not know much about engineering or robotics, but that shouldn't stop you from drawing high-tech equipment.

3 Keep track of details you like about this mecha and reuse them for other drawings. After a while you will be able to mix and match elements to create an infinite variety of mecha.

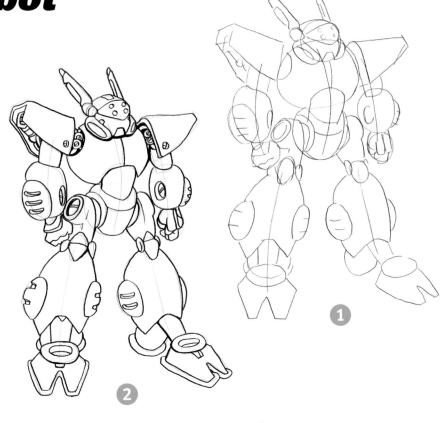

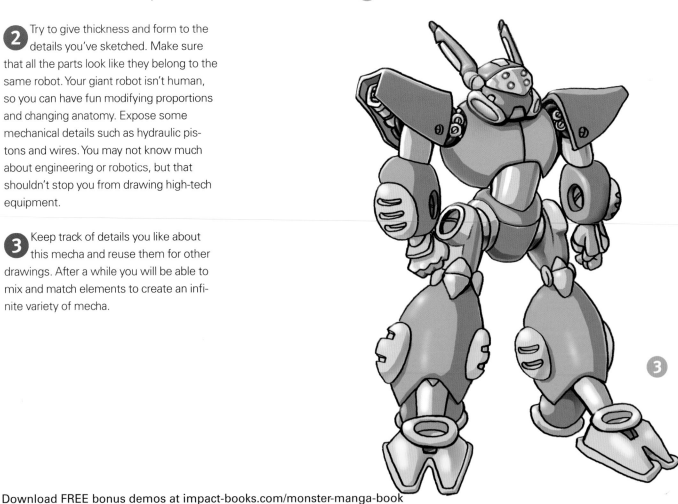

Download FREE bonus demos at impact-books.com/monster-manga-book

Crab Bot

Mecha come in all shapes and sizes. They can be inspired by a human or animal, or resemble nothing natural at all. Since mecha are built and not born, their proportions and anatomy do not need to accurately correspond to their real-life counterparts. Try basing a robot on a human or animal, then exaggerating one or more of its features for the mecha form.

1 Crabs and spiders are traditional inspirations for mecha in manga. Keep your shapes simple at this stage. High-tech doesn't mean hard to draw.

2 Carefully add details and clean up the lines. The bunny ears are sensors. There is one main optical sensor along with several smaller sensors.

3 Dents in the surface of the mecha mean it has seen some damage. This robot might be used to move through difficult terrain or act as a search and rescue mecha. A spy bot might have a camouflage feature that changes the color of its armor to match its surroundings, or a cloaking device that renders it virtually invisible. This mecha might be the size of a minivan or fit into the palm of your hand.

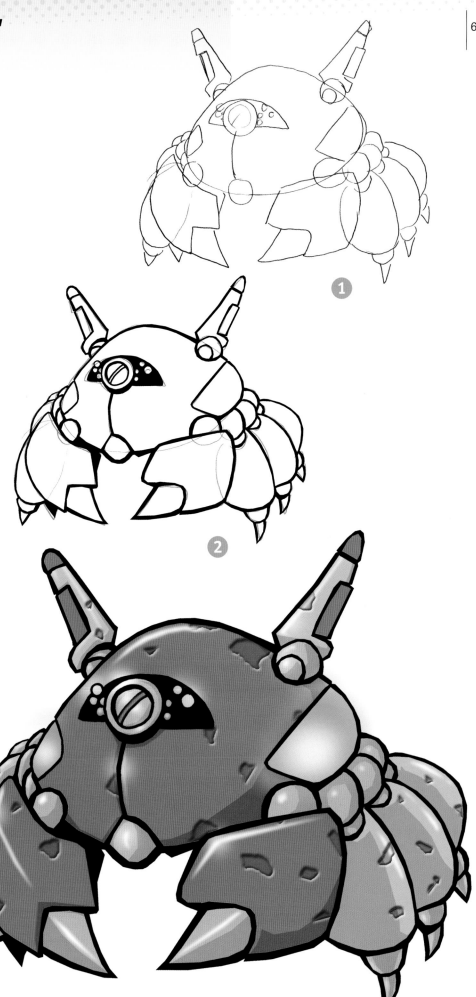

Flying Car

Who says a car can't fly? As you design a flying vehicle, consider how it flies. Will it use huge jet engines, retractable wings, antigravity crystals? Then work these details into the drawing. Even though this vehicle doesn't exist in reality, don't be afraid to use real vehicles as models when you draw.

1 Even though you may want a curvy car in the end, that doesn't mean you have to start with one. You might find that starting out with straight lines you can draw with a ruler is easier, and you can always smooth the corners into curves later.

2 At this point you can make the boxy lines sleeker. Add details much like you would for a spaceship or a mecha. Air vents, tubes, flaps and sensors add to the futuristic look of the vehicle and give the viewer an idea of what it can do.

3 You may want to streamline the vehicle at this point, removing some details that ruined the lines or felt too forced. It should look cool, but you don't want to upstage the stars of your story: the characters.

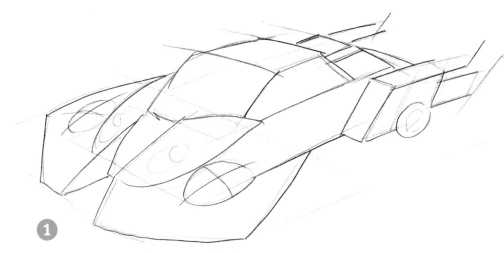

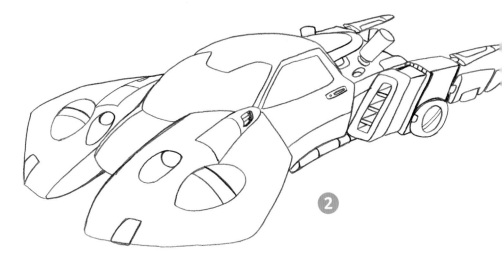

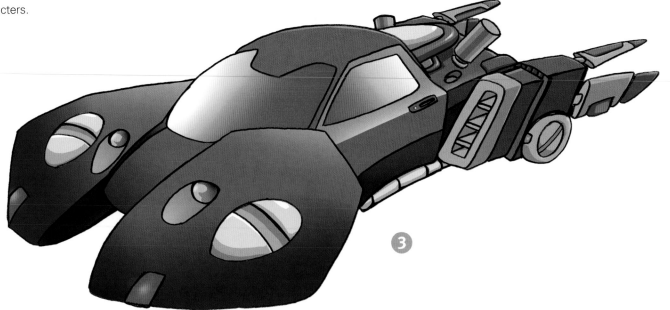

Sky Cycle

If a car can fly, then why not a motorcycle? It's a simple matter of taking something familiar and turning it into something special. The tricky thing about drawing a cycle is positioning the rider so that the character appears to be sitting naturally on the vehicle. You don't want the rider to look as though she were just plunked on top of the drawing of the cycle.

1 Draw through the vehicle to show the entire figure of the rider, keeping her proportions in mind as you go. Even if part of her will be hidden by the vehicle later on, it is important to know where all the parts of the figure are so you can make her sit naturally. Her left foot can be seen under the front of the cycle.

2 Clean up your lines as you add more detail. Don't forget to consider how the cycle works. This sky cycle has a big engine on the back, but it also has some large wing attachment on the bottom. This wing might help stabilize the vehicle or it could be the primary antigravity unit. Look at real motorcycles to help with details like the handlebars and the engine block.

3 Be careful: the more highlights you include, the shinier and more metallic everything will appear. Shade the drawing bearing in mind that you must keep the direction of your light source very clear in all of your drawings.

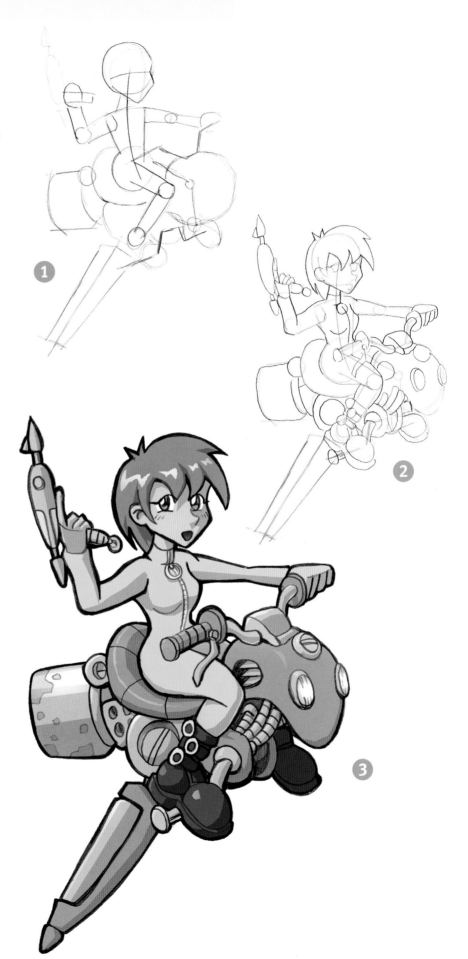

Good-Guy Space Fighter

Space fighters don't really need to be aerodynamic because there is no friction outside of the atmosphere. But don't let a little science ruin your science-fiction manga! Manga space fighters are usually streamlined and sleek, resembling modern jet fighters.

1 Use perspective rules and guidelines to make the fighter appear to be screeching through space. (There is no sound in space, either, but that shouldn't stop you from using all kinds of sound effects.) Block in the shapes loosely, keeping your lines exploratory and expressive. You want to capture the essence of the design with your first lines.

2 Carefully erase all of the unwanted lines, clean up the main lines, and then begin adding details. Some perspective lines still remain so that the final details will be precise. The technology should look possible but futuristic at the same time.

3 Colors and shading are especially important. Make sure the fighter stands out against a black star field.

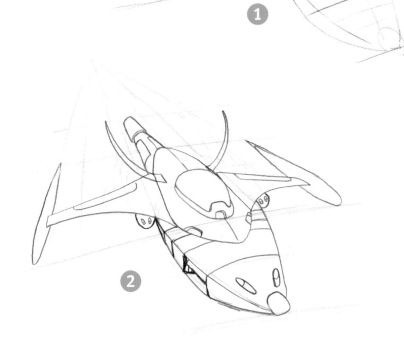

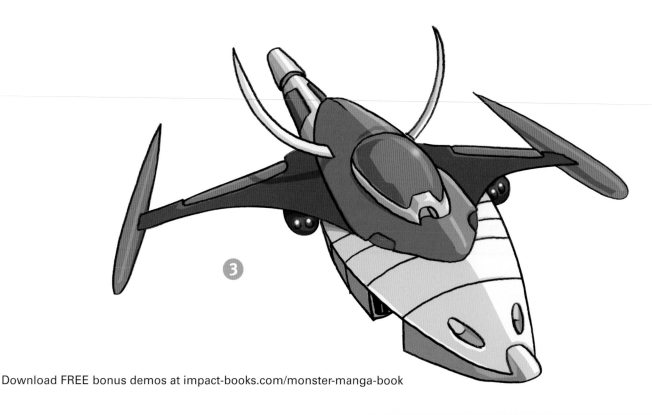

Pirate
Space Fighter

Try to make the spaceships and fighters of the opposing forces look very different from those of the good guys. The reader should be able to figure out who the good guys and bad guys are almost immediately.

1 Use perspective lines to make the object appear to exist in space, flying toward the viewer.

2 Some aspects of manga are not known for their subtlety. The skull and crossbones design makes very clear which side this fighter is on. It also uses part of the ship to look like teeth. Cool!

3 The skull design is even more striking with strong color. The ship is recognizable as a space fighter, but has a unique wing design and different colors that distinguish it from the good-guy ship.

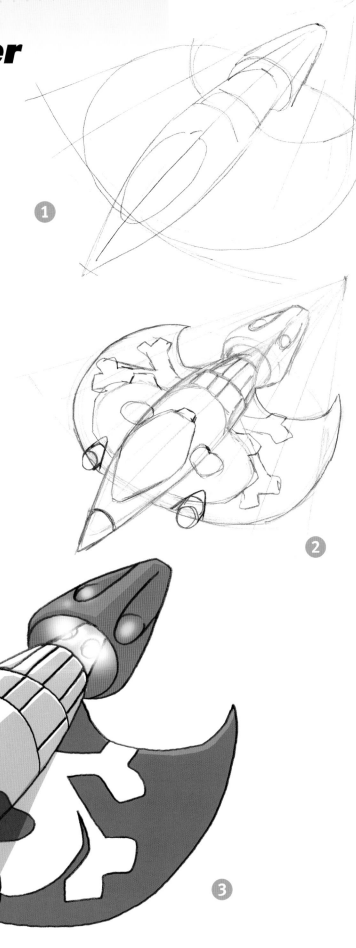

MANGA SUPERHEROES AND VILLAINS

Superheroes come in many shapes and sizes, but all hold a special place in our hearts. They are the ultimate power fantasy. Who hasn't dreamed they could fly or draw upon super strength or skills when needed? They are more than human, but they all have problems and weaknesses that we can identify with. Heroes usually have a special villain or group of villains tied to their origins that makes their lives difficult. These are the guys you love to hate. Villains often steal the show from the heroes with dubious plots to take over Earth or destroy the universe. The characters on these pages are just a sample of what is possible!

The *Ultimate Hero*

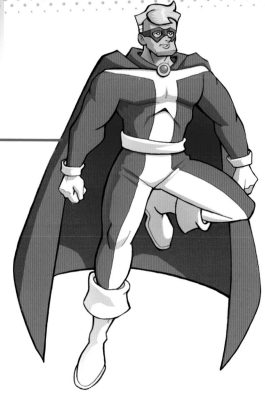

The Ultimate Hero is the toughest hero on earth. Whenever there is a problem the Ultimate Hero is there to save the day. He's been around for a few years and has been an inspiration and mentor to countless other heroes.

Like the ancient Greek hero Achilles, the Ultimate Hero often has a weakness that renders him powerless. It could be a special type of space rock or chemical, magic or technology. Inventing the details of the weakness is part of the enjoyment of creating this character. It's not very interesting if the Ultimate Hero always saves the day unless he really has to work for it.

1 Create a strong line of action and then use sticks, ovals and circles to create the basic figure. This character is very broad chested and powerful. Exaggerate his proportions by making the chest bulkier and the shoulders wider. Notice the foreshortening of the pose: The arms are closer to us and therefore look much bigger than the legs.

2 Add muscle mass to the figure. Make him beefy! Keep things loose at this point. Block in the feet and hands and define the hips and torso. I've tried to create a character that is strong and blocky.

3 Add costume and anatomy details over the musculature. Draw the details of the hands, feet, torso, neck and hips. He has a secret identity to protect, so give him a mask. Keep the lines of the cape flowing from the specific points of tension where it is attached to the costume. He's been a hero for a long time, so his costume is traditional and somewhat old-fashioned.

Character Profile

Name: The Scarlet Avenger

Origin: Former test pilot was bathed in cosmic rays to become one of Earth's mightiest heroes.

M.O.: Always fights fair and tries to be a positive force in the world.

Powers: Super strength and invulnerability. Fires bolts of cosmic energy from his hands.

Weaknesses: Susceptible to modified cosmic radiation. Long history of villainous enemies comes back to haunt him.

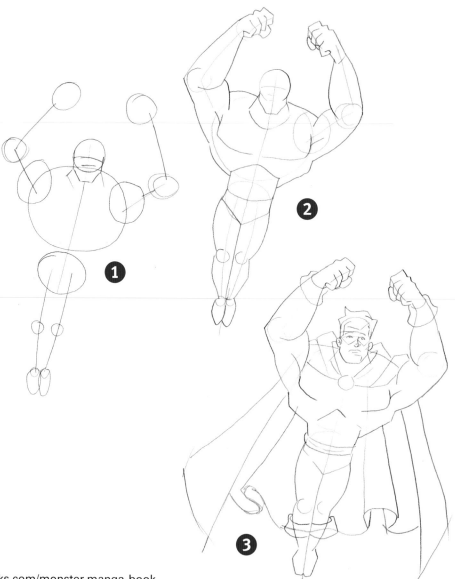

4 Simplify and exaggerate the muscles. He should appear big and strong but not monstrous. Erase the light guidelines and develop the costume details. The billowing cape makes him look even bigger.

5 Finish the drawing with colored pencils. Have a clear idea of where your light is coming from as it falls on the figure, and don't forget the reflected highlight on the other side of him. Choose a costume color that is bold and heroic. The Ultimate Hero doesn't have to hide in the shadows. He should be flashy and stylish, standing out in the crowd.

Ultimate Options

The Ultimate Hero might have an evil twin or clone such as Dark Avenger lurking in his shadow, jealous of the hero's never-ending presence in the spotlight. The hero could be a female such as Pink Fury, carving out her own reputation as a powerful crimefighter. Another popular variation is Power Kid, combining earth-shattering power with teen attitude.

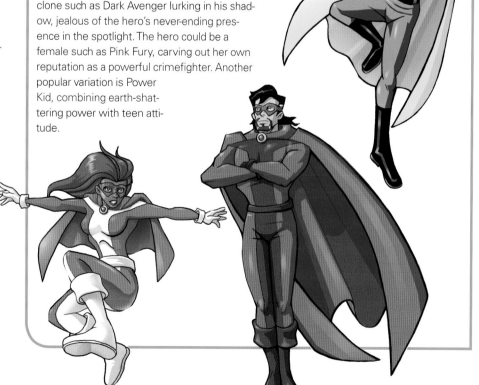

The **Arch Villain**

The Arch Villain is one of the most powerful enemies the superhero will ever encounter. The origins of the main superhero and the Arch Villain are usually linked, creating an instant conflict between them. The hero should always appear to be overwhelmed by the power and magnitude of the Arch Villain as the story progresses.

Arch villains should have earth-threatening goals of power, conquest and destruction. The heroes must have a really good reason to risk their necks time after time. The black-hearted Arch Villain is almost always defeated when the hero exploits some little-known weakness or character flaw and foils his dastardly plans. But the defeat of the villain should never be the death of the villain. Buildings might collapse around them, but no body should ever be found. The villain should always have a chance to return again another day.

1 Block in the basic structure. Even though Sir Skull is a disembodied spirit, you should still block in where his legs would be. His fingers are long and claw-like. He is leaning back as if he is floating.

2 Begin adding the misty darkness that surrounds Sir Skull, making up his lower torso. The tendrils of darkness should appear to be snaking out in all directions. Block in other anatomy and costume details, referring to references for ideas.

3 Finalize the details of the costume and anatomy, keeping them as consistent as you can. The darkness should appear solid and impenetrable. The tendrils should be fluid; the fact that they appear to be dripping upward adds eeriness to the image.

Character Profile

Name: Sir Skull

Origin: 500-year-old evil spirit of insane highwayman.

M.O.: Possesses his victims, turning them into violent criminals. Involved in crimes pertaining to bones or tomb treasures.

Powers: Darkness manipulation and illusions. Spiritual possession and control.

Weaknesses: Mental attacks, direct sunlight.

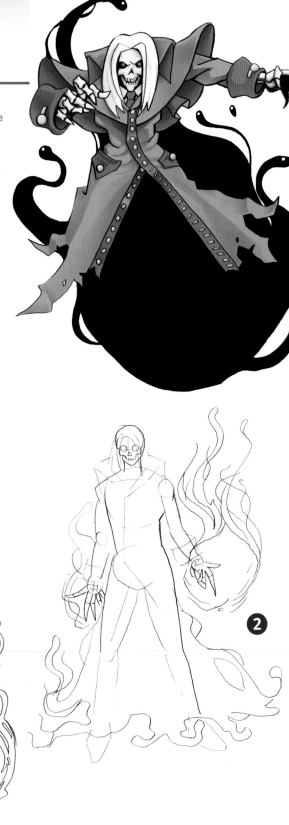

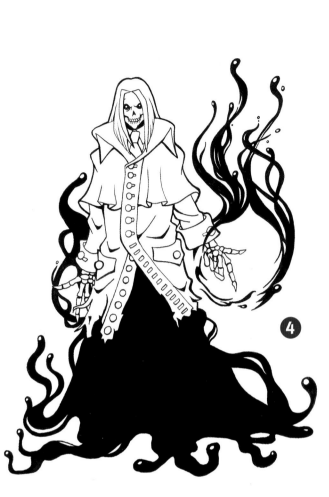

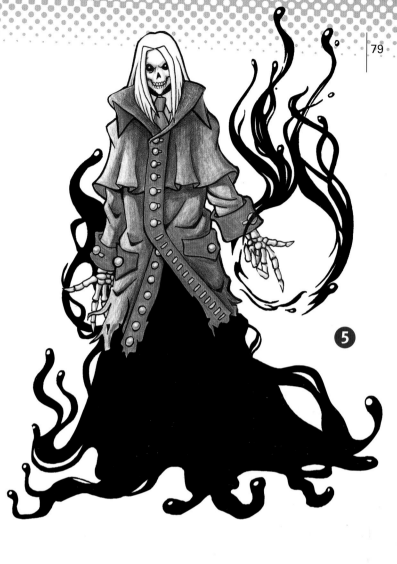

4 Erase the guidelines. The image should be detailed, but the lines should be simple. Some details such as the wrinkles on the coat, the hairlines and teeth should only be suggested, not fully drawn. Use as few lines as possible; too many can be distracting and hard to read.

5 Watch the coloring of fine details such as the finger bones and brass buttons. Make sure that they appear 3-D and realistic. Keep the highlights and shadows consistent with the direction of the light source. Keep the colors simple and muted. Too many colors would be inappropriate for a creature of darkness like Sir Skull.

Assorted Villainy

Some Arch Villains are more flashy than scary. Zorth enjoys making overblown speeches and billowing his cape dramatically. Dark Minerva is cool, calculating and dangerous. She has all the training and knowledge of Minerva—the Detective Hero you'll draw next—but she also possesses magical relics that give her the powers of the ancient Roman gods.

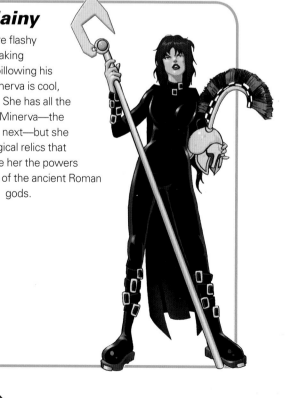

The **Detective Hero**

The Detective Hero is a tireless investigator. Although she usually possesses no superhuman abilities, she has been trained to the peak of human ability both physically and mentally. Her lack of powers doesn't stop her from jumping into the most challenging cases against powerful villains. There is often a wide range of weapons, tools and gadgets available to the Detective Hero to help level the playing field. She usually works alone, but a sidekick or two may assist her at times.

The Detective Hero is one of the oldest character types in comics. Many of the most popular superheroes were originally featured in detective or crime comics. The key motivation of the Detective Hero is acting as an agent of vengeance or defender of the innocent. This driving desire for righting wrongs makes it difficult to have a "normal" life, especially when she can't rely on superpowers. Every spare moment is devoted to research, training and pursuing leads—anything to give her the edge against her superpowered foes.

1 Draw a single guideline for the spine to show the line of action. This line continues along the figure's left leg. She is leaping up and forward from a crouching position, so the torso overlaps the abdomen. Keep the line of action fluid and smooth to reflect the springiness of the pose.

2 Don't make her too muscular, but give her arms and legs some form. She should appear graceful and quick, not blocky and chiseled. Her power comes from the coiled tension of her pose, not necessarily her muscles. Keep the knees and the feet pointed in the same direction.

Character Profile

Name: Minerva

Origin: The latest in an age-old line of crimefighters supported by a secret organization that follows the doctrine of Minerva, the Roman goddess of wisdom and war.

M.O.: Tireless investigator with access to a global information support network. Uses various gadgets and weapons in a war on crime.

Powers: Possesses no known superpowers but has trained physically and mentally to maximum human potential.

Weaknesses: Single-minded devotion to crimefighting allows no time for a social life or relationships. Minerva has many old enemies who seek revenge.

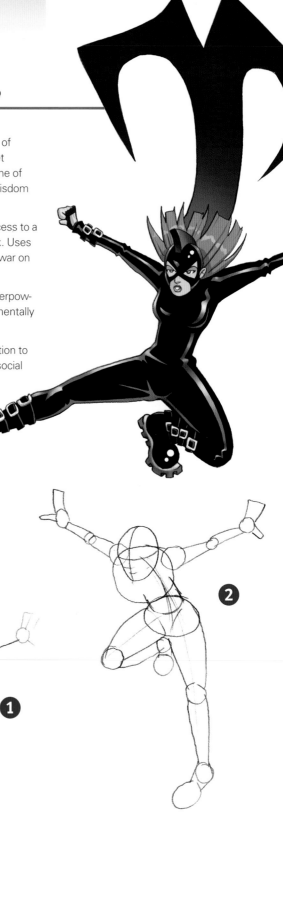

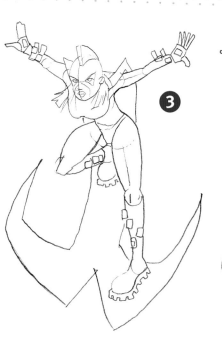

3 Erase some guidelines and then add costume details such as the mask, boots and cape. Note the unique eyeholes on this mask and the distinctive "fin" on the top of the head, which refers to the helmets worn by the ancient Greeks.

4 Clean up all sketchy lines and start defining muscle and costume details. Her distinctive cape splits in the middle and rises up on the sides to create handles when the cape is used for gliding. The cape also dramatically creates the letter "M" as she falls. Fill in the dark areas and leave highlights to express the shiny nature of her leather costume.

5 Keep the highlights bright. Figures drawn with large areas of black run the risk of appearing flat, so the highlights are very important to define the figure and details such as the buckles on her arms and legs, as well as the flow of her cape. Her muted and mysterious colors allow her to easily disappear into the shadows.

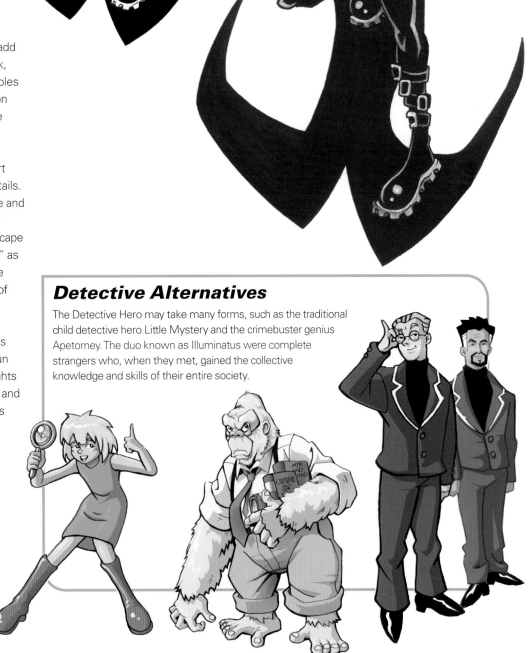

Detective Alternatives

The Detective Hero may take many forms, such as the traditional child detective hero Little Mystery and the crimebuster genius Apetorney. The duo known as Illuminatus were complete strangers who, when they met, gained the collective knowledge and skills of their entire society.

The **Tough Villain**

The Tough Villain is the adversary that superheroes face on a regular basis. The lieutenant of the Arch Villain, he ends up doing all the dirty work. This character must be defeated before the heroes can get to the Arch Villain. Much stronger than a lone hero, it often requires the teamwork of several heroes to overcome him.

In ancient myths, the Tough Villain was usually a guardian monster that tried to stop the hero from completing the quest. Keep the readers guessing by making it appear as if the Tough Villain is defeated, only to have him rise again to battle some more.

1 Start loosely with large, rounded shapes. Be more expressive than realistic. Bend the rules of anatomy and proportion to make him appear stronger and inhuman. Make his neck, hands and feet large and powerful.

2 Block in the details. The body should be bulky and thick but still appear fluid and mobile. His mouth should be sneering, and his attitude or swagger should be obvious even at this stage. Even though the Tough Villain is exaggerated and simplified, it should still have a sense of 3-D structure.

3 Avoid adding unnecessary anatomy and costume details. His face and body are simplified, and the only costume visible is flame. Give him scowling eyes and a heavy brow ridge.

Character Profile

Name: Magma Menace

Origin: Geologist studying lava flows was exposed to deadly volcanic gasses. Instead of dying, his latent mutant powers transformed him into a monster.

M.O.: Magma Menace likes to crush and burn whatever gets in his way.

Powers: His body temperature is a scorching 1,000 degrees Centigrade. He burns whatever he touches. His liquid form can squeeze between the cracks of what he can't burn through.

Weaknesses: Susceptible to cold and water attacks. Will turn to stone if covered in water or starved of oxygen.

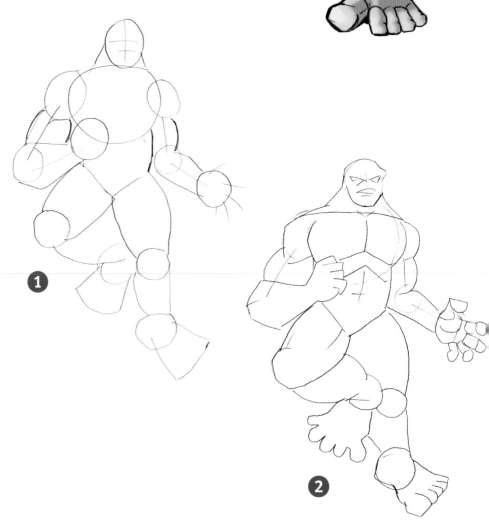

1

2

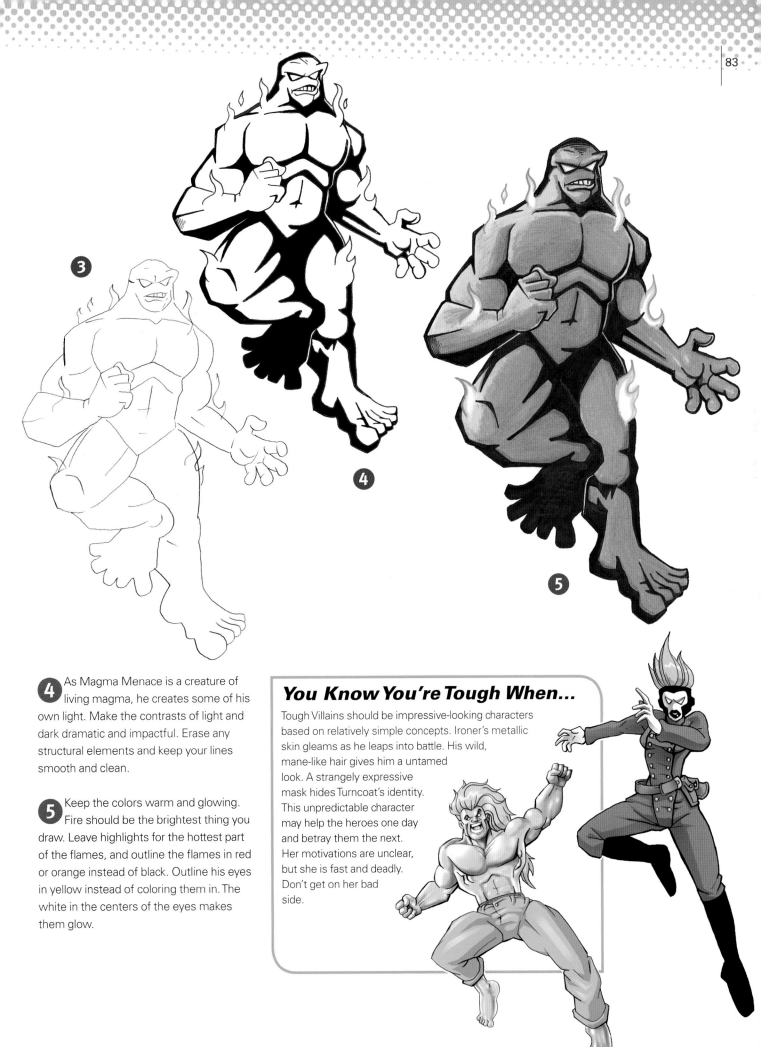

4 As Magma Menace is a creature of living magma, he creates some of his own light. Make the contrasts of light and dark dramatic and impactful. Erase any structural elements and keep your lines smooth and clean.

5 Keep the colors warm and glowing. Fire should be the brightest thing you draw. Leave highlights for the hottest part of the flames, and outline the flames in red or orange instead of black. Outline his eyes in yellow instead of coloring them in. The white in the centers of the eyes makes them glow.

You Know You're Tough When...

Tough Villains should be impressive-looking characters based on relatively simple concepts. Ironer's metallic skin gleams as he leaps into battle. His wild, mane-like hair gives him a untamed look. A strangely expressive mask hides Turncoat's identity. This unpredictable character may help the heroes one day and betray them the next. Her motivations are unclear, but she is fast and deadly. Don't get on her bad side.

The *Flying Hero*

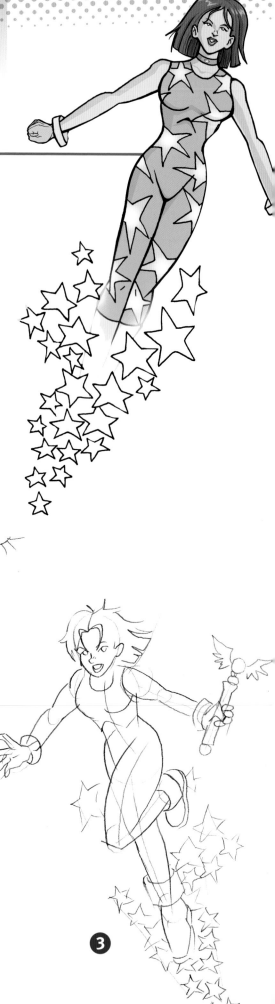

One of the most basic yet awe-inspiring superpowers is flight. The sight of a colorful superhero soaring above the city is one of the most familiar images in comics. Flying heroes are necessary to save all the people who fall out of airplanes and tall buildings daily in the comic book universe.

1 Create a definite line of action as you sketch the basic form. Starlighter should look like she's rising up from the ground. Her pose is confident and strong.

2 Give her teen proportions and keep her body rounded and soft. Block in the feet and hands, plus a few details like hair, facial features and her wand.

3 Develop the details that were hinted at in step 2 and work on her costume. Sketch loosely and lightly so you can explore and erase extra lines later. A multitude of stars trail behind her when she flies.

Character Profile

Name: Starlighter

Origin: Her powers stem from the magical wand given to her by a mysterious wizard; it reputedly holds a piece of a magical meteor.

M.O.: She is a very inexperienced hero who works with Star Cat to battle a seemingly endless supply of evil monsters.

Powers: Along with the power of flight she can fire star beams at her opponents and protect herself with a force field of stars.

Weaknesses: If someone else gains possession of the wand, she loses her powers.

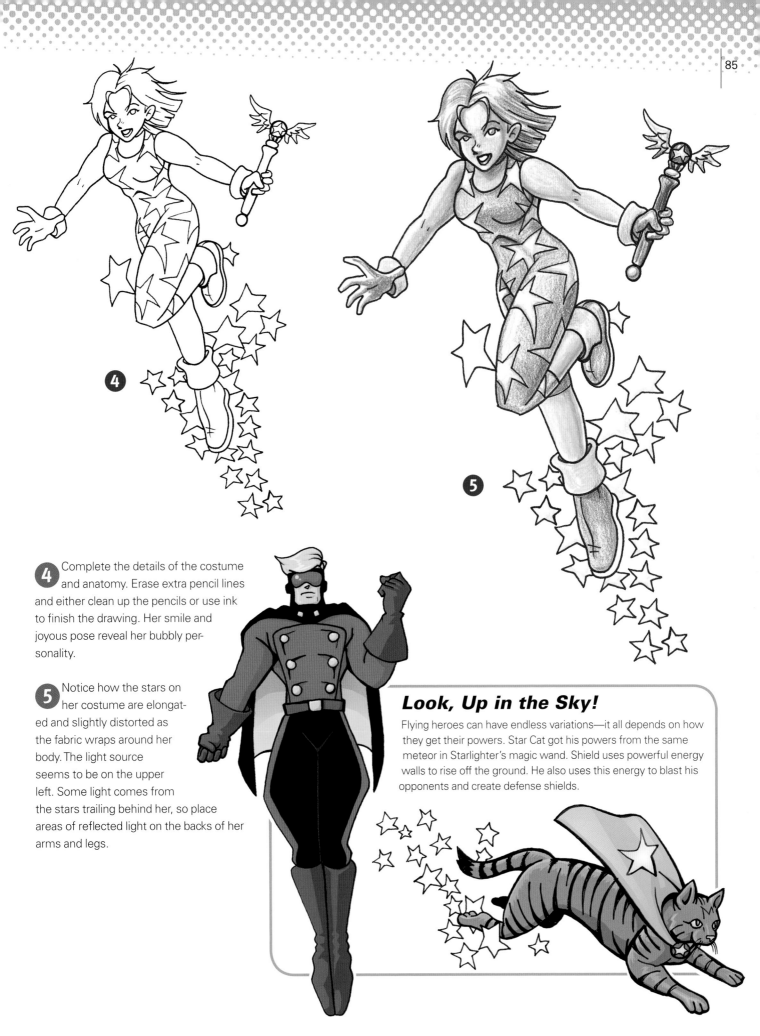

4 Complete the details of the costume and anatomy. Erase extra pencil lines and either clean up the pencils or use ink to finish the drawing. Her smile and joyous pose reveal her bubbly personality.

5 Notice how the stars on her costume are elongated and slightly distorted as the fabric wraps around her body. The light source seems to be on the upper left. Some light comes from the stars trailing behind her, so place areas of reflected light on the backs of her arms and legs.

Look, Up in the Sky!

Flying heroes can have endless variations—it all depends on how they get their powers. Star Cat got his powers from the same meteor in Starlighter's magic wand. Shield uses powerful energy walls to rise off the ground. He also uses this energy to blast his opponents and create defense shields.

The **Gadget Hero**

The Gadget Heroes always have just what is needed to get out of a tricky situation. They may not have any special powers, but they can join the ranks of superheroes by using items that can be just as powerful. They may not be able to hurl bolts of energy from their fingertips, but they could build a device to do the job.

Their identities are usually more defined by their gadgets than the Detective Hero. Gadget Heroes might be funded by governments or huge corporations, or they may be backyard inventors. Or, they may have just stumbled across their gadget or received it as a gift to carry on the traditions of the superheroic identity.

Character Profile

Name: Azadim

Origin: Dismissed from a top-secret military project, Azadim built a collection of gadgets to continue his own research.

M.O.: A man of few words, he is a ruthless crimefighter, but refuses to carry weapons.

Powers: Azadim uses his gadgets to track criminals, swing from buildings and entangle his opponents. He has no superpowers.

Weaknesses: He is virtually powerless without his equipment and is growing tired of his life as a costumed crimefighter.

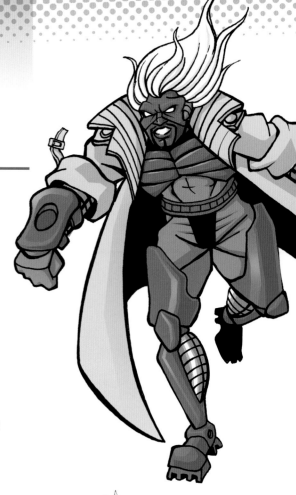

1 The pose is powerful and extreme. The character is in combat mode running at full speed toward the viewer. Tilting the figure off-balance exaggerates the intensity of the action.

2 Block in the anatomy and equipment. He should have an impressive presence. His gear pops out of his armor, and extra equipment is bolted on for special missions.

3 His identity and personality is starting to show. His mask has a wild shock of white hair, further hiding his identity but making him appear bigger. Develop the details of his costume and gadgets.

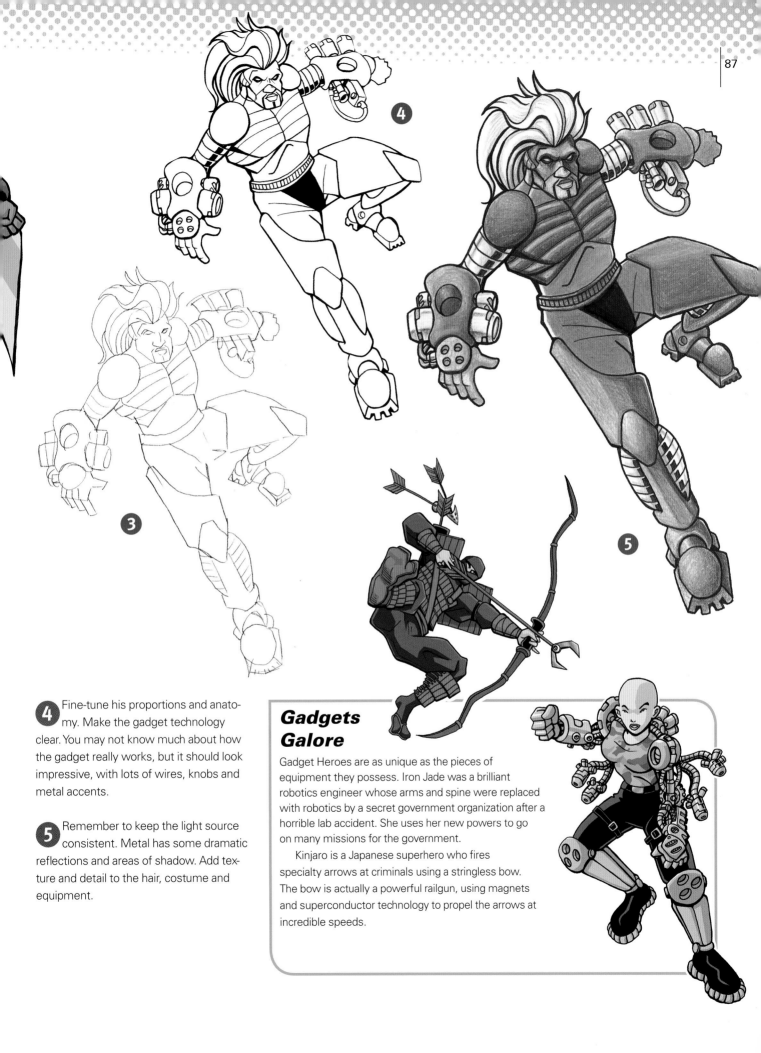

4 Fine-tune his proportions and anatomy. Make the gadget technology clear. You may not know much about how the gadget really works, but it should look impressive, with lots of wires, knobs and metal accents.

5 Remember to keep the light source consistent. Metal has some dramatic reflections and areas of shadow. Add texture and detail to the hair, costume and equipment.

Gadgets Galore

Gadget Heroes are as unique as the pieces of equipment they possess. Iron Jade was a brilliant robotics engineer whose arms and spine were replaced with robotics by a secret government organization after a horrible lab accident. She uses her new powers to go on many missions for the government.

Kinjaro is a Japanese superhero who fires specialty arrows at criminals using a stringless bow. The bow is actually a powerful railgun, using magnets and superconductor technology to propel the arrows at incredible speeds.

The *Powered Armor Hero*

Powered Armor Heroes are a very specialized form of Gadget Hero. Their powers come from high-tech suits that they wear, which also hide their true identity. Underneath they are normal people. The armor doesn't need to be technological in nature. It could be magical armor, or even an organic life form that merges with the hero to create a new identity.

1 This pose is unusual in that the armored character is putting on her helmet as she launches into combat. Keep the action dynamic, but remember to start with the basics. Don't jump right into the details without planning the image.

2 Make the armor sleek and high-tech. Some influences from medieval armor and anime robots give it a unique, stylish design. As you block in the areas of armor, use feminine proportions and anatomy references to make her appear convincing.

Character Profile

Name: Windburn

Origin: Jessica Mathers worked tirelessly for the government to develop the Windburn armored suit.

M.O.: Flies in and bashes the bad guys with powerful blasts of wind and debris.

Powers: Very protective armored shell. Flight and blaster systems linked to elaborate windblast mechanism.

Weaknesses: The suit will run out of power after a few hours of intense use.

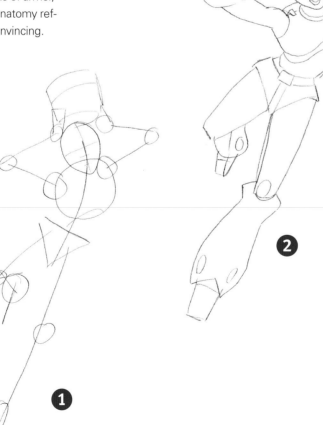

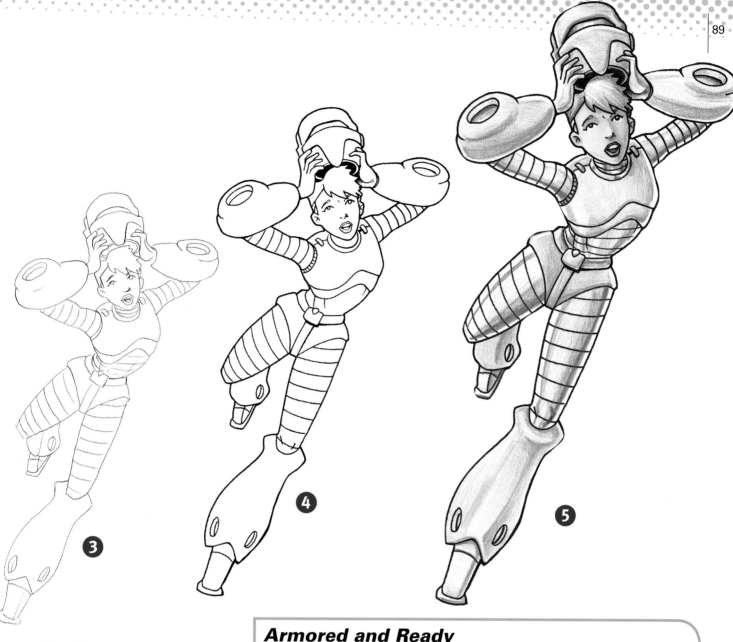

3 Detail the armor but keep the lines simple and dynamic. Too many lines can be confusing.

4 Vary the thickness of your lines. Use dark, thick ones for areas of shadow or emphasis. Thick lines also look closer to the viewer than thin ones. Alternating thick and thin lines creates a strong sense of 3-D form.

5 Watch how light reflects on metallic surfaces. Strong and bold differences of light and dark and reflected light are common on metal objects.

Armored and Ready

The power within armor can be technological, biological or magical. Crust was a fisherman who almost drowned but was saved when an alien mollusk merged with his body and formed a protective organic shell. He takes his second chance at life seriously and has set out to make a difference as a superhero. Sneak wears a suit of powered armor that uses advanced cloaking technology to become invisible to radar and other sensors. Sneak is a former colleague of Windburn's who stole his suit from his lab before it could be used for military purposes.

The Sidekick

The Sidekick is the second banana that follows the hero into battle against the forces of darkness. The writer usually uses this character as an opportunity for the hero to explain what is happening in the story. The Sidekick also provides convenient bait to lure the hero into a trap. The hero knows it will be a trap, but his sidekick must be rescued at any cost. The Sidekick can also temper the more vengeful vigilante tendencies of some heroes.

The Sidekick provides a bridge between the reader and the hero. Readers who are younger and less powerful than the hero can identify with The Sidekick living the dream of a junior superhero. Many former sidekicks graduate to become independent heroes who pursue their own adventures.

1 Block in this teen figure in action. Gargirl is small and willowy compared to most of the heroes and villains she encounters. Her feet are drawn larger than usual because of her big suction-cup boots.

2 Don't make her too muscular. She should be softer and more rounded than the standard hero. Note how her torso hides her left arm and how her forearm and hand are visible. Similar overlapping occurs with her raised leg. Details like this avoid the "flat" look.

Character Profile

Name: Gargirl

Origin: Became the sidekick of the vigilante hero Kimera after he saved her parents' lives from a suspicious fire.

M.O.: Moves quickly and uses home-made gadgets to fight crime.

Powers: No special powers, but relies on gadgets such as suction cups for climbing and clinging.

Weaknesses: Is often shocked and disappointed by Kimera's lack of respect for the law.

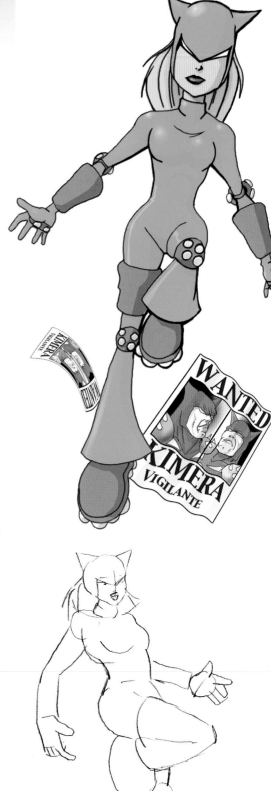

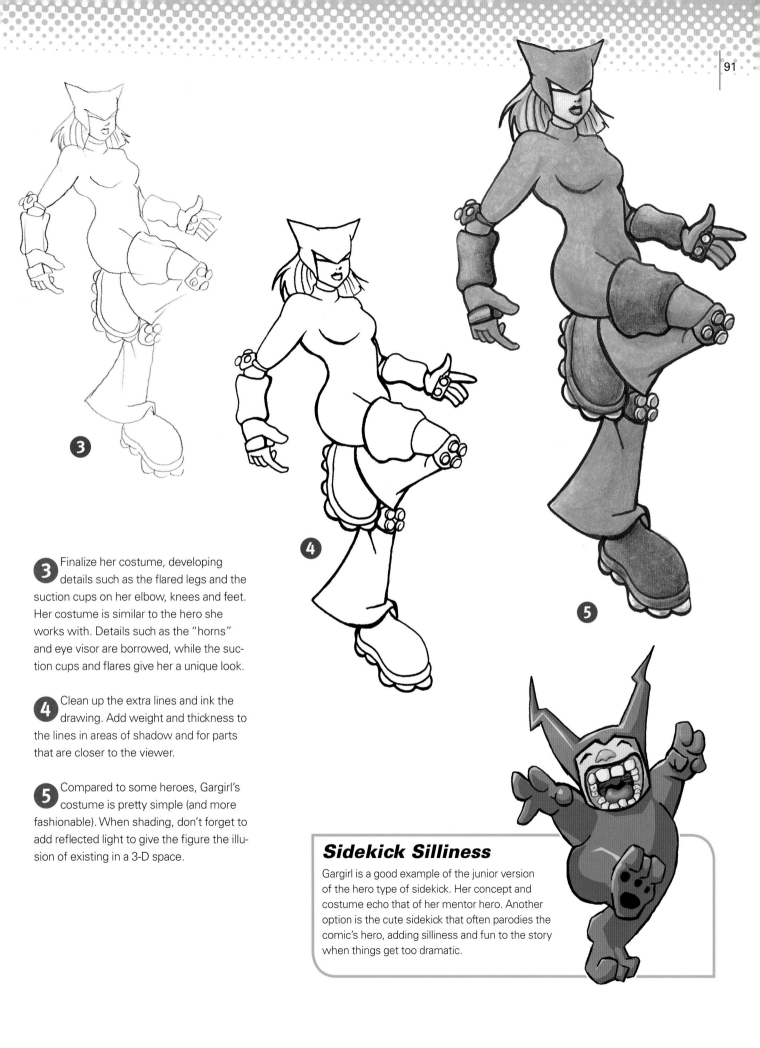

3 Finalize her costume, developing details such as the flared legs and the suction cups on her elbow, knees and feet. Her costume is similar to the hero she works with. Details such as the "horns" and eye visor are borrowed, while the suction cups and flares give her a unique look.

4 Clean up the extra lines and ink the drawing. Add weight and thickness to the lines in areas of shadow and for parts that are closer to the viewer.

5 Compared to some heroes, Gargirl's costume is pretty simple (and more fashionable). When shading, don't forget to add reflected light to give the figure the illusion of existing in a 3-D space.

Sidekick Silliness

Gargirl is a good example of the junior version of the hero type of sidekick. Her concept and costume echo that of her mentor hero. Another option is the cute sidekick that often parodies the comic's hero, adding silliness and fun to the story when things get too dramatic.

The *Energy Blaster Hero*

Energy Blaster Heroes can focus vast amounts of power and launch it at their enemies. This energy can come from a wide variety of sources. The hero may be able to summon bio-electric energy from a mutated nervous system and fire it from his eyes or hands. Other heroes must rely on special objects such as wands, rings or other artifacts.

1 The pose is very dynamic and full of action. The blaster should be prominent in the pose, as it is the source of Pierce's powers.

2 Block in the muscles and some details. Keep the costume simple; it's just supposed to be a shell that wraps around his regular clothes. Even though you won't be seeing any facial features, it is still a good idea to block in where they would be.

Character Profile

Name: Pierce

Origin: David Stillson was a petty criminal looking to reform. One night an alien escape pod crashed on the highway; when he rushed to help he was given an unusual blaster from a dying alien.

M.O.: Stillson uses his shady contacts to gain information on criminal activity and then rushes in as Pierce to stop them.

Powers: The alien's gift acts as a force field and blaster. It also covers Stillson in an armored suit that hides his identity and protects him from the harsh conditions of space.

Weaknesses: The blaster is so attuned to Stillson that if it is taken away, it will just reappear in his hands. When it needs time to re-energize, however, he is left very vulnerable.

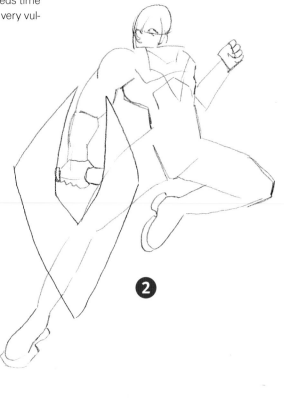

1

2

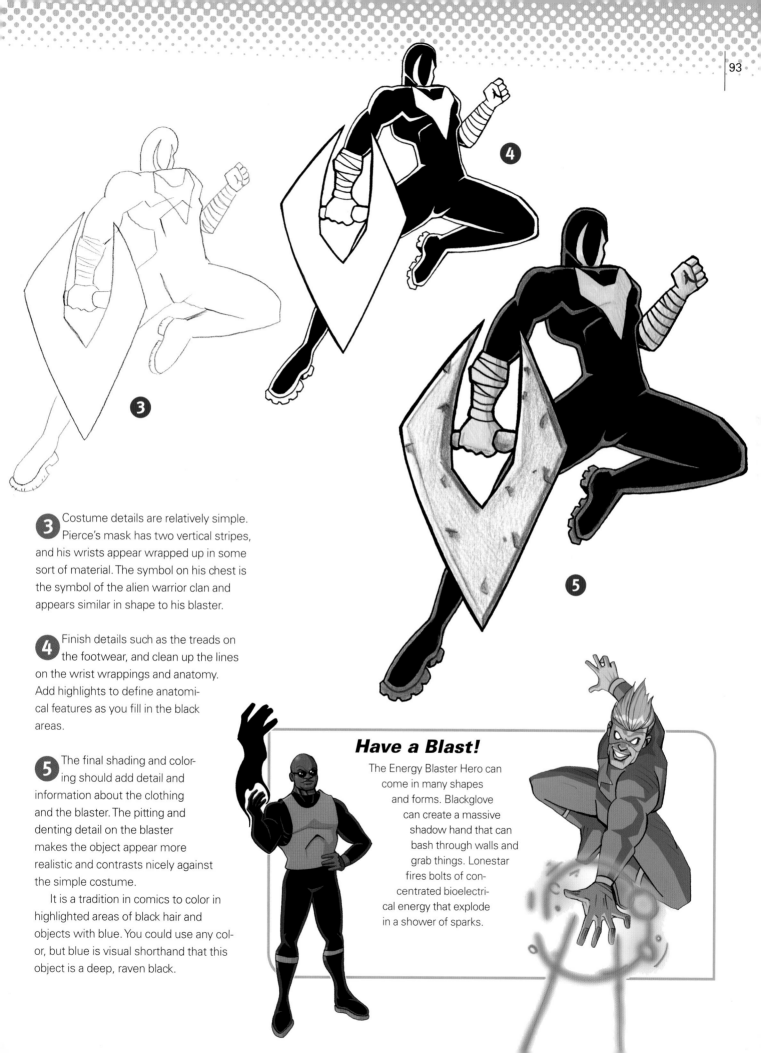

3 Costume details are relatively simple. Pierce's mask has two vertical stripes, and his wrists appear wrapped up in some sort of material. The symbol on his chest is the symbol of the alien warrior clan and appears similar in shape to his blaster.

4 Finish details such as the treads on the footwear, and clean up the lines on the wrist wrappings and anatomy. Add highlights to define anatomical features as you fill in the black areas.

5 The final shading and coloring should add detail and information about the clothing and the blaster. The pitting and denting detail on the blaster makes the object appear more realistic and contrasts nicely against the simple costume.

It is a tradition in comics to color in highlighted areas of black hair and objects with blue. You could use any color, but blue is visual shorthand that this object is a deep, raven black.

Have a Blast!

The Energy Blaster Hero can come in many shapes and forms. Blackglove can create a massive shadow hand that can bash through walls and grab things. Lonestar fires bolts of concentrated bioelectrical energy that explode in a shower of sparks.

The Magic Master

One of the first classic superhero types was the mystical hero. Some were masters of magic; others had the ability to cloud the minds of men with amazing mental powers. Magic Masters provide endless stories where their magic gets out of control or produces effects they could have never imagined. How they cast their spells, either from massive spell books or by saying magic words, is part of the fun of creating the character.

1 Sorceress stands firm, ready to cast a spell. Her arms and hands should be in motion, as if she's weaving some sort of spell. Notice how she is twisting slightly and her head is slightly tilted down. She is still fairly young, so use teen proportions.

2 One arm covers part of her torso. Draw the covered part anyway so you can understand what's going on underneath. Lightly sketch some costume details. She's young, but her daemon blood makes her powerful. Her expression is confident.

Character Profile

Name: The Sorceress

Origin: Caught in the middle of a wizard war, the young Sorceress was blasted into the present day from the 12th century.

M.O.: Sorceress uses her magic in a flashy, forceful manner. She comes from a time when magic was more common.

Powers: All manner of magical spells and abilities.

Weaknesses: It was rumored that her father was the daemon lord Scortan—a past that could come back to haunt her.

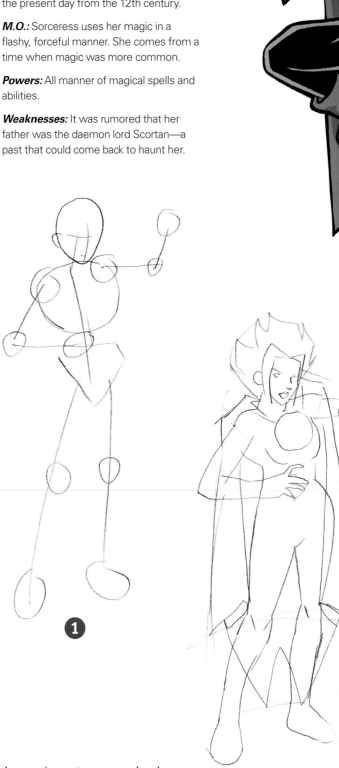

1

2

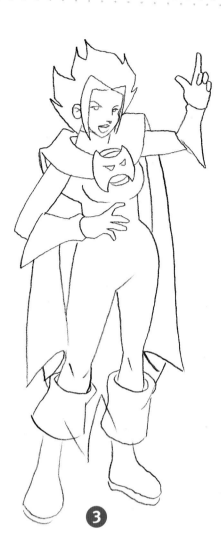

③

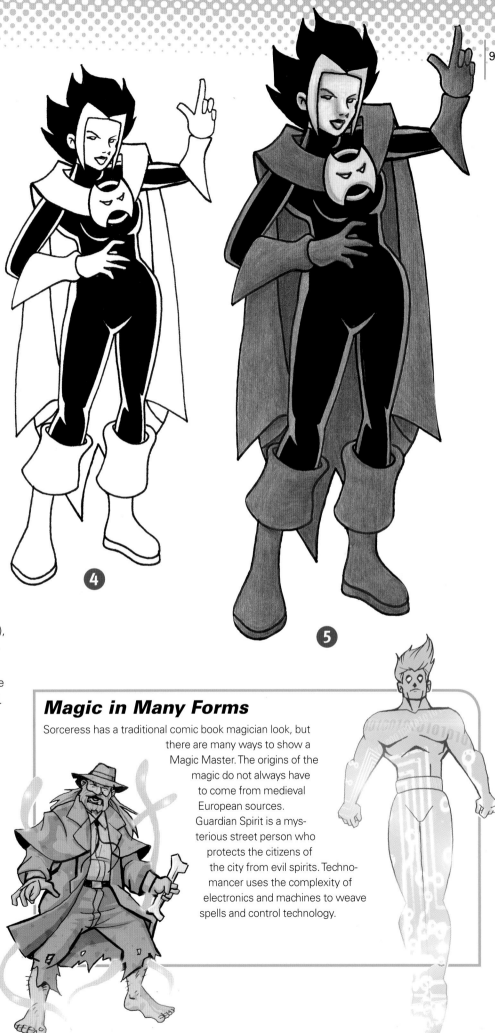

④

⑤

③ Clean up the details such as her spiked hair (tousled by many spells), her unique cape, gloves, boots and oversized brooch. The mask-like brooch is a symbol of her magical heritage. Her cape echoes the shapes found on her symbol.

④ As you ink the drawing, fill in the details such as the black bodysuit. When the ink dries, carefully erase the pencil lines. The highlights on the body ensure that the details of anatomy are not lost or flattened by coloring everything in black.

⑤ Purple lends a royal look. Her golden bangs and symbol stand out against the dark, cooler colors. Her eyes glow red, revealing a darker nature just under the surface.

Magic in Many Forms

Sorceress has a traditional comic book magician look, but there are many ways to show a Magic Master. The origins of the magic do not always have to come from medieval European sources. Guardian Spirit is a mysterious street person who protects the citizens of the city from evil spirits. Techno-mancer uses the complexity of electronics and machines to weave spells and control technology.

The Mythic Hero

Mythic Heroes are based on legends and myth, but unlike Magic Masters, they don't necessarily use magic powers. Some resemble heroes like King Arthur or Hercules. Others are mythical creatures like satyr or pixies. Mythic Heroes were, of course, the first tales of superheroes.

1 The Hooded Man is a man of action, so his pose should be as dynamic as his reputation. The bow is indicated at this early stage because it is such a major part of the character's identity.

2 Block in more details, including the cape, hood, quiver of arrows and anatomical features. The boots will be classic "heroic" boots with big cuffs.

3 Clean up the details and add little touches like the fact that the boot cuffs do not hug the legs tightly and the finger is holding the arrow down. Develop the hair, beard and scale-mail shirt. Stagger the scales so they fall in an alternating pattern.

4 Clean up the lines. Don't overdo it with detail: A few lines on the arrow feathers are much more effective than trying to draw every line that you know is there. The same rule applies to drawing hair, whether it's the hair on his head or his beard.

5 Show the roundness of form on the boot cuffs and the cape. The earth tone colors support the medieval source of inspiration for this character. Shade using complementary (opposite) colors: reddish brown to darken the green cape and green to darken the reddish brown. This adds a richness to the color that using black would not do.

Character Profile

Name: The Hooded Man

Origin: The current incarnation of the "Robin Hood" character. He took over the identity of the hero from his father.

M.O.: He robs from the rich and gives to the poor, but he also fights injustice.

Powers: He has a magical bow and enchanted arrows. He may perform feats of supernatural acrobatics and strength when he is helping the downtrodden.

Weaknesses: He is considered to be an outlaw by some heroes.

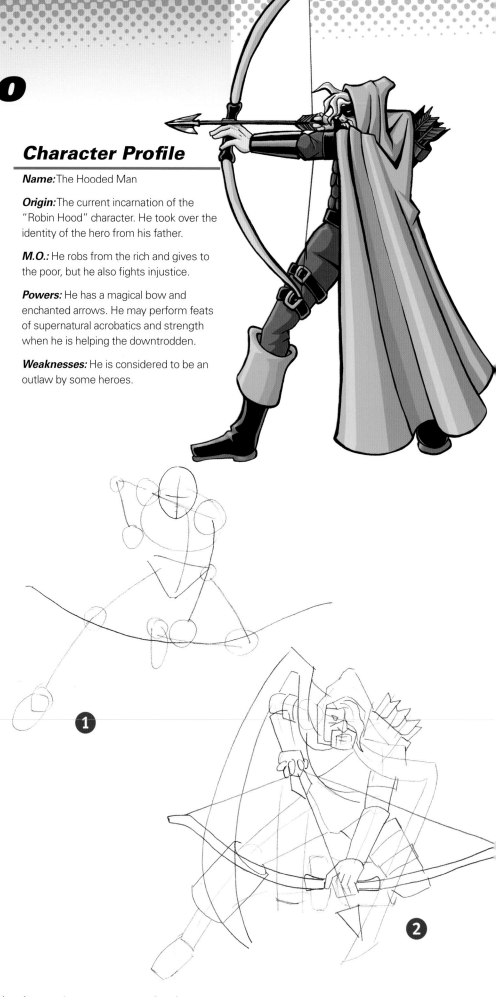

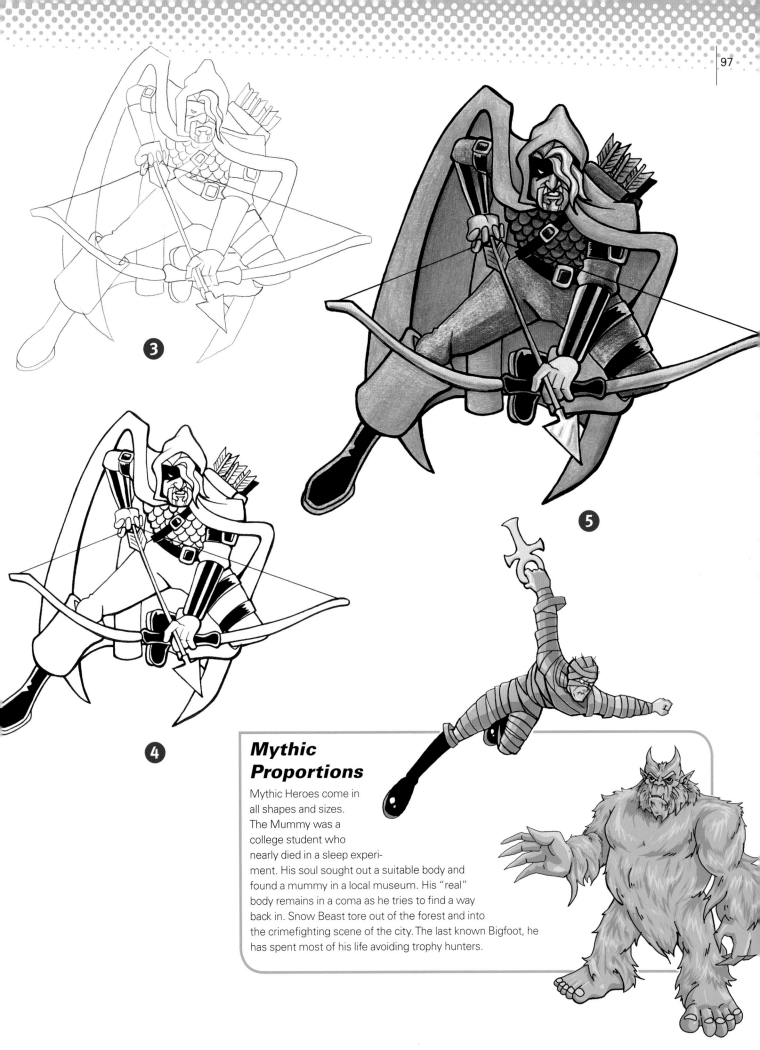

③

④

⑤

Mythic Proportions

Mythic Heroes come in all shapes and sizes. The Mummy was a college student who nearly died in a sleep experi- ment. His soul sought out a suitable body and found a mummy in a local museum. His "real" body remains in a coma as he tries to find a way back in. Snow Beast tore out of the forest and into the crimefighting scene of the city. The last known Bigfoot, he has spent most of his life avoiding trophy hunters.

The Big Tough Guy

The Big Tough Guy towers over his teammates and can often level a building with a stomp of his foot. This villainous type represents the extremes of anatomy and raw strength with inhumanly exaggerated muscles and proportions. What could be more intimidating than a screaming wall of muscle tearing through the landscape, heading right for you?

1 His proportions are inhumanly exaggerated, but you should still start with the basic shapes to make him appear convincing. His head is small and his fists are huge. He is leaning forward in an all-out run.

2 Establish the details of the anatomy and the costume. Add some details of the ground to show the powerful effects of his stomping.

The Mighty Blue Genie

The Mighty Blue Genie is a good example of a superhero that takes on an alternate form while fighting crime. Payne Gray found a magic lamp in the antiques store he inherited from his uncle. Usually a quiet antiques dealer, he transforms into the Mighty Blue Genie every time he rubs the lamp. His body is sucked into the lamp and he gains the physical strength and strange powers of a youthful genie. He also gains elements of the genie's forceful personality.

The Mighty Blue Genie is big and bold and breaks everything he touches. He's popular and confident, everything that Payne Gray isn't. It's a classic Jekyll and Hyde act. He returns to his human form when he falls asleep or is knocked unconscious, and the Genie form returns to the lamp and awaits the next adventure.

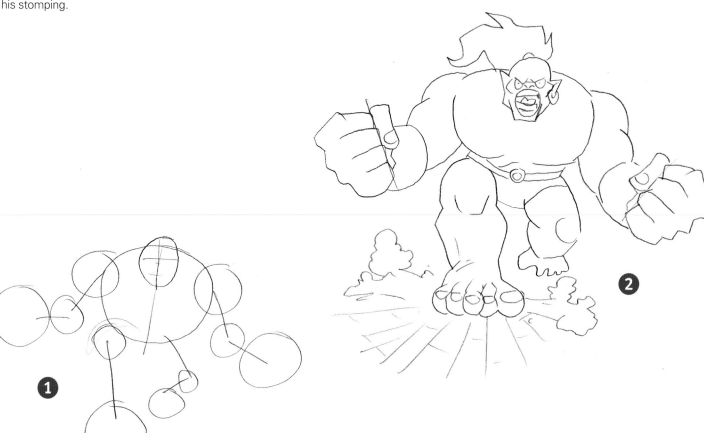

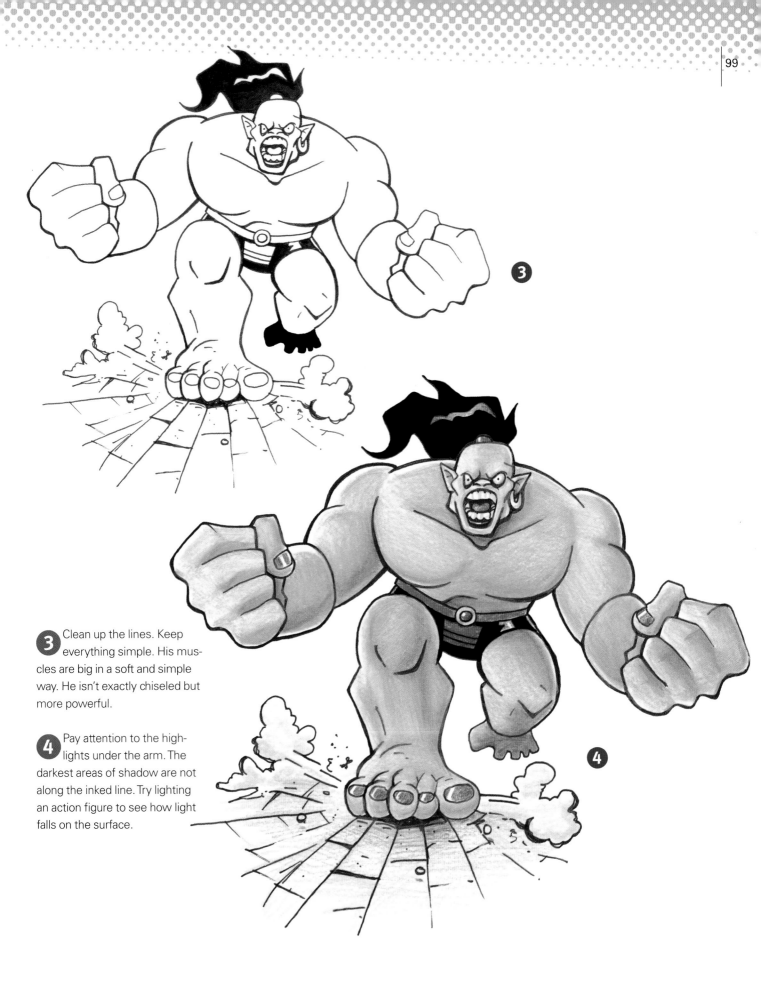

3 Clean up the lines. Keep everything simple. His muscles are big in a soft and simple way. He isn't exactly chiseled but more powerful.

4 Pay attention to the highlights under the arm. The darkest areas of shadow are not along the inked line. Try lighting an action figure to see how light falls on the surface.

The *Secret Identity* Hero

Superheroes make a lot of very powerful enemies. Most heroes can take care of themselves, but their friends and loved ones can't. Why hide your identity? Because keeping your identity secret keeps your "normal" life normal. Villains are a cowardly, vengeful lot and would love to use someone special to the hero as food for a man-eating plant or bait for an elaborate trap.

1 This dramatic pose will show the figure's transformation from Wanda to Book Smart. Keep your lines simple and easy to follow. Don't worry about the costume lines yet; just figure out where the amulet will be (swinging out from her neck).

2 Flesh out the details of the anatomy (including her upswept hair) and block in the lines for her costume, which seems to come together from ribbons that shoot from the amulet.

3 You can see how her costume goes right over her street clothes and even provides her with a handy mask to hide her identity. I chose fairly neutral colors for her street clothes. This makes her costume seem even flashier. Nobody would suspect this gentle soul of being a part-time crimefighter.

Book Smart

Mild-mannered librarian Wanda Tome found a mysterious amulet hidden in a false book. When she wears it her body is suddenly wrapped in a magical costume that grants her the powers of the last book she read. Now Book Smart keeps the streets safe from riffraff. Unfortunately for her, she was reading a cookbook just before Sir Skull showed up. Omelets, anyone?

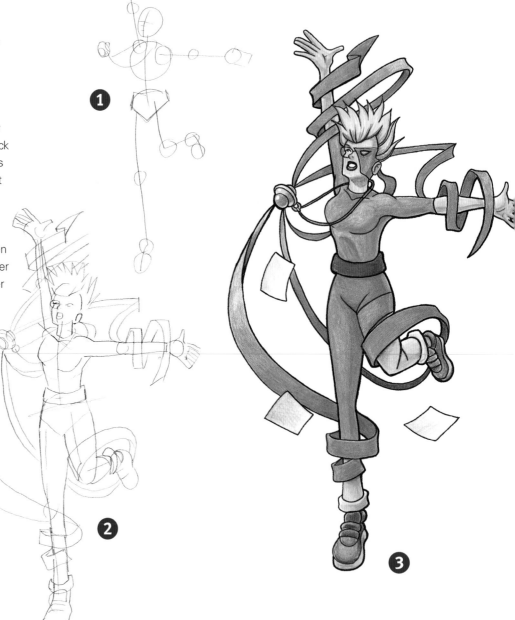

Blue Dodger

Popular high school teacher and amateur boxer Taylor Washington, frustrated by the injustices around him, created an alter ego to solve mysteries and fight crime. The costume was originally worn for the masquerade dance he was chaperoning. No one recognized him as he stopped an attack of robot cheerleaders. Named by the press for his impressive ability to get out of the way, Blue Dodger has no known superpowers but is a top athlete and tactical thinker.

Two students, Chip and Urchin, discovered his identity but kept it secret. They only asked that they be allowed to help his struggle, providing computer savvy and street smarts for the hero. Now Blue Dodger would be lost without them. Together, they solve mysteries, fight crime and learn a thing or two about life.

1 The pose is simple but should be strong even at this stage. He should appear powerful but not superhuman.

2 Add clothing and anatomy details. It's a good idea to keep a stack of old catalogs handy for reference when drawing clothing like button-down shirts.

3 Be careful to accurately draw the wrinkles on his shirt sleeves and pants. His mask and costume are simple, homemade items. Blue Dodger's costume is predictably blue, with red and black accents. Using brown hatching over yellow gives his pants a soft texture. He looks confident and proud, a real hero ready to take on the forces of darkness.

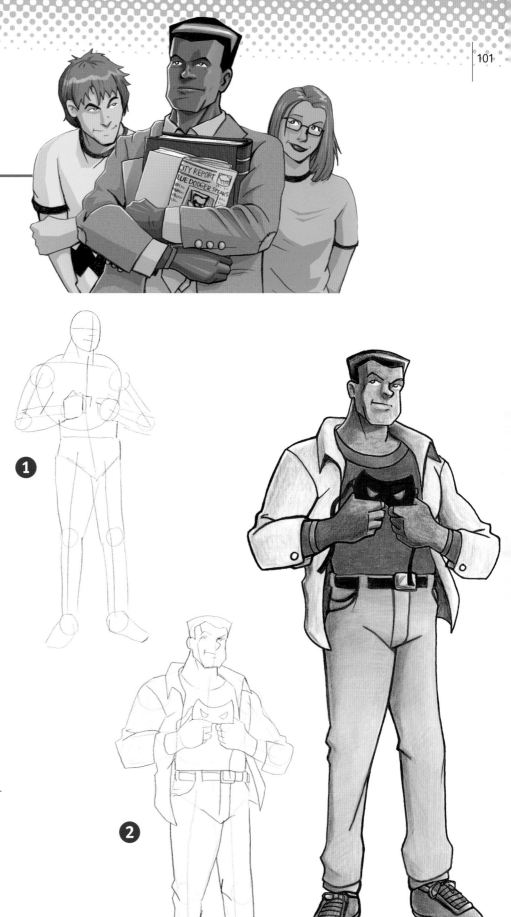

The
Teen Hero

The Teen Hero is a staple in classic comics. Entire comics are devoted to teen heroes. More than just sidekicks, they have set out on their own. Teen Hero stories are characterized by angst-ridden soul searching, betrayal, goofiness, pimples, awkward infatuation and strange powers that make the hero feel alienated.

1 Use teen proportions as a guide for the anatomy. Zombie Boy likes to take in his surroundings before he acts. He's always ready to shamble into action.

2 Flesh out the figure with anatomy and costume details. A wild hairstyle and stitches on his body are defining elements of Zombie Boy.

3 Complete the linework and erase the guidelines. Carefully shade in the costume with black, being careful not to flatten it by making it all black. The highlights on the costume details add a more realistic, fully formed look. His skin should be a pale, greenish blue—he's a zombie, after all. The shadows on his face should be greatly exaggerated by his undead nature.

Zombie Boy

You might think Joey was like any other teenager, but you'd be dead wrong. Joey is a zombie, but his biggest worry is if he'll pass biology. Joey's "condition" developed after he fell into a vat of mysterious chemicals. Quiet and thoughtful, Joey just wants to be like everyone else, but then a monster shows up and it's up to Joey to save the day.

Zombie Boy brings together two things that helped define comics in the early years: horror and teen angst. Despite his frightening appearance and dark back story, Zombie Boy should be presented as an earnest teen who just wants to fit in, though he knows he never will.

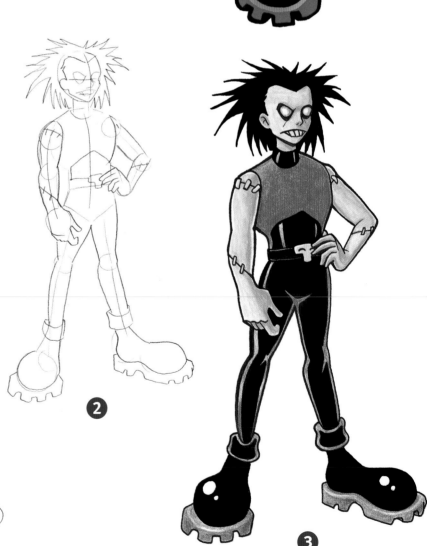

Red Ribbon

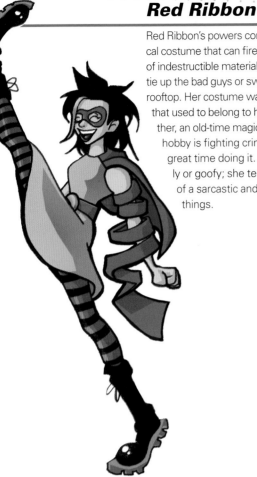

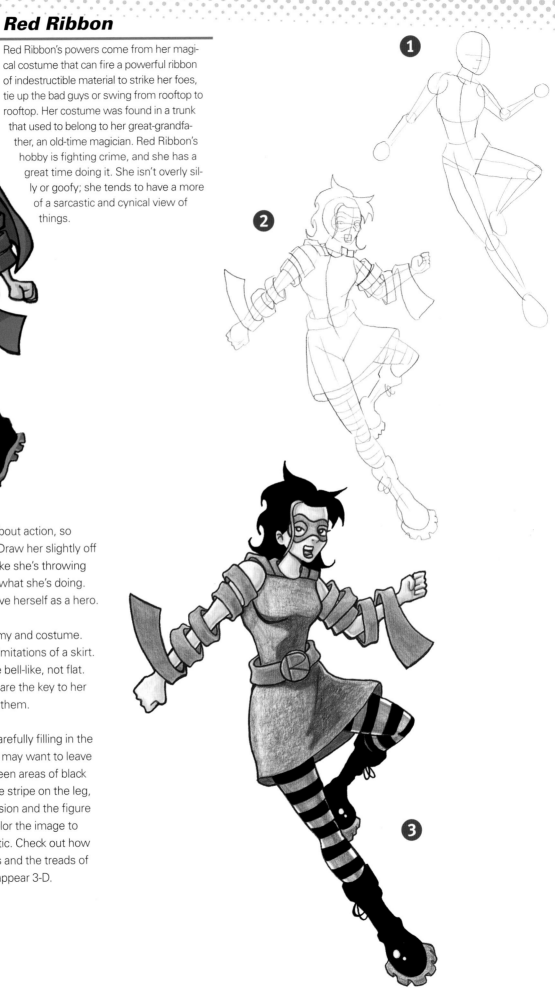

Red Ribbon's powers come from her magical costume that can fire a powerful ribbon of indestructible material to strike her foes, tie up the bad guys or swing from rooftop to rooftop. Her costume was found in a trunk that used to belong to her great-grandfather, an old-time magician. Red Ribbon's hobby is fighting crime, and she has a great time doing it. She isn't overly silly or goofy; she tends to have a more of a sarcastic and cynical view of things.

1 Red Ribbon is all about action, so keep her moving. Draw her slightly off balance; it should look like she's throwing herself completely into what she's doing. She is very eager to prove herself as a hero.

2 Block in the anatomy and costume. Keep in mind the limitations of a skirt. The skirt hem should be bell-like, not flat. The ribbons on her arm are the key to her powers, so don't forget them.

3 Ink the drawing, carefully filling in the areas of black. You may want to leave a small white line between areas of black such as the boot and the stripe on the leg, just so there's no confusion and the figure doesn't look too flat. Color the image to look rounded and realistic. Check out how the curve of the ribbons and the treads of the boots are made to appear 3-D.

Thugs

Thugs are essential in superhero stories. They let the heroes relate to real-world threats, showing off just how powerful they are. Thugs also help slow down the heroes just long enough to let the villains escape.

1 Make the goon's proportions large and impressive. Keep the shapes loose when you block out the form. His arms and legs should be powerful. His fists are huge!

2 Erase the under-drawing and add anatomy and costume details. This goon is a fairly small-time crook, but he still looks mean.

3 Keep the lines clean and solid. Details like the bandage on his nose and the tears in the shirt make him look even rougher around the edges. Keep your light source consistent as you shade the figure. Leaving some areas white gives a harsher highlight and makes the light look brighter. Don't forget about reflected light on the shadow side to give the figure a more convincing 3-D feel. Keep the colors simple.

The Goon

The Goon may not be the sharpest tool in the shed, but he gets the job done. He may be only human, but he can still give a superhero a rough time.

Be ready to draw your goon with all kinds of expressions and attitudes. Just think of the look on his face when his strongest punch has no effect on the Ultimate Hero.

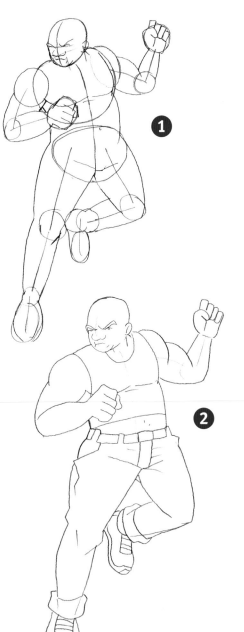

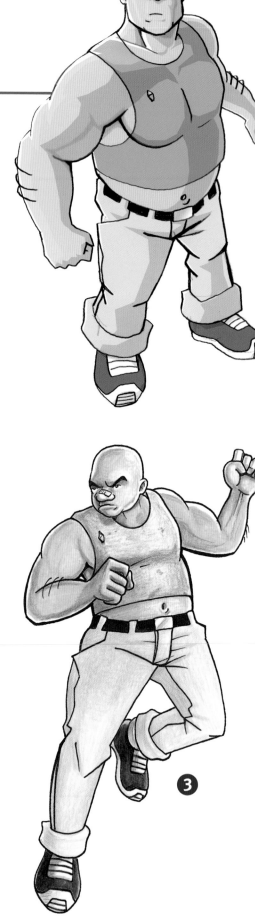

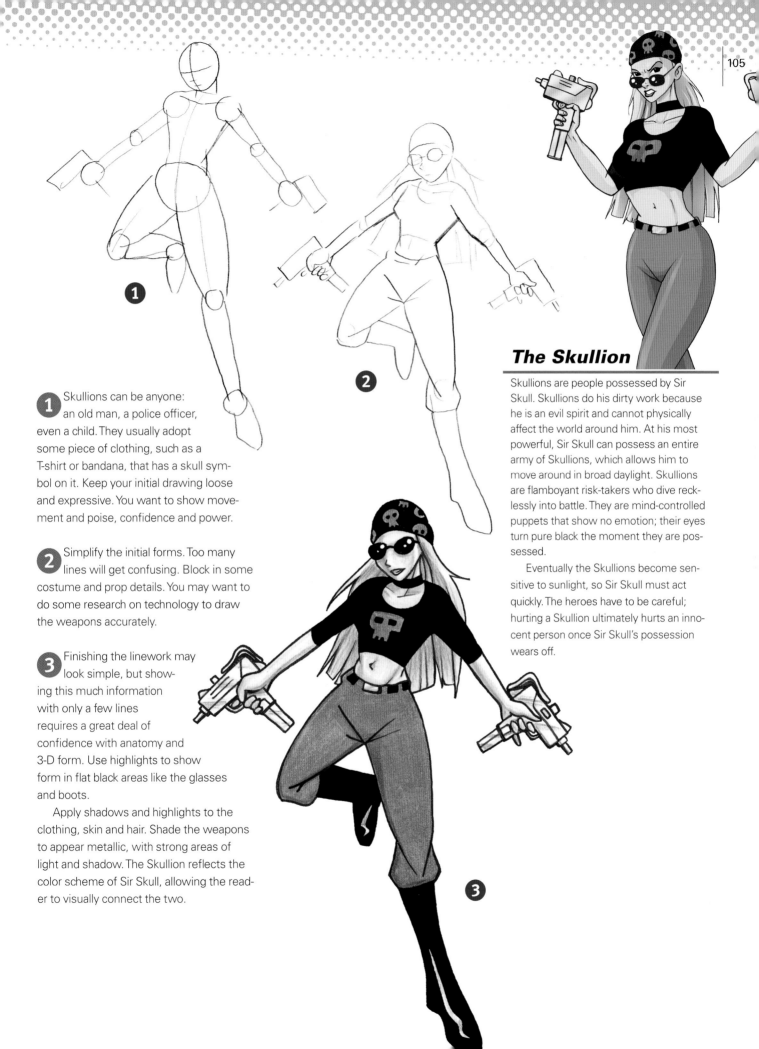

1 Skullions can be anyone: an old man, a police officer, even a child. They usually adopt some piece of clothing, such as a T-shirt or bandana, that has a skull symbol on it. Keep your initial drawing loose and expressive. You want to show movement and poise, confidence and power.

2 Simplify the initial forms. Too many lines will get confusing. Block in some costume and prop details. You may want to do some research on technology to draw the weapons accurately.

3 Finishing the linework may look simple, but showing this much information with only a few lines requires a great deal of confidence with anatomy and 3-D form. Use highlights to show form in flat black areas like the glasses and boots.

Apply shadows and highlights to the clothing, skin and hair. Shade the weapons to appear metallic, with strong areas of light and shadow. The Skullion reflects the color scheme of Sir Skull, allowing the reader to visually connect the two.

The Skullion

Skullions are people possessed by Sir Skull. Skullions do his dirty work because he is an evil spirit and cannot physically affect the world around him. At his most powerful, Sir Skull can possess an entire army of Skullions, which allows him to move around in broad daylight. Skullions are flamboyant risk-takers who dive recklessly into battle. They are mind-controlled puppets that show no emotion; their eyes turn pure black the moment they are possessed.

Eventually the Skullions become sensitive to sunlight, so Sir Skull must act quickly. The heroes have to be careful; hurting a Skullion ultimately hurts an innocent person once Sir Skull's possession wears off.

Acrobats

Acrobats use flips and jumps as a martial art. They can scale the sides of buildings and keep up with flying characters by leaping from building to building. They also have an impressive ability to get out of the way very, very quickly.

1 Panther's movements should appear fluid and graceful. Like his namesake, he should be powerful, yet sleek. Make him muscular, but avoid distorting the proportions to show his strength. His weight may be resting on his hand, but you can see how his legs are going to need to support that weight when he comes out of his cartwheel.

2 Erase the guidelines and keep the lines that create the form of the character. Panther's very distinctive claws need to look large and dangerous.

3 When you are drawing black clothing, draw the highlights on the figure to help define the surface anatomy and make the figure look less flat. The costume is a form-fitting leotard with built-in feet. The small domino mask should match the costume and may indicate that Panther needs to protect a secret identity.

The highlights are colored magenta. There are special areas in the highlights that are themselves highlighted. This reinforces the 3-D quality of the figure.

Panther

Panther is very quick and agile, with razor-sharp claws and a wit to match. He is wild, in more ways than one. His fingers grow into deadly claws that he uses with the ferocious intensity of a wild cat. He's also just a little crazy, which keeps both his enemies and his teammates guessing.

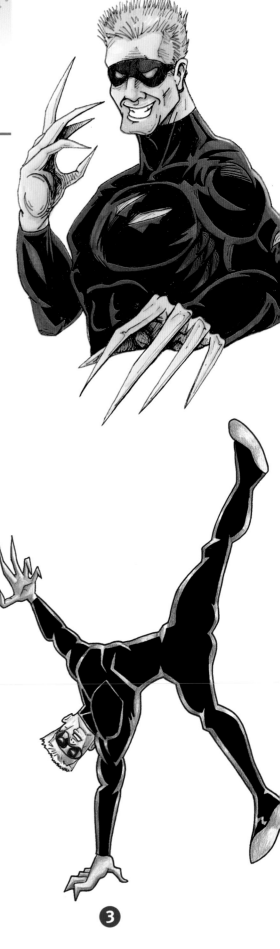

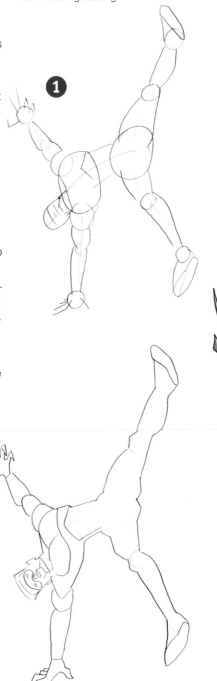

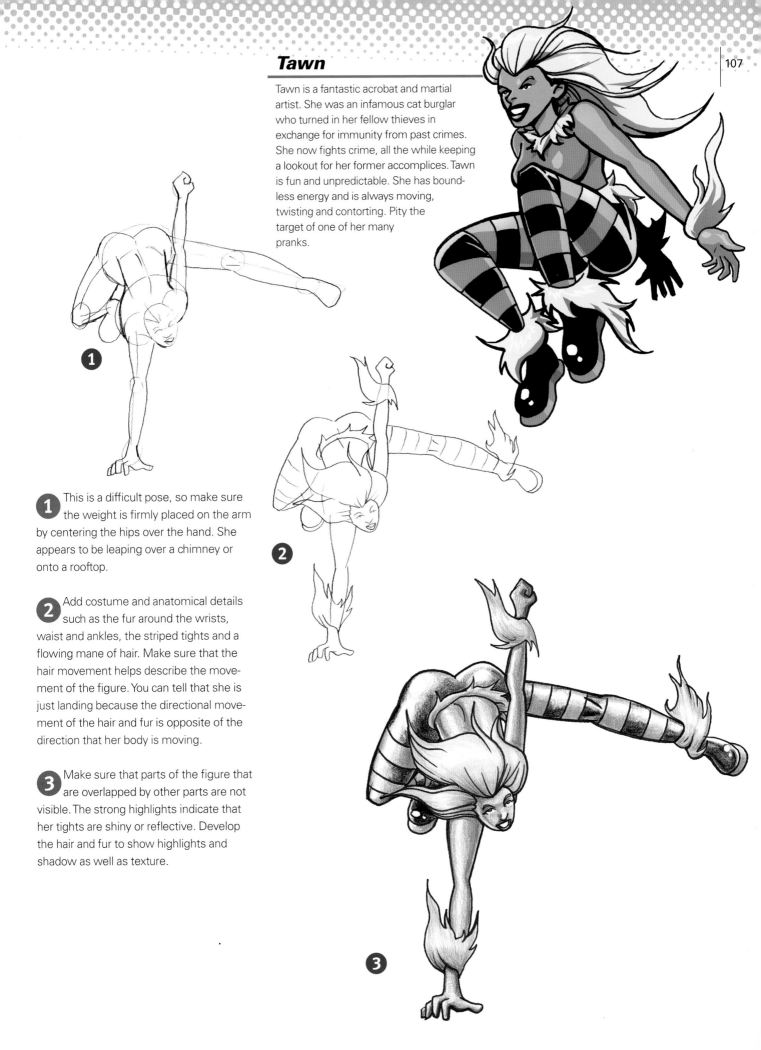

Tawn

Tawn is a fantastic acrobat and martial artist. She was an infamous cat burglar who turned in her fellow thieves in exchange for immunity from past crimes. She now fights crime, all the while keeping a lookout for her former accomplices. Tawn is fun and unpredictable. She has boundless energy and is always moving, twisting and contorting. Pity the target of one of her many pranks.

1 This is a difficult pose, so make sure the weight is firmly placed on the arm by centering the hips over the hand. She appears to be leaping over a chimney or onto a rooftop.

2 Add costume and anatomical details such as the fur around the wrists, waist and ankles, the striped tights and a flowing mane of hair. Make sure that the hair movement helps describe the movement of the figure. You can tell that she is just landing because the directional movement of the hair and fur is opposite of the direction that her body is moving.

3 Make sure that parts of the figure that are overlapped by other parts are not visible. The strong highlights indicate that her tights are shiny or reflective. Develop the hair and fur to show highlights and shadow as well as texture.

Alien Invaders

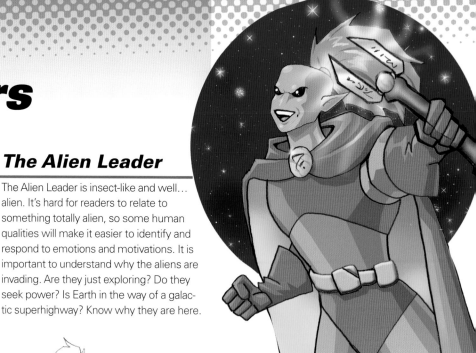

Not all strange visitors from other worlds are friendly. Some of them are downright hostile. It's a big, bad, beautiful universe out there, and it's up to Earth's heroes to save the day!

1 Even though the alien is not human, you still need to establish the basics of its anatomy. Here the lines, ovals and circles create the basic stance and give you much more anatomical information than you will really need for the final image.

2 The costume plays a big role in the way this character looks, so block it in now. He should look mysterious, yet powerful. The less human he looks, the more important it will be to develop a good model sheet so you can remain consistent when drawing him over and over again.

3 The costume is simple and futuristic. The wand he is holding seems to be a catchall technological device that can do anything from scanning a human to blasting a hole in the wall. Purples and greens have traditionally been associated with aliens in comic books. The strange writing on the costume reflects the alien's language.

The Alien Leader

The Alien Leader is insect-like and well… alien. It's hard for readers to relate to something totally alien, so some human qualities will make it easier to identify and respond to emotions and motivations. It is important to understand why the aliens are invading. Are they just exploring? Do they seek power? Is Earth in the way of a galactic superhighway? Know why they are here.

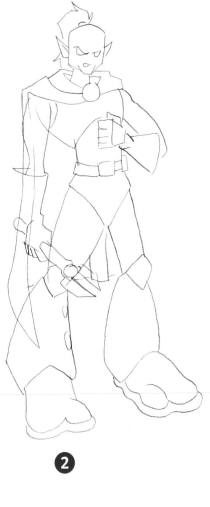

2

1

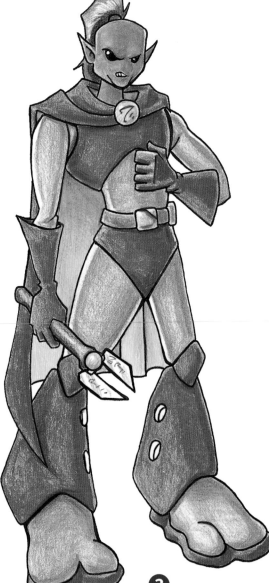

3

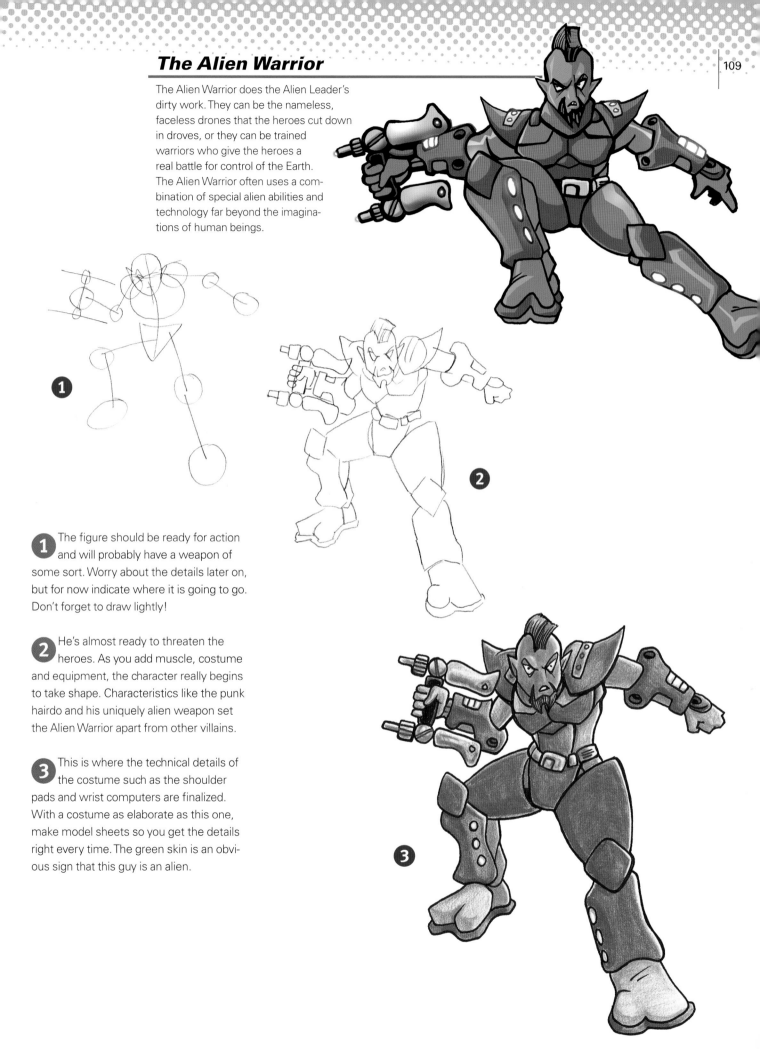

The Alien Warrior

The Alien Warrior does the Alien Leader's dirty work. They can be the nameless, faceless drones that the heroes cut down in droves, or they can be trained warriors who give the heroes a real battle for control of the Earth. The Alien Warrior often uses a combination of special alien abilities and technology far beyond the imaginations of human beings.

1 The figure should be ready for action and will probably have a weapon of some sort. Worry about the details later on, but for now indicate where it is going to go. Don't forget to draw lightly!

2 He's almost ready to threaten the heroes. As you add muscle, costume and equipment, the character really begins to take shape. Characteristics like the punk hairdo and his uniquely alien weapon set the Alien Warrior apart from other villains.

3 This is where the technical details of the costume such as the shoulder pads and wrist computers are finalized. With a costume as elaborate as this one, make model sheets so you get the details right every time. The green skin is an obvious sign that this guy is an alien.

Robots

Robots are ideal opponents for superheroes. They can be horribly beaten and nobody feels bad because they are just creatures of metal and plastic, not flesh and blood.

Robots embody humanity's fears of becoming obsolete and being replaced by machines. There is also something chilling about the precision and cold logic of the robot. Robots provide an endless supply of untiring opponents that relentlessly pursue their goals.

1 Because someone or something built this robot, you can be a little creative with anatomy specifics. Start with the standard lines and circles to create the pose and place the figure in space. The pose is wide and dynamic. The robot seems to be bracing itself as it unleashes a blast of automatic-weapon fire.

2 Lines on the arms, legs and neck give the figure a flexible, metallic feel. The lines also help reinforce the contour lines that make the limbs appear 3-D. The face is strong and determined, with few details.

3 The light source seems to be the blast from the arm weapon. Areas of shadow and intense reflection, like on the arms and legs, will be darker. Details such as the bumps on the shoulders and the structure of the weapon and legs make the robot seem more convincing.

Exterminator Robot

An unstoppable creature with no mercy, the Exterminator Robot is a single-minded destruction machine. It has a powerful laser beam/machine gun built into its arm, and seems designed to cause as much havoc as possible. Who sent this threat and what do they want?

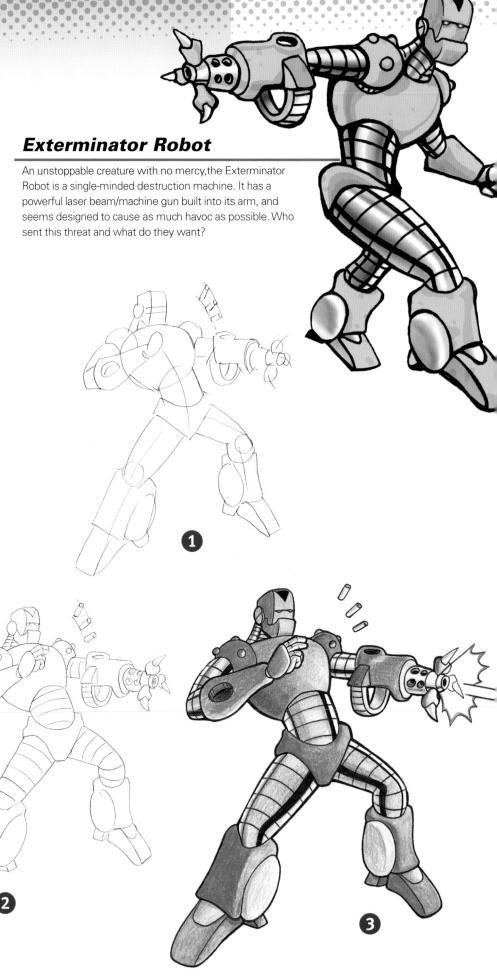

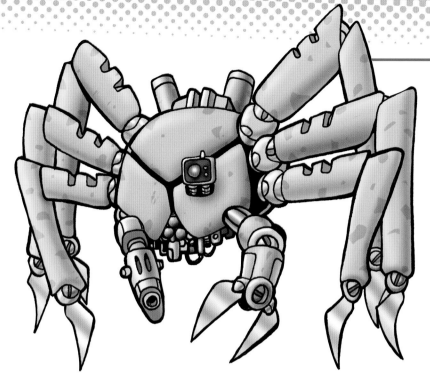

The Crab Bot seems alien, almost insect-like. The many legs, killer claws and blaster weapon would make a superhero scratch his head and wonder what to do first when confronted by this mechanical nightmare. Crab Bots could be more spider-like and shoot webs that tangle up their targets.

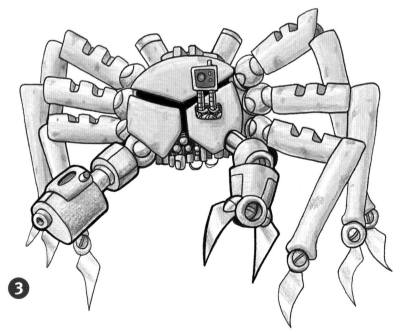

1 The anatomy is kind of complicated, so start with the basics. Draw each leg in relation to the other legs, and the torso needs to be able to support all of these limbs. Check resources on crabs and spiders to draw a convincing structure.

2 Draw the individual parts as they overlap each other. Technological details make this robot unique. Bolts and ball joints maintain the high-tech look. It wouldn't take much imagination to make this an organic creature, some sort of alien or mutant beast.

3 The details finalized, begin inking, remembering that the parts of the drawing that are heavily outlined will look closer to the viewer. Keep the lines to a minimum. As you color and shade, add details such as the rust and weathering spots. Diagonal lines on the feet and claws make them appear thin, metallic and blade-like. The red "eye" views everything relentlessly. Carefully finish some engine details in the back and technological details at the base so the lighting is consistent on the robot's surface.

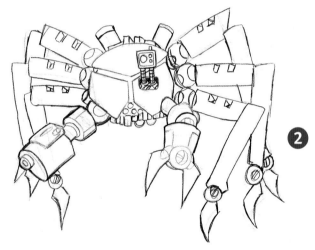

Giant Monsters
and Robots

The Giant Monster is one of the classic calamities that a group of heroes can face. Rampaging through the streets, seemingly unstoppable, it is the ultimate challenge for those with powers beyond mortal men.

What is a supergenius going to do to threaten heroes who can literally move mountains? Make a mountain that hits back. Giant Robots can come from a variety of sources in comics: alien warriors, military hardware, out-of-control prototypes, instruments of vengeance or malfunctioning helpers.

1 This rampaging lizard, a throwback to prehistoric times, could be the result of genetic engineering or a portal through time. Proportion isn't important here; just make him look intimidating. Put an every-day object like a car or lamppost in the drawing to help give the viewer a sense of scale. Viewing the monster from below makes the lizard appear larger and more imposing. The tail should be a fluid extension of the spine action line.

2 Block in details like the claws and facial features. Look at examples of lizards in nature or of dinosaurs in books for ideas.

3 The color choices are up to you. No one really knows what color dinosaur skin was, and modern lizards have a wide variety of colors to choose from. Define the surface texture of the monster. You don't have to draw every scale; a few here and there will be enough to imply scaly skin.

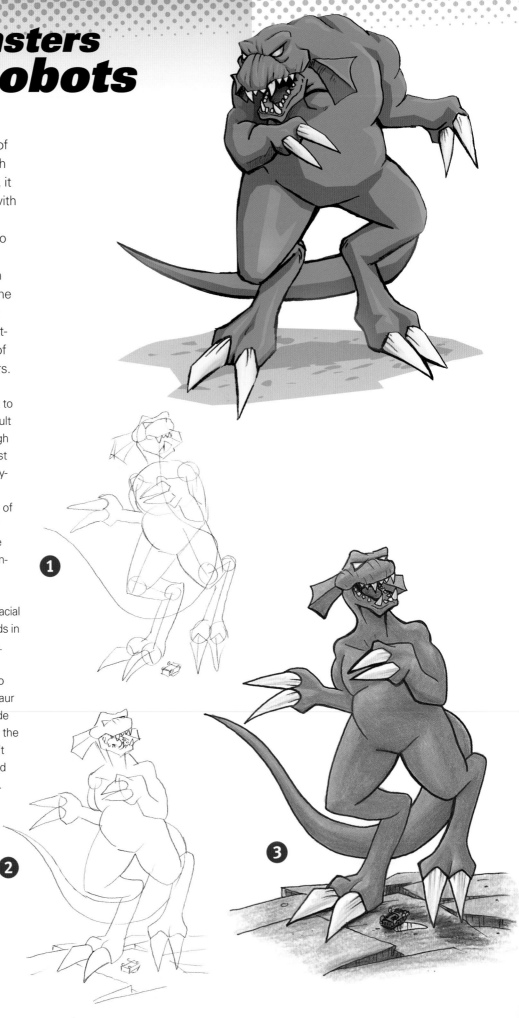

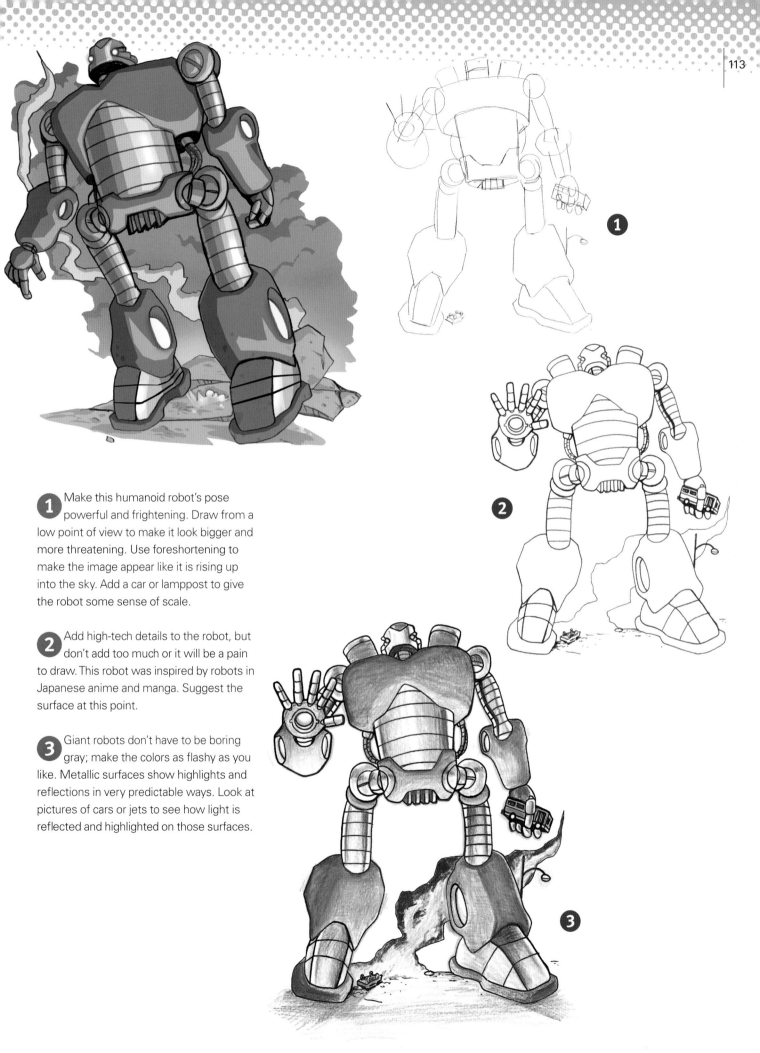

1 Make this humanoid robot's pose powerful and frightening. Draw from a low point of view to make it look bigger and more threatening. Use foreshortening to make the image appear like it is rising up into the sky. Add a car or lamppost to give the robot some sense of scale.

2 Add high-tech details to the robot, but don't add too much or it will be a pain to draw. This robot was inspired by robots in Japanese anime and manga. Suggest the surface at this point.

3 Giant robots don't have to be boring gray; make the colors as flashy as you like. Metallic surfaces show highlights and reflections in very predictable ways. Look at pictures of cars or jets to see how light is reflected and highlighted on those surfaces.

Alien Spacefighter

You have the opportunity to make anything you want look like an alien spacefighter. The stranger the combination of shapes, the more alien it will appear. The inspiration for this vehicle was the shape of a squid and a wasp.

1 Use a strong central axis line and crossing lines to establish the basic shape, and then build the details on top of this framework. The shapes should be loose and exploratory. You want to express the idea of the spaceship at this point, not painstakingly draw every detail.

2 Carefully erase unwanted lines, reinforce the outline and add details. The insect-like nature of the vehicle is much more obvious at this stage. The pincers in the front might be some sort of docking clamps or a weapon.

3 Add interesting patterns, textures and colors. Make sure the vehicle will stand out against the blackness of space. Shading gradually from light to dark should make all those rounded forms look 3-D.

1

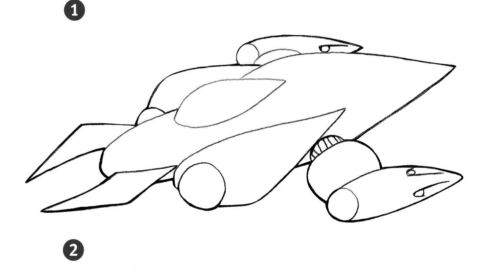

2

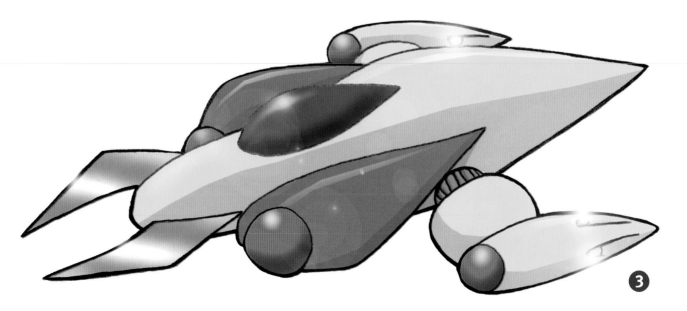

3

Download FREE bonus demos at impact-books.com/monster-manga-book

Alien Space Pod

*I*t's the kind of vehicle that streaks out of the sky, crashes into a farmer's field and then starts unleashing a horde of killer robots. The pod is more of a transport vessel than a battle craft.

1 Block in the guidelines. Use loose shapes to establish the design of the vehicle. Complex technology, when reduced to basic shapes, can be fun to draw. Is that a face on the front of the vehicle?

2 Clean up the extra lines and define the lines that are left. Notice how parts of the vehicle are hidden behind other parts. This adds to the realism and makes the vehicle look like it really exists in space. The technology appears almost alive.

3 Color and shade the vehicle to enhance its alien appearance. Keep it simple. You want to have a classic, cool design that is fun to draw. If you get too complicated, you'll never want to draw the thing again.

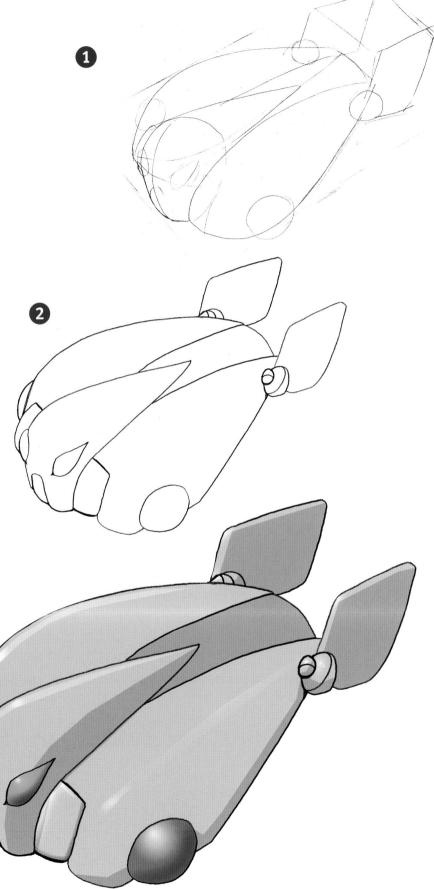

Basic Elements *of a* Comic Book Page

Comic book art has also been called sequential art—that is, a series of images and words that are strung together to tell a story. The comic book artist must be able to draw almost anyone or anything acting in every possible way, but you also must connect these individual images to create a bigger picture—the story.

It is important to think of comics as a medium, not a genre. It is a way of telling a story, not the story itself. Comics encompass all kinds of genres: history, drama, biography, romance, science fiction, fantasy, horror, comedy, action adventure and many more.

Let's look at the basic elements of a comic book page.

Narrative Caption
Narration is usually written in rectangular boxes that overlap the artwork.

Panel
One of the many illustrations arranged in a storytelling sequence.

Surface
Most comics are drawn on 11" x 17" (28cm x 43cm) two-ply bristol board sheets. The artwork area is usually 10" x 15" (25cm x 38cm).

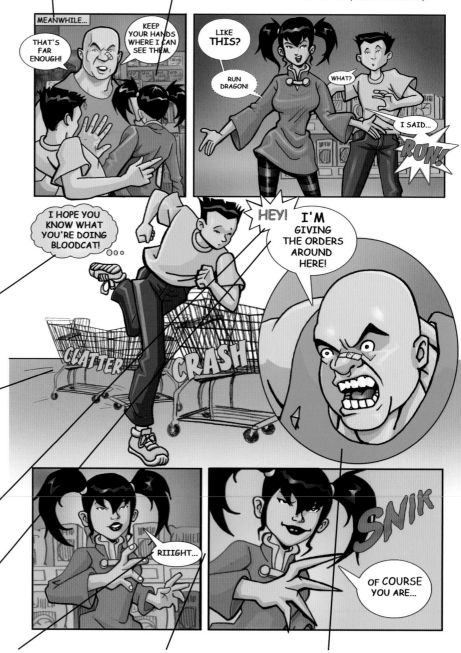

Thought Balloon
A cloud-like balloon that reveals the thoughts of a character.

No Panel Border
Create a more dynamic image and show more of a character by breaking him out of the panel.

Yelling Word Balloon
This balloon is jagged and the lettering is much larger.

Bold Lettering
Larger and/or darker lettering means that those words are stressed or said louder.

Word Balloon
The arrow points to whomever is speaking. A dotted-line balloon indicates whispering.

Gutter
The space between the panels. Keep your gutters consistent.

Panel Variety
Change panel shape from time to time to hold the eye of the reader.

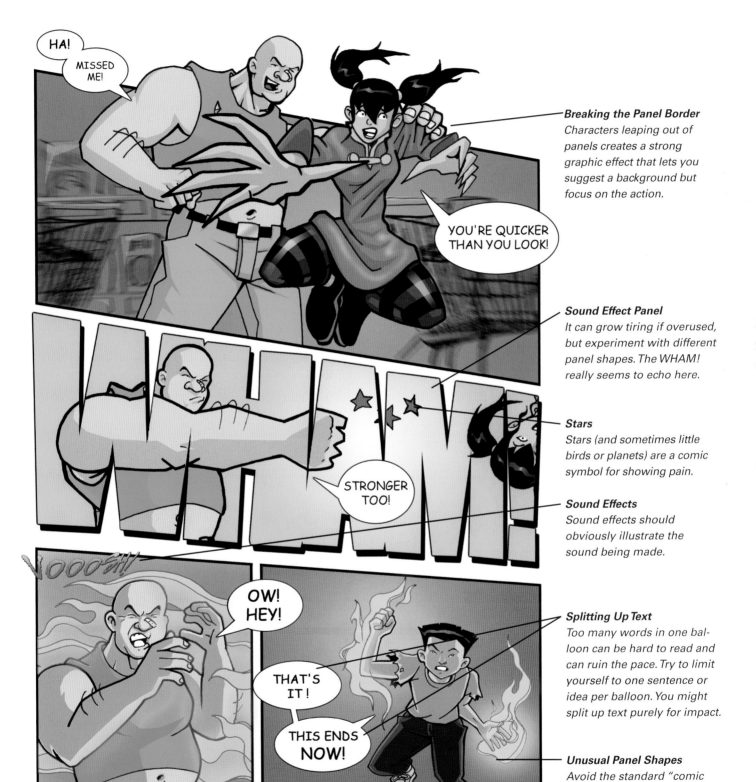

Breaking the Panel Border
Characters leaping out of panels creates a strong graphic effect that lets you suggest a background but focus on the action.

Sound Effect Panel
It can grow tiring if overused, but experiment with different panel shapes. The WHAM! really seems to echo here.

Stars
Stars (and sometimes little birds or planets) are a comic symbol for showing pain.

Sound Effects
Sound effects should obviously illustrate the sound being made.

Splitting Up Text
Too many words in one balloon can be hard to read and can ruin the pace. Try to limit yourself to one sentence or idea per balloon. You might split up text purely for impact.

Unusual Panel Shapes
Avoid the standard "comic strip" approach of equally sized panels lined up one after another.

3 MANGA MONSTERS

We're used to stories where the monster is the "bad guy," but in manga, many times the monster is depicted as the "hero." Even Godzilla defends the Earth from alien invasion from time to time. Powerful heroes who also possess supernatural origins or abilities often confront manga monsters. Monsters appear in Japanese culture not only as horrifying bogeymen, but as cultural touchstones and a warning to maintain respect for tradition and natural balance. Within these pages you'll learn that manga monsters are so much more than snarling villains; they have personalities, motivations and goals.

Anatomy of Bipeds

Bipedal monsters are the closest to humans because they walk and run on two legs, just like us, but the types of legs may vary greatly.

Animal vs. Human Legs

Some monsters, like fauns and werewolves, have animal-like or digitigrade rear legs. This technically means that the weight of the figure is placed on the balls of the feet and the ankle acts as a reverse knee. This can present some unique anatomical problems to solve, because the character will move and act differently from a humanoid biped.

Line Up the Head

The head should line up with the distribution of weight for the figure. This character's weight is spread between the legs, with more weight placed upon his right leg. Notice how his knees are bent and his left heel is just lifting off the ground.

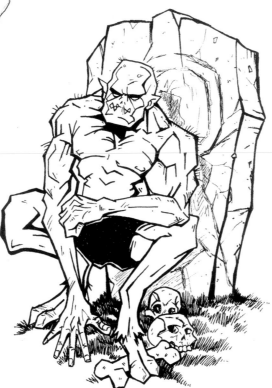

Digitigrade Feet

The feet of digitigrade characters may appear toe- or hoof-like. The character may need to balance with a tail or lean forward and use its hands to spread the weight more efficiently.

The Nature of the Monster

Tails provide a reasonable counterbalance. Other animal-like details may also be added depending on the nature of the monster. This werewolf has a tail, claws, fur and a wolf-like jaw filled with razor-sharp teeth.

Anatomy of Quadrupeds

Designed for four-legged movement, quadrupeds are usually larger and faster than bipeds.

Helpful Stirrups

Stirrups were added to saddles to help riders maintain a steady posture on the horse. Stirrups existed over 1,700 years ago in China and over 2,000 years ago in Mongolia, but were not common in Europe until after the eighth century. After stirrups were invented, warriors could ride wearing armor and fight from their horses; they did not even need to dismount to do battle. Stirrups are also helpful for accurate archery and throwing from horseback.

Alternate Beasts of Burden

Fantasy or alien worlds can produce alternate beasts of burden. This quadruped appears to be part lizard or dragon. There is a saddle and reins but no stirrups for the feet, meaning that this is probably not a beast that is used as a warhorse.

Horse and Warrior as One

A charging warhorse seems to fly across the battlefield. A horse in full gallop shifts its weight to the front and uses its rear legs to propel itself. The rider must lean forward to compensate, actively driving the horse forward with kicks and maintaining a tight rein so the horse does not falter. Horse and warrior become one weapon.

The Gallop of a Canine

Different quadrupeds move in different ways. Canines gallop as well, using their forelegs to pull themselves onward and their hind legs to spring ahead.

An Inhuman Hybrid?

Classic stories of centaurs in ancient Greece probably related to a time when the forefathers of the Greeks battled mounted warriors from the East. Fighting on horseback was so foreign to the ancient Greeks that the invaders were probably thought to be some sort of inhuman hybrid of man and beast.

Wings and Things

Wings are often found on monsters in manga and anime, whether on a graceful tenshi (angel) or a powerful tatsu (dragon).

Small Wings

Similar to sails on a ship, wings rise and billow, trapping air and producing lift and movement. The small wings on the wrists, ankles and temples of this tenshi might help add maneuverability for sudden changes in direction and speed.

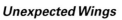

Unexpected Wings

Not all wings have to be realistic in manga. This fighting monster's ears make excellent wings in a pinch. Whimsy and the unexpected are all part of the appeal of manga monsters.

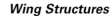

Wing Structures

The structures of the bird wing and the bat wing are radically different. Rigid wings such as the feathered wing of a bird (a) are efficient for creating lift and speed. The leathery, flexible, bat-like wing of the dragon (b) allows for greater maneuverability and quick changes in direction.

a

b

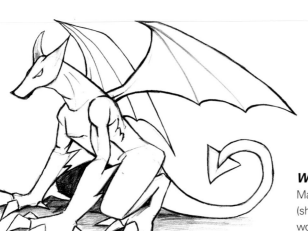

Wing Placement

Make sure the wings are placed on or just above the scapulas (shoulder blades), just behind the shoulders. Operational wings would require a large keel-like sternum (breast bone) reaching out two feet for a human-sized flyer to allow for the muscle necessary to take wing. Fantasy takes liberties with anatomy.

Download FREE bonus demos at impact-books.com/monster-manga-book

Fur, Claws,
Tails and Fangs

Manga monsters may be covered in everything from skin to scales or fur to foam. They are armed with a dazzling array of natural weapons and can often produce attacks of supernatural origin.

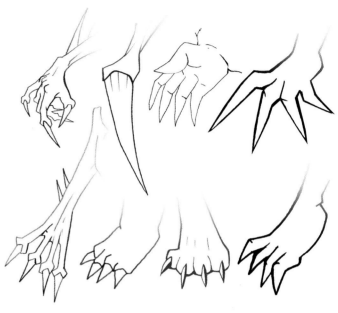

Claws, Fingers and Toes Vary

Claws come in many shapes and sizes. The number of fingers or toes can vary as well. Humanoid creatures are often depicted with four fingers and an opposable thumb. Animal-like creatures often have three fingers and a thumb or no thumb at all. Truly alien beings may have only one cruel claw.

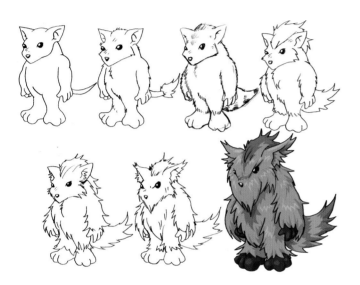

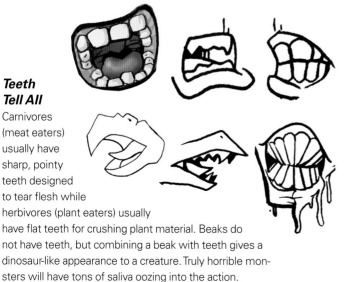

Fur Changes Appearance

The growth patterns of fur can radically change the appearance of a beast. Here the shorthaired version of the monster seems like a totally different being than the longhaired creature. Other issues such as fur color, pattern and placement add to the individual appearance of the monster.

Teeth Tell All

Carnivores (meat eaters) usually have sharp, pointy teeth designed to tear flesh while herbivores (plant eaters) usually have flat teeth for crushing plant material. Beaks do not have teeth, but combining a beak with teeth gives a dinosaur-like appearance to a creature. Truly horrible monsters will have tons of saliva oozing into the action.

The Tail Reflects the Creature

Tails are generally used as a counterbalance but, as in the example of the fish, can be used for movement. The tail should reflect the individual nature of the creature it is attached to. An arrow-point tail is often associated with devils and demons, while a spiny tail is usually associated with lizards and dinosaurs.

Griffon

The Griffon is a strange monster combining the body of a lion with the head and wings (and sometimes talons) of a giant eagle. Griffons were thought to be excellent guards with keen eyesight and powerful claws. Some Griffons had scorpion-like tails that injected powerful venom into their victims.

In medieval heraldry, the Griffon represented valor, bravery and alertness.

1 Block in the basic structure using lines and ovals. Make the pose confident and vigilant. This is a fairly complex creature, with many anatomical features that need to somehow work together visually. The wings shouldn't appear too small or too large for the size of the beast.

2 Lightly block in over the rough structure the details of the head, wings and claws. It isn't necessary to draw every feather on the wings. You can suggest a few feathers now and a few more later when you color and shade the image.

Use Reference Photos

Look at reference photos of lions and eagles to draw convincing anatomy. Even though the image is a stylized cartoon image of a fantasy monster, the basic details of feather growth patterns on the wings and basic anatomy should be carefully observed.

Combination Beasties

Griffons appear in the legends and art of ancient Persia, Assyria and Babylonia. They represent the common trick in mythology of combining two unrelated creatures. Variations of this theme are Pegasus (horse and bird), the hippogriff (horse and eagle) and the manticore (lion body, human head and scorpion tail).

1

2

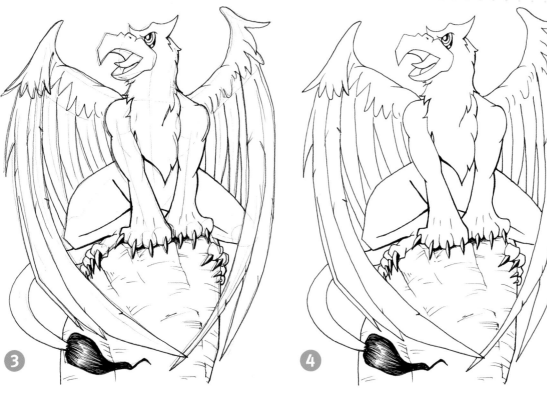

3 Clean up the rough pencil lines with ink. Details on the feathers and highlights on the tail help make the image more convincing. The eyes should look piercing and wise.

4 Take care erasing the rough pencil lines. You may need to darken some lines and vary the thickness as you go. Keep your shading consistent. The highlights on the eyes should relate to the highlights on the claws and the hair on the end of the tail.

5 The feathers of the wings are very complex. Keep your shading consistent with that of step 4; changing the direction of the shading at this stage would ruin all of your hard work.

Remember to keep things simple by suggesting detail rather than drawing every particular. Manga artists use shortcuts whenever they can because of the sheer volume of work and the frequent deadlines involved.

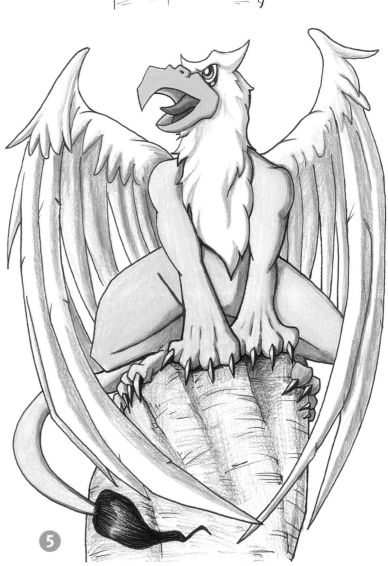

Tyrannosaur

This terrible lizard was the dominant predator of the Cretaceous Age. Daikaiju (meaning "giant monster") stories of lost worlds or time travel often include a rampaging dinosaur or two to keep things interesting. Tyrannosaurs were around fifteen feet tall and roughly forty feet long. They weighed as much as six tons and had strong jaws full of six-inch-long serrated teeth.

Tyrannosaurs were effective hunters. Draw them sleek and graceful, like a coiled spring; avoid the clunky dinosaur look.

1 Keep the initial drawing quick and loose. Focus on the pose and action lines. The jaw and neck muscles should look strong, but the forearms should look small and useless. The tail should help to counterbalance the front-heavy creature. Use simple guidelines at this stage and avoid too much detail. You don't want to have to erase all your hard work if you make an error.

2 Block in the details, keeping the forms rounded and cylindrical, never flat. Draw the wrinkles and other anatomical details to show the 3-D form. Draw muscular feet that end in sharp talons.

3 Keep the details of the claws and teeth consistent. They should appear as 3-D forms, not flat cutouts. To avoid confusion, tighten up your drawing and erase extra structural lines.

Tyrannosaurus Wrecks

Rampaging monsters such as the Tyrannosaur or smaller Velociraptors are dangerous because they are wild predators with a deadly combination of power and cunning. Not as large as some daikaiju monsters, the Tyrannosaur is still a dangerous opponent for a group of heroes.

The manga *Gon* focused on a young Tyrannosaur and his rampaging misadventures. The fierceness and power of the predator became fodder for jokes.

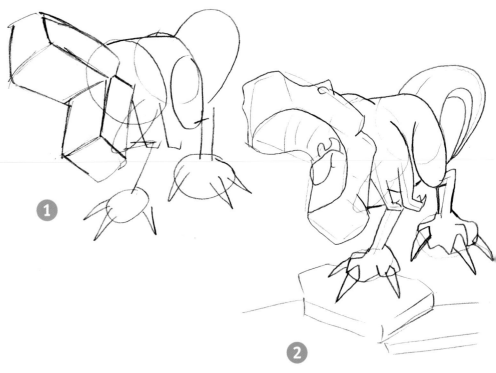

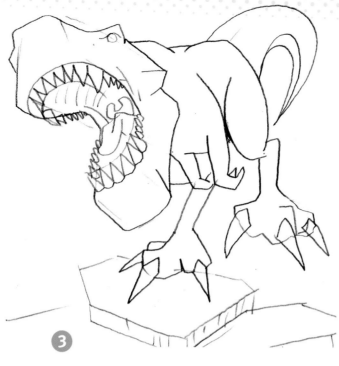

3

4 Make the final inked image with a degree of line variety to give it a real sense of form. This form will be obvious after you erase the pencil lines.

5 When you finish the image, try to maintain a consistent light direction. Know where your shadows and highlights will be before you begin shading (the skin does not have to be a solid color). Dinosaurs may have had patterns or markings like today's predators. Tigerlike stripes or leopard spots may not be too unusual for these ancient predators.

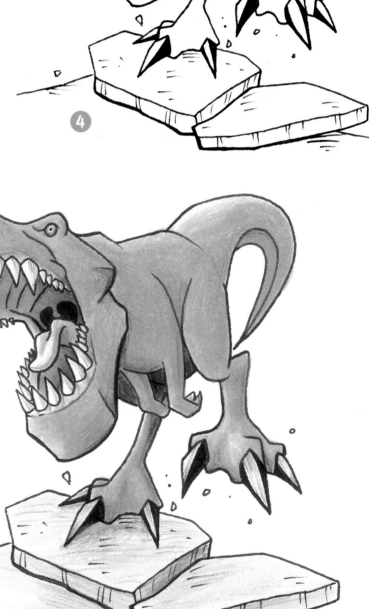

4

Form and Movement

Capturing the 3-D form and sense of movement in the earlier steps will create a dynamic and dangerous presence. This creature is on the hunt.

5

Giant Ape

Since the release of *King Kong* in 1933, the giant ape has been a staple in daikaiju films. One of the most famous scenes in film is the image of King Kong on top of the Empire State Building. It seems hard to believe, but even Godzilla battled a much larger King Kong in the 1962 film *King Kong vs. Godzilla* and the classic 1967 film *King Kong Escapes*, which introduced the wonder of Mecha Kong. The giant ape theme also occurred in *The Adventure of the Gargantuas* (1966).

King Kong helped to define the genre and made the giant ape one of the more traditional daikaiju monsters.

Monster Island

King Kong helped define many of the traditions that later became standard in daikaiju movies. One of the main concepts was that of a special island, forgotten by modern man and home to all manner of giant creatures. Monster Island has also been the home of lost civilizations from Atlantis to Lemuria and the base for alien invaders bent on taking over the Earth.

The precise location of Monster Island is never accurately described. Sometimes it is in the South Seas; other times it is close to mainland Japan. It was the primary location for the Japanese TV series *Zone Fighter* (1973).

1 Use basic lines and ovals to block in the anatomy. In the daikaiju film tradition, a man in a rubber and fur suit usually plays the monster. Therefore, you should extend the arms to appear apelike, but make the anatomy less apelike and more human. The pose should be strong and powerful, as if the creature is beating its chest.

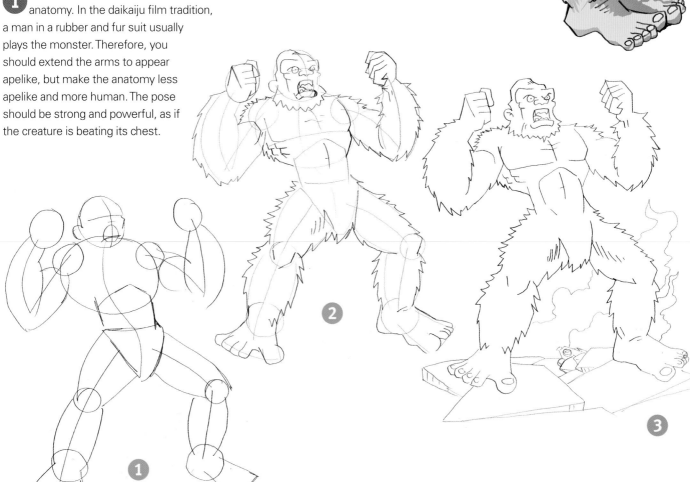

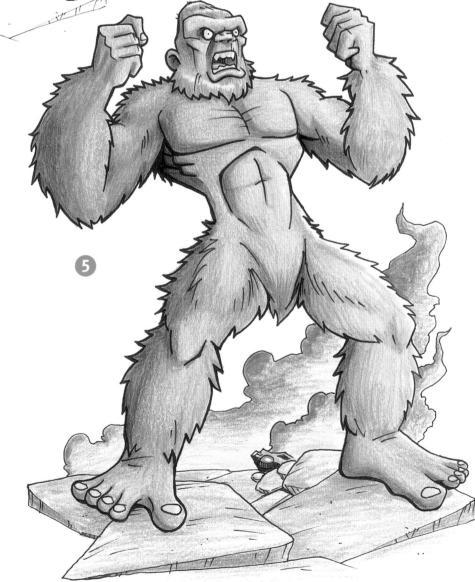

From Films to Manga

Evidence of giant apes and monkeys appears elsewhere in manga and anime. In the original *Dragonball* manga and anime, Goku turns into a giant rampaging monkey when he looks at the full moon. And who can forget the lovable Donkey Kong from many successful Nintendo games?

2 Add details such as feet, hands and facial features. Block in the fur and make the head more gorilla-like in appearance.

3 Clean up the extra pencil lines with an eraser and add the ruined street. Show smoke and dust rising from the rubble and draw a demolished car that is just noticeable in the background. Keep the image as simple as possible at this point; extra lines will appear confusing. Every line should describe something. Use colored pencil for the shading.

4 Ink the image and when the ink is dry, erase the pencil lines. Remember to vary the thickness of the lines to add areas of shadow and mass. This helps your drawing appear more polished and 3-D.

5 Make sure the areas of light and darkness seem to relate to a common light direction. Highlight the fur to give the ape a 3-D appearance. The giant ape looks like he is ready to battle the giant lizard!

Giant Lizard

Because of the colossal success of Godzilla and his imitators, when people think of giant monsters they usually think of a giant lizard. The giant lizard is usually a combination of a dinosaur and a dragon, and it has been invented and reinvented in countless films, television shows, anime, manga and video games.

Ishiro Honda, the director of many Godzilla movies, wanted to make the daikaiju into something more than just a rampaging beast. He wanted the audience to connect with the character of the monster. Honda recognized that daikaiju have a tragic beauty and did not choose to be evil. Daikaiju are just born too tall, too strong and too heavy for the world around them.

1 Keep things simple. Begin the drawing with standard circles and tubes. Make the figure appear humanoid in recognition of the fact that most of these creatures were actually men wearing rubber suits stomping on miniature models.

2 Block in the features with more detail. Carefully indicate the teeth, claws and spines along the back. Also indicate some surrounding rubble and smoke.

3 Finish the lines and add detail to the mouth and the rubble. (The eyes will later be colored in as if they were glowing.) Make the tail look as if it were swaying from side to side.

Monstrous Manga

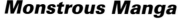

Daikaiju manga have not been as plentiful as the film, TV and video games featuring giant monsters, but manga often include giant monsters as part of the storyline.

Some keys to successful daikaiju:

- Create cool and original monster designs.

- Give the monster personality and quirks the audience can relate to.

- Draw lots of stomping and property damage.

- Combine other genres such as aliens or fantasy to add variety and keep readers guessing.

- Include one or two human protagonists to endanger, but be sure to make them "likeable" or the reader won't care about their fate.

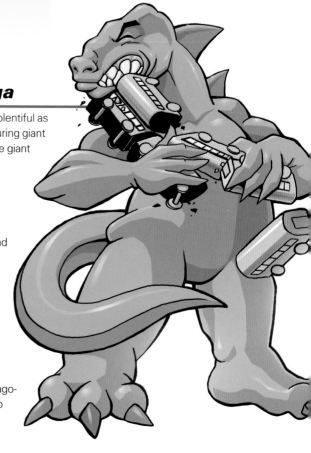

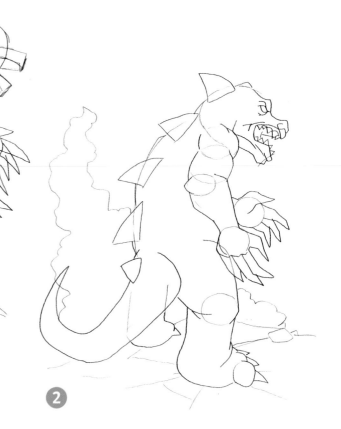

1

2

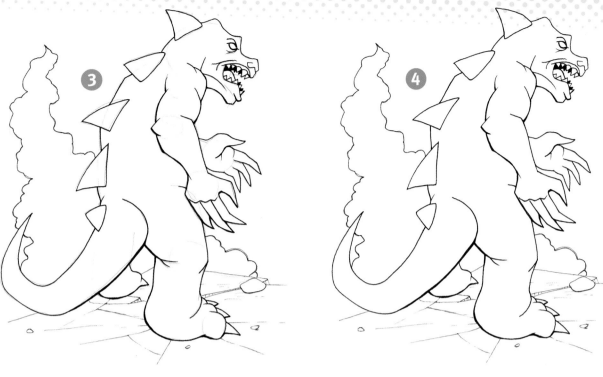

4 Finish inking your drawing and clean up any stray pencil lines. The ground seems to be literally collapsing under the massive weight of this beast.

5 I chose green for this monster, but almost any color variation will work. The gene that controls size also controls skin color; that's why large creatures such as whales and elephants are often not very colorful. This is a fantasy, however, so make the monster as colorful as you like. The fireball that is raging behind the lizard could be a burning oil refinery or a military assault on the enormous creature. The fire should illuminate the cloud of smoke and the side of the creature. Keep the lighting dramatic and make sure it is defining structure properly.

A Man in a Rubber Suit?

The physical limitations imposed by the fact that the monster is really a man dressed up in a rubber suit somewhat restricts the potential character design, but daikaiju creators have always found interesting ways around the problem.

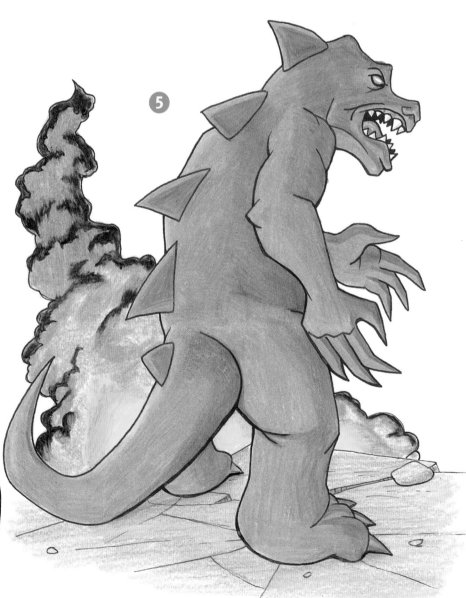

Giant Robot

Giant robots can be anything—alien invasion machines, out-of-control artificial intelligence, or even the weapons of an anti-giant-monster squad. Some giant robots have even been known to grow from human size to giant monster proportions.

1 Begin the drawing by blocking in details. Be sure to keep things simple at this stage.

2 As details are added, try to keep in mind the 3-D geometric forms of what you are drawing. The head, torso, arms and legs are cylinders.

3 Make small details such as the knobs on the shoulder units and the knees appear to wrap around the sphere and not sit flat. Keep the essentials consistent and unify the design by repeating elements. For example, all air vents should be round, as they are on the shoulders and forearms.

10 Possible Purposes for Those Shoulder Units

1. Heavy metal projectiles attached by retractable chains
2. Cosmic energy power collectors
3. Dual escape pods for the crew
4. Magnetic electrical charge bombs
5. Force field generators
6. Stabilizing gyroscopes for balance
7. Solid fuel tanks
8. Multiple micro missile launchers
9. Hydraulic fluid canisters
10. Connection clamps for combining with other robots

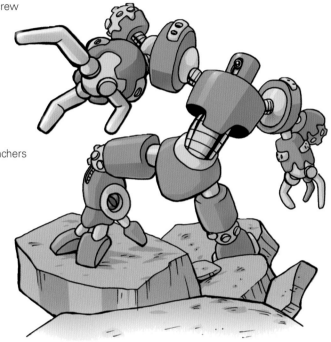

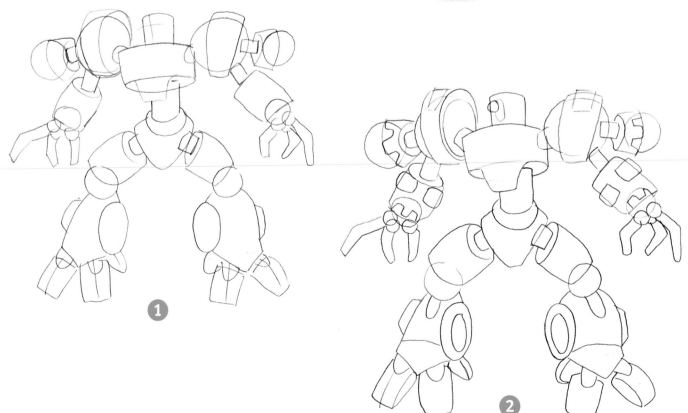

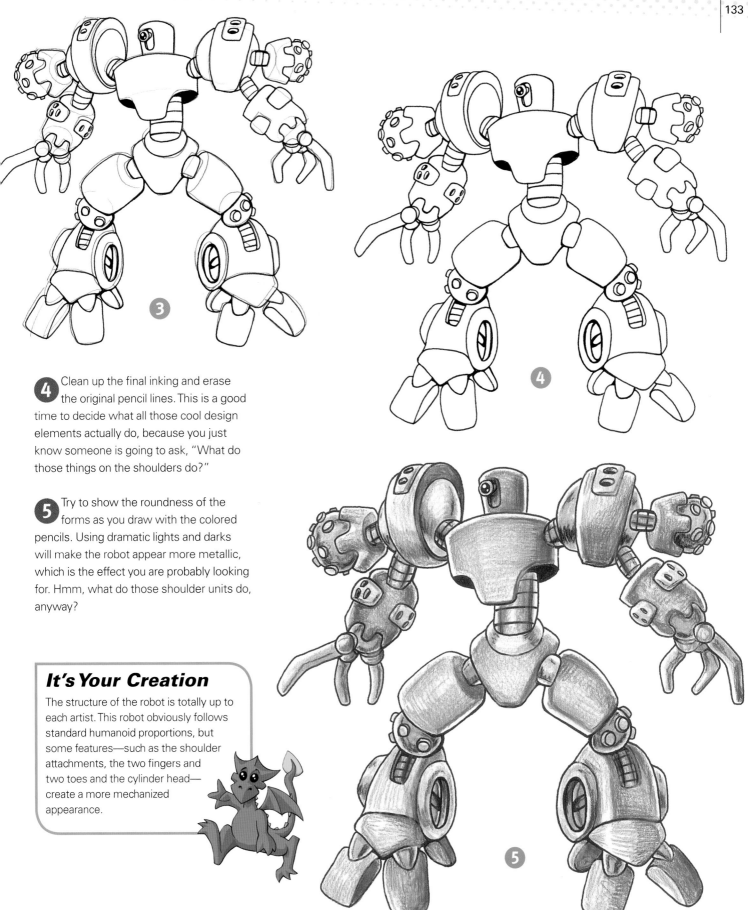

4 Clean up the final inking and erase the original pencil lines. This is a good time to decide what all those cool design elements actually do, because you just know someone is going to ask, "What do those things on the shoulders do?"

5 Try to show the roundness of the forms as you draw with the colored pencils. Using dramatic lights and darks will make the robot appear more metallic, which is the effect you are probably looking for. Hmm, what do those shoulder units do, anyway?

It's Your Creation

The structure of the robot is totally up to each artist. This robot obviously follows standard humanoid proportions, but some features—such as the shoulder attachments, the two fingers and two toes and the cylinder head—create a more mechanized appearance.

Invader Warrior

This is a good example of an alien that looks different from a human but still has enough humanlike elements to seem plausible. A basic "space marine," the invader leaps from the capsule and starts shooting. This warrior is wearing an armored spacesuit and holds a nasty-looking bolt pistol.

1 Start with the basics. Use sticks and circles to block in the anatomy.
The most striking features at this stage are the digitigrade structure of the legs and the two big "toes" on the feet.

2 Block in the details and add the elements that will become the armor and the pistol. Continue drawing as if you can see through the figure to make sure the anatomical structure is not distorted. This will be erased in the final stages of penciling so that it is not confusing.

3 Erase the extra pencil lines to get a clearer idea of what the final drawing will look like.

4 Ink the drawing and clean up any confusing or inaccurate lines. Make sure the ink lines vary in thickness to reflect the mass and weight of the figure.

5 Shade and color the image. The armor may be a little tricky because it needs to be somewhat reflective. Show strong highlights, shadows and reflections to create a metallic appearance.
The green orbs are a design feature that can easily be extended to other technological devices used by these aliens.

Tragic Love

It's true: Many alien-invasion manga stories become tragic tales of forbidden love. That's what makes manga and anime so accessible. Behind all the plasma-beam warp cannons, giant robots and alien monsters is a very "human" story full of emotion and intrigue. Love may conquer the inhumanity of war, or the lovers may become tragic victims of the conflict. Either way, love is eternal and the story rises above the expectations of standard science fiction.

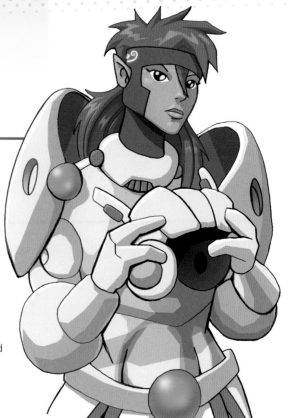

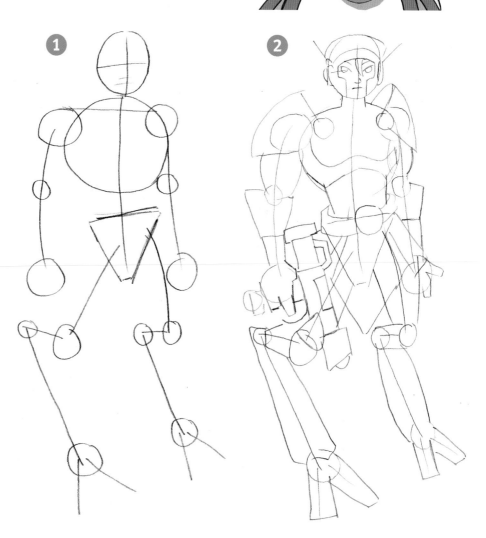

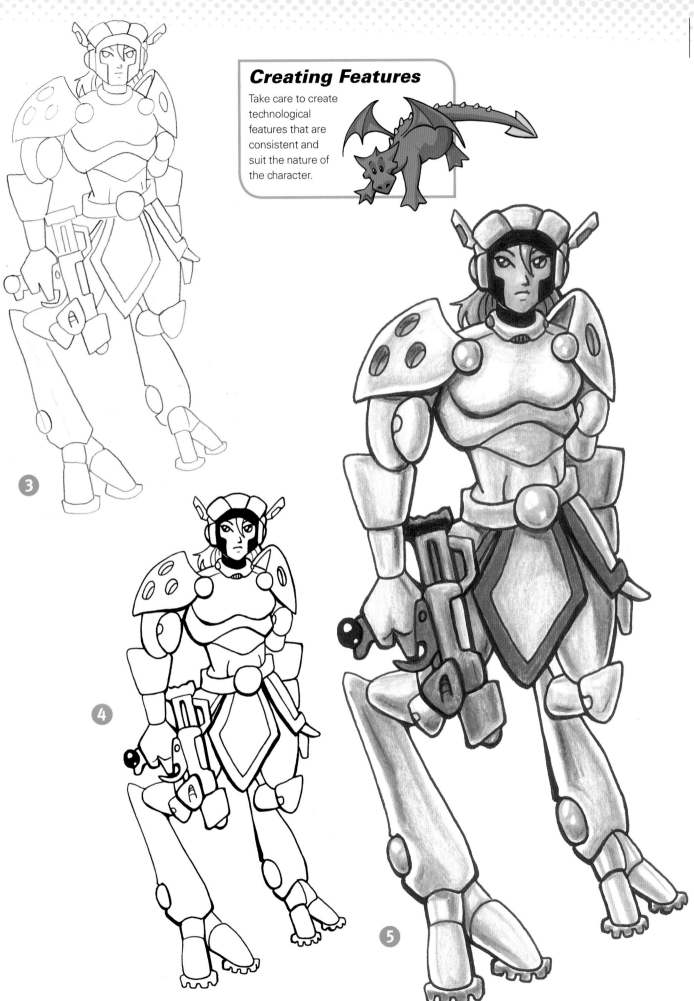

Creating Features

Take care to create technological features that are consistent and suit the nature of the character.

Invader Leader

In some manga and anime stories, invader leaders provide comic relief, reporting back to some higher power time and again with failure after failure. Other invader leaders are brilliant strategists and honorable warriors quickly winning the respect of their opponents. Invader leaders are often mutated or covered with a mask or armor to make them appear less human than other alien invaders.

1 Block out the basic structure, paying attention to the details that make the character appear distinctly alien.

In this example, the digitigrade legs and two toes make the character appear alien. Note that the chest appears wide and powerful and the head is leaning forward. This is a very strong, stable pose.

2 Make the details and finery of the alien leader similar to that of the warrior, but make sure there are some noticeable differences in the costumes. Make the helmet cover the entire head and include a built-in breathing apparatus. Make the shoulder armor elaborate so the leader seems larger.

Take Me to Your Leader

Alien leaders are sometimes the most interesting aspect of anime or manga. It's fun to create the cultures and design the "look" of the aliens. Some artists and writers like to reference existing Earth cultures for inspiration, often combining or reversing beliefs, practices and appearances.

Alien leaders are often scarred, mutated or somehow even less human than the other alien invaders. Also, they often possess magic or mental abilities that make them more powerful and therefore stronger—and scarier—leaders.

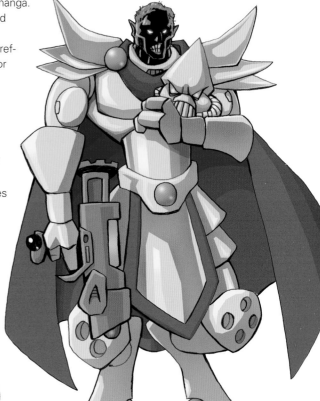

Earth Invasion

Make the alien leader more than just a snarling villain. Give him a really good reason to invade Earth, like a natural disaster on his home world or some ancient claim to Earth.

The cape adds a regal touch. Capes in space?

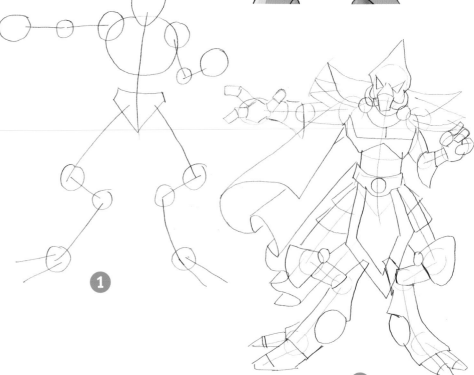

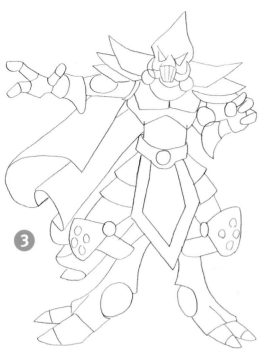

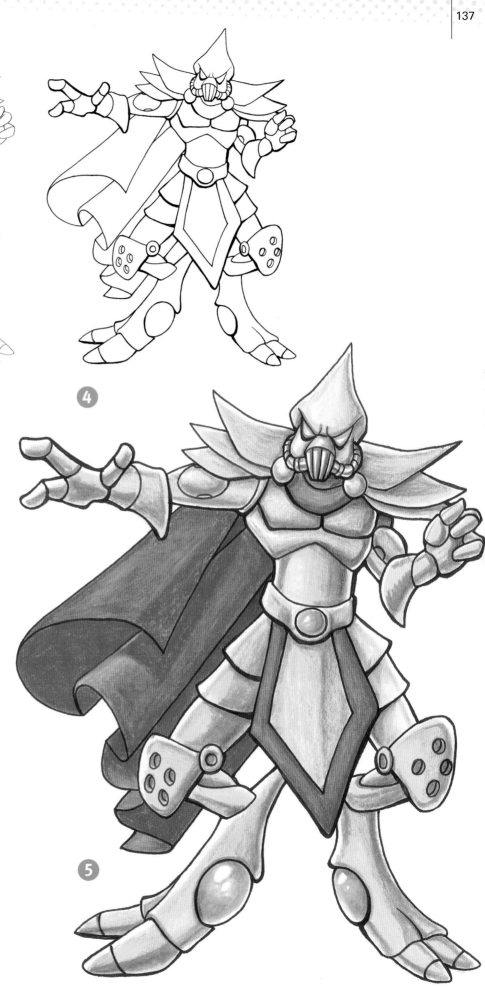

3 Clean up the details and fine-tune the proportions and anatomy. Make the technology of the armor clearer at this point. The overlapping armor and articulated joints should be consistent.

4 The inking stage should clarify the drawing, not muddle it up with extra lines and scrawls. Keep the ink lines crisp and clean, never scratchy. Remember to vary the thickness of the lines to reveal 3-D mass and structure.

5 Make the armor reflective, just like the alien warrior, but color it to appear more golden by using yellows, browns and oranges. Leave areas of white to create a shiny, metallic appearance.

Try this technique on a couple of rough drawings to get the hang of it. Make sure the light is coming from the same direction in each area of your drawing.

Invader Beast

Sometimes the alien isn't something you can negotiate with, or the invaders might have these beasts as a sort of "secret weapon" in their invasion arsenal. Whatever the case, the invader beast is an almost unstoppable adversary. This monster appears to have elements from lizards, insects and sea creatures combined into one very scary package.

1 Block in the figure with circles and sticks just as you would any other drawing. Keep in mind any unusual anatomical details as you draw, such as the tail and digitigrade legs.

2 Flesh out the figure and add specific elements such as the claws and fangs. Strange spikes seem to rise from the back and forearms. The purpose of these spikes isn't obvious at this point; they could be weapons or a defensive feature, or even a social adaptation (such as peacock feathers).

Bred in Holding Tanks?

This alien seems to be a sleek predator that would hold down its prey with its claws. The oversized canines indicate that it probably uses its mouth to tear flesh. The wedgelike head suggests an aquatic origin. Perhaps this beast is bred in holding tanks aboard the alien invasion fleet and then unleashed onto the battlefield to "soften up" the enemy before the invasion begins.

Monster of the Moment

Alien monsters are great enemies in manga. The appearance and abilities of the creatures can be changed from story to story to create the standard "monster of the week" that is found in popular magical girl, sentai manga and anime. The format works very well when combined with a strong, character-driven story.

Eventually the focus of the manga will be the characters and what they are going through emotionally, as opposed to what funky monster will be beaten up this week. The funky monsters are the "hook" that gets readers to understand the characters better. Having nothing but funky monsters is fun for a while, but readers eventually will get bored. Try to create stories and characters that readers can relate to.

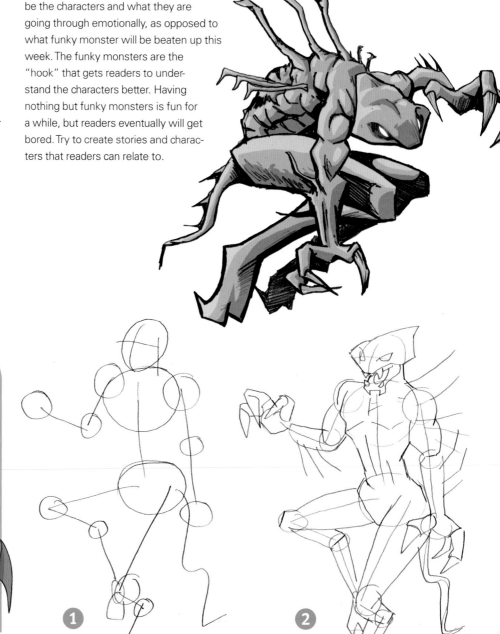

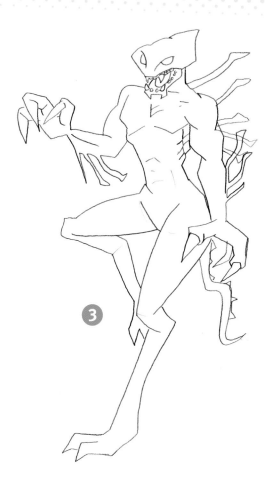

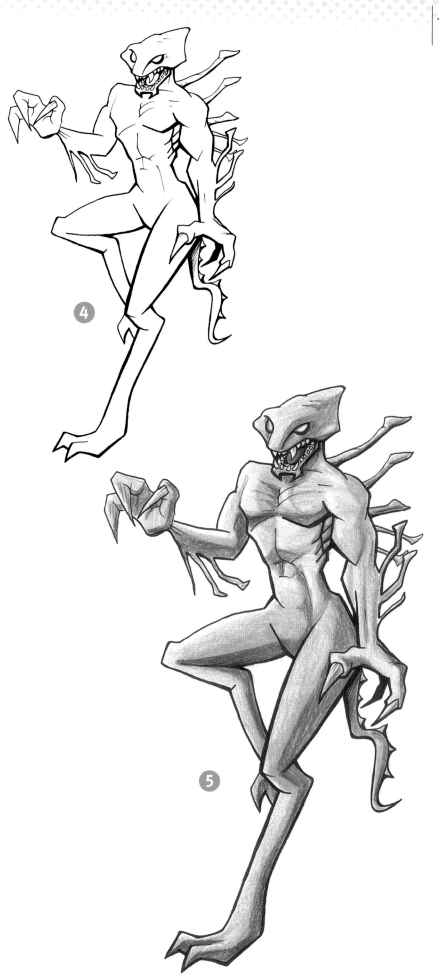

3 Clean up the details and complete some of the anatomical elements of this inhuman creature. Make the figure appear lean and powerful but not overly muscular.

4 Clean up the pencil lines and carefully ink the drawing. Use the ink lines to show depth and form. Thick lines come forward and thin lines recede. Thick lines also show areas that are darker, indicating the source of the light.

5 Use a neutral gray for the skin tone because this creature has to blend into any environment. A brightly colored predator would find it difficult to hunt its prey. The creature may have some chameleon-like ability to blend into its surroundings, or it may release a chemical from those spikes on its back to confuse or incapacitate those unfortunate enough to meet it.

Alien Monstrosity

If you thought the invader beast was horrifying, meet the granddaddy of them all: the alien monstrosity. This could be a separate entity or it could be what the invader beasts turn into after a period of hibernation. The alien monstrosity should be large and imposing, an almost unstoppable creature that can flip tanks and crash through blast doors.

1 Begin the drawing by blocking in the figure with sticks and circles.

2 Flesh out the structure to create a very imposing monster.

3 Clean up the extra lines to reveal a lean, mean hunting machine. Make this creature look like all claws and teeth. Develop the details of the spikes, teeth and claws. Don't forget the fins running down the back of the tail.

Oh the Inhumanity!

When designing aliens, you don't have to follow the same rules as for earthbound creatures. The less human they appear, the more terrifying they will seem. When you are designing your own alien monsters, don't be afraid to combine features of existing animals together in new and unusual ways.

The claws on this monstrosity actually were inspired by walrus tusks and the arms of a praying mantis. The body was obviously meant to be snakelike, and the head is a combination of the praying mantis and an elephant skull. The spines and fins along the back were meant to give the creature a slight lizard or dragon-like appearance.

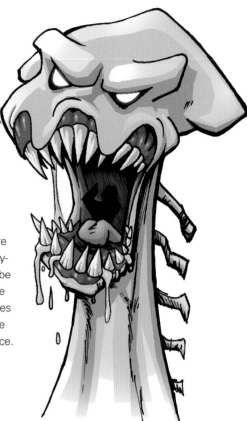

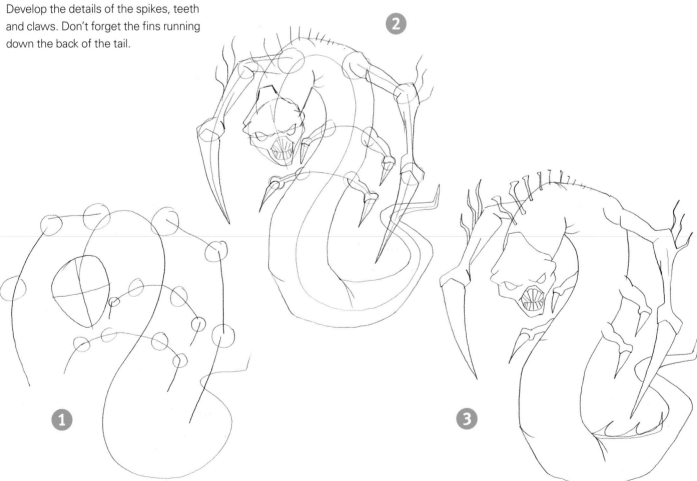

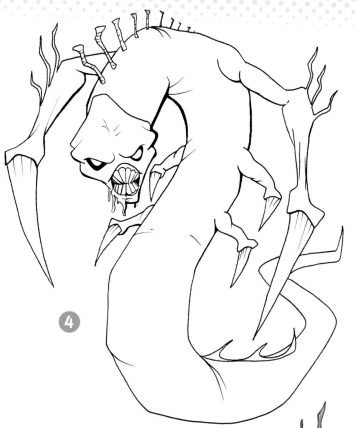

Add Finer Details

Small details have been added to give the monster some … ahem … personality. The drool adds a disgusting touch, and making one eye slightly larger than the other gives him a crazy "I can see you" look.

4 Ink the image and carefully erase the pencil lines to give the picture depth and form.

5 This monster is not only dangerous; it's unhygienic. The teeth and claws should never be white. Make them gross and yellowed with age, use and neglect.

Use lots of small hatching and cross-hatching lines so the light seems to fall across the form of the creature. Add a sense of realism to this unreal monstrosity with details such as arm muscle definition and an uneven claw surface.

A Dangerous Predator

The anatomy of this creature is definitely not human. It has a snakelike body and six arms.

This creature shares some of the same basic elements as the invader beast, but is an even sleeker and more dangerous predator.

Psychic Warrior

When this guy gets a headache, everyone gets a headache. Characters with amazing mental powers have appeared in manga for decades. Many of these psychic warriors must flee concerned government forces or even other psychics who use their powers for evil purposes.

When veins pop up from under the skin and blue energy begins arcing around his head, it's probably too late to run away.

1 Using sticks and circles, draw a pose that shows tension and force. Lean the body forward, almost off balance, as if every bit of mental and physical energy is being directed at the target.

2 Flesh out the character to reveal the intense concentration and effort required to use psychic powers. Make the face contorted in concentration. Make sure he is pushing forward onto the balls of his feet.

Psychic Abilities

So just what can different psychic warriors do anyway? Here is a list of ideas to help you create some of your own amazing mutants.

- **Pyrokinesis:** mental creation and control of flame
- **Telepathy:** speaking and listening with thoughts
- **Precognition:** sensing what will happen in the future
- **Retrocognition:** seeing what happened in the past
- **Clairvoyance:** seeing what is happening somewhere far away or seeing what can't be seen by normal people
- **Clairaudience:** hearing what can't be heard by normal people
- **Clairsentience:** the ability to feel sensations and emotions related to a place or event
- **Channeling:** communication with spirits of the deceased
- **Psychometry:** receiving information (visions, sounds or feelings) by touching an item
- **Healing:** repairing injury or illness with a touch

Reveal the Psychic Force

Showing how the surroundings are affected by the power of the character not only grounds the figure into a setting, but also reveals the level of force in his psychic abilities.

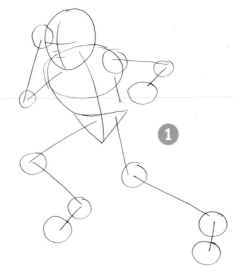

1

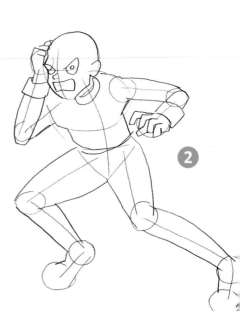

2

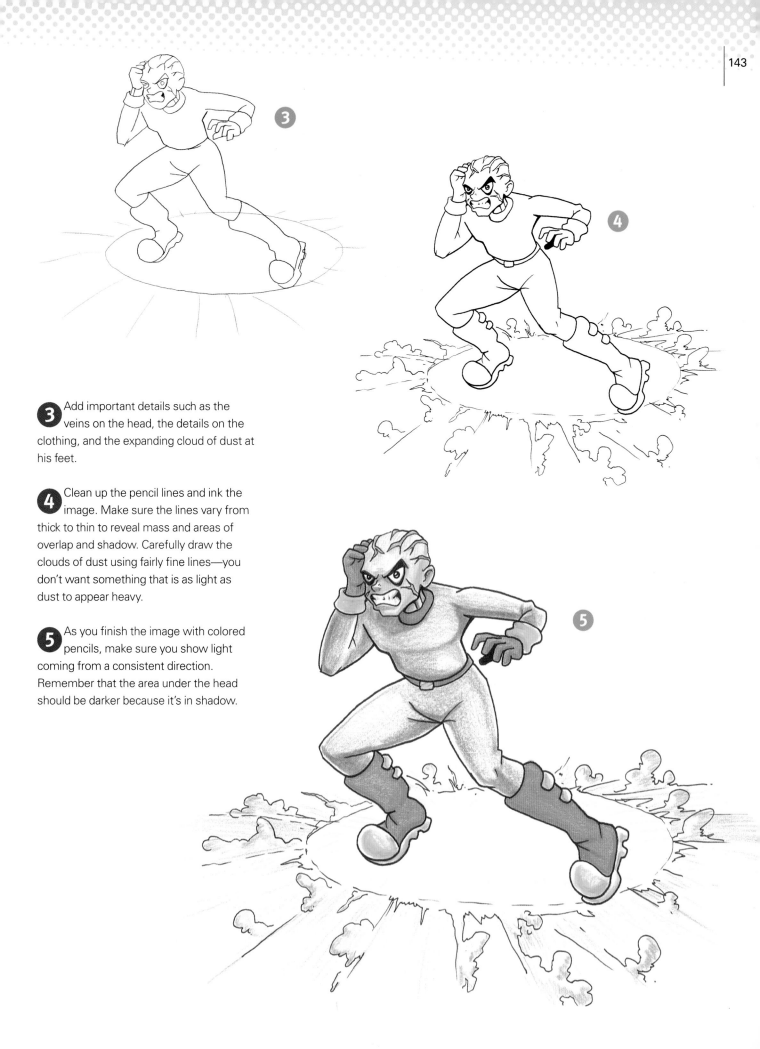

3 Add important details such as the veins on the head, the details on the clothing, and the expanding cloud of dust at his feet.

4 Clean up the pencil lines and ink the image. Make sure the lines vary from thick to thin to reveal mass and areas of overlap and shadow. Carefully draw the clouds of dust using fairly fine lines—you don't want something that is as light as dust to appear heavy.

5 As you finish the image with colored pencils, make sure you show light coming from a consistent direction. Remember that the area under the head should be darker because it's in shadow.

Cat Warrior

Cat/human hybrids are the most popular type of animal-based character in anime and manga. It's uncommon to find a catboy in manga (too tame), but a human that is spliced with the genes of a lion makes a powerful warrior.

1 Using sticks and circles, begin drawing the basic structure. Because the character is leaning forward, the head overlaps the chest and shoulders. The arms and the bent leg are foreshortened (drawn with shorter lines) to create dimension.

2 Block in the details of the character, making sure to maintain the fine balance between human and feline. Use the guidelines to maintain the proper anatomy and structure.

3 Erase the extra construction lines and fine-tune the details of the costume and figure. The image should be sleek and strong, just like a big cat.

4 Ink the image and erase the pencil lines carefully. It can be difficult to keep the drawing clear of extra lines, but it allows for you to shade carefully using colored pencil or the computer for the next stage. Little clues in your drawing, such as the highlight on the nose or the shadow on the barrel of the gun, reveal the direction of the light.

5 Use at least three shades of blue for the jumpsuit; blend them together using a white colored pencil. Use a darker blue to reinforce the shadows on the costume. The dark areas around his eyes keep light from reflecting into them to help him see better.

Genetic Mutations

Anthropomorphism refers to the condition when animals are given human characteristics. Japanese mythology has thousands of years of tradition in which animals act like humans, such as the tricky kitsune (fox people) or tanuki (raccoon-like dogs who like to dress up as monks).

With advances in genetic technology, it's possible that in some futuristic manga, humans might opt to splice themselves genetically with animals to become frighteningly powerful warriors. Such a character might also be the result of a failed experiment or medical procedure. Either way, the monstrous results would make for cool characters.

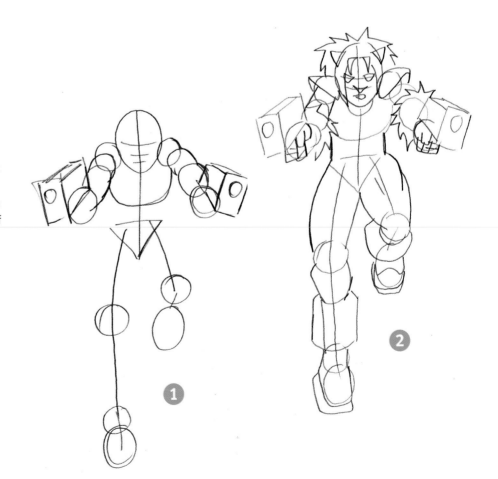

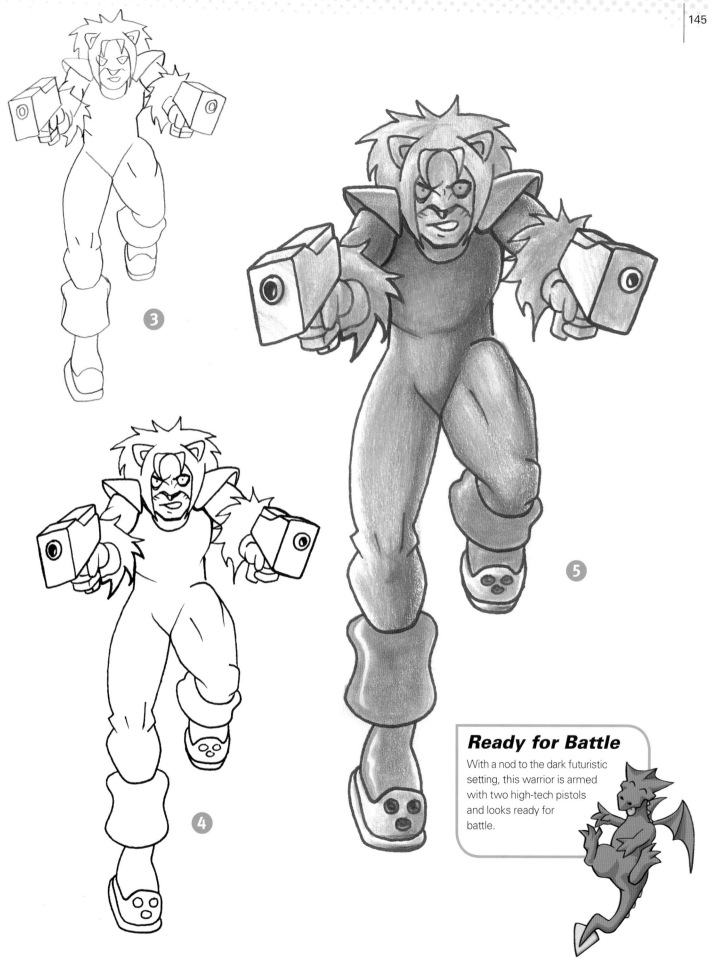

Ready for Battle

With a nod to the dark futuristic setting, this warrior is armed with two high-tech pistols and looks ready for battle.

Pet Rodent

Fighting pet monsters may be cute, but they often have surprisingly dangerous powers such as electric shocks, poison quills or hypnotic eyes. The pet rodent is cartoonlike and cute, like a plush toy.

The relationship between pet and owner is usually rocky until the owner learns to respect the power and independence of the pet. Eventually they become inseparable friends who mutually respect and care for one another.

1 Use basic shapes to loosely block in the anatomy of the monster. Make the head large and toylike. The pose should be active, energetic and fun. Make the proportions suit the nature of the character. Block in the details of the face and limbs. Keep the figure simple and uncomplicated.

2 Flesh out the details of the figure such as the fingers, toes, eyes and ears. The head is turned almost in full profile, as if the monster were looking over its shoulder and running from a bigger monster. The mouth is open in shock. Make sure the pose and the body language make sense before you move on. If you need to make changes, now is the time.

Living in Harmony

In recent manga and anime, fighting pet monsters are an unusually popular genre. Stories featuring the relationship between a child and a "cute" monster appear again and again. The hero usually has to win the trust of the creature somehow. By treating the monster with respect, rather than by conquering the creature's wild nature, the hero gains access to its fantastic powers. This respect is symbolic of the rewards we gain when we work together with nature, not against it. At first glance, pet monster manga may appear to be about a master/servant relationship; but when you look deeper, positive environmental issues of respect and harmony are at the core of the story.

The Ideal Pet Monster

Small, round and always cheery, the pet rodent is the ideal pet monster.

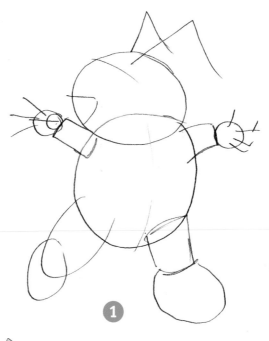

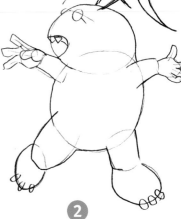

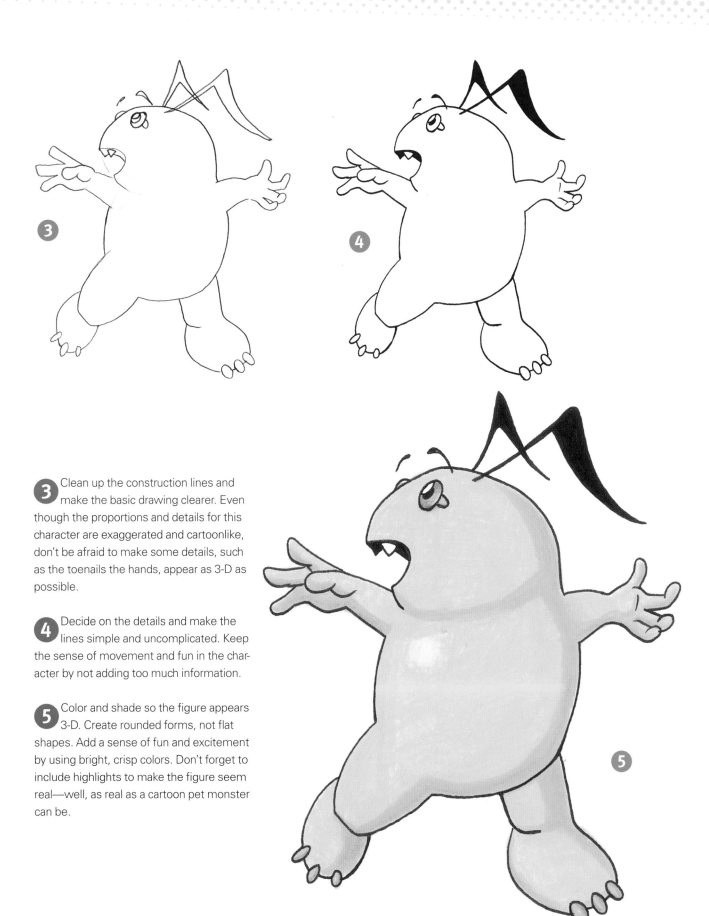

3 Clean up the construction lines and make the basic drawing clearer. Even though the proportions and details for this character are exaggerated and cartoonlike, don't be afraid to make some details, such as the toenails the hands, appear as 3-D as possible.

4 Decide on the details and make the lines simple and uncomplicated. Keep the sense of movement and fun in the character by not adding too much information.

5 Color and shade so the figure appears 3-D. Create rounded forms, not flat shapes. Add a sense of fun and excitement by using bright, crisp colors. Don't forget to include highlights to make the figure seem real—well, as real as a cartoon pet monster can be.

Mini Dragon

Wouldn't you like a pet dragon of your very own? The mini dragon solves the problem of where to keep a giant, fire-breathing lizard. The mini dragon is usually the size of a cat or small dog. It can sit on your shoulder, curl up at the foot of your bed and generally look cute.

1 Use circles and sticks to indicate the anatomy of the dragon. The figure should be cute and pudgy. Keep the pose fun and playful. Don't include too much detail at this stage; just decide where everything belongs.

2 Add details to indicate the shape and structure of important features like the head, wings, claws and tail. The eyes should be closed and the tongue sticking out in a mischievous way. Keep the anatomy simple. This is not a genre that shows a lot of realistic detail.

3 Carefully erase the construction lines to clean up the drawing. Even though you are simplifying the forms, try to think of this creature as if it existed in 3-D space. Making the image too simple can flatten it. Use techniques such as overlapping the foot on the body and hiding a wing behind the neck to add a sense of dimension and realism to the pet dragon.

Dangerous Pets

In pet monster manga, there are usually very few "real world" problems related to owning a pet that is more dangerous than a tank. The pet's special powers may change or evolve in the course of a story. What might start out as simple fire breathing might develop into concentrated bursts of powerful fireballs or finely focused beams of heat energy. To make the character interesting, keep the idea of the power simple at first, then make it more complex later on.

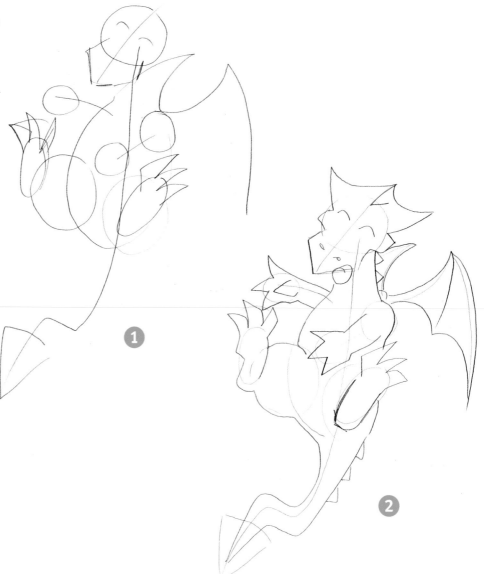

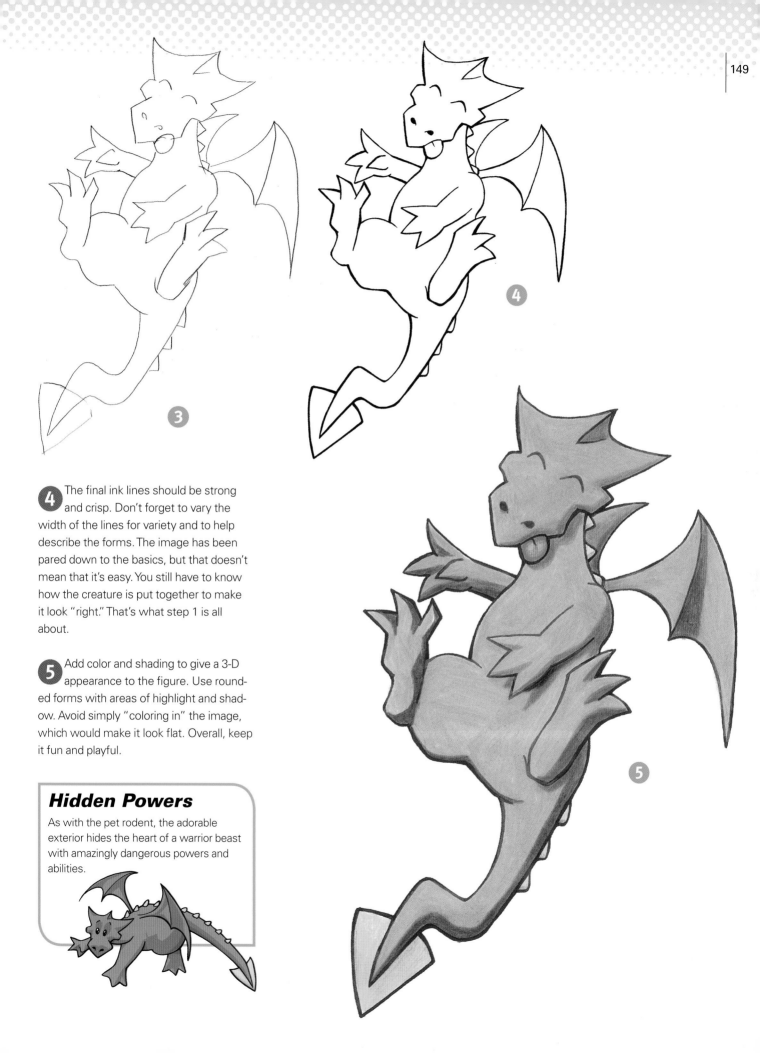

4 The final ink lines should be strong and crisp. Don't forget to vary the width of the lines for variety and to help describe the forms. The image has been pared down to the basics, but that doesn't mean that it's easy. You still have to know how the creature is put together to make it look "right." That's what step 1 is all about.

5 Add color and shading to give a 3-D appearance to the figure. Use rounded forms with areas of highlight and shadow. Avoid simply "coloring in" the image, which would make it look flat. Overall, keep it fun and playful.

Hidden Powers

As with the pet rodent, the adorable exterior hides the heart of a warrior beast with amazingly dangerous powers and abilities.

Cabbit Mascot

*T*he "cabbit" is a peculiar creature common in manga and anime that appears to be a combination of a cat and a rabbit. It usually is used as a sidekick or mascot character that serves no purpose other than to look cute on cue. It stops grooming itself momentarily to look at what the hero is doing, and when things look really bad it transforms into a powerful weapon.

1 The proportions that you block in should be all about making the character look cute. Keep the lines loose and fun.

2 Use the guidelines to develop the basics of the character. Make the eyes supersized, almost half the size of the face. Details of the fur should be suggested simply, with jagged lines to indicate the growth direction. Don't draw every hair.

3 Erase your rough pencil lines and generally clean up the image. This will make inking easier and let you solve any problems before you commit the drawing to a more permanent medium.

Kawaii!

Kawaii (kah-wah-ee) means cute in Japanese. It is one of the most commonly used words in Japanese pop culture. Cute images appear on everything from pens and paper sets to phone cards and handbags. The origin of this obsession with cute characters and childlike imagery was probably a trend in the early 1970s called burikko-ji or "fake-child writing." Teenage girls in Japan began using a childishly cute handwriting style. This new style irritated adults because it was hard to read, and it became so pervasive that it was banned from schools. Cute culture spread from an underground handwriting movement to fashion and design. In some ways it's an attempt to regain a childlike innocence or sense of fun. Kawaii characters are familiar, cozy and happy— that's the secret of their success and widespread use by corporations. Today the culture of cuteness is a huge business, with Sanrio (creators of Hello Kitty) earning billions of dollars on their kawaii kitten.

Supersized Eyes

The eyes of the cabbit should be super-sized, almost half of the size of the face. Just remember: The larger the eyes, the cuter the cabbit!

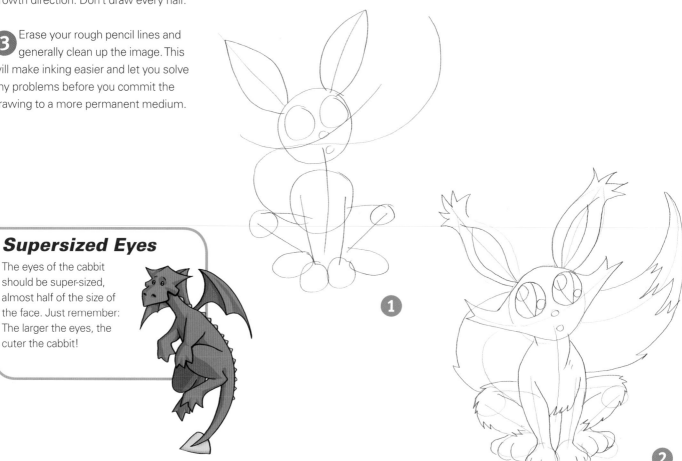

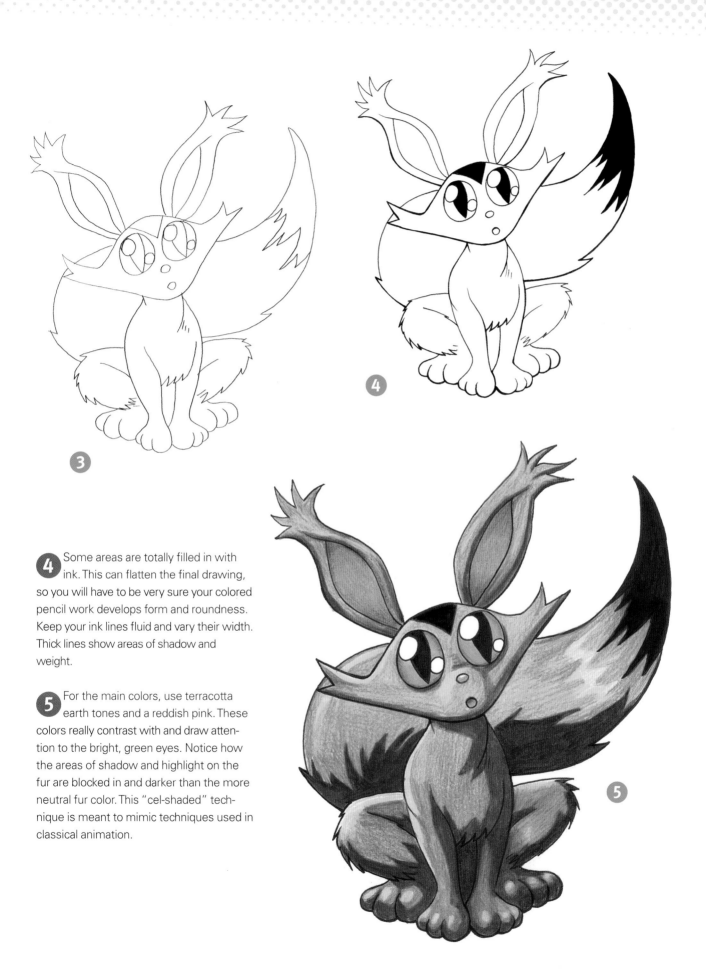

4 Some areas are totally filled in with ink. This can flatten the final drawing, so you will have to be very sure your colored pencil work develops form and roundness. Keep your ink lines fluid and vary their width. Thick lines show areas of shadow and weight.

5 For the main colors, use terracotta earth tones and a reddish pink. These colors really contrast with and draw attention to the bright, green eyes. Notice how the areas of shadow and highlight on the fur are blocked in and darker than the more neutral fur color. This "cel-shaded" technique is meant to mimic techniques used in classical animation.

Demon

The demon is usually considered a creature of evil and darkness, often more tricky than powerful. In Japan, the legends of the oni (Buddhist demons) reveal a more complicated approach to personifications of evil. Some oni are even depicted as itinerant priests, a symbolic parody of humanity's failings. Manga and anime have used oni as adversaries for heroes and as the inspiration for many heroic characters.

This demon is drawn in the classic Halloween demon tradition, with red skin and a pointed tail.

1 The basic structure should be strong, with a wide leg base. The demon's hand is raised and will be glowing with fire. Make his tail pointy to reinforce the devilish nature of the character.

2 Loosely block in the basic 3-D structure. Remember that the arms and legs should be cylindrical, not flat. Details such as the hands and some facial features should be developed at this stage.

3 Erase unnecessary guidelines and structure references. Add the fire special effects and clothing details.

Demonic Oni

In Japanese Buddhist tradition, oni are supernatural creatures that travel between the land of the living and the land of the dead. They are not necessarily wicked, but are wild forces of nature that often bring bad fortune to whatever unfortunate soul gets in their way. Sometimes, however, they may bring good fortune.

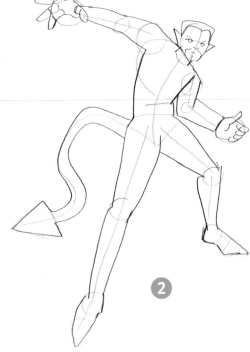

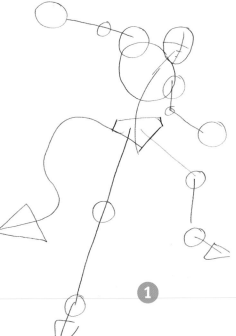

Trying to Fit In

The suit and tie may seem odd at first, but they show how the demon is trying to appear "professional" to fit in with the modern world.

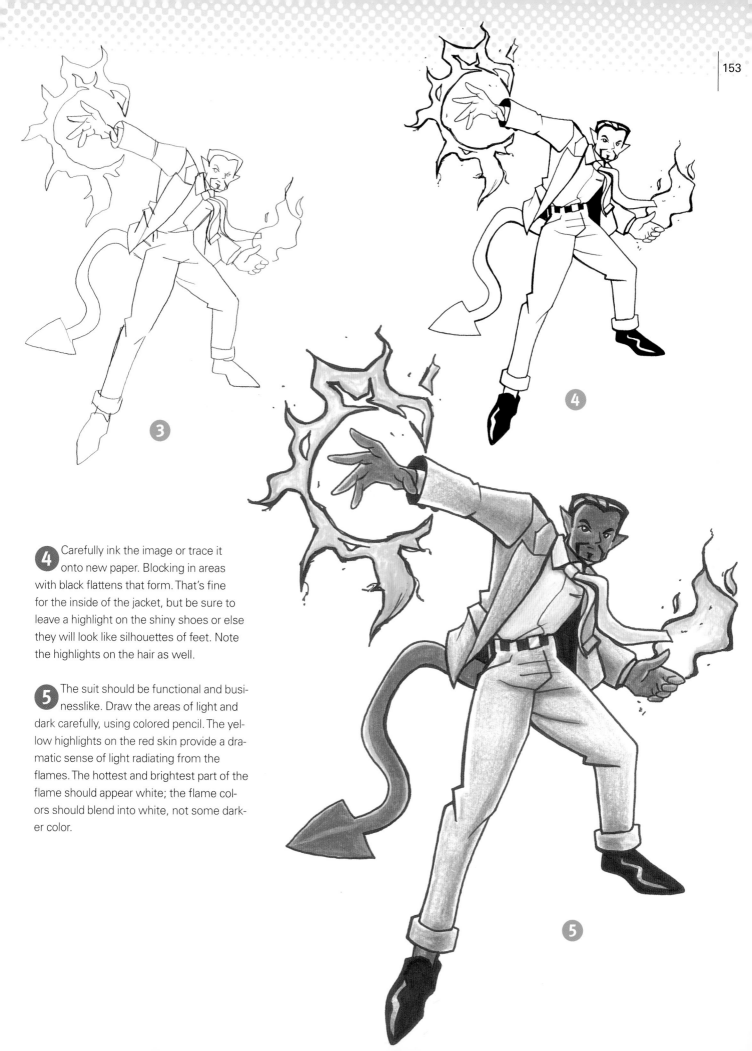

4 Carefully ink the image or trace it onto new paper. Blocking in areas with black flattens that form. That's fine for the inside of the jacket, but be sure to leave a highlight on the shiny shoes or else they will look like silhouettes of feet. Note the highlights on the hair as well.

5 The suit should be functional and businesslike. Draw the areas of light and dark carefully, using colored pencil. The yellow highlights on the red skin provide a dramatic sense of light radiating from the flames. The hottest and brightest part of the flame should appear white; the flame colors should blend into white, not some darker color.

Vampire

The vampire depicted here wears a costume similar to clothing worn by eighteenth-century nobility. Vampires are immortals who must suck the blood of humans to maintain their youth and power.

In anime and manga, vampires sometimes have been depicted as the heroes of the story, battling others of their own kind to punish the wicked and preserve humanity.

1 At this stage, block in the anatomy just as you would any other image.

2 The leathery skin on the bat wing creates a very specific shape where it joins the finger bones in the wing. Make sure you include that shape when drawing the wing. Make the vampire seem even more "realistic" with correct anatomy and costume details. Make the claws of the vampire look dangerously sharp.

Vampires of the East

The vampire legend, as personified by Dracula in Western literature, most likely originated in China. It was believed that everyone had two souls, a rational soul and an irrational soul (p'ai). The p'ai could preserve and even animate a body, especially if the death had been violent or there was an improper burial (or no burial at all). Some legends state that even if a cat jumped over a dead body, it would turn into a vampire.

The chiang-shih vampires of China had terrible fangs and fierce claws. Their hair grew long and white, and they could change into wolves. One major weakness of the chiang-shih was that if they came upon spilled rice or seeds, they would have to stop and count each grain before continuing. They were also afraid of garlic and salt. They could be chased to their resting places with a broom. The only sure way to destroy a chiang-shih was with fire.

The Japanese vampire is a kyuuketsuki. This vampire may have been buried in cursed earth, or it may have died without breathing its final breath. Kyuuketsuki usually preyed upon members of their own family.

There is also a legend of a Japanese vampire cat known as O Toyo that had the ability to transform into a human woman. O Toyo made the royal guards fall asleep and drank the blood of the Prince of Hizen. She was eventually hunted down and destroyed.

Two Distinct Elements

This image is unusual because it has two distinct elements: the bat and the vampire. Classic vampire mythology states that vampires can transform into animals such as wolves and bats.

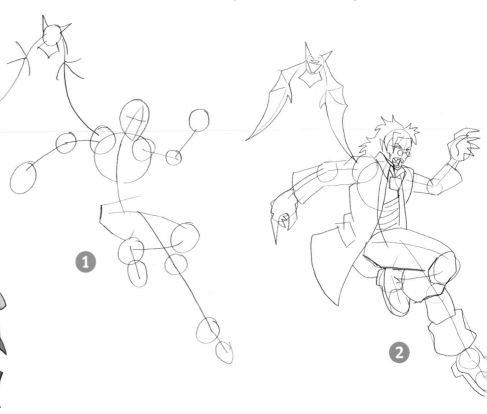

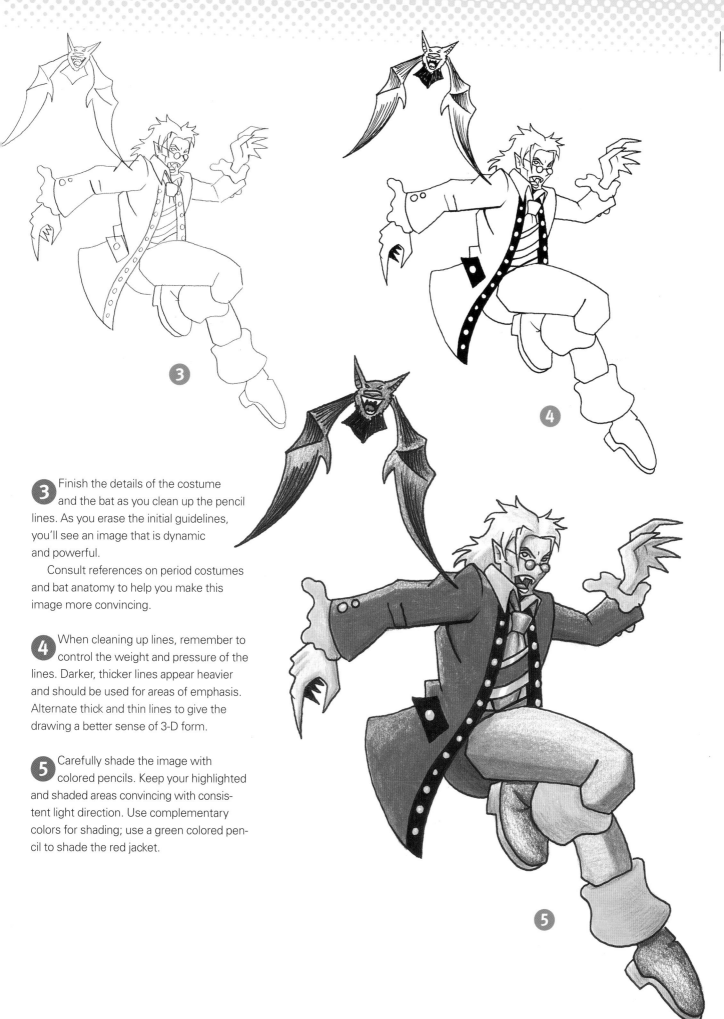

3 Finish the details of the costume and the bat as you clean up the pencil lines. As you erase the initial guidelines, you'll see an image that is dynamic and powerful.

Consult references on period costumes and bat anatomy to help you make this image more convincing.

4 When cleaning up lines, remember to control the weight and pressure of the lines. Darker, thicker lines appear heavier and should be used for areas of emphasis. Alternate thick and thin lines to give the drawing a better sense of 3-D form.

5 Carefully shade the image with colored pencils. Keep your highlighted and shaded areas convincing with consistent light direction. Use complementary colors for shading; use a green colored pencil to shade the red jacket.

Werewolf

One of the classic monsters of legend, literature and film, the werewolf is a cursed human who transforms into a monster during the full moon. Japanese mythology is full of transforming creatures. However, these are usually animals that turn into humans, not vice versa. The legend of the werewolf seems to have come from Norse myths of berserk warriors totally losing themselves to an animal nature, or the Greek myth of Lycaon, who was transformed into a wolf by Zeus.

The werewolf should be a hairy, half-human beast with terrible claws and sharp teeth.

1 Draw a front-on view of the werewolf in a crouched position. This stance represents a direct, aggressive threat that would scare the werewolf's victim. Keep the lines light so they are easier to erase later on.

2 Block in the structure, including details such as the hair, claws and wolf-like face. Make the claws on the hands and feet huge. Give the werewolf a large tail and a stance that distributes his weight efficiently.

Crying Wolf

Considered rabid and dangerous, wolves were systematically hunted down and destroyed in Europe during the middle ages. As a result, wolves are virtually extinct in some parts of Europe today. North American wolves were also hunted.

Wild wolves generally like to keep their distance from humans, but although attacks on humans are rare, they sometimes occur when food is scarce.

The slow, horrifying death from the rabies often associated with wolves may be the origin of some werewolf myths.

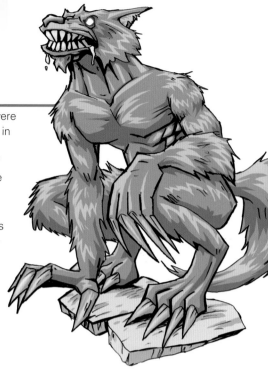

Preliminary Structure

No matter how inhuman the monster is, the final image always benefits from preliminary anatomical structuring.

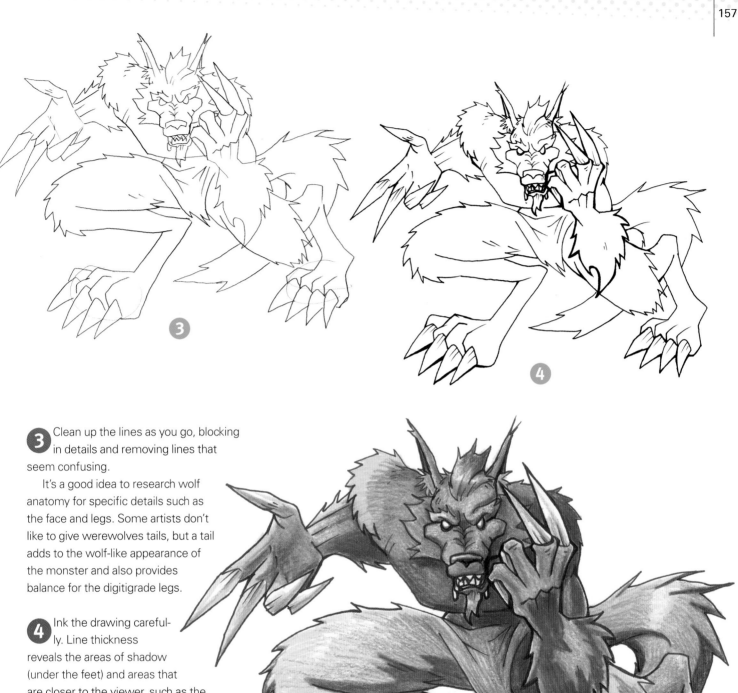

3 Clean up the lines as you go, blocking in details and removing lines that seem confusing.

It's a good idea to research wolf anatomy for specific details such as the face and legs. Some artists don't like to give werewolves tails, but a tail adds to the wolf-like appearance of the monster and also provides balance for the digitigrade legs.

4 Ink the drawing carefully. Line thickness reveals the areas of shadow (under the feet) and areas that are closer to the viewer, such as the werewolf's left arm.

5 Make the coloring show roundness and some texture. Shade the fur in chunks. Avoid the temptation to draw every hair on the monster; all those hairs never look realistic, just busy. Draw the hair in the direction that it grows so the pencil lines will help reveal the character's 3-D form.

Sea Creature

That's no mermaid sitting on that rock; it's a sea creature who is better suited for life in the depths of the ocean than skulking around on dry land. She has fins for agile movement underwater, gills for extracting the oxygen out of water and webbed feet and hands for efficient swimming.

1 Make the legs appear foreshortened as they move forward and backward in imaginary space. Make the tail a natural extension from the initial action line that relates to the spine of the sea creature.

2 Block in details such as the fins and underbelly scales. Make the fingers and toes of the sea creature webbed to allow for enhanced swimming. Make the gills on the side of the neck just visible at this stage.

Earth's Final Frontier

The sea is mostly undiscovered territory, full of uncataloged life forms and mysterious locations. Water covers over 80 percent of the Earth's surface, but less than 5 percent of the ocean has been mapped. What people do not know or understand, they fear. Horrors from the sea include giant squids, ship-sinking sea serpents and giant sharks. American horror writer H.P. Lovecraft even placed his most horrifying monster, the dreaded Cthulu, sleeping deep under the sea.

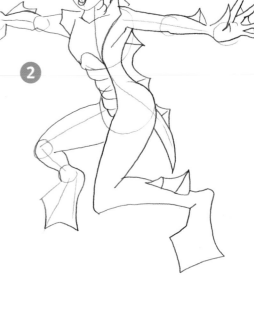

Forget the Rules

The pose for this drawing shows a figure swimming underwater, so the usual rules of weight and stance are not applicable.

Download FREE bonus demos at impact-books.com/monster-manga-book

3 Clean up the details and try to simplify some of the information for the drawing. Add details, such as the webbed feet and the shape of the face, to make the finished drawing appear more fluid and 3-D.

4 Erase the remaining guidelines and ink or trace the figure on a clean sheet. The image should be clean and crisp, not scratchy and splotchy.

5 Make the cylinder-like shape of the limbs very obvious at this stage. Show as much 3-D information as you can using colored pencil. The trick to realism is to use consistent highlights and shadows. Add the red tiger stripes to further reinforce the rounded forms of the figure.

Giant Insect

Most people hate creepy crawlies. The sight of a cockroach or ant in the kitchen can send even the most balanced person into a fit. Now imagine that the creepy crawly has grown to the size of a house—and it's hungry. Some classic daikaiju films have featured giant moths, praying mantises or ants.

You can learn a lot about insect anatomy as you draw it. You'll find that bugs are more interesting than scary once you get to know them.

1 Define the structure with tubes and spheres. Notice how the six legs all come out of the thorax (the midsection). This is almost like drawing a six-legged robot.

Draw some background to indicate the scale of the mighty monster.

2 Once the lines are cleaned up, the way the pieces of the exoskeleton fit together will become more obvious.

Do some research on details that you add might want to add, such as the spiky legs of the ant, the shape of the antennae or the bottom of the car.

3 Red ants just look angrier and more dangerous than black or brown ants. The surface of the ant should appear shiny and shell-like, with strong reflections.

Remember, ants are rarely found alone; where there's one, there's usually an entire colony.

Sea Serpent

The sea serpent is one of the oldest forms of giant monster. Sailors have told stories of these creatures for thousands of years. The sea serpent generally stays in the water—but imagine everyone's surprise when the watery fiend drags itself onto dry land and begins bashing things.

1 Start with basic guidelines, keeping the lines fluid and simple. The sea serpent is really just a big water snake with a more dragon-like head.

2 Erase extra pencil lines and make sure the ink lines are crisp and clean. As you complete some of the details of the monster, pay attention to how you draw the water. Have the splashing water show movement by making the waves ripple around the creature as they rise and fall into the water.

3 Keep the direction of the light consistent as you draw. Make the skin appear smooth and sort of slimy. (The scales are too small to appear obvious from this distance. A close-up drawing might reveal some fish-like scales.) Softly draw in the water, including some areas of reflection, to add some realism to the final image.

Cosmic Warlord

I't's a big, bad universe out there, and there are those who will take advantage of the chaos and confusion to seize control. The cosmic warlord usually controls a sector of space and makes deals with all the major powers to remain independent. The cosmic warlord operates outside the law. He has gained power through illegal means and will do anything to keep it. Don't get on his bad side!

1 Block in the basic structure, remembering that a series of simple shapes put together creates a complex form. The pose should be strong and confident.

2 Ink the image to simplify the forms even further. Unlike the head, areas that are filled in with pure black appear flat and without highlights.

The bolts on his back might be part of an elaborate jet pack or they could provide power to his powered armor. Either way, they are simply four cylinders. Don't forget to draw them as 3-D forms. The symbol on his chest should be repeated on the armor of his lackeys, on the side of his starships and on banners in his throne room. Keep the design elements consistent and your imaginary world will seem real.

3 Make the colors bold and cartoon-like. This character is over the top and very flamboyant. He's powered up and looking for a fight!

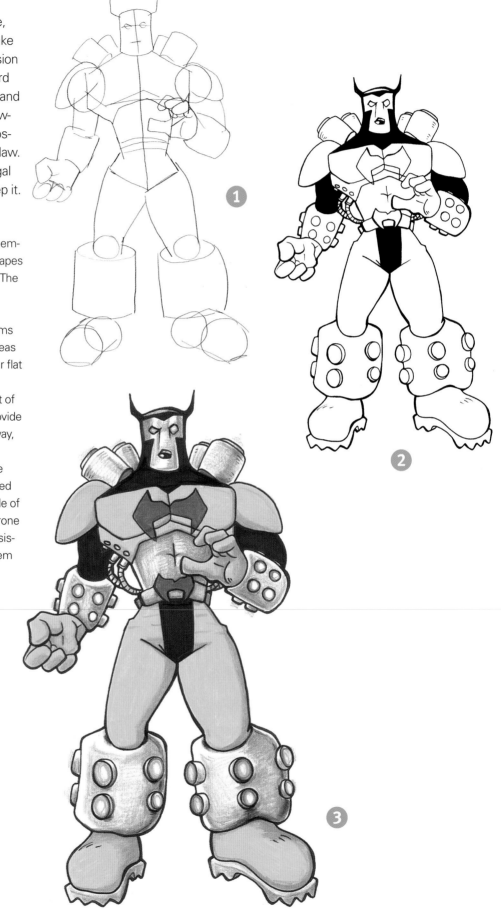

Galactic Pirate

Plying the spaceways are the suave and dashing galactic pirates. Wearing the Jolly Roger skull and crossbones with pride, they thumb their noses at authority and make their own rules. They are fierce fighters, but they are also incurable flirts and swashbucklers who are simply out for fun and profit rather than power or political gain.

1 Make the proportions long and lanky. The weapons should be exaggerated and almost playful.

 The strange antennae and long neck give him an almost insect-like appearance. The flared pants and platform shoes are very retro, even for space.

2 Clean up the figure and add the necessary anatomical and costume details. Make the antennae curl at the end, just like a snail's antennae. Give him three fingers and a thumb to remind us that he isn't human and that the basic rules don't need to apply to aliens.

3 Make this galactic pirate exotic and sophisticated. He should appear very inhuman with his red eyes, blue hair and green skin.

 The laser gun was inspired by pirate pistols of the eighteenth century.

Killer Robot

Killer robots are designed for battle and come in all shapes and sizes. This robot has oversized, jet-propulsion boots that allow it to soar through the air. It also has a collection of vicious weapons tucked away within its access panels. With its set of powerful mini-missiles, this robot is armed and dangerous.

1 Block in the basic structure. This robot has a definite arch as it leans back, taking aim with the missile. One of the nice things about drawing robots is the fact that you can be creative with anatomy—pretty much anything goes with constructed creatures.

2 Add details such as the access panels and the wire "dreadlocks" to give the robot some believability and personality. Complete the wires that connect the torso to the waist, arms and head.

3 Carefully shade in the costume with colored pencil, designating areas of highlight, shadow and reflection, particularly on the silvery metal areas. Make sure you are not just "coloring in" your image but really drawing and shading 3-D forms. Look at reflective metal objects such as household appliances or even cutlery to see how light, shadow and reflection all interact on the surface.

Alien Pet

Sure it's cute and cuddly, but it's a dangerous fury of arms and fangs when it gets mad. An alien pet could be the sidekick of an adventurous spacefarer or a pest that won't go away. Look out! It's gnawing the hyper-warp drive wires again!

1 Use simple shapes such as spheres and tubes to block in the wee beastie. Make the proportions like those of a chibi, almost to the point of SD.

No matter how dangerous this creature ultimately may be, it should still look huggable.

2 Carefully draw the final lines in ink and erase the pencil work. It is important to remember to draw the guidelines lightly so they are easy to erase and to prevent impressions in the paper, which will make the coloring stage difficult.

3 Use this stage to add some details that are not readily obvious in step 2. By adding color you will separate the teeth from the fur (this wasn't immediately clear in step 2). Draw the shading and highlights on the fur so it appears coarse and unkempt. Shade and highlight the nose.

Mutant Thug

A necessary evil of the dark, cyberpunk future are nameless armies of mutant thugs for the heroes to battle. A mutant thug should appear horrifically inhuman. This makes the character scarier and more unpredictable than something human. This example has tentacles for arms and unnaturally purple skin. Another mutant might have green skin, sharp claws and kangaroo feet. The possibilities are endless.

1 Keep the basic structure and anatomy of a normal human male, but add the tentacles. He's a mutant, so have fun. Create any combination of physical features that you can possibly imagine.

2 Erase the pencil work and add the anatomical and costume details. The bolts on the head and the glasses over the eyes remove even more humanity from his appearance.

3 Use clean and solid lines. Keep the direction of the light consistent as you shade the figure. Leaving areas of white gives a brighter highlight and makes the light appear stronger. Reflected light adds a sense of 3-D form to the figure.

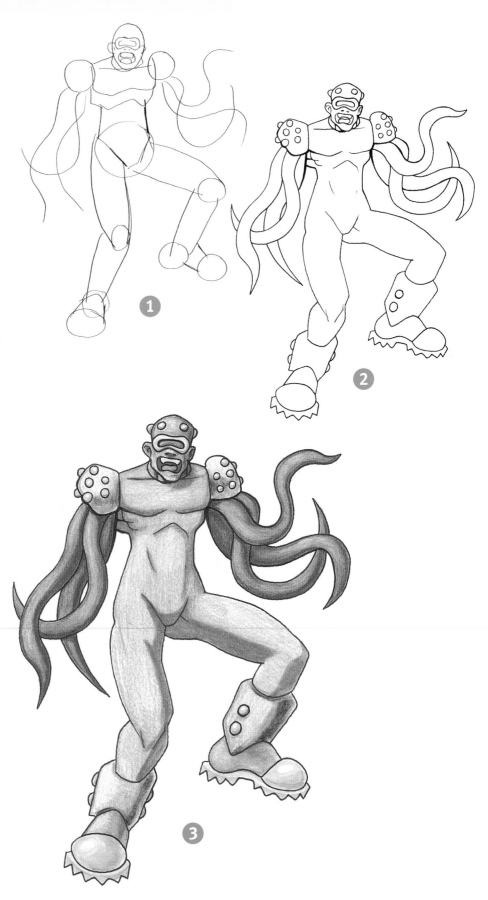

Mutant Cyborg

A rising from the whims of nature and mad scientists, even ordinary mutants can be pretty intimidating. When you add high-tech cybernetics to the mix, you can get an even more formidable mutant. This mutant cyborg seems almost indestructible.

1 Block in the basic anatomy. The basic proportions should be exaggerated and the addition of the massive shoulders and oversized boots will create a real monster.

2 Finalize the details and erase the pencil carefully. The cybernetic jaw gives this guy a robot-bulldog appearance. The surgery was not performed to win friends, but the results will certainly influence people—to run in terror!

3 Adding color allows the humanity of the flesh to contrast with the inhumanity of the metal. Burnish the metal surfaces with a white colored pencil to blend the colors so they appear smooth and reflective. Use strong highlights and reflections to add to the metallic look of the arms, jaw and legs.

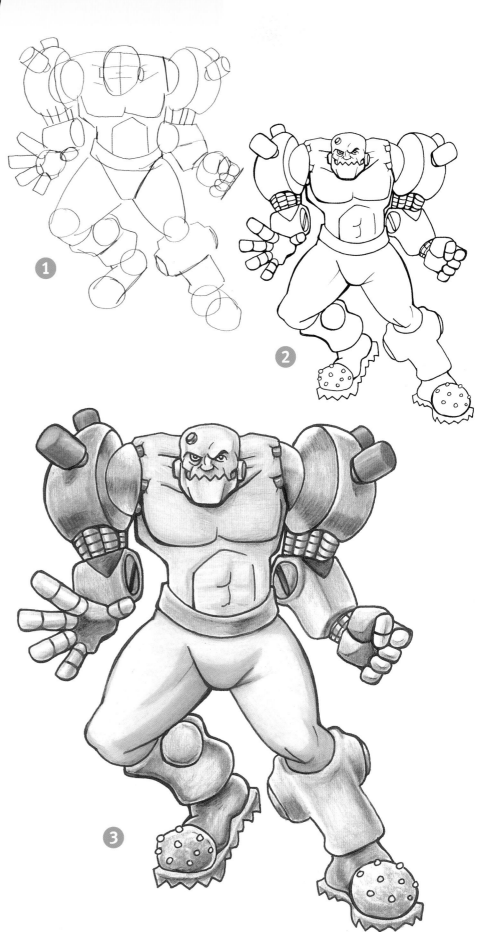

Snow Beastie

From the far reaches of the arctic comes the abominable snow beastie. The hat and mittens on the furry body are an attempt to make the snow beastie appear like a cross between a yeti and a child's snowman. Even though he has powerful tusks, keep him jolly and good-natured looking.

1 Make the proportions short and cute for this cuddly monster. Carefully sketch in the details such as the hat and teeth.

2 Cover the hands in mitts that are too big for the monster. Make the hair scruffy and fuzzy. Make the hat look old and worn out. He should look like a laughing snowman.

3 Carefully shade the monster, trying to reveal 3-D form with areas of shadow and highlight. Choose blue for the fur because it is a "cool" color and will reinforce the "abominable snowman" theme for the character. Everything else should stand out and be vibrant.

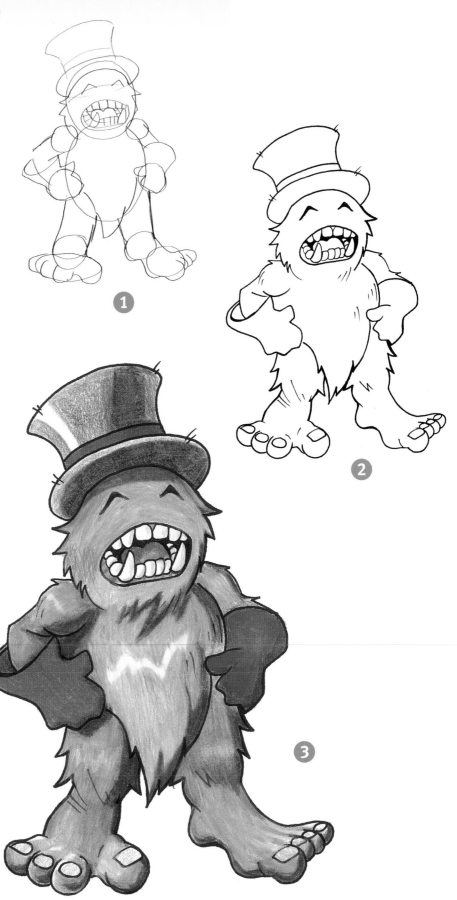

1

2

3

Elementals

*T*he four elements—water, fire, earth and air—are spirits of the earth that can be controlled by powerful magicians to do their bidding. The elementals are actually four monsters who could do a lot of damage if they got out of control. Water would flood things, fire would burn things, earth could cause a landslide and air might lift the roof off the house.

1 Block in the basic shapes of the elements. Keep the level of detail down to a minimum at this stage. If you make an error, you don't want to have to redraw everything.

2 Have fun inking these guys. Make the lines vary in thickness so some parts stand out and others recede. Erase your pencil lines and remember that you are trying to depict what these monsters look like as 3-D forms no matter how cute or simplified they are.

3 The color choices are going to be pretty obvious and related to the element at hand. Keep in mind that the 3-D forms should be fairly organic and fluid. The eyes should glow, revealing their supernatural origins.

Ghost

Ghosts can appear in many forms. This ghost is an apparition of ectoplasmic mist and energy. Japanese ghosts do not have obvious legs, but appear to be floating on air. The horrifying appearance of the skull and the glowing red eyes add to the sense of terror.

The skull and shock of hair are the only indications that this creature was once humanoid.

1 This image is fairly simple; you want to totally block it in at this stage. The trickiest thing to do is to make the tentacles of mist or ectoplasm appear fluid and mobile.

2 Develop the details such as the skull and the wispy tendrils. Use dark lines to reveal areas of shadow and mass. The shapes of the tendrils are reinforced with lines that help describe the forms of limbs.

3 Shade and color the ghost simply, being sure to echo the lines that describe the form. Make the hair look as if it were glowing, like some kind of exploding halo. Make the eyes aflame with a mysterious red glow.

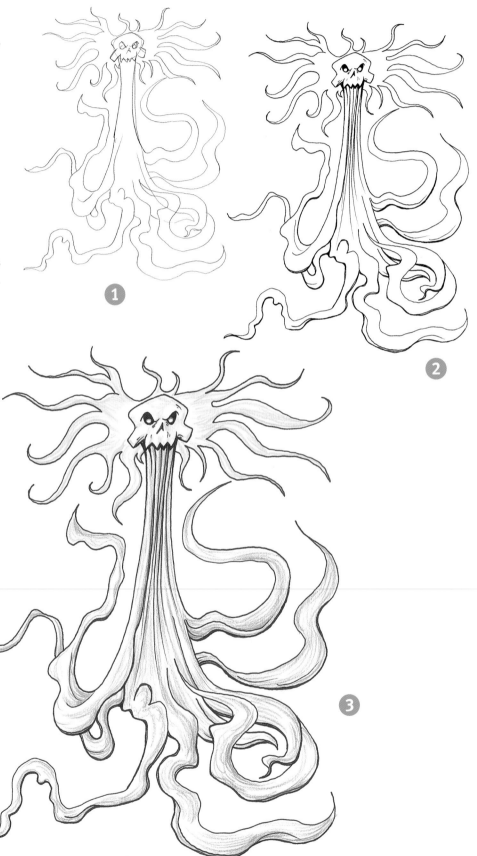

Zombie

What can be more terrifying than the shambling dead, raised from the grave and seeking the destruction of the living? The mindlessness and seemingly indestructible nature of a zombie makes it scary, but the prospect of being confronted by thousands of these things is truly horrifying.

Draw zombies with human proportions, but twist and contort them in unnatural ways to create something that seems inhuman.

1 Block in the figure as usual, but make him twisted and contorted. The legs look barely able to support the figure and the head is way off the center of gravity, giving the zombie the appearance of falling or poor balance.

2 Ink the drawing, adding details such as torn clothing and a shriveled anatomy. The skeletal structure of the zombie should be evident; it will require some research on anatomy to make it look convincing.

3 Choose unusual skin colors to make the skin look unhealthy. This skin is a lovely mix of blue, aqua green and some purple. Add some green goo dripping from the mouth—you know, that wonderful mystery fluid that zombies seem to exude. Keep things simple. Know which direction your light is coming from and try to make all of your highlights and shadows consistent with it.

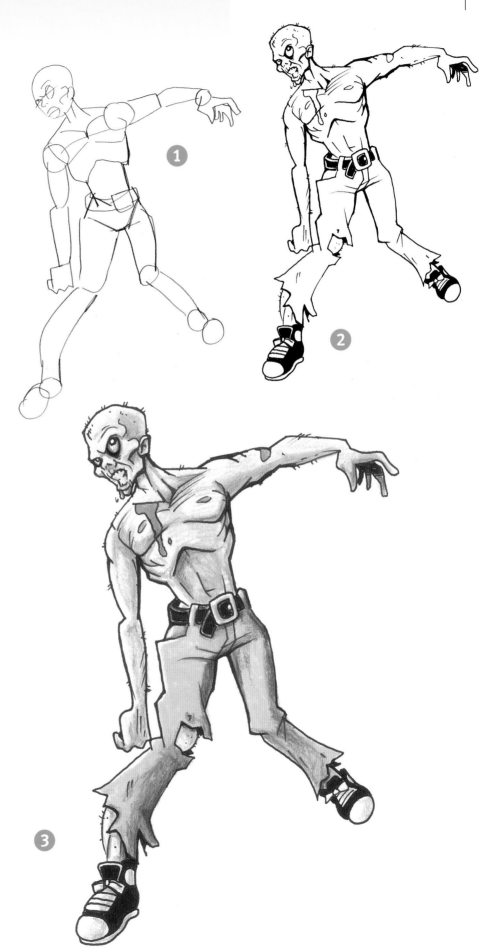

4

MANGA FANTASY

In fantasy manga, you have greater freedom and fewer rules, because fantasy is the realm of the imagination. But, just because the worlds you create don't exist doesn't mean that the characters who live in them should be inconsistent and random. The basic character types (or archetypes) in this chapter are based on some standard fantasy characters that tend to show up time and again in fantasy manga. It's up to you to develop them and make their qualities and challenges unique.

Battle Stances

Drawing convincing combat sequences is challenging. Make your scenes dynamic—show more than panels with stiff figures just standing around, moving their arms. You must show shifts in body weight when your character is wielding a weapon or getting out of the way of someone else's. Liven things up by drawing battles from interesting directions and angles. Above all be clear and keep your compositions simple. Some compositions can be overly complex, making them hard for the reader to understand.

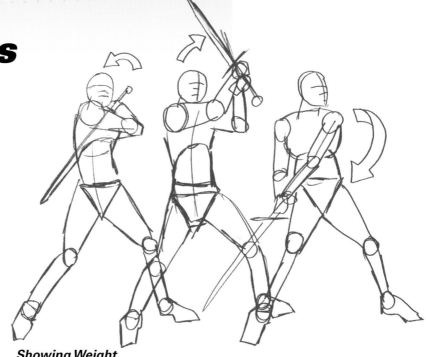

Showing Weight

Weapons have weight, and when a figure wields a weapon, his body should reflect that. Show the shift of weight as the swing occurs, in this case from the back of the figure to the front right side of the figure. The head has a tendency to rest wherever the balance is centered. If the head is drawn directly above the center of where the two legs are placed, then the figure is well balanced. If the head rests above or close to one leg, then the weight of the figure is concentrated on that leg.

Draw Dynamic Action

More than having someone just swinging a sword, heroic fantasy is full of swashbuckling action and derring-do. Draw your character leaping in the air. Based on the velocity of the leap and the weight of the leaper this is a strategic attack against a much larger opponent.

Use References

Fill a sketchbook with drawings of people in a fencing or Kendo club. Look at the stances and postures. Note how the legs and weapons move. Pause a video or DVD during a particularly well-done battle scene, then quickly sketch the poses in each frame until you find the most dynamic way to show that action in one image. You can also learn a lot picking up a broomstick and swinging it around in your backyard. Just make sure nobody is close to you when you do it.

Aim to Please

You might not know much about archery or swords, but you can probably find someone who does. Join an archery club to get a real sense of what it's like to draw a bow and fire off an arrow. You could also purchase a bow and arrow at a sporting goods store and practice on your own. Whatever you do, just be careful and respectful of the weapon. Bows and arrows can be dangerous. Your "real-life" experiences will add a touch of realism to your fantasy drawings.

Sticks and Stones

Martial arts weapons are used differently according to the type of martial arts the character is doing. The traditional use of a staff in Wushu and the traditional use of a staff in karate are very different from each other. The weapon should act as an extension of the wielder. Focus on showing the weight, force and flow of the character as the weapon is used.

Headgear

Protecting the head is an important function of armor, yet in manga and anime the face of the character is often exposed to let the reader easily identify the protagonist of the story. Face-covering helmets are usually reserved for the faceless minions of the evil overlord.

Helmets

Helmets come in many shapes and sizes. Wearers of helmets would usually wear chain mail over padding underneath. Some had chain mail attached to them and later models had visors that could be lowered when danger approached. Helmets are one of the few items of armor still worn today by the modern military.

Donning a Helmet

1 A padded hood is worn first. This helps absorb any impacts from falling or weapons such as maces or clubs.

2 A chain mail coif is worn over the padded hood. Chain mail is much too heavy to be worn without padding for long periods of time. Chain mail provides excellent defense against cutting weapons, but is useless against blunt weapons because the chains dig into the skin when hit.

3 The "bucket helmet" is strong and simple. It is still vulnerable to some chopping attacks and most blunt attacks. As you can well imagine, it's difficult to see what's going on through that tiny slit, but you are better protected with a full-face helmet.

Download FREE bonus demos at impact-books.com/monster-manga-book

Weapons

Traditional medieval weapons inspired manga fantasy weapons, but manga weapons are often larger and more ornate than their real-world counterparts. Let's cover the basics.

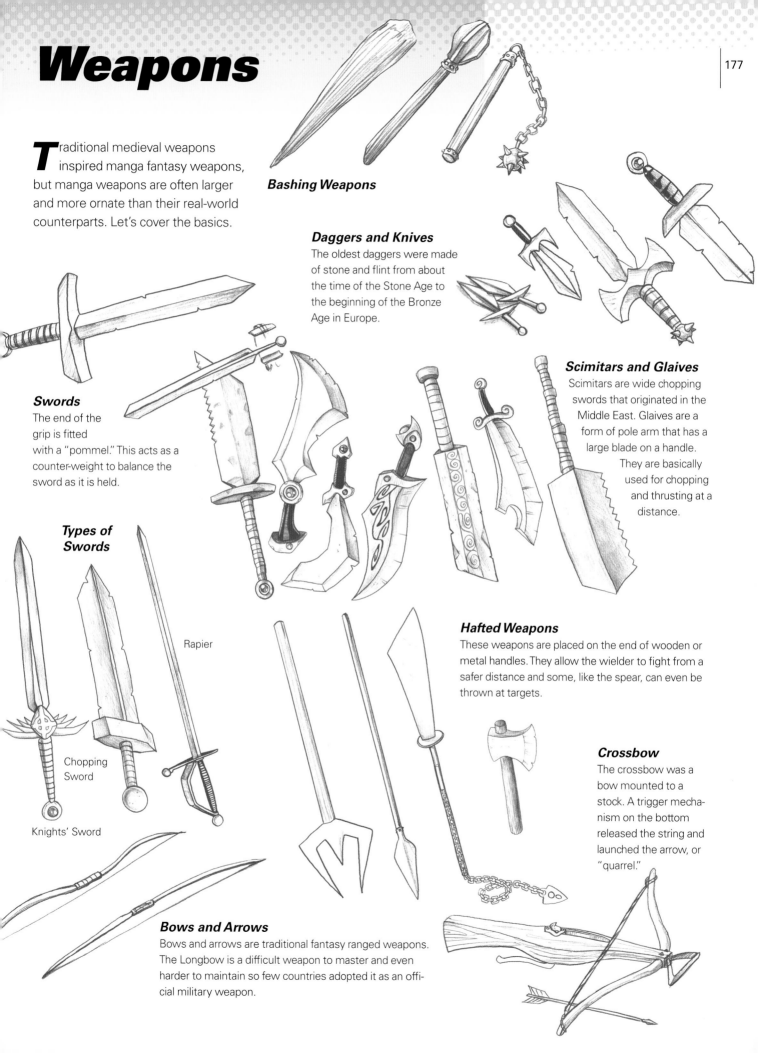

Bashing Weapons

Daggers and Knives
The oldest daggers were made of stone and flint from about the time of the Stone Age to the beginning of the Bronze Age in Europe.

Scimitars and Glaives
Scimitars are wide chopping swords that originated in the Middle East. Glaives are a form of pole arm that has a large blade on a handle. They are basically used for chopping and thrusting at a distance.

Swords
The end of the grip is fitted with a "pommel." This acts as a counter-weight to balance the sword as it is held.

Types of Swords

Rapier

Chopping Sword

Knights' Sword

Hafted Weapons
These weapons are placed on the end of wooden or metal handles. They allow the wielder to fight from a safer distance and some, like the spear, can even be thrown at targets.

Crossbow
The crossbow was a bow mounted to a stock. A trigger mechanism on the bottom released the string and launched the arrow, or "quarrel."

Bows and Arrows
Bows and arrows are traditional fantasy ranged weapons. The Longbow is a difficult weapon to master and even harder to maintain so few countries adopted it as an official military weapon.

Youthful Adventurer

Young and curious, the Youthful Adventurer is most often the main character of the fantasy adventure story. He usually has an unusual birth or origin and has some power or ability that will help him win in the end. Typically he is unwittingly thrown into an adventure guided by a mentor and aided by companions who compliment his skills and character—and also provide comic relief. The hero sets out for adventure in a world that seems alien and menacing. Eventually he is captured, overwhelmed or surrounded and must endure a series of tests in order to confront the final challenge (symbolically a dragon). He then fights a horrible battle and has a near-death experience, but the hero ultimately uses his powers to win the day in a magical chase or flight, and he successfully completes the quest. Returning home, the hero has become stronger by his adventure and is duly rewarded for his efforts.

1 Ask any manga villain: Heroes just don't stand still. His hero is on the move. Ensure that the sword appears to have some weight in the hero's hands. The head leans forward to show the momentum of the movement, but also to counterbalance the weight of the sword. Keep the initial lines simple and clean. Too many lines can become distracting and may be difficult to erase later.

2 Block in the details of the figure, such as hands, costume and facial features, correcting the stance as you go. The hero's youth is reinforced by the fact that he is not too bulky.

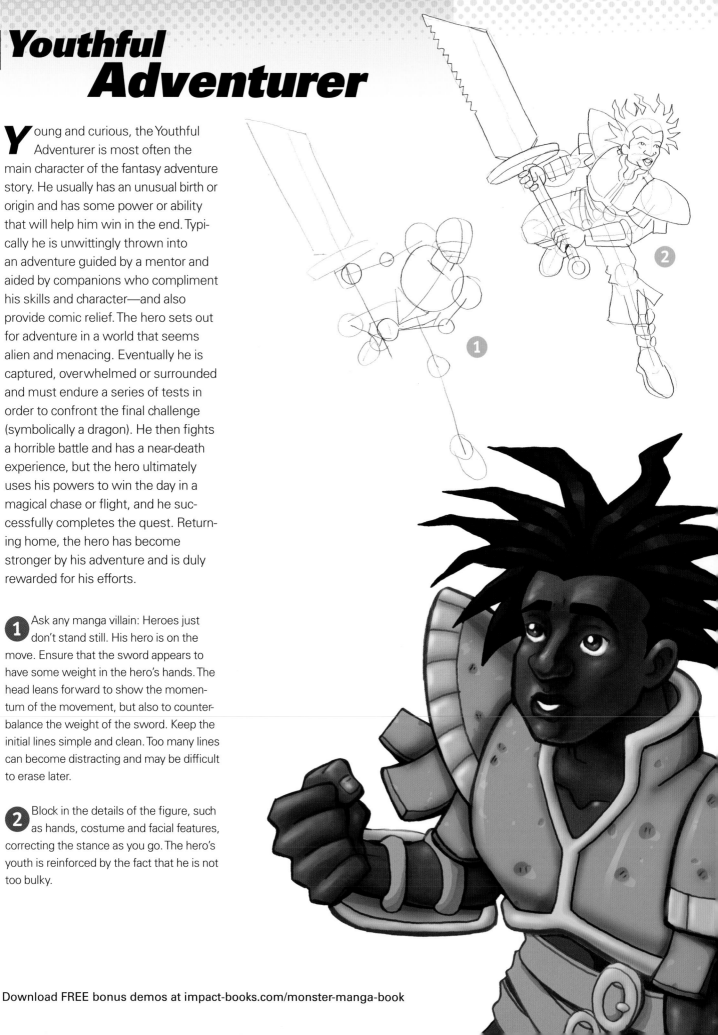

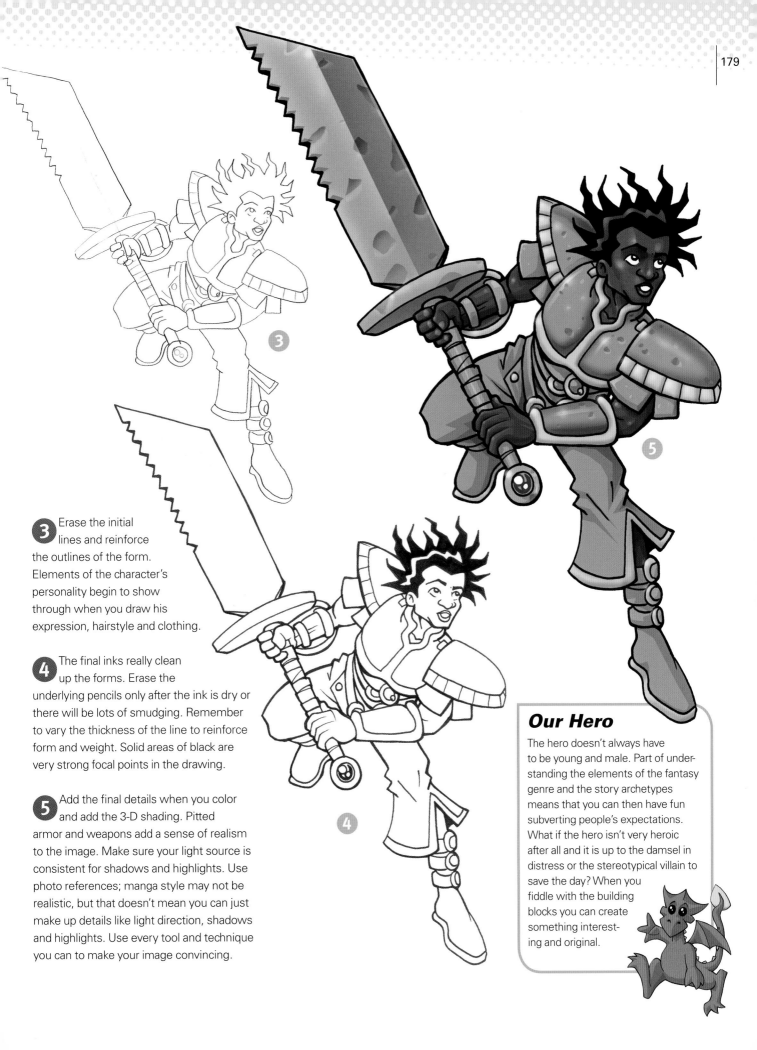

3 Erase the initial lines and reinforce the outlines of the form. Elements of the character's personality begin to show through when you draw his expression, hairstyle and clothing.

4 The final inks really clean up the forms. Erase the underlying pencils only after the ink is dry or there will be lots of smudging. Remember to vary the thickness of the line to reinforce form and weight. Solid areas of black are very strong focal points in the drawing.

5 Add the final details when you color and add the 3-D shading. Pitted armor and weapons add a sense of realism to the image. Make sure your light source is consistent for shadows and highlights. Use photo references; manga style may not be realistic, but that doesn't mean you can just make up details like light direction, shadows and highlights. Use every tool and technique you can to make your image convincing.

Our Hero

The hero doesn't always have to be young and male. Part of understanding the elements of the fantasy genre and the story archetypes means that you can then have fun subverting people's expectations. What if the hero isn't very heroic after all and it is up to the damsel in distress or the stereotypical villain to save the day? When you fiddle with the building blocks you can create something interesting and original.

Princess Warrior

The Princess Warrior has much in common with the Youthful Adventurer, but she often has the added burden of dealing with the prejudices of her culture, which underestimates her abilities because she is female. Once she overcomes this prejudice she usually has the same kinds of adventures as the male heroes. The Princess Warrior often has some magical item that allows her to transform into a more powerful form. Manga and anime have a long tradition of strong Princess Warrior characters who embark on epic quests and gain fantastic abilities to defeat overwhelming adversaries.

1 Block in the basic pose quickly and loosely. Draw her holding the weapon so it appears to have some actual weight, but is balanced and controlled. At this stage you are just planning where things are going, but notice how the head is centered for maximum stability.

2 Add details to flesh out the stick figure. The weapons and armor are based upon Japanese samurai equipment. At this stage make sure you are checking your anatomy and proportions in case you have made any errors. Draw lightly; you will erase these construction lines in your final drawing.

3 Clean up the underlying sketch lines. This helps focus the details of the armor and weaponry. The chain is particularly troublesome. Take your time and try looking at real chains for reference. Don't worry if you can still see through some parts of the drawing where things are overlapped; you won't see these in the final image. Drawing through helps maintain precise proportions, anatomy and a sense of structural form.

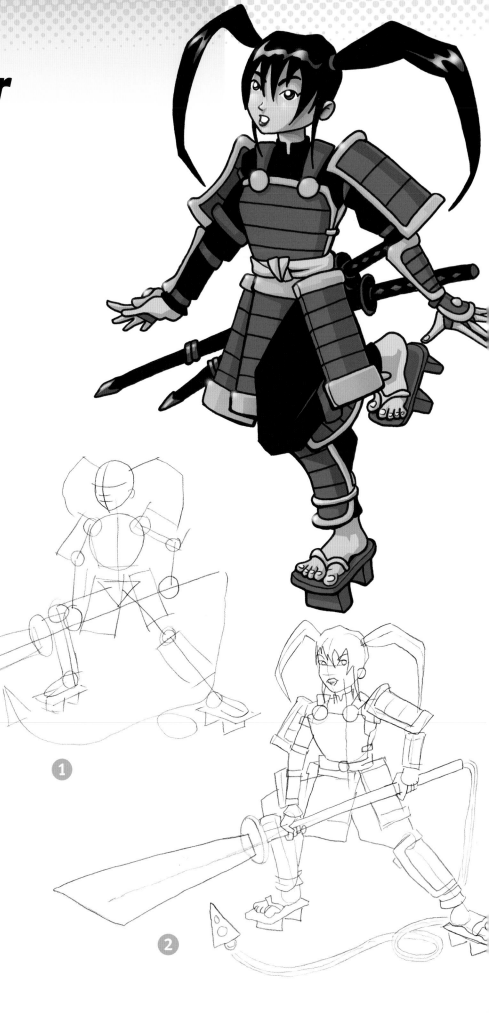

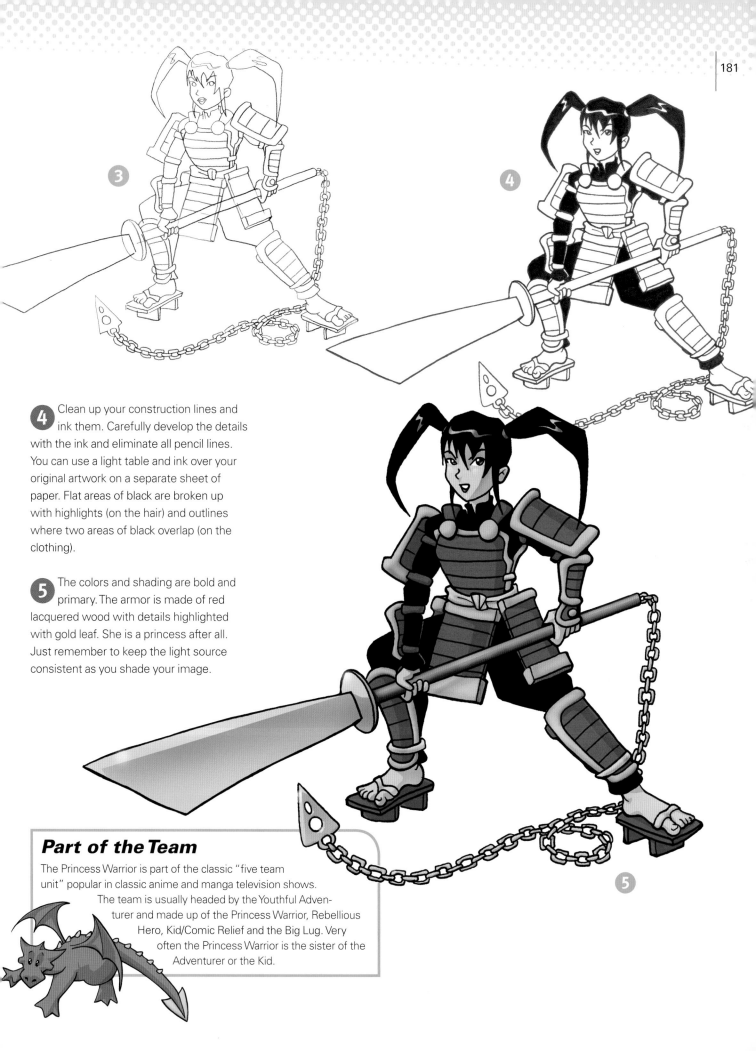

3

4 Clean up your construction lines and ink them. Carefully develop the details with the ink and eliminate all pencil lines. You can use a light table and ink over your original artwork on a separate sheet of paper. Flat areas of black are broken up with highlights (on the hair) and outlines where two areas of black overlap (on the clothing).

5 The colors and shading are bold and primary. The armor is made of red lacquered wood with details highlighted with gold leaf. She is a princess after all. Just remember to keep the light source consistent as you shade your image.

Part of the Team

The Princess Warrior is part of the classic "five team unit" popular in classic anime and manga television shows. The team is usually headed by the Youthful Adventurer and made up of the Princess Warrior, Rebellious Hero, Kid/Comic Relief and the Big Lug. Very often the Princess Warrior is the sister of the Adventurer or the Kid.

Youthful Wizard

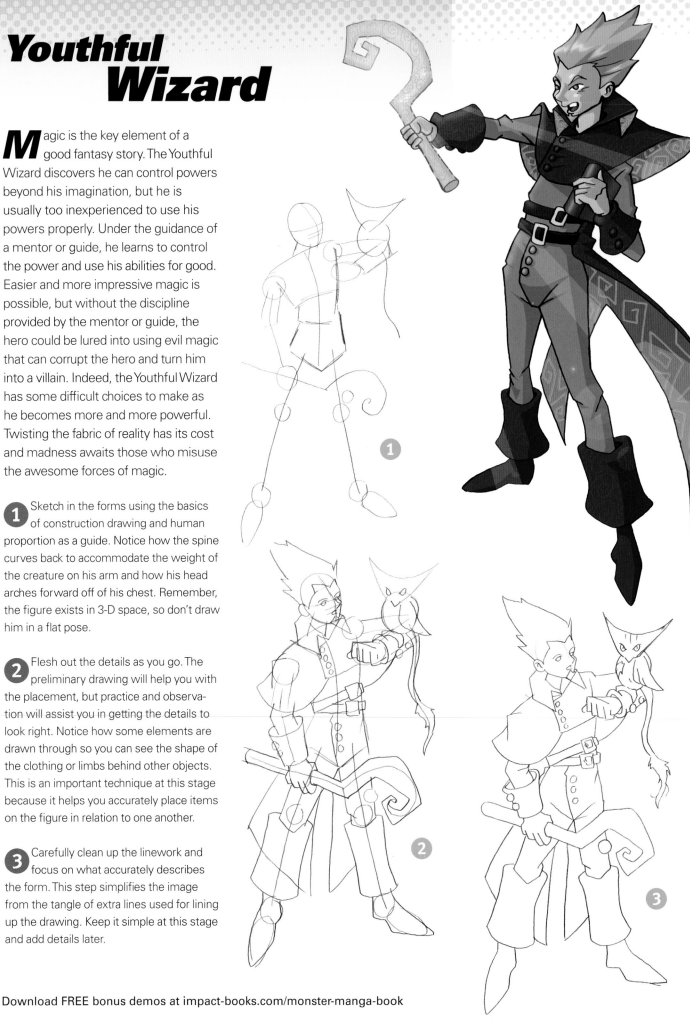

Magic is the key element of a good fantasy story. The Youthful Wizard discovers he can control powers beyond his imagination, but he is usually too inexperienced to use his powers properly. Under the guidance of a mentor or guide, he learns to control the power and use his abilities for good. Easier and more impressive magic is possible, but without the discipline provided by the mentor or guide, the hero could be lured into using evil magic that can corrupt the hero and turn him into a villain. Indeed, the Youthful Wizard has some difficult choices to make as he becomes more and more powerful. Twisting the fabric of reality has its cost and madness awaits those who misuse the awesome forces of magic.

1 Sketch in the forms using the basics of construction drawing and human proportion as a guide. Notice how the spine curves back to accommodate the weight of the creature on his arm and how his head arches forward off of his chest. Remember, the figure exists in 3-D space, so don't draw him in a flat pose.

2 Flesh out the details as you go. The preliminary drawing will help you with the placement, but practice and observation will assist you in getting the details to look right. Notice how some elements are drawn through so you can see the shape of the clothing or limbs behind other objects. This is an important technique at this stage because it helps you accurately place items on the figure in relation to one another.

3 Carefully clean up the linework and focus on what accurately describes the form. This step simplifies the image from the tangle of extra lines used for lining up the drawing. Keep it simple at this stage and add details later.

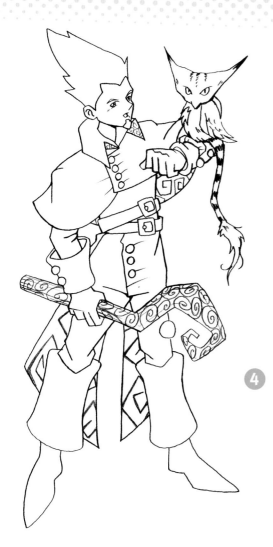

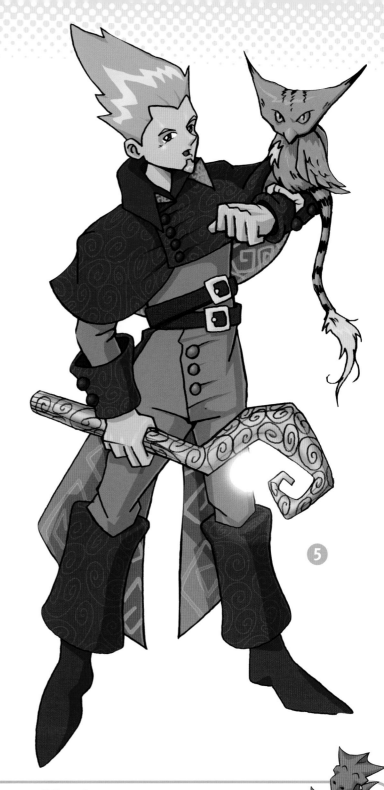

4 Carefully ink over the existing pencil lines and add texture, weight and pattern on the drawing. Make sure that patterns, such as the spirals on the wand and the rings on the tail, help reinforce the roundness or general form of the object upon which they are drawn. Very often patterns can flatten the image unless they wrap around the forms on which they are applied.

5 Never "color in" the image. Use color and shading to make the image appear 3-D. Cel shading can be a little harsh, but it is a simple and effective way to mimic the look of anime and manga. Softer use of computer shading, markers, colored pencil, or paint still requires the artist to think of the legs as cylinders and the shadows and highlights on the final image. Use photo references for shading that will let you see the relationships of light and dark on the figure.

Fantasy Magic

Magic in fantasy manga is dynamic and dramatic. Effects are flashy and powerful, often destroying sections of entire towns with one blast of energy. The wizard often pays for this use of supernatural power by losing part of what makes him or her "human." The dark magic is easier and more powerful with less apparent sacrifice, but it sucks the soul away and can turn the Wizard into something much darker and scarier than the monsters the characters meet. In anime and manga, magic is often a flashy special effect that requires much yelling, arm waving and dramatic transformation sequences with lots of sparkles and bolts of lightning.

Noble Paladin

Called by a divine presence to don armor and battle evil, the Noble Paladin often wanders the land doing good deeds and defending the weak. Unlike the Youthful Hero, the Noble Paladin understands his quest and has the equipment and training to get the job done. Shining and golden, he faces insurmountable odds and overcomes them with an effective combination of faith, ability and powerful relics and equipment. The Noble Paladin's main problem is his tunnel vision and inability to stray from his goal. He is willing to sacrifice himself for the greater good and it is that fearlessness and selflessness that often turns the tide of battle when his allies become inspired to leap to his aid.

1 Break down the complexity of the pose and armor into a simple ball and stick gesture study. Make lots of these studies in your sketchbook from photographs and posing friends. Once you have the biomechanics of the human form memorized you can draw the character from your memory. The head usually rests over the area of weight distribution. The weight of this character is clearly over his right leg.

2 Block in the elements of the figure and the costume. Refer to references for convincing armor construction and detailing.

3 Clean up the details as you add more information in the drawing. Erase some of the original pencil lines and reinforce the final lines as you go. The character's attitude begins to emerge now. Make sure the Noble Paladin appears strong and confident. If he plunges headlong against the forces of evil, he'd better be tough.

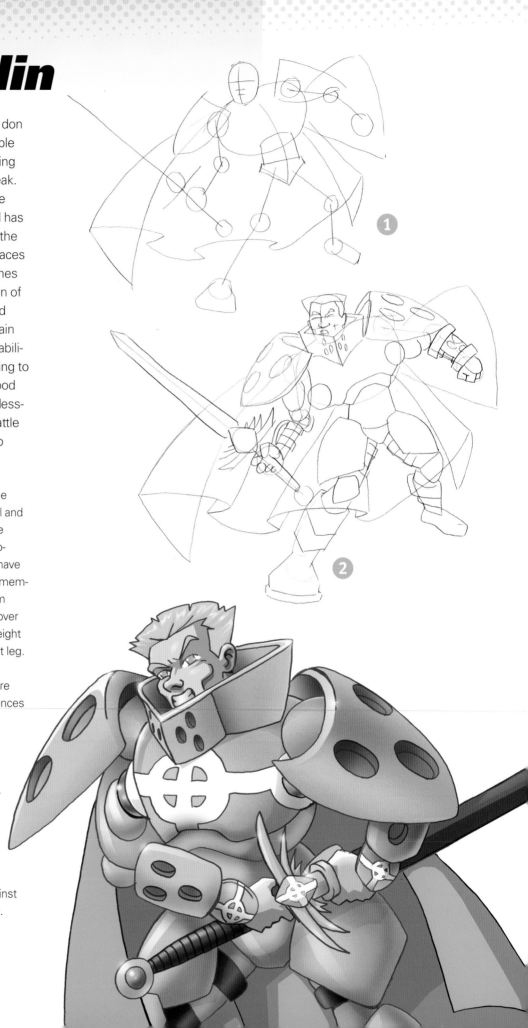

4 Line width should reinforce the weight and form of the objects you are drawing. Thick lines appear heavier and more in shadow. Thin lines recede and are appropriate for areas of highlighting.

5 Color and shading will reveal even more about the forms you are drawing. The blue cape is a symbol of spiritual nobility and the shining golden armor adds a sense of magic and glamour. This is the archetypical knight in shining armor.

The Ultimate Quest

The Noble Paladin is a knight devoted to the ideals of spiritual belief. He seeks out evil and destroys it. He is a knight devoted to chivalry and heroism. Divine inspiration has been the spark of many magical quests from King Arthur and the Knights of the Round Table to Charlemagne and his Paladins.

Lovable Rogue

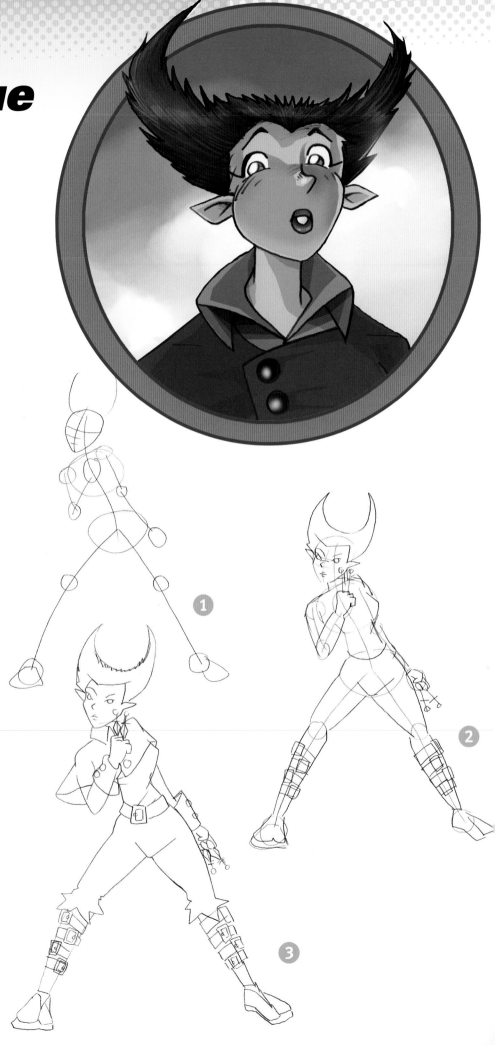

The Rogue is a sneaky character who is often a thief or spy. The hero often meets the Rogue after something has been stolen from the hero or his friends. The Rogue then joins the adventure only for profit, but soon becomes caught up in the spirit of the quest and shows an unexpectedly gallant and dignified nature. The Rogue often saves the day in the end, distracting the villain or rescuing the hero at the last moment when everyone thought she had long disappeared into the shadows. The Rogue also has the best wisecracks in the story, being a cynical character who has been around a bit and thinks she knows a thing or two about how the world works.

1 Keep the pose sneaky. Moving the body weight to one side keeps the viewer wondering what the character is going to do next. I chose to make this character long and lean, very fox- or cat-like. Those lines on top of the head are there to block in her crazy hair.

2 Build up the structure of the figure over the initial gesture lines. Give her hair volume. Draw her ears slightly pointed, indicating that she is half-human, half-elf. Some elements of the costume, such as the belts on the shins, are more about defining the rounded shape of the leg than actually serving a practical function. Also it just looks cool.

3 Erase the construction lines or trace the image onto another sheet of paper. Develop the details of the clothing. Details really help define the character. Ninja warriors in Japan used the split toe slippers or "tabi" shoes. Reinforce the character's nature by providing sneaky, sure-footed footwear.

4 Carefully erase the guidelines and clean up the quality of the lines in your finished drawing. Attention to details like the buttons and buckles helps convince viewers that what they are seeing is "real."

5 Colors for the Rogue should be dark and muted, allowing for easy lurking and general sneaking around. The costume should also be simple and easy to move around in. Rogues don't usually carry huge weapons. They usually run from a fight or if they must fight, they fight on their own terms.

Gray Area

The Lovable Rogue is a good example of how someone who appears to be breaking the rules (or the law) can become a folk hero and redeem himself by doing good deeds or using his "special skills" for a good cause. Famous outlaws such as Robin Hood or the Scarlet Pimpernel can get jobs done that the average knight in shining armor would never dream of doing. Need a dragon slain? Call a knight. Need a dragon's treasure? Call a rogue.

Elfin Archer

The Elf is a fantasy archetype that has translated very well into manga fantasy. Elves are the physical embodiment of the spirit of nature in the world, which is a common element in anime and manga. They are often the conscience and the heart of the heroic struggle against destructive forces of evil. Elves are powerful mages who can control natural energy. They can even communicate with elements of nature such as the spirits of the trees, hills and streams.

1 The Elf is light-footed and has fluid, sweeping movements. Some legends even claim that the Elf is so in tune with her environment that she doesn't even leave footprints. Keep things simple to start, realizing that you will add details soon.

2 Keep a sense of the 3-D forms: cylinders for the legs and arms and spheres for the head, torso and hips. The legs shouldn't be lined up flat—show some depth! Draw the leg closest to the viewer lower than the leg further away.

3 Erase your rough construction lines and darken the final figure lines. Add details such as the tattoos or war paint on the face; they give the Elf a more feral, primal look. The bow and arrow quiver was inspired by representations of Mongolian archers of the fourteenth century. The pointed boots are a nod to traditional fairy-tale depictions of Elves.

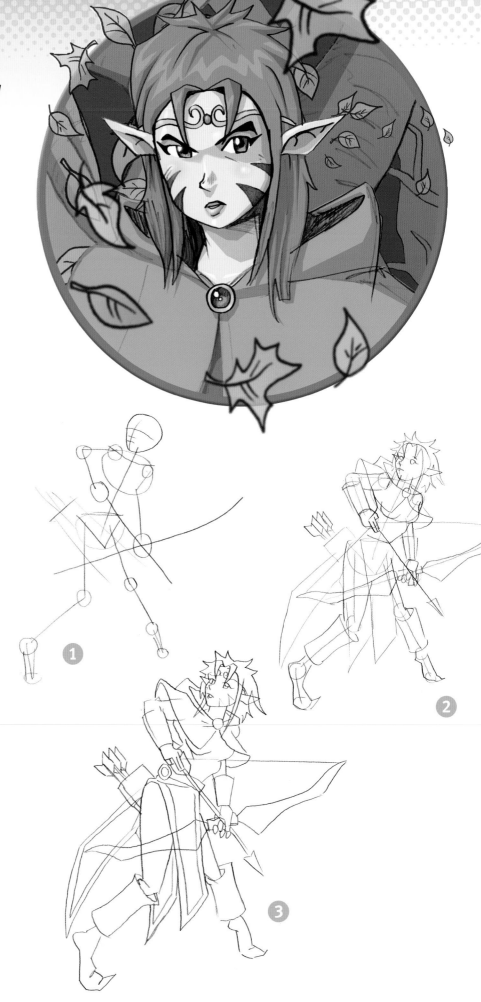

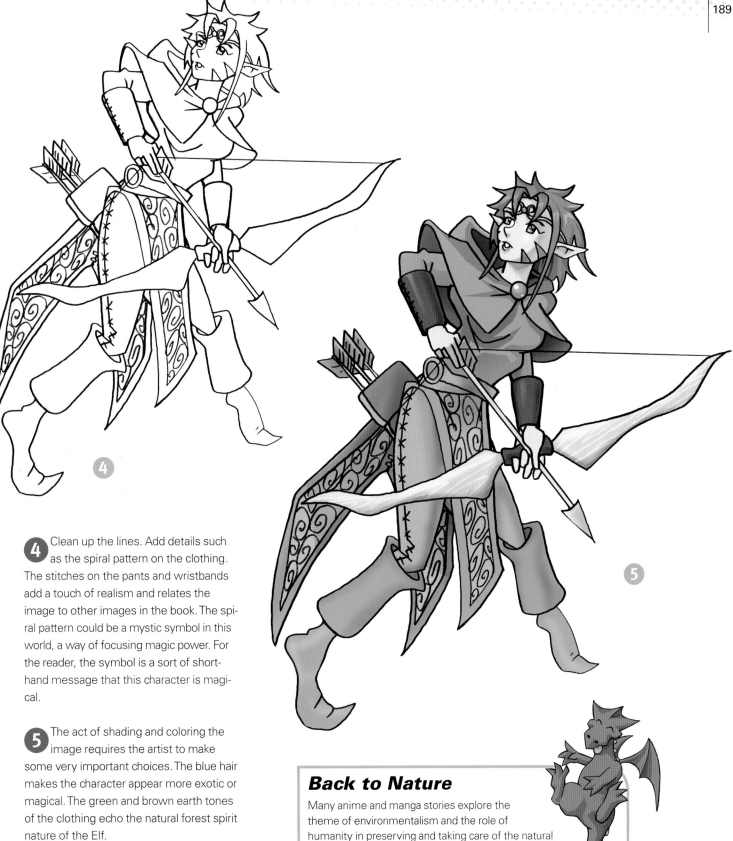

4 Clean up the lines. Add details such as the spiral pattern on the clothing. The stitches on the pants and wristbands add a touch of realism and relates the image to other images in the book. The spiral pattern could be a mystic symbol in this world, a way of focusing magic power. For the reader, the symbol is a sort of shorthand message that this character is magical.

5 The act of shading and coloring the image requires the artist to make some very important choices. The blue hair makes the character appear more exotic or magical. The green and brown earth tones of the clothing echo the natural forest spirit nature of the Elf.

Back to Nature

Many anime and manga stories explore the theme of environmentalism and the role of humanity in preserving and taking care of the natural world. Despite the fancy robots, spaceships and martial arts mayhem, the main message of manga seems to be to take care of the environment and it will take care of you. Good advice.

Bounty Hunter

He's big, he's bulky and he's looking for the bad guys because that's his job. The Bounty Hunter is a big guy doing a big job. He is a mercenary, working for the king one week and the evil prince the next. The main characters of the story usually win him over by offering promises of riches, sometimes even paying him more than his boss to disregard an order or undertake new orders. The big guy is rather softhearted too and can sometimes be talked out of a job with an appropriate sob story. What a pushover.

1 He's too big to draw on the page? No, he's just leaping with his weapon to chop some unsuspecting bad guy in two, or at least scare him. Bounty Hunters aren't known for their subtlety or good manners. They often slash first and ask questions later. The pose is dynamic and full of action. This big guy is in mid flight!

2 There should be more muscle than flab on this guy. Draw him like someone who can capture even the toughest hombre and win the reward. His sword is huge and even though he's built to bench press an Ogre, he should only just be able to wield it. He is dressed like a pirate or a barbarian, keeping things simple as he travels from town to town in search of his bounties.

3 Block in the details over the under drawing. Erase extra lines and only save the lines that best describe the form. Too many lines will make the drawing appear sketchy and unsure. If your rough work is too dark to erase or you want to keep the illustration fresh, trace the image onto a fresh sheet of paper.

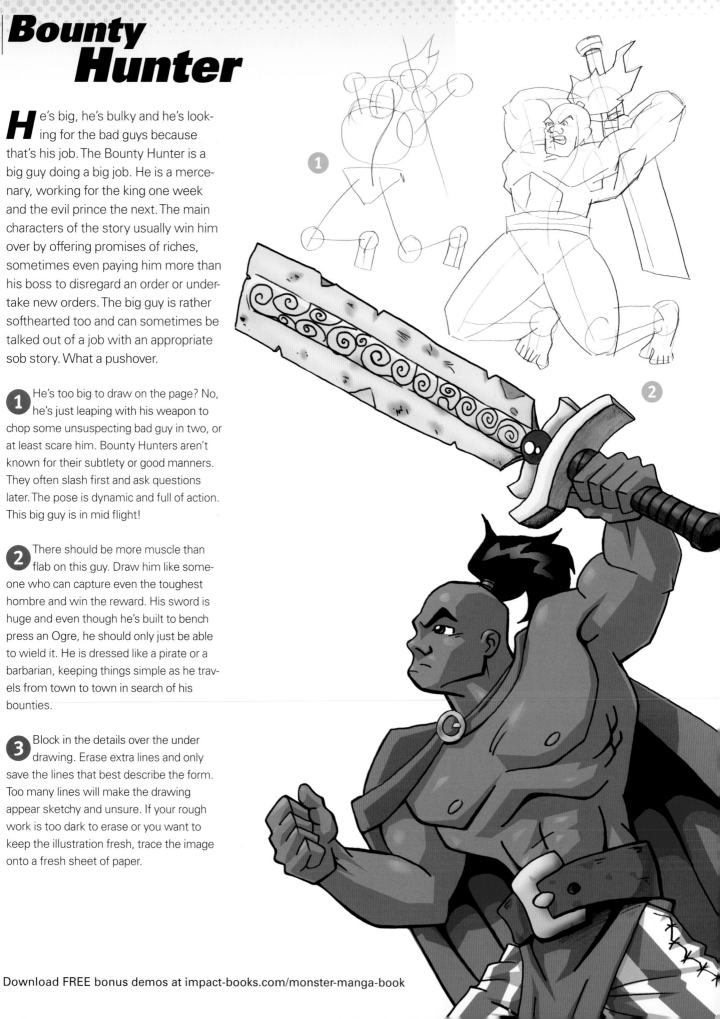

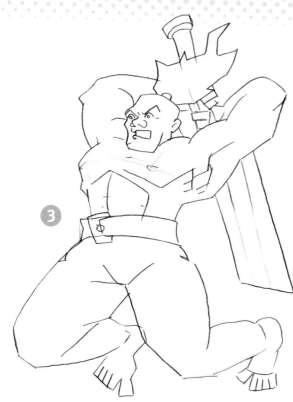

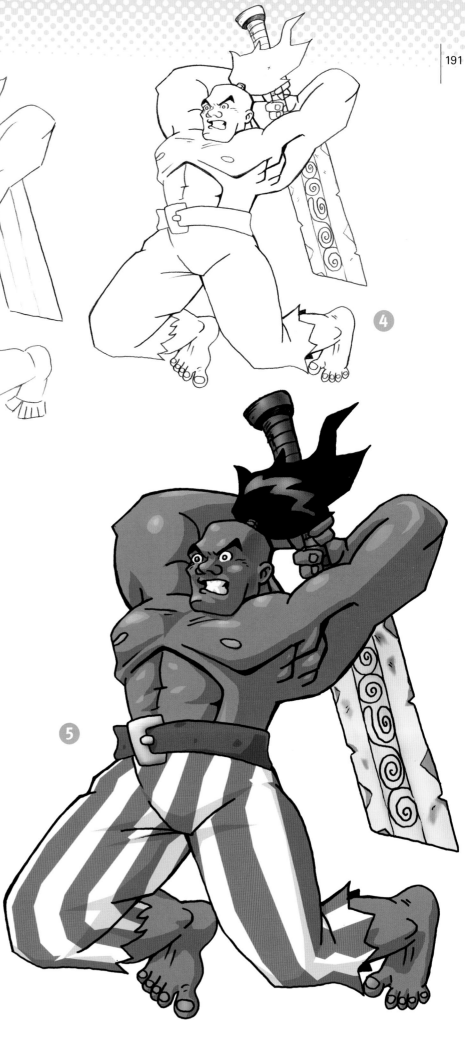

4 Clean up the rest of the lines and pay attention to details such as his ribs, muscles and his sword. The little x in his hair indicates that the final image will be colored in black later.

5 The striped pants echo his pirate look and create a bold, graphic image. Make sure that your figure is rounded and shaded in a convincing way. Don't forget about the highlight in his hair. Pay attention to the folds and creases of his pants as well as the distressed surface of his humongous sword.

The Big Lug

The Big Lug is a manga and anime classic. Most often this guy terrifies everyone with his hulking presence and frying-pan hands, but turns out to be a real softie, crying when one of his pet Blood Dingos dies. Alternately the Big Lug is a country bumpkin or simpleton who just happens to be really clever with mechanics/languages/computers/insert technical skill here.

Dragon

Dragons have found their way into the mythology of many cultures. Perhaps ancient storytellers sought to explain the remains of dinosaurs or maybe they struggled with the basic personifications of good and evil and settled on the serpentine creatures we have come to know as Dragons.

The Dragon is a symbol of evil and greed, and often defends priceless treasures. Defeating a Dragon is the ultimate challenge of any fantasy warrior. Most Dragons are asleep, hidden away under mountains, waiting to be awakened to defend their treasures. Others are active forces of destruction, spreading pestilence and corruption. In the world of the Kingdoms, almost all the Dragons were hunted and it is impossible to say how many survive.

1 Block in the basic pose with lines and circles. Keep things loose and rough. More detailed elements such as the hands and tail can be fleshed out later. For now capture the basic structure.

2 Flesh out the body and add details. The wings are large and bat-like and the leathery skin is webbed between long, bony fingers. The hook on top of the wing corresponds to the wing's "thumb." Block in large defensive belly scales and wrap them around the bottom of the body. They make excellent fireproof shields for experienced dragon slayers.

3 Draw through as you add details. The spikes on the forearms and lower legs relate to the spikes down the spine and on the wing. These spikes help propel the dragon through difficult underground passages and are nasty weapons in a fight. Place the wings just above the shoulders. Dragon cousins, known as Wyverns, have massive wings instead of forearms.

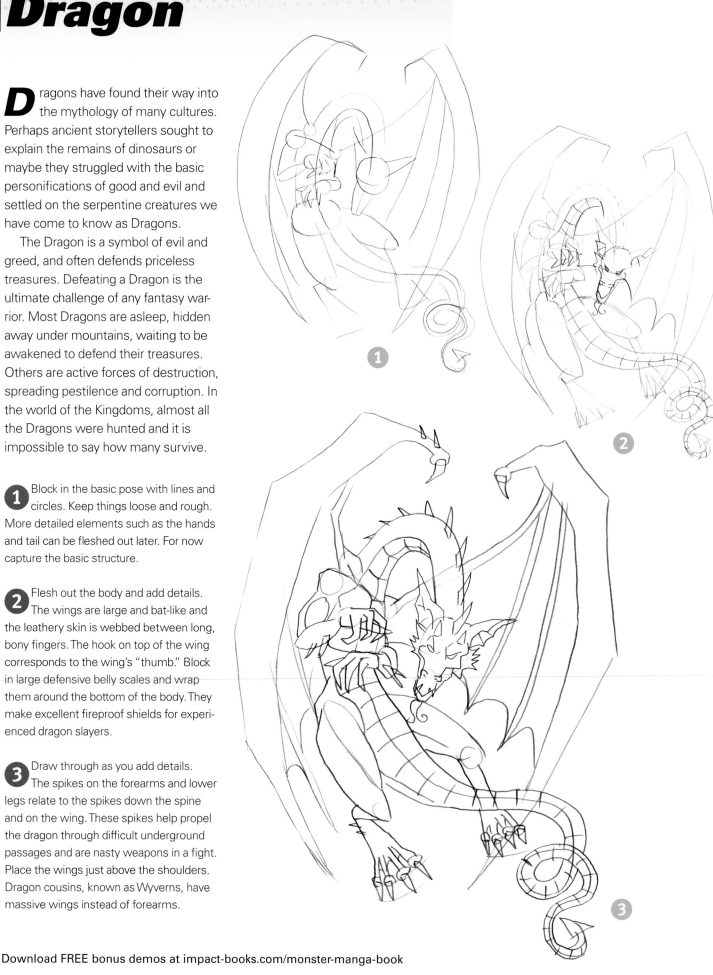

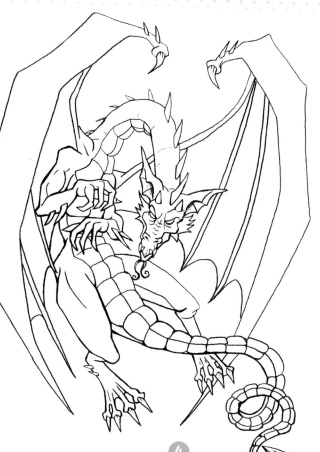

Ancient Guardians

Dragons were not always symbols of evil. Most dragon legends see the Dragon as a guardian creature, more of a watchdog than a mad dog. Asian Dragons are even more benign, floating on clouds and dispensing wisdom and good fortune. Dragons are magical creatures of immense power, intelligence and magic. They are the ultimate challenge and the guardians of the ancient treasures and knowledge.

4 Carefully ink the image, varying line thickness to help define the form and make parts of the image appear closer. When the ink is dry, erase your initial pencil lines.

5 Make your Dragon any color—gold, red, blue, green. I chose green because it seems more natural for a lizard. The wings are textured to appear veined and leathery. The body is covered in small scales. Because dragons are so huge, each scale might be the size of a saucer or plate. Shade the figure to make it look 3-D. Light rakes across a surface creating predictable areas of highlight and shadow. Pick a light source and stick with it.

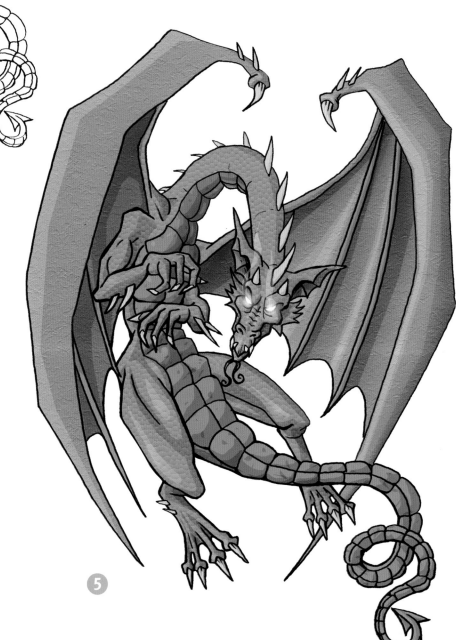

Ogre

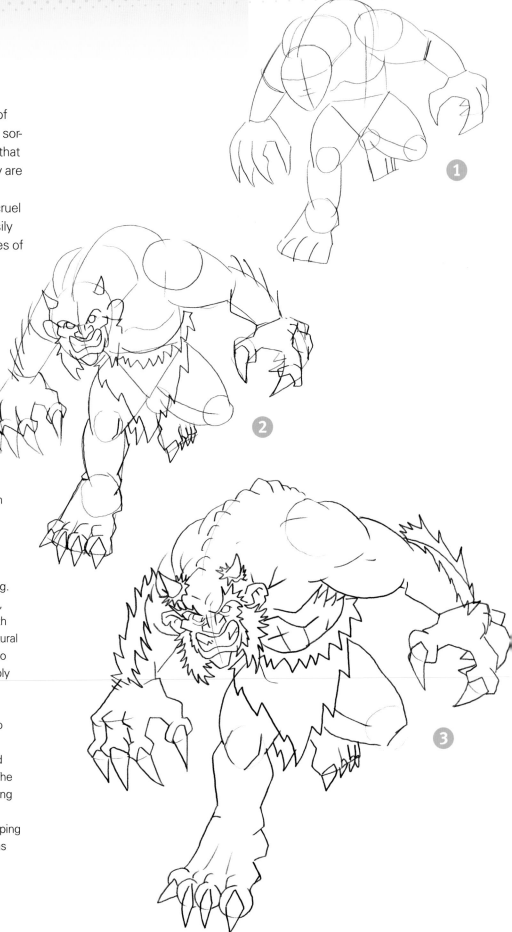

In the world of the Kingdoms, the Ogre is a demonic creature born of chaos magic from an ancient time of sorcerer kings. Ogres have huge claws that they use to tear apart their prey. They are always hungry and are motivated by promises of lots of food. Ogres are cruel and stupid creatures who can be easily tricked. They often gather huge armies of Goblyns to pillage and terrorize the countryside. The Ogre is the alternate guardian or opponent in some myths. Variations of the Ogre include the one-eyed Cyclops of Greek mythology, the Japanese Oni, the Stone Giants of native North American legend, and the biblical Goliath.

1 Start by blocking in the basic structure of the figure. Emphasize the powerful claws so you remember to develop them later. Think of the 3-D forms of cylinders, spheres and prisms as you are planning your image.

2 Add mass and detail to your drawing. The horns and claws provide a feral, demonic appearance. The simple loincloth reflects the Ogre's technological and cultural level. Draw lightly in these early stages so you can lift the pencil lines when you apply the ink.

3 Define the details and remember to establish the anatomy using a clear sense of space and structure established by the basic shapes you drew in step 1. The forms should appear 3-D. The basic running pose is more complex because of the hunched shoulders and the head overlapping the torso. Erase underlying pencil work as you go to avoid confusion.

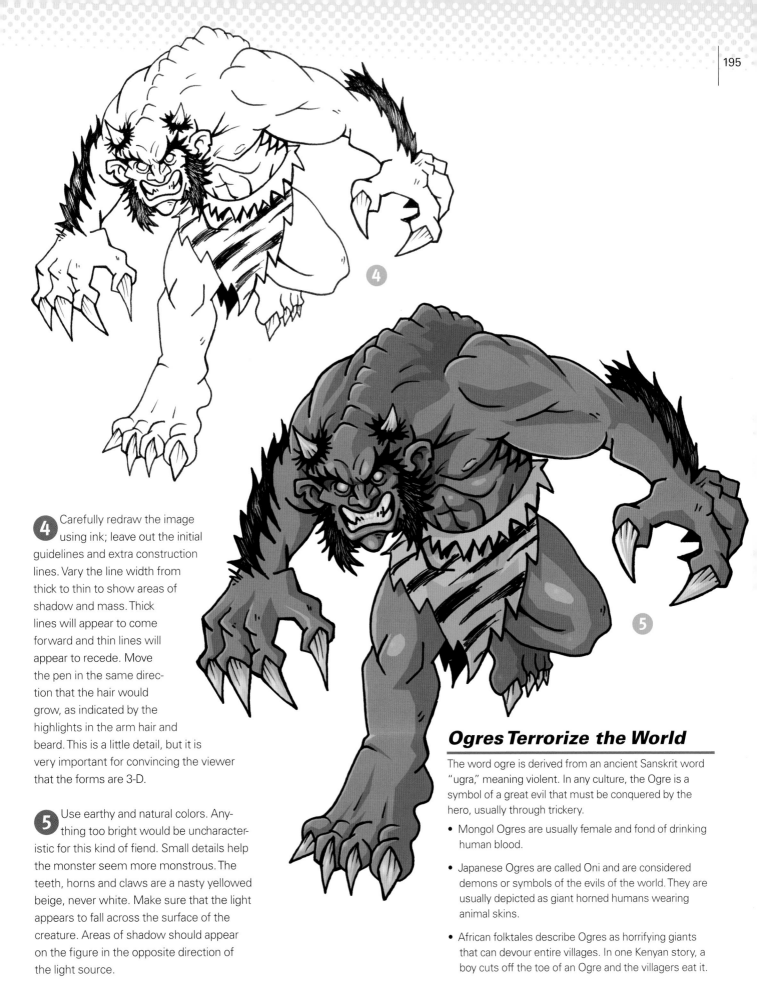

④ Carefully redraw the image using ink; leave out the initial guidelines and extra construction lines. Vary the line width from thick to thin to show areas of shadow and mass. Thick lines will appear to come forward and thin lines will appear to recede. Move the pen in the same direction that the hair would grow, as indicated by the highlights in the arm hair and beard. This is a little detail, but it is very important for convincing the viewer that the forms are 3-D.

⑤ Use earthy and natural colors. Anything too bright would be uncharacteristic for this kind of fiend. Small details help the monster seem more monstrous. The teeth, horns and claws are a nasty yellowed beige, never white. Make sure that the light appears to fall across the surface of the creature. Areas of shadow should appear on the figure in the opposite direction of the light source.

Ogres Terrorize the World

The word ogre is derived from an ancient Sanskrit word "ugra," meaning violent. In any culture, the Ogre is a symbol of a great evil that must be conquered by the hero, usually through trickery.

- Mongol Ogres are usually female and fond of drinking human blood.

- Japanese Ogres are called Oni and are considered demons or symbols of the evils of the world. They are usually depicted as giant horned humans wearing animal skins.

- African folktales describe Ogres as horrifying giants that can devour entire villages. In one Kenyan story, a boy cuts off the toe of an Ogre and the villagers eat it.

Barbarian

Fantasy stories are full of barbarians stomping off to chop apart some unlucky monsters. Barbarians are stereotypically hulking men with huge muscles and loincloths, so having a female Barbarian helps shatter some of the boring expectations of the archetype. We have given her a large saber-tooth tiger as a pet and a huge sword to drag from adventure to adventure.

1 Quickly block in the basics of the figure, including the wild ponytails and huge sword. The tiger is really another character in the lesson; he's just lying down at the moment. What mischief could these two get into?

2 Although not historically accurate, Barbarian clothing is usually in pretty rough shape, often torn, hanging, or poorly mended. The hairy leggings (I hope they are leggings!) show that she is often tromping through deep snow battling monsters. Little details such as the snake armband and the skull-shaped hair adornment give her attitude.

3 In addition to the jewelry and hairstyles, add blue paint or tattoos for a more tribal look. The cool colors of her hair and pale skin make her seem at home in an icy wasteland. Shade and highlight the figure to ensure that she appears 3-D.

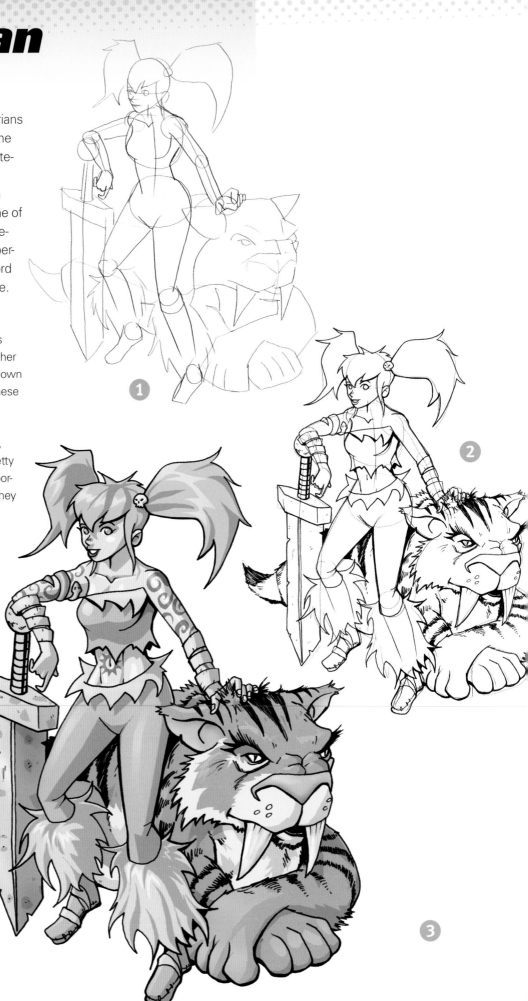

Sword Master

*F*ighting with two swords is very tricky. Fighting with two huge broadswords is impossible! Fantasy has fun with reality and lets humans do superhuman things from time to time.

1 Sketch the figure leaning far forward because of the weight of the mammoth swords he is swinging. His legs are wide as he struggles to remain upright. Realistic or not, he's going to chop something in half with those bad boys.

2 Finalize the lines. The spiral bracers show that he may have some connection to the Elves or magic. Make the hair and sideburns look out of control and streamlined to echo the sharp lines of the weapons and the fur on the boots.

3 The tattoos connect the Swordsman with the Barbarian. Other connections, such as the hair color and the clothing style and color, help establish a relationship between the two visually, even before you know anything about them.

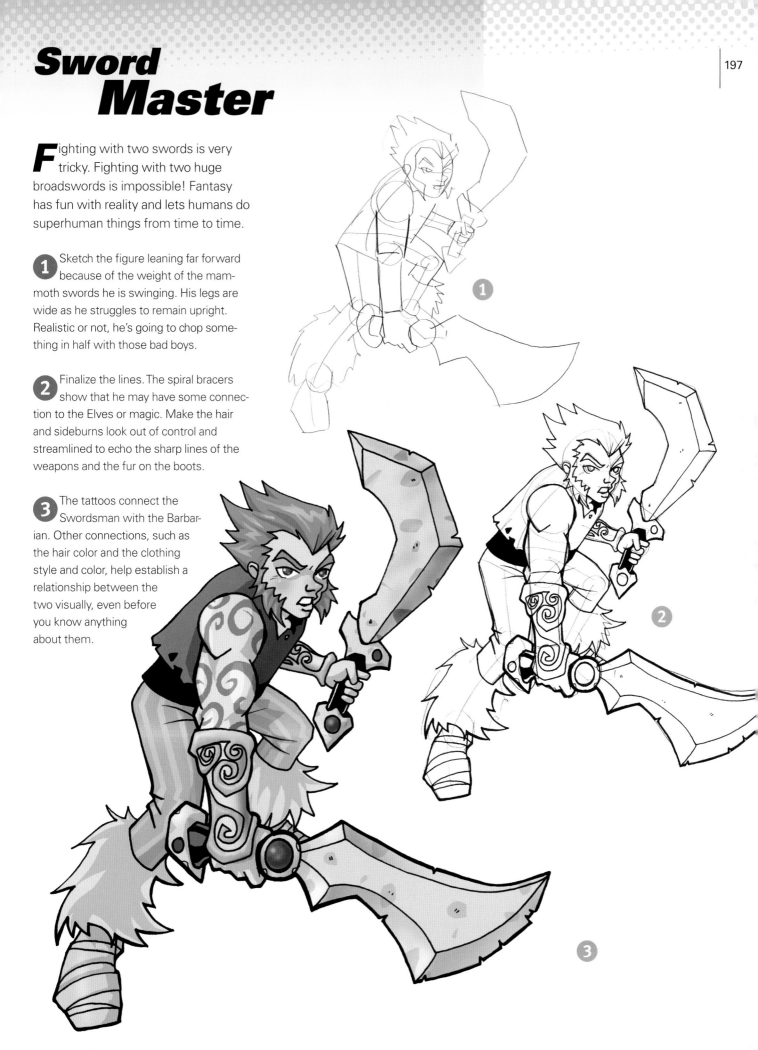

Necromancer

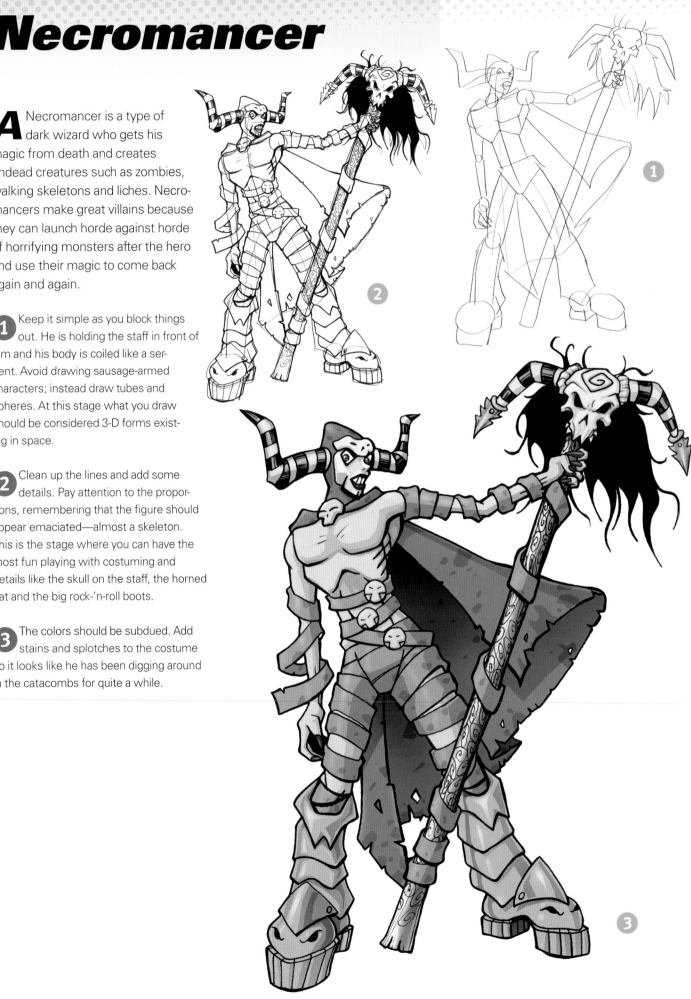

A Necromancer is a type of dark wizard who gets his magic from death and creates undead creatures such as zombies, walking skeletons and liches. Necromancers make great villains because they can launch horde against horde of horrifying monsters after the hero and use their magic to come back again and again.

1 Keep it simple as you block things out. He is holding the staff in front of him and his body is coiled like a serpent. Avoid drawing sausage-armed characters; instead draw tubes and spheres. At this stage what you draw should be considered 3-D forms existing in space.

2 Clean up the lines and add some details. Pay attention to the proportions, remembering that the figure should appear emaciated—almost a skeleton. This is the stage where you can have the most fun playing with costuming and details like the skull on the staff, the horned hat and the big rock-'n-roll boots.

3 The colors should be subdued. Add stains and splotches to the costume so it looks like he has been digging around in the catacombs for quite a while.

Wicked Witch

She sits at the top of a dark tower surrounded by her evil minions, and glares into a cauldron scrying the future or at least checking out what trouble those heroes are up to now. The Wicked Witch uses her magic powers to try to stop the heroes from achieving their goal. She rarely ventures out to battle them unless she is in disguise and then only when her dark minions fail. It's so hard to find good help these days.

1 The figure should appear regal and tall, almost hovering over the ground even though she is planted firmly on the floor. The base of the dress flows out in long strips like an octopus's tentacles. Sketch in elements of the costume and details like the writhing magic ball and the evil cat-monkey at her feet.

2 Begin to develop the details in an organized way, inking carefully over the original pencils. The wing-like cape and oversized collar make her appear sinisterly like a bat. After carefully inking everything, let the ink dry and then use the eraser to remove the pencil lines.

3 Keep the cat-monkey dark because it is a creature of shadow, a naughty little imp looking for mischief. The costume is fairly simple and not very colorful or flamboyant. The stripes on the sleeves help break up the monotony while adding some interest to an otherwise plain design.

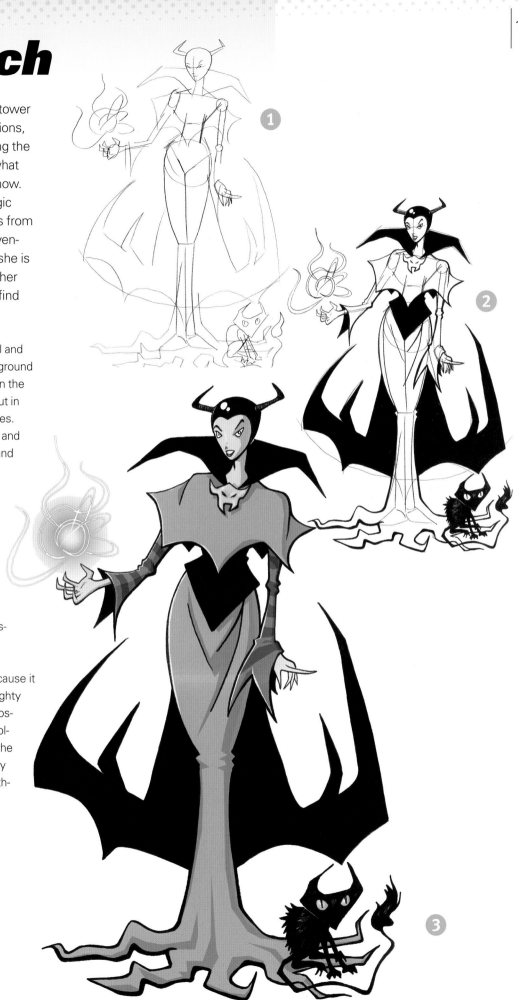

Cat Girl

Hey, it's manga and it's fantasy manga so there's got to be a Cat Girl. Cat Girls work in fantasy, modern, historical and science-fiction settings. They are just so darn cute.

1 Carefully block in the figure. This helps you plan the look of the finished drawing and compose the placement of the figure on the page. Start drawing basic forms and lines, then gradually flesh out the skeleton until the figure takes shape.

2 Clean up the linework, inking the final lines with lines that alternate from thick to thin. Thicker lines will appear closer and seem to have more weight. Thin lines will recede and appear more as highlights. Take care when you are erasing the pencil lines; ink can get smudgy if it isn't dry yet.

3 Remember, the figure is 3-D, not flat, so carefully depict the areas of light and shadow. Pick fun and bright colors for the Cat Girl. You may want to look at patterns on real cats to get ideas on how to color the character.

Kitsune

The Kitsune is a shape-shifting fox from Japanese folklore. It usually takes the form of a pretty human girl and bewitches men causing all kinds of mischief. In the land of the Kingdoms, the Kitsune is a species of enchanted fox people who traveled west with the Cathasians when the forces of Chaos tore apart the lands of the east. It can still take the form of a human but it prefers the middle state, a human/fox hybrid. Kitsune can live for thousands of years and gain a tail for every thousand years they live. The most magical Kitsune have silver fur instead of orange fur. Watch out for them!

1 Block in the forms of a figure sitting down. The most prominent features are the large head and ears and the big bushy tail. Quickly block in the shapes of the bowl and shoes.

2 The details of the clothing, the geta sandals, the fox attributes, and the bowl of rice all took some research before I could confidently draw them at this level. The line thickness ranges from thick to thin in an effort to describe the form and weight of the figure. Spots of black on the ears and tail really stand out at this stage.

3 So this is a silver Kitsune; the color is a sign of great power and great age. The clothing is bright yellow with an orange obi (belt). This Kitsune is mischievous, but he's not trying to hide; he's looking for trouble and is starting out by stealing a lovely bowl of rice. Make sure that the light source makes sense. Carefully place areas of shadow and highlight to help define the form of the figure.

Pirate Captain

One of the appeals of the fantasy genre is the ability to draw elements from various historical eras and combine them into one setting or story. Pirates and their swashbuckling fencing are a wonderful contrast to the traditional swords and sorcery dungeon lore.

1 He's bold, he's dynamic, and he should be standing like he's about to jump into action. It's a good idea to experiment with various poses in this stage to get a handle on the attitude and physical presence of the character. Roughly block in costume and anatomical details at this stage.

2 Clean up the pencil lines and carefully apply ink to define the forms and show areas of shadow. Add details like the skull on the hat and the buttons on the jacket. Inject a sense of realism and personality to the drawing.

3 The Pirate Captain doesn't have anything to hide, so his color scheme is bright and bold. Consistently develop areas of highlight and shadow with a main light source in mind. Notice how the darkest area of shadow on the clothing is in the back of the coat.

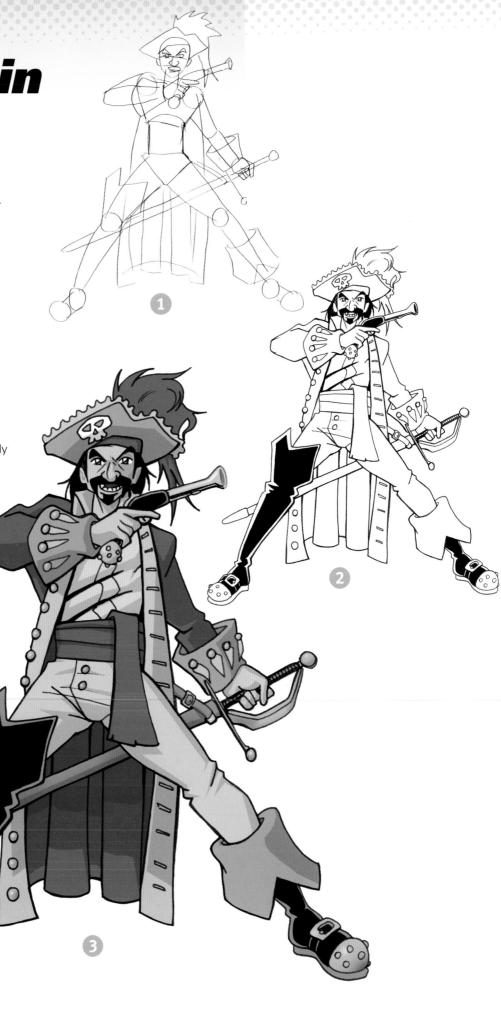

Pirate Thug

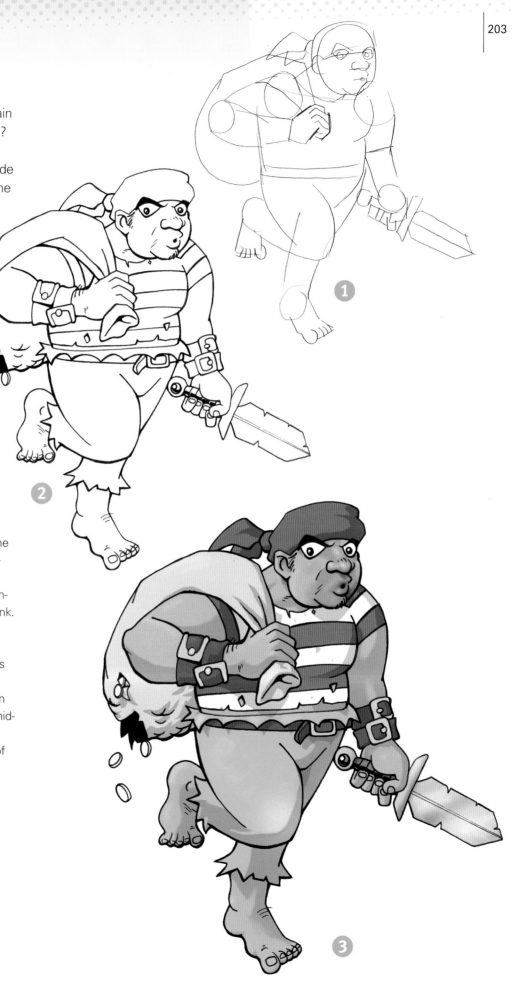

What good would a Pirate Captain be without a ship full of thugs? Pirate Thugs come in all shapes and sizes and are drawn from the multitude of cultures and species throughout the known world (even some from the unknown world). Historical pirates were surprisingly democratic and fair in making decisions and sharing treasure.

1 Keep it simple as you block out the image. Slightly exaggerate the proportions for comedic effect. Have fun with the characters you draw. Minor manga villains are often suitable targets for the hero's awesome fighting or magic skills and for overall comic relief.

2 Adding the hole in the money bag and the falling coins helps explain the look of dismay on his face. Vary the thickness of your lines to help define the 3-D form and shadow. Carefully erase the pencil lines without smudging the overlying ink.

3 Color and shade with a sense of cast shadows and highlights. Pirates traditionally wear what clothing they can steal. The British navy didn't really have an official uniform for their sailors until the mid-eighteenth century, so sailors wore traditional working clothes. The "used" look of the clothes reinforces how they worked, slept, fought and swam in the same clothes for months at a time.

Corrupt Noble

Bad guys come in all shapes and sizes. The Corrupt Noble is powerful because he rules over an army of thugs and often has control of the strongest castles in the land. Many people listen to the corrupt noble because he has somehow gained power and traces his lineage to the royal family. If he isn't stopped, he may try to take over the whole kingdom!

1 Quickly block in the figure and details. The perspective is from above, focusing on the blade he is holding. Keep things loose at this point and avoid making lots of scratchy lines that can confuse the inking later. Keep your construction drawing clean and confident.

2 Ink the image and erase the rough pencil lines. Details such as the bird crest on his chest and the pointed dagging (decorative edges) on his surcoat (long tunic worn over armor) provide elements that quickly identify and define the character.

3 Choose dark colors so he appears somewhat sinister. The crystal dagger he holds could be the item of power he uses to control his people or it could be the prize in a contest designed to trap the hero. Add details of the armor. Use highlights and shading to reinforce his form. Also use shading to define the anatomical details such as the cheekbones, rib cage, and chest muscles. Make sure he looks mean.

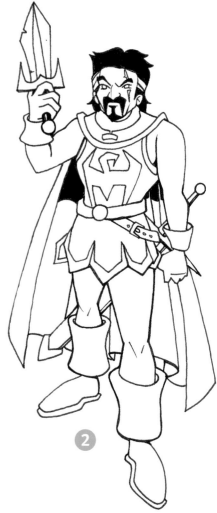

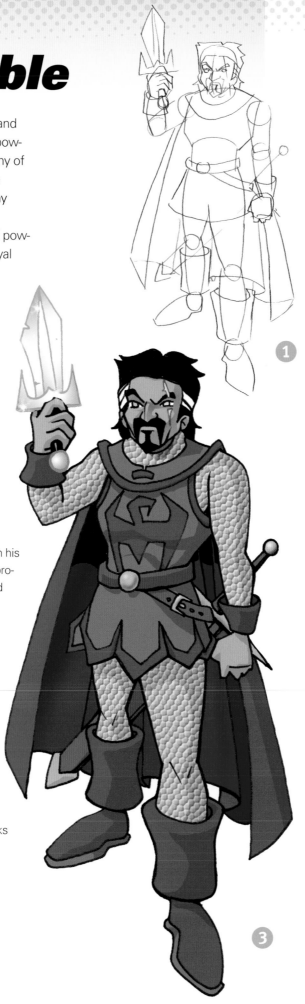

Mindless Guard

*T*he Mindless Guard is actually one of a whole army of inept opponents who find themselves pitched against the superior forces of the heroes. Sometimes there are variations of the Mindless Guard; there may be a pair of guards, one short and rounded and the other tall and skinny; another might be sympathetic to the heroes and secretly help them out. The Mindless Guards frequently have very capable armor and weaponry, but even so they typically fall with one strike.

1 The pose is a little more dynamic than usual. The Guard appears to be bracing himself for combat. Block in the stick figure, then thicken it up using tubes and other 3-D forms. Draw the preliminary costume and equipment shapes.

2 Ink the figure and clean up the pencil lines to give him some character. Little touches such as the dented shield and dinged-up sword provide a sense of realism in your drawings. The stylized bird symbol on his chest links him to the Corrupt Noble.

3 Pay attention to light sources so you can put shadows and highlights in the right place. I choose one direction of the drawing (usually determined by the highlights in the eyes) as the location of the light source and then make sure everything else in the drawing relates to that. For added realism and a wider gray scale, place a realistic wood grain in the shield and smoothly shade the metal of the sword and helmet.

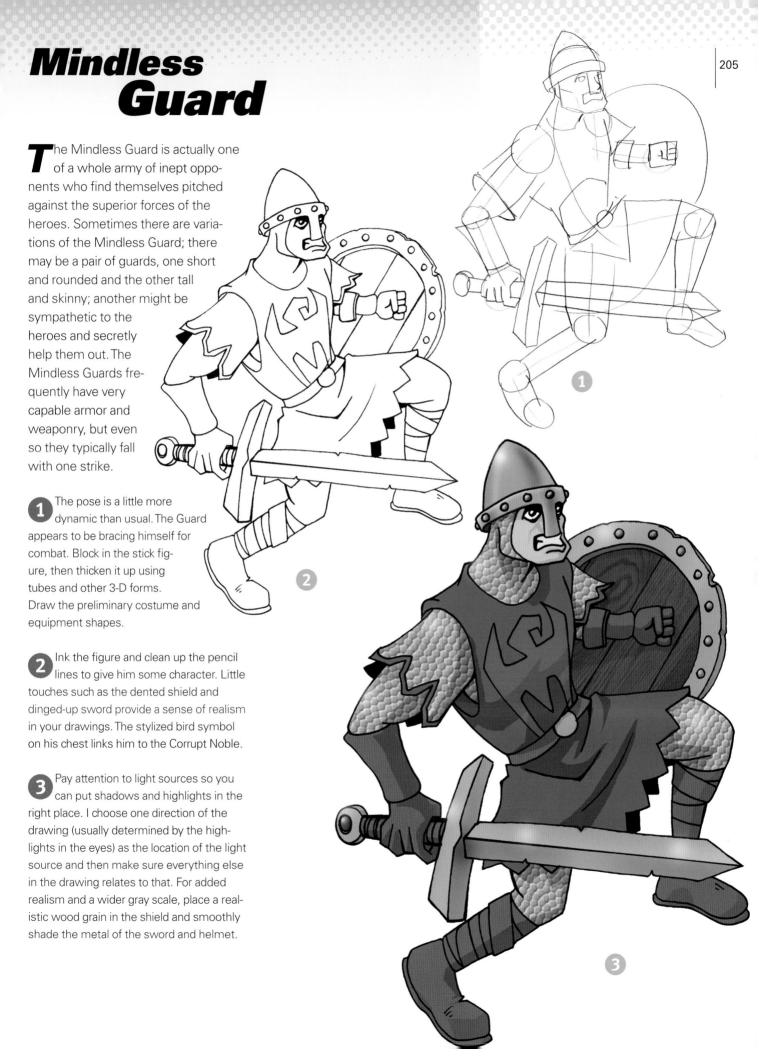

King

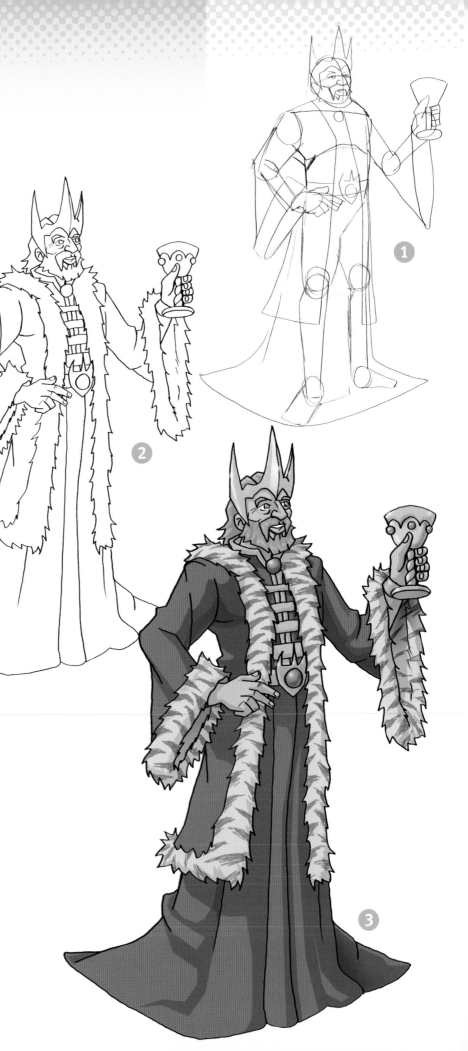

The King is a fearless leader who pronounces royal decrees and sends heroes off to battle powerful evils that threaten the kingdom. In many manga and anime, the King is a stoic leader who is strong, silent and wise.

1 Even though you won't see the legs in the final drawing, it's still a good idea to block them in at this stage so you can make sure you have consistent proportions. Roughly block in details as if they were transparent. This ensures that the structure is correct before you continue. Anatomical elements impact folds and creases in clothing that appear in the final drawing.

2 The robes are loose and flowing, bunched up, and folded and creased here and there. The underlying drawing will help determine where these areas are, but so will careful observation of folds in material. Wrap someone up in a sheet to see how folds and creases appear in relation to the underlying forms and the pull of gravity. Ink the lines, then erase the pencil lines. Add details such as the crown, cup and fur lining to give the character some life.

3 Keep the light and dark consistent, reflecting the form of the figure as well as the shadows cast by other elements such as arms and coats. Smoother shading on the metal makes it appear more reflective and realistic.

Princess

She may be small, but she's got a lot of power and attitude. The Princess is accustomed to getting what she wants. Some people might call her a spoiled brat, but they usually end up in the dungeon. This is a classic fairy-tale princess complete with pointy hat and flowing dress, but she also has a lot of attitude. If the bad guys capture, her she often complains so much that they are happy when she is rescued.

1 Draw simple forms to help create complex images later. Draw in the legs even though the gown hides them. Block in the entire figure to avoid distorting her. Also block in the cat creature using simple forms. The foot and arm that appear to be coming towards us will hide some of the figure, but are drawn transparent at this stage.

2 Clean up the rough pencil lines and ink the image as you go. This will create a simpler, more polished drawing. Shade and highlight the cat's stripes to echo the light source reflected in its eyes. Keep things as consistent as possible.

3 The pattern on the dress is subtle, but evocative of the medieval era. Make sure the pattern follows the curves of the figure or else it will appear too flat. Add highlights and shadows to make the figures appear 3-D. Give her a flustered, youthful expression by adding a rosy color to her cheeks.

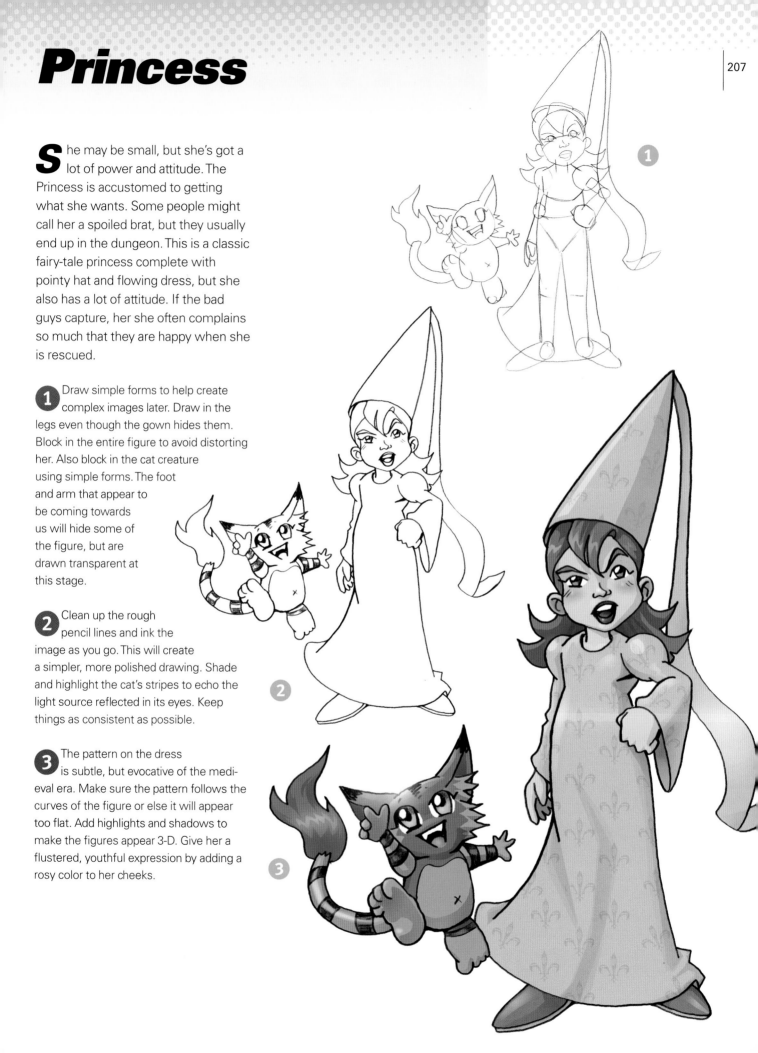

Lich King

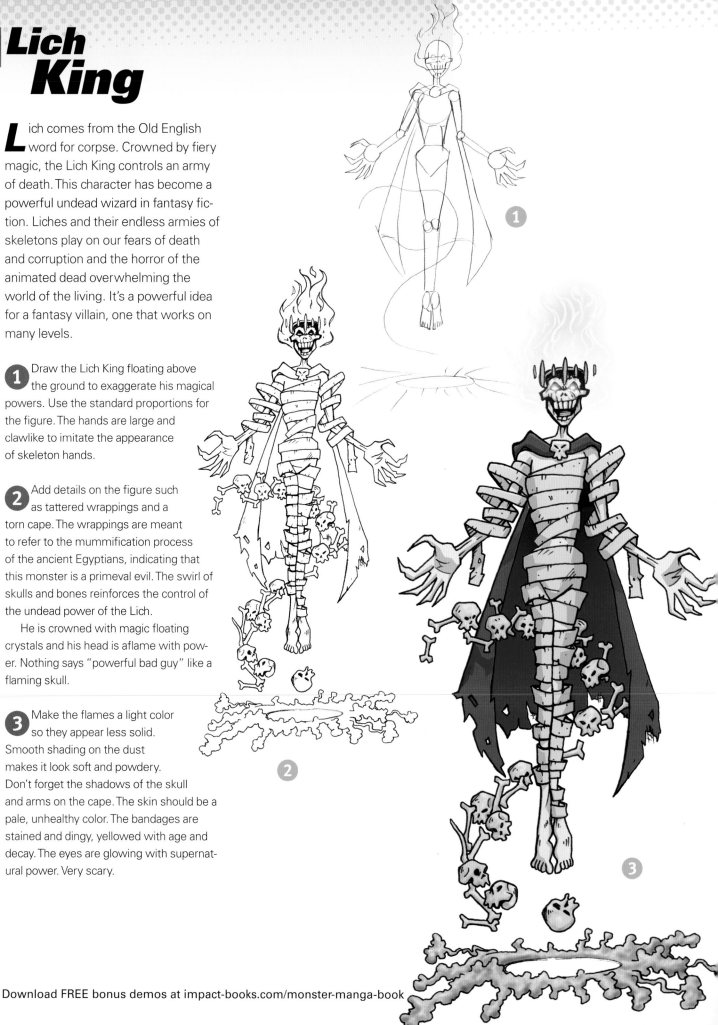

L ich comes from the Old English word for corpse. Crowned by fiery magic, the Lich King controls an army of death. This character has become a powerful undead wizard in fantasy fiction. Liches and their endless armies of skeletons play on our fears of death and corruption and the horror of the animated dead overwhelming the world of the living. It's a powerful idea for a fantasy villain, one that works on many levels.

1 Draw the Lich King floating above the ground to exaggerate his magical powers. Use the standard proportions for the figure. The hands are large and clawlike to imitate the appearance of skeleton hands.

2 Add details on the figure such as tattered wrappings and a torn cape. The wrappings are meant to refer to the mummification process of the ancient Egyptians, indicating that this monster is a primeval evil. The swirl of skulls and bones reinforces the control of the undead power of the Lich.

He is crowned with magic floating crystals and his head is aflame with power. Nothing says "powerful bad guy" like a flaming skull.

3 Make the flames a light color so they appear less solid. Smooth shading on the dust makes it look soft and powdery. Don't forget the shadows of the skull and arms on the cape. The skin should be a pale, unhealthy color. The bandages are stained and dingy, yellowed with age and decay. The eyes are glowing with supernatural power. Very scary.

Skeleton Warrior

The skeleton warrior is a classic creature of fantasy fiction and mythology. Undead warriors are horrifying opponents because they beg the question, "How do you kill something that is already dead?" Skeleton warriors are mindless creatures, shambling across the landscape in a relentless mission to destroy the living.

1 The skeleton warrior is a very complex and daunting subject to draw. You can't fake your knowledge of anatomy in a drawing. Block in the pose and begin indicating major anatomical details such as the rib cage and pelvis.

2 Don't be afraid to use anatomical reference books or go out and buy a plastic toy skeleton to look at. Line thickness really helps describe the weight and structure of the bones. After carefully inking the drawing, erase the pencil lines and prepare for coloring.

3 Softly shaded bones appear more 3-D. The bones should be yellowed and weathered. The shield and sword are dented, dinged and falling apart. Is that blood or rust on that sword?

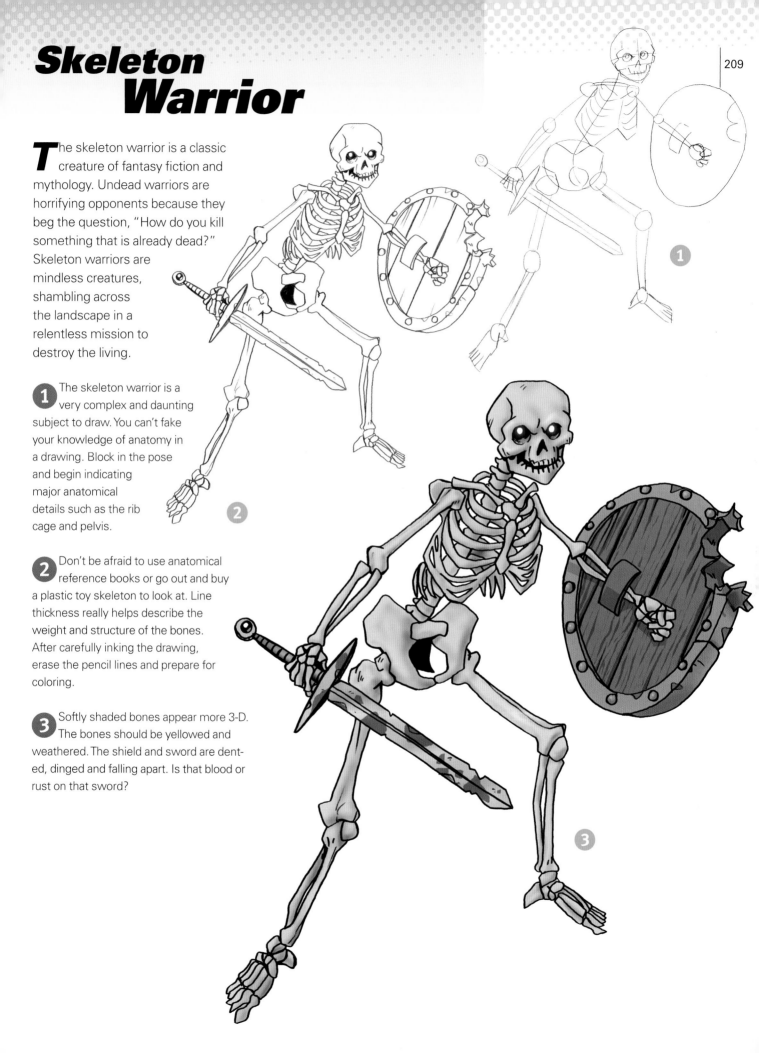

Dark Elf

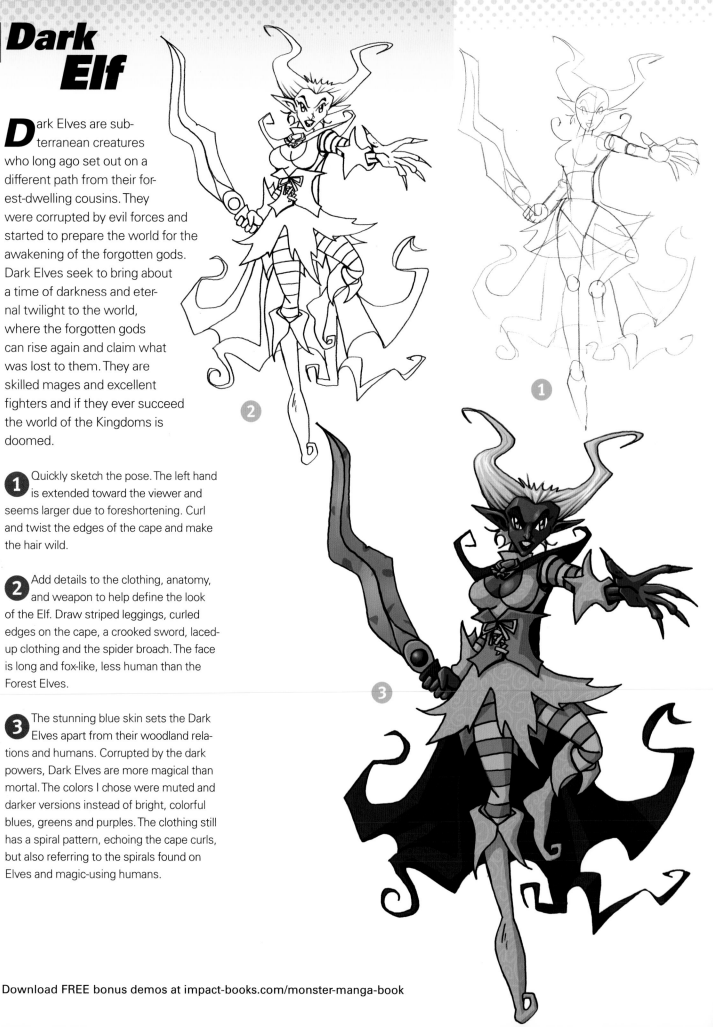

Dark Elves are sub-terranean creatures who long ago set out on a different path from their for-est-dwelling cousins. They were corrupted by evil forces and started to prepare the world for the awakening of the forgotten gods. Dark Elves seek to bring about a time of darkness and eter-nal twilight to the world, where the forgotten gods can rise again and claim what was lost to them. They are skilled mages and excellent fighters and if they ever succeed the world of the Kingdoms is doomed.

1 Quickly sketch the pose. The left hand is extended toward the viewer and seems larger due to foreshortening. Curl and twist the edges of the cape and make the hair wild.

2 Add details to the clothing, anatomy, and weapon to help define the look of the Elf. Draw striped leggings, curled edges on the cape, a crooked sword, laced-up clothing and the spider broach. The face is long and fox-like, less human than the Forest Elves.

3 The stunning blue skin sets the Dark Elves apart from their woodland rela-tions and humans. Corrupted by the dark powers, Dark Elves are more magical than mortal. The colors I chose were muted and darker versions instead of bright, colorful blues, greens and purples. The clothing still has a spiral pattern, echoing the cape curls, but also referring to the spirals found on Elves and magic-using humans.

Satyr

Satyrs are nomadic creatures who plunder towns and caravans. They are small, but powerful warriors and can outrun most horses. In mythology, Satyrs were wise teachers, keepers of ancient knowledge. This Satyr is a small lion-humanoid creature from the plains of Estavia. He has spirals tattooed on his head and holds a bone carved with mystic spirals. He is likely a chief or a shaman of a Satyr tribe.

1 Even though the figure is not human, you should think of the forms as real structures in a 3-D space. Start drawing the figure with basic forms to simplify complex images. Keep your pencil lines light; you have to erase them later.

2 Add an odd assortment of physical features such as toe-walking (digitigrade) legs, a lion-like tail, and an odd-toed foot (Perissodactyla). The earrings are a playful addition making this creature less wild and more mainstream than most monsters.

3 The Satyr is small, maybe 3 to 4 feet (91cm to 122cm) tall, but it has a powerful form and strong, stable legs. This Satyr appears 3-D thanks to consistent light source and thoughtfully placed areas of highlight and shadow.

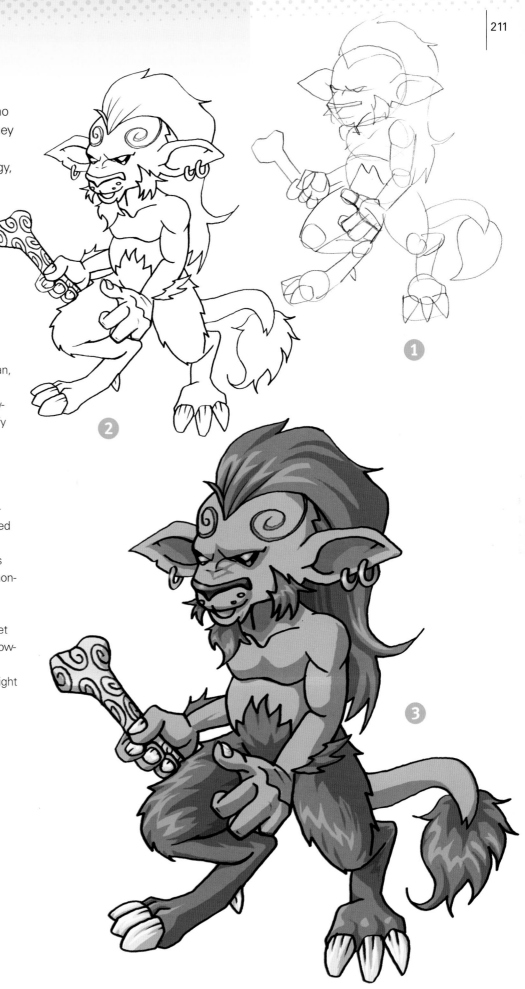

Fey

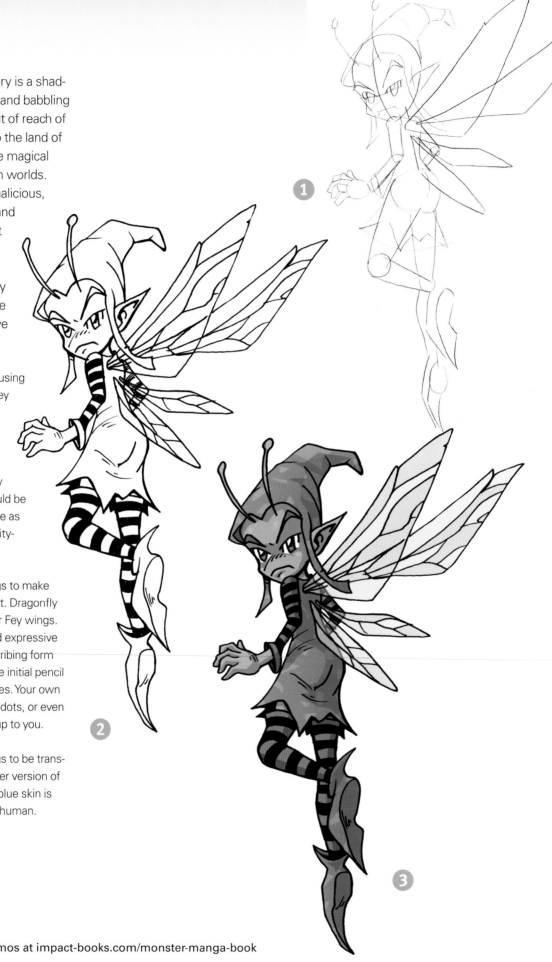

*T*he other world of Faery is a shadowy realm of forests and babbling brooks. It is tucked just out of reach of our world and connects to the land of the dead in places. Fey are magical creatures that flit between worlds. More mischievous than malicious, Fey are small and playful and love sweets. But don't get them angry or they will use their reality warping magic, or glamour, to really mess you up. This little one looks a bit upset that we've seen him.

1 Sketch in the structure using child-like proportions. Fey have two sets of wings and insect-like antenna. The wings can be transparent like an insect or colorful like a butterfly. It isn't known why Fey appear like insects; it could be part of their shy nature to hide as bugs or an effect of their reality-warping magic.

2 Look at real insect wings to make sure the details are right. Dragonfly wings make good models for Fey wings. Keep the ink lines simple and expressive with thick and thin lines describing form and mass. Carefully erase the initial pencil lines and fill in the black stripes. Your own Fey could have spirals, polka dots, or even patterns on its clothes—it's up to you.

3 Carefully color the wings to be transparent and show a lighter version of the color through them. The blue skin is more alien and bug-like than human.

Spirit

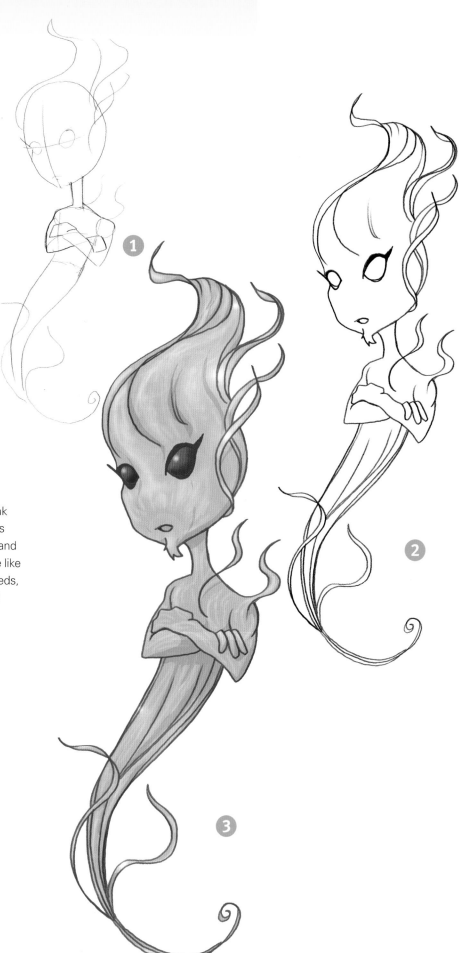

Spirits aren't necessarily ghosts; they can also represent the forces of nature. Some are good and some are bad. Japanese nature spirits are called Kami. Spirits can be helpful, mischievous, or hostile; it just depends on how much respect is shown to them.

1 Quickly block in the Spirit. It is drawn with a humanoid torso so the expressions are familiar to the reader. Lines of wispy air rise off the figure to show its incorporeal nature.

2 The image is simple and dynamic. Clean up any confusing lines and ink the drawing. Areas that are thicker or darker will be focus points. Draw the eyes with a heavier line so they become the center of attention of the figure.

3 The heavy lines have been drawn blue. This can be done with blue ink or digitally as in this case. The blue helps knock down the contrast on the image and makes it appear lighter and softer, more like an air spirit. If this figure were done in reds, oranges and yellows it would be a good fire elemental.

Dwarf

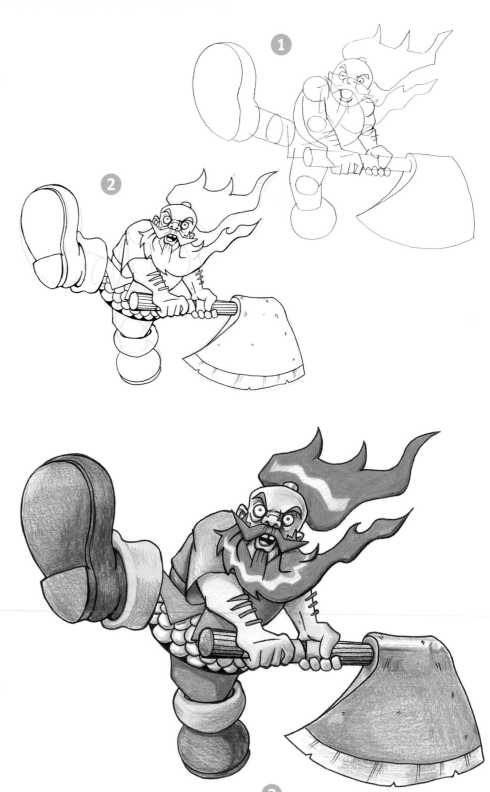

Stories of Dwarves developed out of Norse mythology. Dwarves were the first things to stir on the Earth and were created from the body of the giant Ymir. Dwarves lived under the Earth and their treasures and weapons were legendary. They were considered excellent craftsmen and were so adept at metal work that they became smiths to the gods.

Other stories claimed that the Dwarves lived underground because they turned to stone in sunlight. In high fantasy, Dwarves are loyal companions and fierce warriors adventuring for gold and glory.

1 Draw a dynamic pose with extreme foreshortening of his right leg as the Dwarf prepares to swing his mighty axe. Make the hair and beard appear to be flying. Make the mouth open and the eyes wild. So much can be stated in this simple sketch. Be as expressive as possible in your initial drawings.

2 Add information such as the beard, scale-mail skirt and big boots. This will hide your original anatomical work, but by paying attention to the underlying structure, you'll have a very solid-looking drawing. Little details such as the gap in the teeth, the hair tied in a topknot and the hairy arms add character and personality to the image.

3 Clean up the basic structure and make the clothing and axe appear more 3-D. Erase extra pencil lines and carefully shade and color the drawing. Keep in mind the range of light and dark as you indicate the areas of highlights and shadows.

Goblyn Thief

Goblyns don't have a very sophisticated sense of how to build things. They like to take things that are already made—it's a lot easier that way. Goblyn thieves are small, silent and intelligent opponents who can get past any traps or guards with an almost diabolical ease. As you can tell from this drawing, they have a lot of fun while they're doing it.

1 Block in the basic structure using child-like proportions. You can make the head a little bigger and the feet and hands a bit lankier as well. The ears point back and less out to the side than on an Elf.

2 Add details such as the wild expression and the ornate heavy sword to give the drawing personality. Carefully shade the stripes on the leg with ink lines to help describe the rounded form. Add highlights to the leg stripes and eyes to establish the light source for the drawing. Use thick and thin lines to describe the form and carefully erase the underlying pencil.

3 Shade the figure with care, always being aware of the light source in the upper left-hand side. Use highlights and shadows to develop the forms, and place cast shadows such as the area under the head and under the far leg help to help reinforce the structure of the figure.

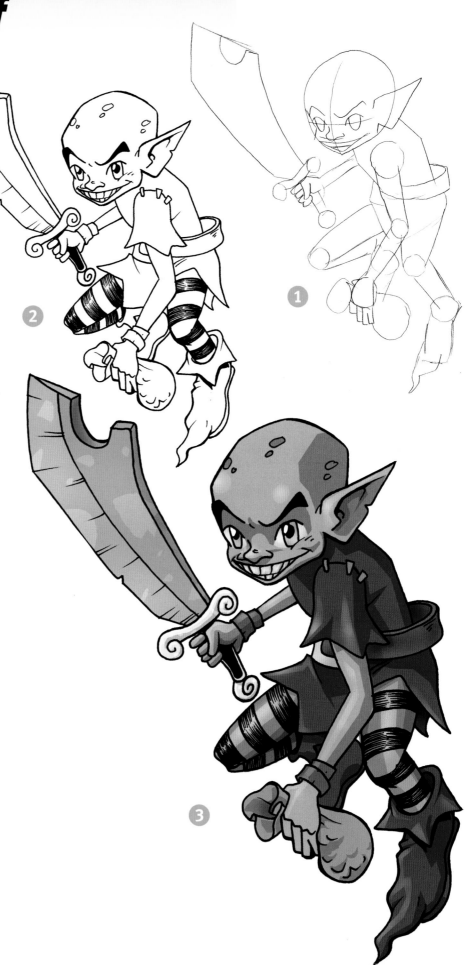

Elfin Sorceress

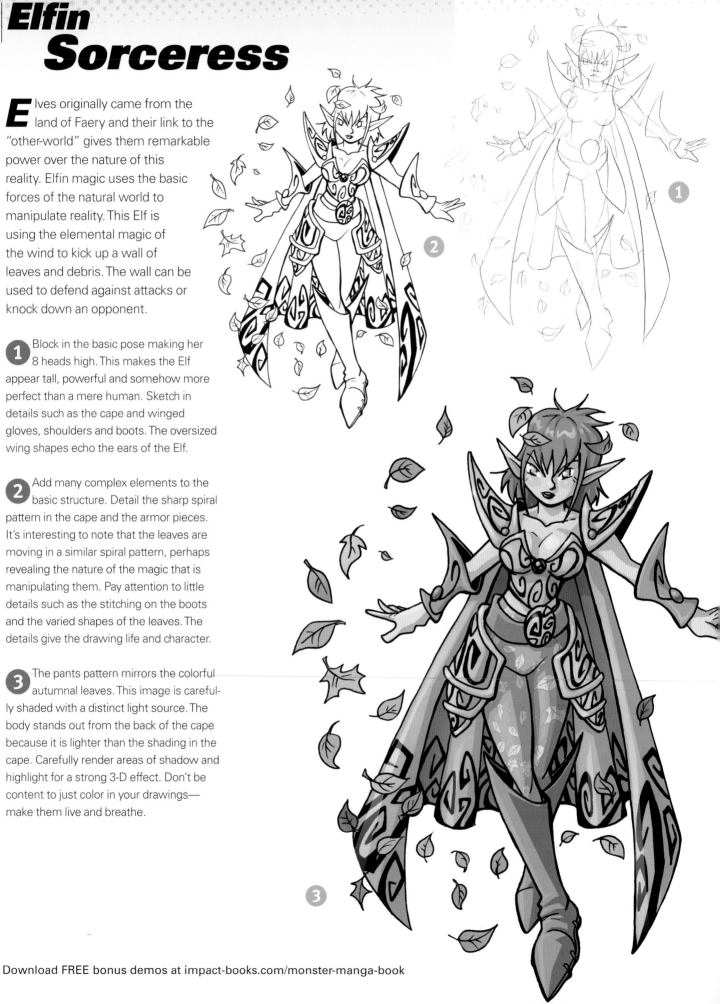

Elves originally came from the land of Faery and their link to the "other-world" gives them remarkable power over the nature of this reality. Elfin magic uses the basic forces of the natural world to manipulate reality. This Elf is using the elemental magic of the wind to kick up a wall of leaves and debris. The wall can be used to defend against attacks or knock down an opponent.

1 Block in the basic pose making her 8 heads high. This makes the Elf appear tall, powerful and somehow more perfect than a mere human. Sketch in details such as the cape and winged gloves, shoulders and boots. The oversized wing shapes echo the ears of the Elf.

2 Add many complex elements to the basic structure. Detail the sharp spiral pattern in the cape and the armor pieces. It's interesting to note that the leaves are moving in a similar spiral pattern, perhaps revealing the nature of the magic that is manipulating them. Pay attention to little details such as the stitching on the boots and the varied shapes of the leaves. The details give the drawing life and character.

3 The pants pattern mirrors the colorfully autumnal leaves. This image is carefully shaded with a distinct light source. The body stands out from the back of the cape because it is lighter than the shading in the cape. Carefully render areas of shadow and highlight for a strong 3-D effect. Don't be content to just color in your drawings—make them live and breathe.

Elfin Warrior

Elfin Warriors are staunch defenders of their realm. They are mystical fighters with supernatural abilities to disappear into the forest and surprise their enemies by suddenly reappearing and attacking.

1 Quickly block in the structure using geometric forms and keeping a strong sense of movement and action in the pose. His armor and weapon are wildly oversized for his proportions, but they make him appear larger than life and even more powerful.

2 Flesh out the figure. Add the spiral carvings on the armor to connect him to the Elfin sorceress. Make sure the image is rounded and in proportion before you add the details. It's easy to lose sight of the basic drawing when you are adding details. Erase the pencil lines and make sure the ink helps describe the form and isn't scribbled. The lines on the sword blade or the hair on the helmet should reinforce the shape and structure of the surface.

3 The hair on the helmet is based upon the ancient Greek hoplites and the Roman centurion. Raise and detail the spirals on the armor with highlights and shadows to make them appear rounded. Shade the spiral carving on the sword to make it appear recessed in the metal. Use this last stage as an opportunity to really make the forms appear rounded and 3-D.

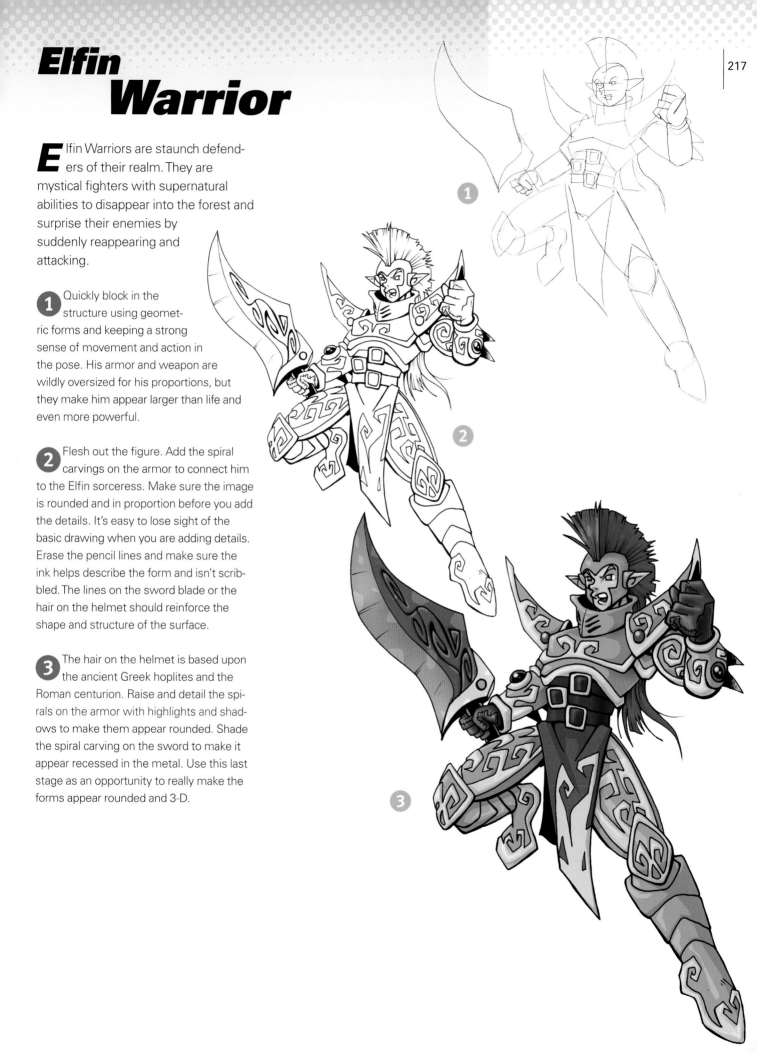

5

MANGA MARTIAL ARTS

Martial arts in manga and comics is dynamic, violent and flashy; more of a mystic plot device than an accurate depiction of reality. Usually, what looks cool is emphasized more than what is stylistically accurate or physically possible. This chapter is designed to bridge the gap between style and substance, fantasy and reality, and to help you understand the basic differences between some of the most popular martial arts so that you can draw hand-to-hand combat convincingly.

Disclaimer

Although the martial arts depicted in this chapter are real and every effort has been made to depict them in a realistic or authentic fashion, this chapter is not intended to be an instruction manual. It is a reference tool for manga artists, not a how-to book for martial artists. Attempting to duplicate the moves shown without proper instruction or supervision from a qualified martial arts instructor is foolish and potentially dangerous.

Aikido: *Developing* Mind, Body *and* Spirit

Aikido attempts to develop the spirit as well as the body through important skills such as falling, concentration, alertness, breathing, strength and flexibility.

Aikido also has very strict codes of etiquette regarding instructor respect and purity of the dojo. It's also important to respect Morihei Ueshiba (the founder of aikido) and display courtesy to fellow martial artists by bowing.

The Way of Harmony

Aikido attempts to create a harmonious response to aggression by matching and restraining the attacker. Almost all techniques rely on the opponent making the first move. The aikido practitioner may actually present a wrist or arm so that the attacker acts first. The idea is to use the opponent's energy, aggression and momentum to immobilize them rather than cause harm.

Hanmi

This is the basic back triangle stance of aikido. The front foot should point forward and slightly outwards. The back foot should point out away from the body at a 60-degree angle. Knees should be slightly bent and the weight should be distributed 60 percent on the front leg and 40 percent on the back leg. The heel of the front foot should line up with the heel of the back foot as if you were standing on an imaginary line. Hands should be raised in defense from attacks and to present something for the opponent to grab.

This stance helps ground the practitioner, maintaining the figure's center of balance. The head is alert and centered above the area between the feet.

Foot Placement

Place the feet as if the heels are standing on an imaginary line. This allows the practitioner to pivot and move in a natural way. The traditional hakama uniform does a good job of hiding the feet from the attacker, making it difficult to judge the defender's intentions.

Movement

Movement in aikido should use circular footwork and pivots to avoid a temporary loss of balance. One of the first things to consider is moving away from the attack by matching the attack momentum and stepping aside. The next thing is to grab the attacker using hands, wrists and arms in order to stretch nerves and tendons and immobilize the opponent.

Control

Grappling and wrist locks are designed to control the attacker. Using pain, joint manipulation and inertia control, an attacker is immobilized and rendered harmless. Here, a circular movement is used to gain control of the attacker and then a triangular movement is used to pin them to the ground.

Using Momentum

What aikido lacks in offense it makes up for in defense. The idea is to match the movement of the opponent, remain grounded, wait until the attacker presents an opportunity to grab a limb, then gain control and put them on the ground in an uncomfortable hold.

Throwing

The most dynamic of all aikido movements are the uke waza throwing techniques.

Keys to the Wristlock

Key areas (highlighted here with red circles) are important in maintaining control of the hold. The elbow can be secured with the upper arm, the wrist is held in place by a strong grasp and the fingers are bent backwards. Simply pivoting the feet and rotating the body can send the opponent down.

Entering Throw

For this technique the defender moves behind the attacker, turns to face the attacker's direction, pulls the attacker to the shoulder and strikes through, knocking the attacker to the ground. The side step avoids the initial attack and the counter attack uses a circular swoop with the right arm aimed just under the chin of the attacker in combination with a step through with the right foot. The attacker should become unbalanced and fall to the floor.

Women's Self Defense

This technique is often referred to as "women's self defense," not necessarily because it was meant primarily for women, but because the circular technique and use of the aggressor's force is effective no matter how small the defender.

1 The attacker should be fully committed to the strike. If the defender steps aside too soon, the attacker might be able to change course.

2 Make the forms as three-dimensional as possible. Consider, for example, that when you draw the sleeve the arm is a tube, not a flat shape. Keep your initial construction lines light so they may be erased easily. Clothing details should be settled upon and be consistent with each illustration of the character.

3 When coloring and shading the final image try to remember that the forms are three-dimensional. If areas of black are shaded in they will disappear into each other. To define the individual forms, you need to indicate highlighted areas outlined on the clothing that show anatomical and clothing detail. To reinforce the darkness of the clothing, the highlights here are shaded blue.

Aikido
First Form Throw

This is the first principle of arm pinning that is the foundation for other aikido techniques. An overhead strike is blocked by both hands that intercept the attacking arm in a smooth, flowing motion. The arm is then twisted and turned, flipping the attacker to the floor.

1 The pose depicts the point of the defense where the attacker is flipped to the ground. The attacker should appear to have rotated fully to match the twist of their arm and shoulder. The hands of the aikido defender are level, the stance is solid and grounded.

2 Erase the construction guidelines as you block in details. Remember to differentiate similar colored objects with highlights that reveal individual form, details and anatomy.

3 Color and shade with a sense of cast shadows and highlights. If you imagine where the light source is in the drawing (in relation to the figures), it's easier to remain consistent. When depicting the grappling martial arts, it's a good idea to make each combatant's skin color slightly different so that you can tell which arm is which.

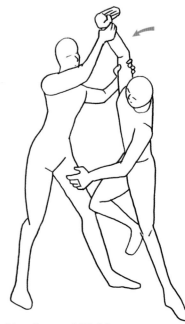

Circular and Fluid

The initial instinct would be to draw the defender striking the attacker's arm as the strike is intercepted, but the movement should appear circular and flowing, not stiff and static.

Aikido
Wrist-Out Turn

Kotegaeshi literally means "wrist-out turn." This is a basic technique where the defender grabs the back of the attacker's hand, applying pressure inward to stop the power of the attacker's arm and wrist, and outward to knock the attacker off balance and cause him to fall down.

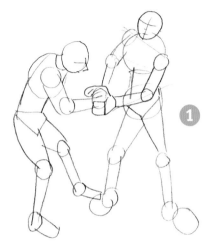

Close-Up of Hand Placement
Notice how the attacker's wrist is twisted back toward them and the fingers are pushed down to the wrist. This stretches the tendons and nerves and immobilizes the opponent through pain and physical restraint.

1 This pose shows the stage in Kotegaeshi where the attacker's wrist and arm have been locked and brought down in between the attacker and defender. Keep the shapes loose and explorative. Make sure that the feet are placed so it appears that the figures are standing in a physical space and that they are well balanced and stable.

2 Carefully choose the details that make sense as you clean up your drawing. A look of calm on the defender's face is preferable. The attacker will probably appear to be in a lot of pain from the wrist hold. Erase extra pencil lines.

3 As you color the final image make sure to keep the characters distinct by making sure their skin tones are slightly different, that they have contrasting color schemes (in this case warm vs. cool colors) and have details (such as dark hair vs. light) that make them quickly identifiable.

Continue the Circle
Flipping the attacker onto his back requires stepping through with the left leg. Make sure the hand is still firmly grasping the wrist. Continuing the circle by moving the left leg and pushing the hands downward in the same direction of the leg will cause the attacker to roll on his back.

Aikido
Back Technique

Aikido is ultimately a self-defense martial art. Attacks from behind are as effectively neutralized as those from the front. The defender uses the inertia of movement to unbalance and ultimately turn the tide in this situation. This defense reinforces the movement of circular footwork, matching momentum and grappling.

Knocked Off Balance

From another angle you can see how the attacker has been knocked off balance and the defender has set up a number of counterattacks ranging from a wristlock to a knockdown.

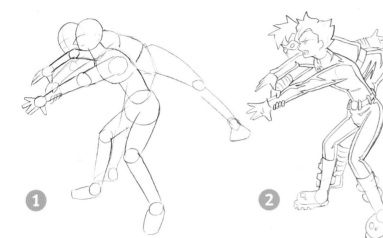

1 Depict the figures as individual simplified forms. Differentiate each combatant from the other. Notice the wide stance of the defender. By moving her left leg back and under the attacker she has dropped very low. Moving forward and flinging the arms out breaks the grab and also knocks the attacker off balance.

2 Clean up the lines and define the individual forms to separate each figure. Erase the guidelines.

3 Color and shade to show the shadows and highlights of each figure. It's important because of the close-combat grappling and that they are both wearing black. Different color highlights help keep your characters sorted out.

Boxing: *Float Like a Butterfly,*
Sting Like a Bee

With those immortal words, Muhammad Ali, arguably the twentieth century's greatest professional boxer, described his signature style. A mixture of measured grace and devastating power goes a long way in the boxing ring. Boxers don't just stand in one spot and trade punches. A boxing match is more like a dance where two combatants test, measure and eventually pummel each other.

Boxing Manga

Boxing manga is a specific, but exciting subset of manga devoted to heroic depictions of sports and athletes. *Tomorrow's Joe* is a good example of a popular manga and anime devoted to boxing. The death of Joe's greatest rival in 1970 drew over seven hundred people out to a funeral for the fictional character. The show is still a huge cult favorite in Japanese culture, often near the top of lists of favorite TV anime shows.

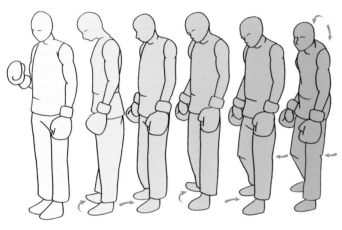

Assuming the Stance

Set the legs as wide as the shoulders to provide stability. Place the right foot back a half step behind the left foot (if the boxer is right-handed) with both feet pointed slightly inward. Raise the right (or back) heel to allow the fighter to pivot. Bend the knees slightly, lowering the body.

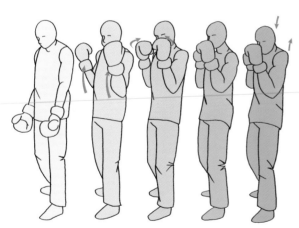

Raising the Arms

Raise the arms up to the chin and twist the wrist so the knuckles are vertical in relation to the floor. Place the left hand slightly forward about 6 inches (15cm) in front of the face at eye level. Place the right (rear) hand beside the chin and the elbow of the right arm along the body to protect the ribs. Finally, lower the head and point the chin down to reduce the chances of taking one in the jaw.

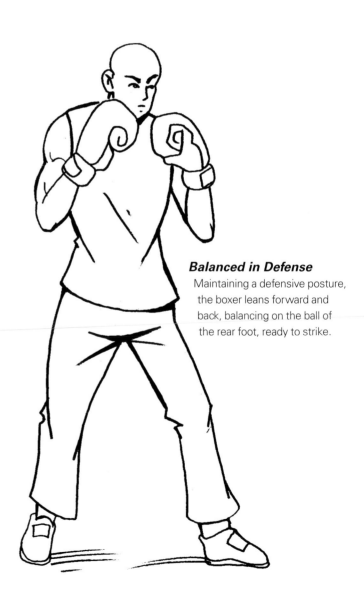

Balanced in Defense

Maintaining a defensive posture, the boxer leans forward and back, balancing on the ball of the rear foot, ready to strike.

Download FREE bonus demos at impact-books.com/monster-manga-book

Movement

Constant footwork maintains a level of intensity and energy in the boxer and keeps the opponent guessing. Good footwork will propel the punches and add power to a strike.

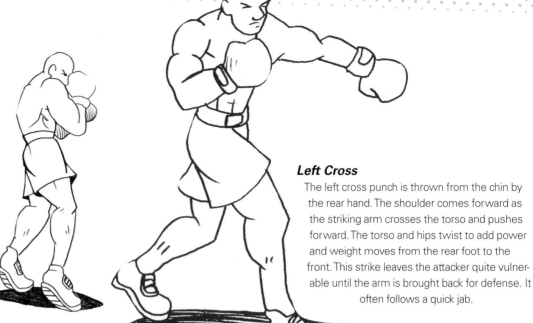

Left Cross

The left cross punch is thrown from the chin by the rear hand. The shoulder comes forward as the striking arm crosses the torso and pushes forward. The torso and hips twist to add power and weight moves from the rear foot to the front. This strike leaves the attacker quite vulnerable until the arm is brought back for defense. It often follows a quick jab.

Footwork

When the time is right to throw a punch the boxer steps forward with the lead foot. Putting a half step into the strike adds the momentum and weight of the boxer behind the punch. Keeping an eye on the shoulders of an opponent allows a boxer to set up a reasonable defense, whether it be a block or an evasion.

Guarded Body

Don't forget to make sure the glove guarding the face doesn't appear too far away from the chin. If it's too far, it will still strike the chin when hit. Draw the elbows close to the body so they can defend the rib cage.

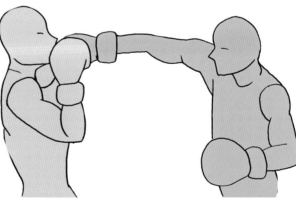

Proper Guard Position

In proper guard position the face and rib cage are protected. Here, the glove is tight with the chin and the force of the impact is soaked by the body. The head has been snapped back by the impact. Make sure that the head appears to be tucked down when the target is about to be hit.

| # Boxing
The Jab

The most basic of all boxing punches and the least powerful, the jab is mainly used to feel out the opponent, to set up a cross or a hook. The leading arm should be level to the guard position and the fist should rotate so that the hand is facing down and the knuckles are horizontal. The rear hand stays back to defend the chin and the hand should snap back to defend against a counterstrike.

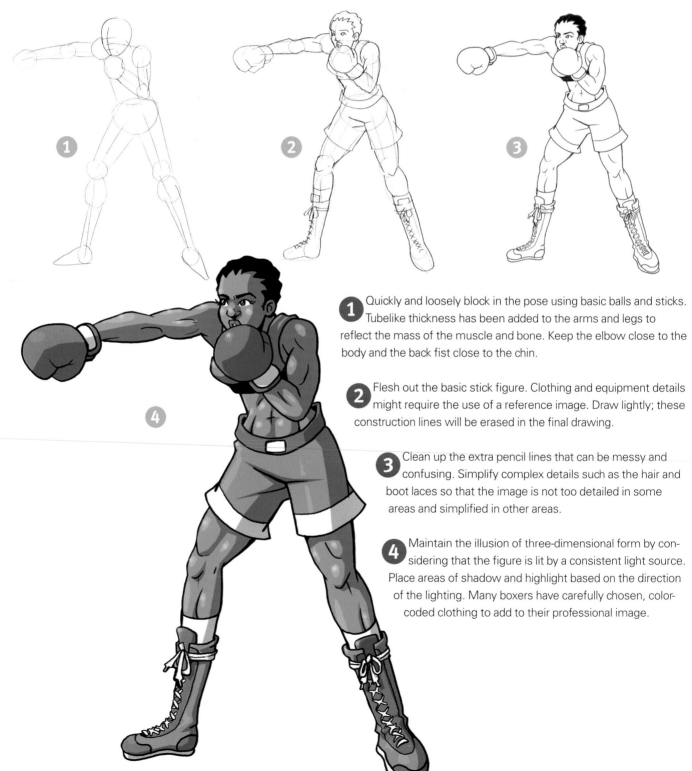

1 Quickly and loosely block in the pose using basic balls and sticks. Tubelike thickness has been added to the arms and legs to reflect the mass of the muscle and bone. Keep the elbow close to the body and the back fist close to the chin.

2 Flesh out the basic stick figure. Clothing and equipment details might require the use of a reference image. Draw lightly; these construction lines will be erased in the final drawing.

3 Clean up the extra pencil lines that can be messy and confusing. Simplify complex details such as the hair and boot laces so that the image is not too detailed in some areas and simplified in other areas.

4 Maintain the illusion of three-dimensional form by considering that the figure is lit by a consistent light source. Place areas of shadow and highlight based on the direction of the lighting. Many boxers have carefully chosen, color-coded clothing to add to their professional image.

Boxing
The Hook

The hook is usually thrown with the lead hand. The elbow rises and the fist arcs across horizontally as the figure rotates the hips to reinforce the direction of the punch. The lead foot twists with the body as well and the toes will point in towards the boxer's body. This strike is meant to hit the side of the head. If lower, it can hit the jaw, ribs or impact organs such as the liver.

1 The direction and structure of the figure are the most important at this phase. Keep the lines simple and organized. Some lines, such as the lines that illustrate the direction of the shoulders and hips, reveal a figure that is twisting in space and is not a flat form.

2 Details are added and the extra lines are cleaned up. Remember that the figure is made up of tubes and balls and that the striking arm should appear to be moving back in space and appear to be coming toward the viewer at the same time. The eyes have a wild killer instinct. That's helpful when you fight for a living.

3 Erase rough construction lines and carefully shade and color the final image. If you like, logos can be added to the spaces left blank on the shorts and the gloves.

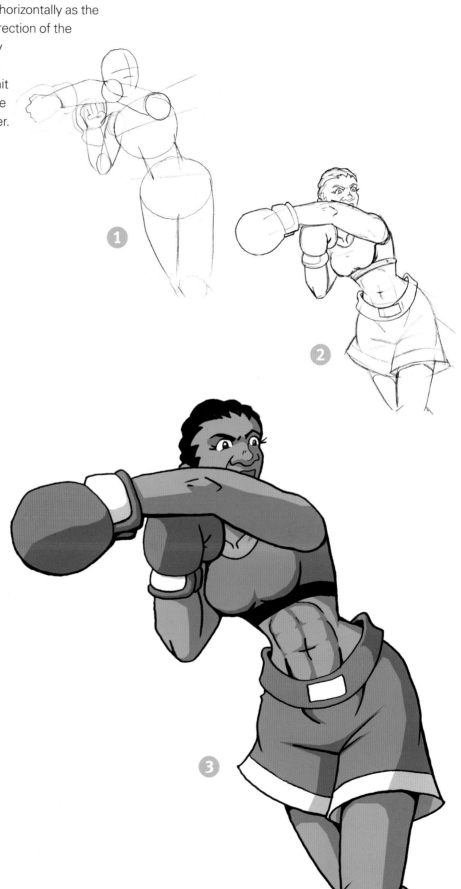

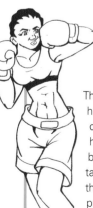

First Movement

This image shows how the hook begins, with the elbow drawn back and the fist raised horizontally. It looks awkward, but the hook can be a devastating punch. Coming in from the side it can be quite a surprise as well.

Boxing
The Uppercut

The uppercut uses the rear hand and drives upward along the center line of the target, aiming for the chin or upper body. This can be a difficult punch to execute because it opens up a defense and takes time to perform. The benefits of this punch are that the defender's gloves will be knocked aside and will be less of a defense for the chin. It is also a difficult punch to see coming as it travels from below the field of vision and is often obscured by the gloves up in defensive position.

1 It's important to understand the direction the knuckles are facing before the details of the glove are added. The arm should drive up and the body should push upward quickly. The hip should twist counter-clockwise as the rear heel twists out, adding to the force of the strike. This attack is devastating on its own, but it should also be able to straighten the opponent and set up future attacks.

2 This allows you to draw important details of the figure's pose and clothing. Erasing the preliminary pencil lines at this stage creates a crisp, less confusing image in the end.

3 Complete the intensity of the pose with color and shading. Make sure that you consider the fact that the figure is three-dimensional, not flat when you shade it. To show greater speed or power you may want to draw movement lines from the glove or draw it blurred on the edges.

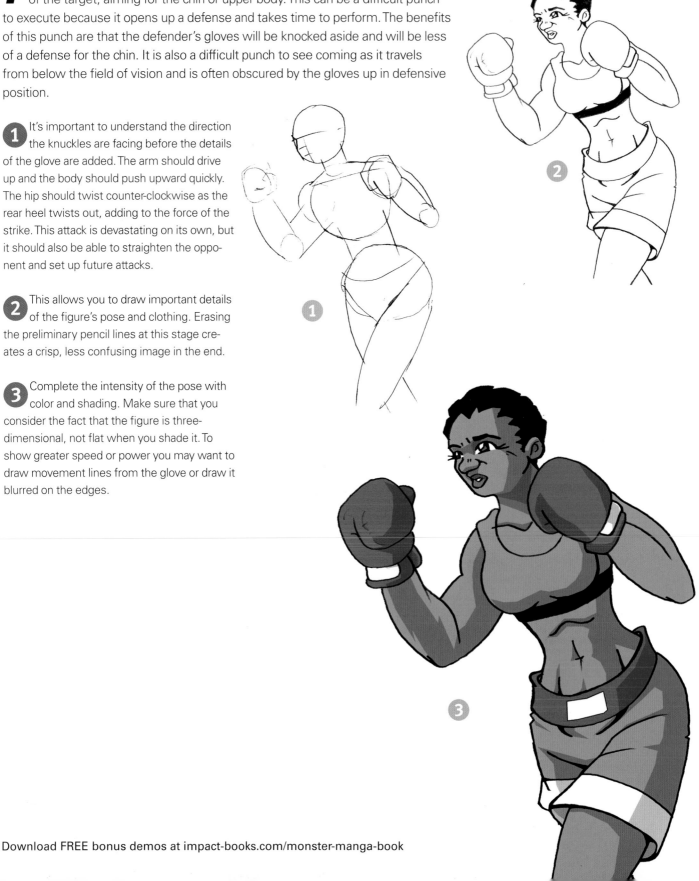

Boxing
The Knockout Cross

The basic cross is thrown from the rear hand and the entire body twists counter-clockwise as the cross is thrown. The body weight shifts from the rear foot to the lead, adding the weight and twist to the power. This punch is shown from a more dynamic angle and is much more exaggerated than the other, but it shows how speed lines create movement and describe the path of the punch.

Don't Overdo Speed Lines

Use them for dramatic effect when the punch is meaningful to the story.

1 Remember the basics of construction drawing and foreshortening. The arm should appear as a three-dimensional tube, not flat. Part of that illusion is to draw it as a cylinder at this stage so that when details are added they conform to that shape.

2 As you are drawing in the final lines, be very aware of the weight of the lines. Heavy lines appear closer and also have a greater sense of weight and form. Thin lines can help indicate highlights and objects that are further back. The movement lines add to the sense of action and energy.

3 This is a powerful punch, but you can see how it sets up the attacker for a wicked counterstrike. The attacker should really be sure this will stagger her opponent or the tide of the battle could turn, fast. This kind of punch also wears down the attacker quickly. Tired boxers forget to defend themselves. A big part of the strategy of boxing is tiring out your opponent and conserving energy to go round after round.

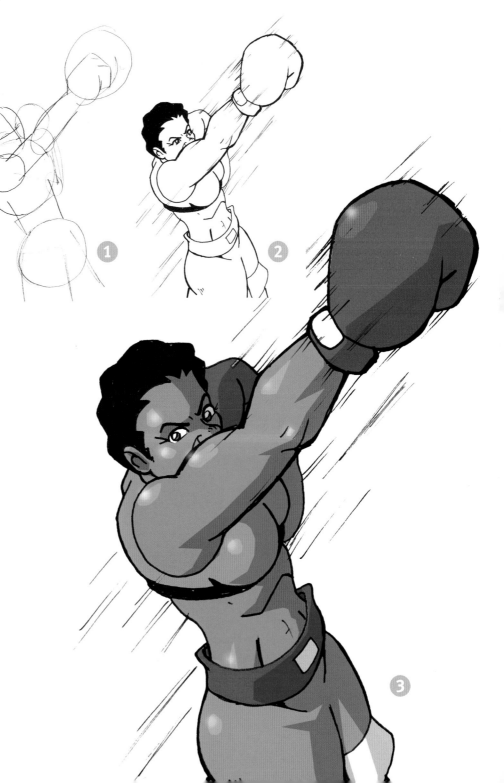

Judo: *the Bigger They are,* *the Harder they Fall*

Judo is an excellent self-defense system because it focuses on redirection of offensive strikes, self-defense and restraint, not injuring the opponent. Because personal size and weight are not as much of an issue, it is also a popular martial art for women and children.

Etiquette

Etiquette is important in judo, ensuring courtesy and respect towards the opponent, but it also ensures that everyone is safe. The bow is a traditional sign of respect, but make sure there is enough room between the characters in your drawing, you don't want them to bump heads. Ouch!

Stance

Judo stance is what is known as a "ready stance." The knees are slightly bent, the head is held up and the torso is bent slightly forward. The feet are placed less than shoulder-width apart and turned out at a 45-degree angle with the heels lined up. The arms should be held relaxed at the side and the hands can be in a fist or relaxed.

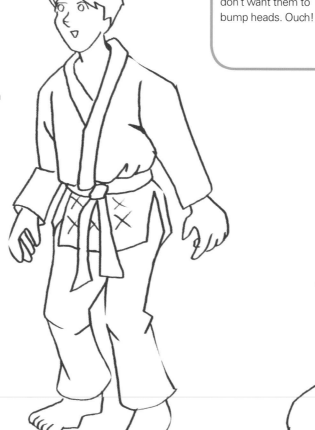

Correct Sitting (Seiza)

Personal development and spiritual growth are important founding principles of judo. The seiza (literally, "correct sitting") position is the traditional formal way of sitting in Japan. Seiza should be executed thoughtfully and with respect.

Movement

One of the important skills learned in judo is the art of breakfall. Knowing how to break a fall properly lessens the chance of injury when practicing throws. Throws require the defender to move into the attacker's center of gravity, break his balance and use his own weight and momentum against him.

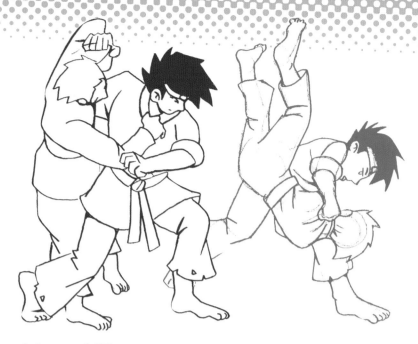

A Successful Throw

The elements of a successful judo throw are: dropping below the opponent's center of gravity, secure grappling, leg sweeps or trips and using momentum and body weight as leverage. Someone who doesn't know how to fall could get seriously injured.

Hip Throws

Getting under the opponent's center of gravity makes it easier for a smaller person to throw a larger person.

Breakfall

Practice and drills also make breakfalling second nature or instinctive. The trick is to roll with the fall and spread out the impact by extending an arm.

Armlocks and Pins

Armlocks and pins can be very painful. The opponent's ability to break free or even move is limited. Slapping the floor is a sign of surrender. A contorted face also sends an obvious message.

Establish the Ground

Drawing groundwork is important to establish the actual ground. Without the impact lines here, it appears as if one person is carrying another through the air. These action lines can define the force of impact in a battle.

Breakfall

One of the first things learned when studying judo is how to fall properly. Practicing falling avoids countless injuries during training and provides a valuable skill to the student of judo. Ukemi requires a relaxed body and the ability to roll with the throw or fall. This, combined with an outstretched arm evenly distributes the impact. Make sure you draw the figure with a chin tucked in close to the chest to avoid whiplash.

Slap!

In the judo dojo the sound of students slapping to the ground from falls can be deafening during class.

1 A falling figure looks out of control at first, but closer inspection will reveal that the figure is taking precautions to avoid injury. When drawing the figure in a complex action like this, "draw through" the figure, showing the arm and leg through the head, limbs or torso. This allows proper placement of body parts in the drawing and avoids distortion.

2 When details are added, it's easier to see how the figure is falling (movement of hair and clothing) and how the figure is preparing a breakfall (looking in the direction of fall, arm extended to help distribute weight and chin tucked down to chest). The belt is made of a heavy cotton and doesn't fly around too much.

3 Be mindful of the source of light in this drawing when coloring and shading. In the end, the figure should appear three-dimensional. Flat color looks flat while rounded, shaded forms give the illusion of a three-dimensional illustration.

Download FREE bonus demos at impact-books.com/monster-manga-book

Judo
High Circle Throw

This is a sacrifice throw where both people fall during the technique. It's a classic case of falling backwards and propelling the attacker off and away with a combination of momentum and leg strength. The person executing the throw needs to land in a controlled way and send the attacker flying.

1 Block in the basic pose using shapes and forms. Try to imagine the direction of movement and show the pose in the most dynamic stage of action.

2 Clarify the details, including the placement of the hands and feet. Notice how the fingers create stress marks on the areas where they grasp the clothing. It is also easier to see that the attacker's body weight is supported with the bottom of the defender's right foot as the throw is executed. Complete the illusion of movement with hair direction and the movement of the cuffs.

3 Color and shade to give the image depth and solidity. Make each gi (uniform) and each grappler's skin a different shade to reduce confusion. Try to show a sense of movement in your action drawings. Direction lines or blurring could also indicate more dynamic movement, but don't rely on these tricks too much.

Rewind

The moment before the final image reveals how the move was executed. The foot is quickly placed to allow for a strong kick under the pelvis that assists the throw. The defender's back is curved to allow a roll. The chin is tucked down to avoid neck injury.

Standing Throw

This is one of many standing throws (tachi-waza), utilizing foot, hip, or in this case, hand techniques. The defender grasps the opponent firmly and leads them to the ground as the body pivots and the leg trips.

The main element of this throw is timing. The move requires that the opponent is caught off balance and then the hands, legs and hips can work to throw even the largest opponent.

1 Block in the figures carefully. Notice that the attacker is being pulled to the side with the arms and the twist of the defender's body. The defender's right leg is also used to trip the attacker as the left leg supports the weight required for the throw. The pelvis and shoulders of the defender should angle down toward each other to create an acute angle.

2 Clean up all the lines. When you are blocking in the details over the shapes, be aware of the "drawn through" elements and erase confusing lines. Both hands are used to pull the attacker off balance. The opponent is rotated in a circle and is not driven down until the last move of the technique. The defender should always face in the direction that the attacker falls.

3 Color and shade the figures to show the force in the technique. Add stress lines on the clothing and clenched fists. The shadow of the attacker on the defender helps illustrate that the defender has dropped below the center of gravity of the opponent. Keep things neat and crisp at this stage.

Tachi-Waza Variation

This variation is a standing throw where the opponent's momentum is used against him. The defender drops down, twists his body, driving the right forearm into the opponent's right armpit. This forearm lift helps create the leverage required to execute the throw. The left hand has a firm hold on the right elbow. The opponent is thrown over the defender's right shoulder.

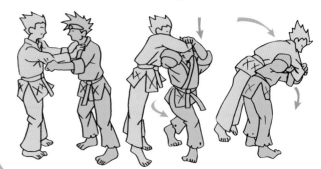

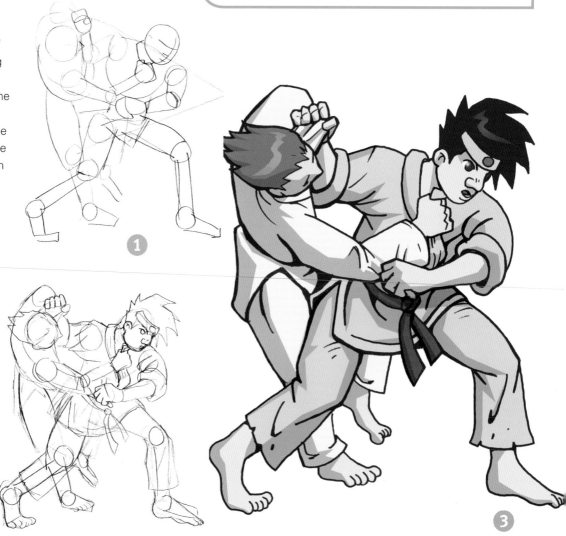

Judo
Sweeping Inner Thigh Throw

This maneuver sweeps the opponent's hips and legs out from under him, propelling him to the ground. It's a combination of the attacker's momentum, the pivot of the hips and a strong pull from the arms in the direction of the fall.

1 This is a fairly complex image, but you need to show both characters in grappling martial arts or else it looks kind of strange. Don't be intimidated showing multiple characters. Break the figure down into basic shapes and pose them. If you have friends you can corral into posing that's great, but if you're unable to muster the troops, action figures can do in a pinch.

2 Elaborate on the details, particularly the hair and clothing to help show movement and momentum. You can see that the leg of the attacker is moving up because the pant leg cuff is moving the opposite direction of the movement. Remembering details like this can really add dynamic movement to your drawing.

3 Finalize the image with color and shading. Don't forget to keep the shadows consistent with the light source. Highlights on the hair add to the three-dimensional appearance of the character and avoid the "flat" look.

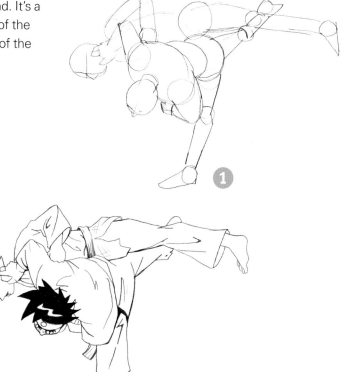

Karate: *Striking Art of the Empty Hand*

Karate has a wide range of stances (dachi), each designed to lower and stabilize the center of gravity and set up the martial artists to defend themselves or deliver a powerful attack. Moving from stance to stance is an important skill used in patterns of movements or kata.

Kata

When opponents square off in a karate sparring match, or for a kata, there are often a series of strikes and blocks that are performed. These kata reinforce technique to condition the body for combat.

Minimizing Yourself as Target

Stances provide an opportunity for the martial artist to maintain a solid footing when striking and defending. This avoids tripping and the possibility of being knocked off balance. Stances also minimize the target that they present to the opponent.

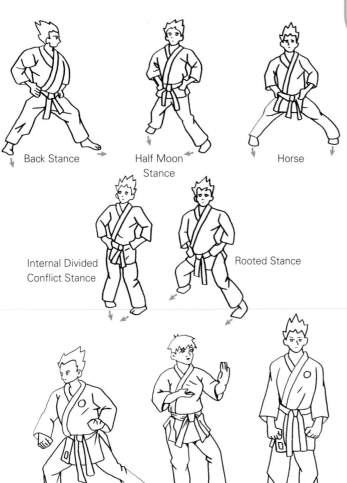

Back Stance

Half Moon Stance

Horse

Internal Divided Conflict Stance

Rooted Stance

Forward Stance

Cat Stance

Ready Stance

Stances

The forward stance (zenkutsu dachi) is one of the most common stances in kata. In the cat stance (neko dachi), most of the weight is on the bent back leg with the forward leg ready to snap out. The next stance is the "ready" (hachiji dachi) stance.

The back (kokutsu dachi) stance, the half moon (hangetsu dachi) stance and the horse (kiba dachi) stance are important yet less common. Originally developed to take on multiple attackers, the internal divided conflict or saddle stance (naihanchi dachi) is used as a close-fighting technique with sure-footed side-to-side cross steps. The rooted stance (sochin dachi) maintains a stable footing and sets up the opportunity to explode into a side snap kick with the rear foot.

A Focused Mind

Karate requires a focused mind and a sense of purpose. Most practitioners sit in sieza position, close their eyes and use controlled breathing to prepare for their training. The back is straight and the shoulders are relaxed.

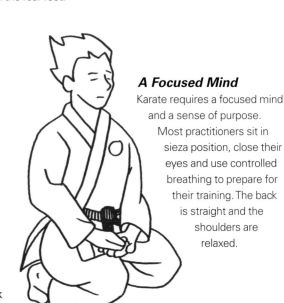

Movement

Movement in stances is kept low and in wide sweeping steps to maintain balance. Notice how close the combatants are in relation to the other and also how low the stances are.

Strikes

Basic hand strikes are launched from the chamber position and use the twist of the hips and torso to add power to the punch. The fist is loose until just before impact.

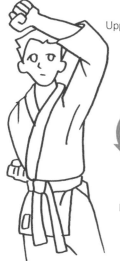

Upper Block

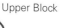

Inside Block

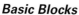

Low Block

Basic Blocks

Some basic blocks include the upper block, which is on an angle above the head. This is intended to deflect the strike away from the head. The low block derives power from a quick exchange along the opposite arm, creating a springlike snap for the block. The inside block is performed just like drawing a sword from a scabbard.

Point of Impact

The fist should strike the target with the inside two knuckles of the hand. These knuckles line up with the bones of the arm and provide a stronger punch. The thumb should be tucked below, but not under the fingers.

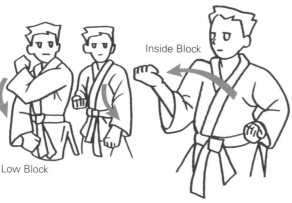

Side Kick

The side kick is an outward push of the leg to strike the target. The kicker twists his back leg around and pushes out. This must be precise and done fast.

Hi-ya!

The kiai is a short yell that accompanies a strike. It is used to focus energy and distract or intimidate the opponent.

Roundhouse Kick

A roundhouse kick brings the back leg up and then uses the momentum of the lower leg and foot to snap into the kick. The ball of the foot or the top of the foot is used to strike the opponent.

Karate
Knife Hand Strike

This is often referred to as the "karate chop." The strike uses the edge of the hand from the knuckle to the wrist. The fingers are slightly bent, temporarily hardening this area as muscles and tendons tighten up. It is particularly dangerous against soft tissue such as the neck.

1 Notice that when the strike hits, the body rotates toward the target and the left hand pulls the target towards the striker, upsetting the balance. Usually the left hand would tuck up into chamber position, but in this case, the left hand has grabbed a weapon hand.

2 As you add details, be aware of folds and creases on clothing to help express tension and movement instead of having to draw action lines for everything. Action lines add to the appearance of force in the strike. Overuse of action lines can cheapen their impact, but it is traditional in manga and comics to use these lines to indicate movement.

3 Color the image to reinforce the three-dimensional nature of the forms and separate the two figures from each other.

Strike Movement

To add to the power of the strike, the right hand is raised to the left ear. The body rotates away from the target slightly. The strike then moves across the body.

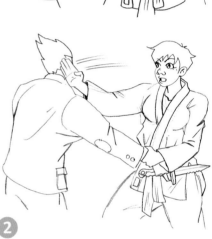

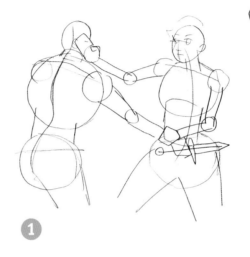

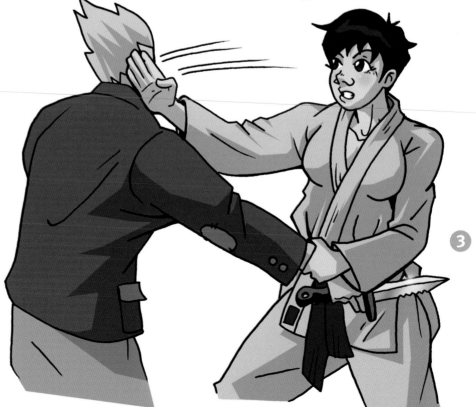

Karate
Elbow Strike

The elbow can be a seriously effective close-combat weapon. It's fast and delivers a solid strike that sets up the attacker for a punishing backhand strike. Elbow strikes are most effective in areas such as the solar plexus, the face and neck, the stomach or the back.

1 Sketch the figure in a back stance with a strongly rooted center of gravity. Depict the point when the strike should hit the target. Notice how the opposite hand supports the striking arm. Twisting the body adds to the power of the strike.

2 Indicate the twist of the body as the strike hits. The belt does not fly around too much because it is made of such a heavy material.

3 Use color and shading to express more folds and creases in the clothing. The figure would probably turn and face the opponent after this strike by pulling the front (left) leg back in a C-shaped step. Movement in karate avoids lifting the leg or changing the height of the fighter as that may lead to potential unbalance.

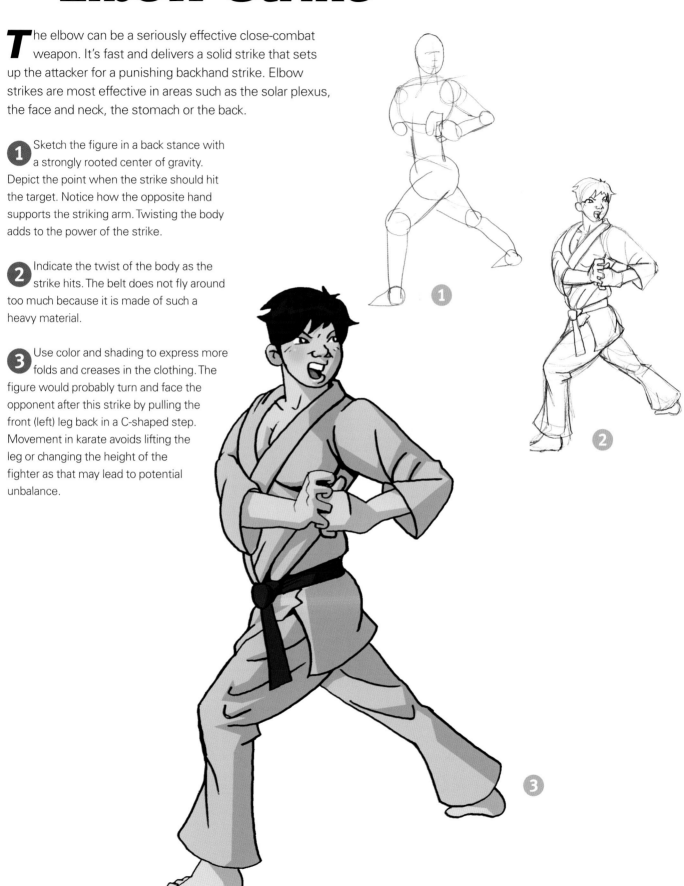

Karate
Side Kick

This very high side kick requires some serious train-ing and warm up. Remember that when you are drawing a kick in karate, there is a definite snap of the leg with the strike. The foot should be twisted so that the knife-edge (outside edge) of the foot or the heel hits the target. A kick this high is often impractical as it uses a lot of energy and can make for an easy target.

1 Notice how the figure leans far back to allow the stretch of the leg to increase the height of the kick. The arms should be kept up to defend from any punches or kicks that might slip through this massive attack.

2 The stretch of the pants shows why it's a good idea to use loose-fitting or stretchable clothing in the martial arts. Other pants might just rip with a wide kick like this. The ripple of the pants on the kicking leg shows the power of the kick.

3 This kind of kick is aimed at the head or neck of the target. It is a devastat-ing strike and is life-threateningly danger-ous. Notice how the light direction affects the color and shade of the figure.

Karate
Flying Side Kick

This is not a very practical kick in reality, but it's fun to look at and great to draw. It's not something very common to karate, which tends to rely on strikes that have focused, penetrating power, not necessarily "knock down" power. In martial arts manga, sometimes the practical is set aside for the flamboyant.

1 This can be a complex pose to draw. The key features to note are the foreshortening of the tucked-under leg. The twist of the foot ensures the knife-edge of the foot strikes and not the toes.

2 Note how the arm goes back into the chamber and the right arm is extended in a strike. This is a very impractical move, but the extended arm could help defend the body or trap an opponent. The dynamism of the movement is reflected in the effect of the wind on the clothing and the hair.

3 Having the figure relating to a background or another character would put the pose in context. We would get a better sense of how high off the ground the kicker is and what connection they have with the target. Remember to add the details of the folds and creases of clothing at this stage, but don't overdo it. Too much detail can be distracting and take away from the overall image.

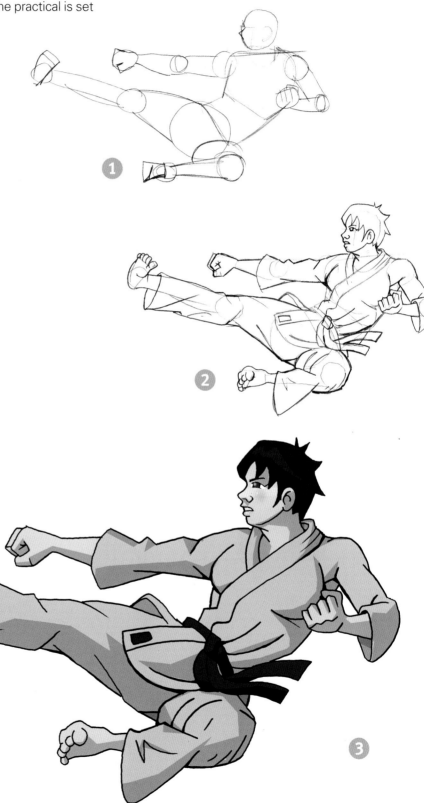

Kickboxing: the Art of the Eight Limbs

Kickboxing is an interesting mix of the traditional martial art Muay Thai (literally, thai boxing) and the competitive boxing match. Action usually resembles boxing until the combatants start kicking, then the devastating power of the kick is revealed. A single kick to the temple can end a fight with a knockout and threaten the life of the target.

Kickboxing For Fun and Fitness

Kickboxing clubs have sprung up recently, cashing in on the fitness craze of the past two decades. Most people study kickboxing in gyms and clubs to tone muscle and burn calories with no desire to enter a ring and duke it out. An hour of kickboxing can burn 400 to 800 calories per hour and is a good stress reliever. There are no formal kata or forms to learn. It's all about technique, balance, flexibility, coordination and stamina. It's also a lot of fun.

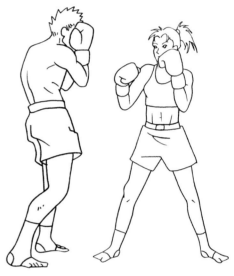

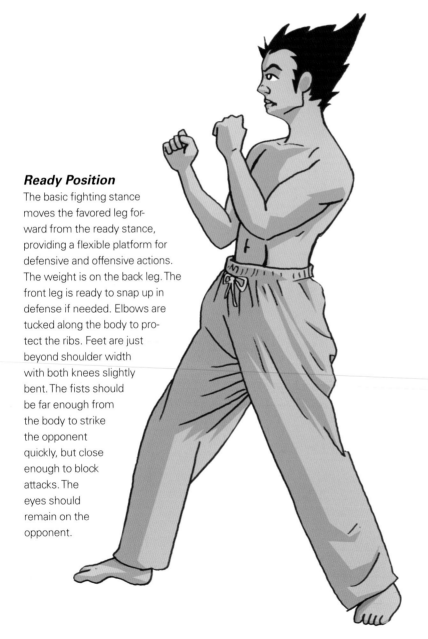

Ready Position

The basic fighting stance moves the favored leg forward from the ready stance, providing a flexible platform for defensive and offensive actions. The weight is on the back leg. The front leg is ready to snap up in defense if needed. Elbows are tucked along the body to protect the ribs. Feet are just beyond shoulder width with both knees slightly bent. The fists should be far enough from the body to strike the opponent quickly, but close enough to block attacks. The eyes should remain on the opponent.

Taking Damage

Kickboxers are trained not only to dish out damage, but also to take it. When preparing to be hit, fighters raise the arms and gloves in defense. They also plant their feet on the ground so they are less likely to be knocked down.

Glove Placement

Avoid placing the gloves too high or too far from the body. This obscures vision and opens the torso to attack. As the fighters grow tired during a match, this becomes harder and harder to remember for the injured. Simple mistakes can cost the match. The lead fist is placed two fists out from the body and the rear fist rests on the chest or chin.

Movement

Kickboxers bob and weave just like regular boxers. Footwork is loose and springy, but not too bouncy. It is important to keep moving in the ring so you are not a sitting duck. Sudden, explosive strikes can come at any time, so maintaining balance is important.

Blocking With the Leg

Raising the leg can stop an incoming kick and set up the kickboxer for a devastating counterstrike. Notice how the elbows and fists stay up to protect the torso and head.

Side Kick

This basic kick starts by raising the knee as high to the chest as possible. The toes point to the floor and the back foot should stay flat on the floor to maintain balance. It's a good idea to keep the fists up to defend the torso and face. The foot should snap out and retract immediately so the leg is not trapped in a clinch. The leg must retract fully in order for tournament kicks to count.

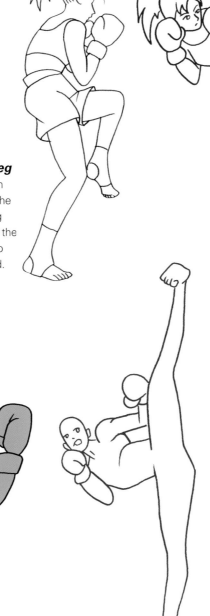

Roundhouse

A roundhouse kick snaps in from the side of the kickboxer. It is a good strike to hit the ribs or head. Part of the power of the kick comes from the snap of the lower leg as the leg is straightened. Some kickboxers jump to deliver this kick, adding momentum and height to the strike.

Punches

Standard boxing punches can also flatten an opponent and the power of the punch cannot be underestimated. The hook, uppercut and jab are used as they are in boxing. Kickboxers soon realize that relying on kicks only can quickly wear down the stamina of the fighter.

High Side Kick

This high side kick shows the importance of keeping defenses up during an attack. The ribs and face are well defended here. This impressive attack is designed to hit the jaw or side of the head. Make sure the back heel is firmly planted on the ground.

The Power Source

All strikes use the whole body, drawing power from hip rotation for kicks, punches and blocks. This can slow down the movement, but adds tremendous power.

Kickboxing
Front Kick

The most basic of all kicks, the front kick is essentially a push out with the leg. The toes should be pulled back and the point of impact is the ball of the foot. The grounded foot should twist out to maintain balance and generate torque. This example shows a fighter leaning back on the ropes and attempting to push away an attacker.

1 Block in the legs and arms as three-dimensional, not flat, shapes. Notice how the arch of the back is indicated by an initial line dropped down from the head to the pelvis. This line of action helps counterbalance the fighter.

2 Reinforce the motion. The fabric of the shorts moves opposite the kick. The defenses are kept up in this drawing. Draw the gloves tilted open as the elbows move out to allow the kick to rise above the hips.

3 Color the image to reveal the shading and form of the figure. Details in manga should be included when it is absolutely necessary in developing the story, not just to fill in space. The blue teeth are actually a mouth guard.

Arms Can Denote Fatigue

This view of the front kick illustrates the tendency to drop the arm of the kicking leg to counterbalance the shift of weight and to get the elbow out of the way. The defenses should be up, but this fighter is getting tired and desperate.

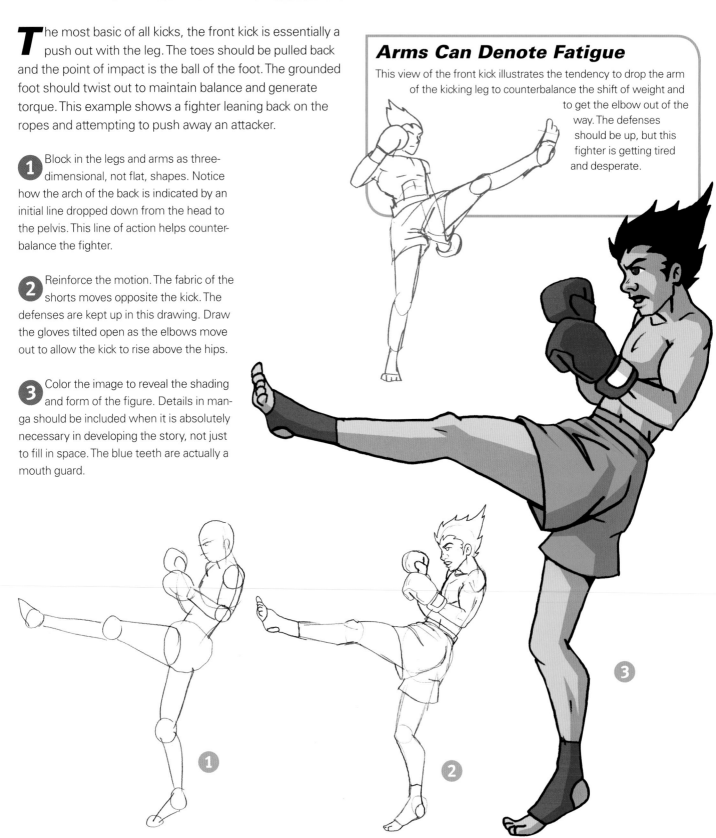

Kickboxing
Axe Kick

This powerful kick is designed to break the defenses and disorient the opponent as it rises. It then crashes down on the head or shoulders to knock down the target. Ouch, that's gotta hurt!

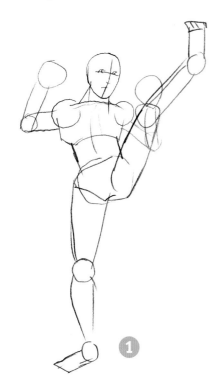

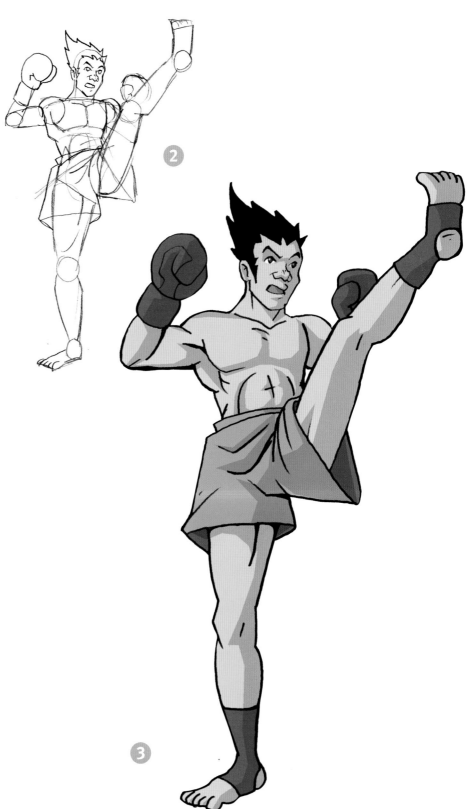

1 Block in the shapes and suggest the simple anatomical details: the back foot twists outward and the gloves are up in defensive position.

2 Add details by blocking in anatomy and clothing information. As the foot rises, the toes need to be pulled back to avoid injury as they break through the opponent's defenses.

3 At this stage, use shading to create details of anatomy and clothing creases. The elbows are raised to make room for the kick, but they should tuck beside the body once the kick is finished. As it is, the arms are providing some defense, but not nearly enough if the axe kick misses.

Spinning Back Kick

Also known as a donkey kick, this kick connects with the heel and is accompanied by a spin of the body. The speed of delivery and focused power of the spin makes this a very potent kick.

1 Pay attention to the biomechanics of the figure as it rotates. The open arms increase the power of the spin by using the weight of the arms to add to the kick's impact.

2 Block in the details of the character at this stage. The elements of the drawing—hair, clothing and muscle detail—should all indicate a twist or torque in the figure to indicate movement. The heel is the point of impact with the rest of the leg and foot used to push back on the target. The momentum of the spin adds to the attack. Note also that the weight is on the balls of the attacker's left foot. This allows the kicker to pivot on the ground, but it is difficult to maintain balance. Notice that as in most martial arts the point where the weight is supported usually lines up with the head.

3 After the anatomy and costume details have been cleaned up, it's time to add color and shading. The shading should help convince the viewer that the subject appears three-dimensional, so make sure you try to depict the forms of the figure as you add shading. To emphasize movement, you may even consider blurring the leg or figure. Relying on special effects such as blurring can detract from your artwork and make it difficult to understand what the character is doing. Use it wisely.

Right Back at You
This alternate view of the spin kick shows the moment of impact. This is a very high kick and must be executed quickly as it leaves the back of the fighter undefended for a moment. The kick is often a surprise as the telltale leg lifting is hidden from view until it strikes.

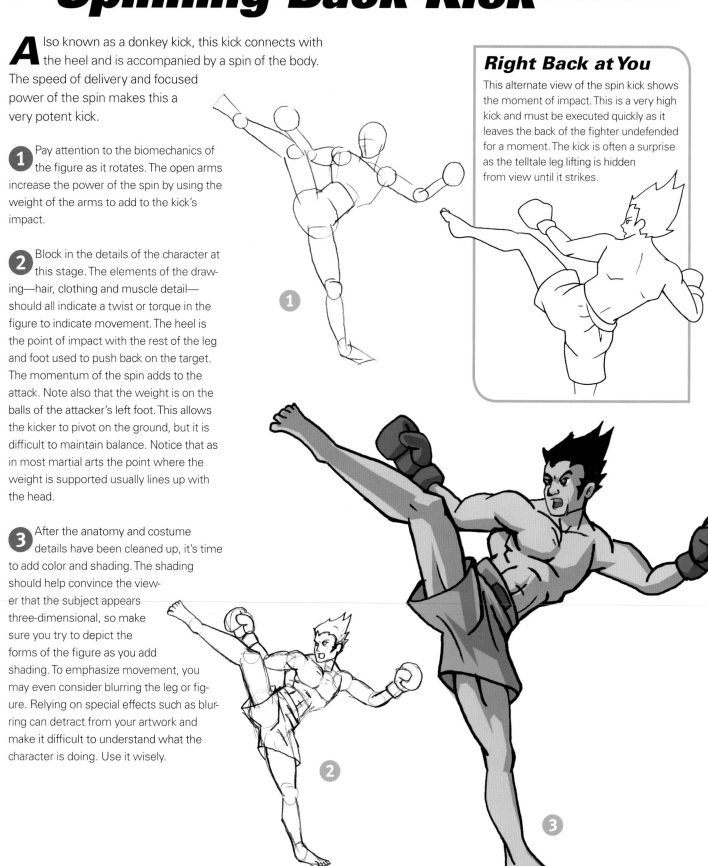

Kickboxing
Flying Spinning Back Kick

You know what's even scarier than a spinning back kick? A flying spinning back kick! Flying kicks are saved as finishing moves as they are not as reliable as standard kicks and have a lot of power invested in them that could tire out the fighter quickly. The fighter is also fairly defenseless for a few moments as he lands. This is a full-out offensive strike that takes a lot of skill and guts to pull off.

1 Draw the line down the back as the line of action to quickly block in the pose. From it, develop other forms to establish the anatomy and body position. The back leg has just left the ground and the toes are pointing down. Notice the foreshortening in the right forearm moving away from the viewer and being obscured by the upper arm.

2 It's detail time! Look how the short's leg is really flying from the force of the spin kick. Emphasize the twisted back to reveal details of the shoulder blades, spine and ribs. Make sure your initial lines are lightly drawn so they can be easily erased.

3 Suggest areas of light and dark. Anatomical and costume details can be added by shading and defining muscles and clothing folds. This sort of kick requires some sort of running start. A jump kick usually targets the body while these flying kicks target the head.

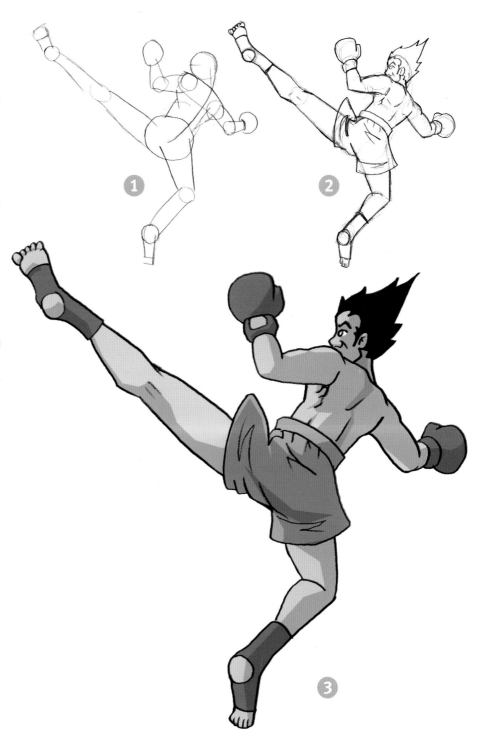

Kung Fu: *Crouching Tigers, Hidden Dragons*

The inspiration for traditional Shaolin kung fu is reputed to come from Buddhist monks mimicking the movements of animals. Kung fu is a relatively circular, open-handed style that uses natural biomechanical body motion and speed to unleash devastating power.

Hard Work

Kung fu (gung fu) means "hard work" or refined skill. Combatants bow to each other respectively and raise their right fist to an open left hand.

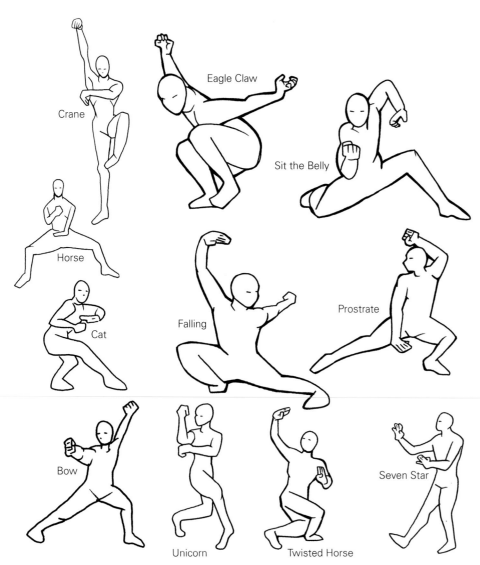

Crane

Eagle Claw

Sit the Belly

Horse

Cat

Falling

Prostrate

Bow

Unicorn

Twisted Horse

Seven Star

Kung Fu Stances

Stances are important for maintaining balance and they reinforce energy or chi. Maintain consistency in stances. There are hundreds of styles and substyles of kung fu. Some styles favor some stances over others. Familiarize yourself with their characteristics.

The power of the crane stance is in the momentum created from swooping down to strike. The horse stance is a solid stance, designed for maintaining ground and balance. The very low cat stance allows the front leg to snap out.

The eagle claw stance is based on a very complex and acrobatic northern form of kung fu. The sit the belly stance is a very low version of the praying mantis. It is a solid, deeply rooted stance. The knee should not be in contact with the ground unless the strike or defense demands it.

The falling stance is an excellent defensive stance, useful for evading attacks. The prostrate stance is useful as a defensive stance that allows for a quick counterattack. The unicorn step (cross) stance allows for the figure to react or "give" to a blocked strike and the twisted horse stance creates a strong twisting force to enhance power. The heel or seven star stance is also seen in tai chi. It is a useful move for scooting forward quickly without lowering defenses or shifting body weight.

Movement

Kung fu movements are fluid and circular. They should erupt from the attacker with speed and power. Don't forget to draw the characters keeping their arms up to defend from a possible counterattack. Maintain supple hips and legs to ensure kicks have a full range of motion. Depict the flexibility of the martial artist by showing them drop into wide, low stances and execute impressively high kicks.

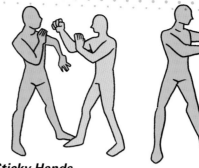
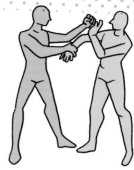

Sticky Hands

Sticky hands is a paired practice from wing chun, one of the most popular forms of kung fu. Wing chun martial artists without a practice partner use a wooden dummy (mook yan jong). The arm movements are circular, using the natural arcs of the human figure.

Snake Style

Snake style is an undulating, weaving style that simulates the strike of a snake. It's precise and fast, targeting the throat, eyes and temples as well as damaging strikes to nerves and pressure points.

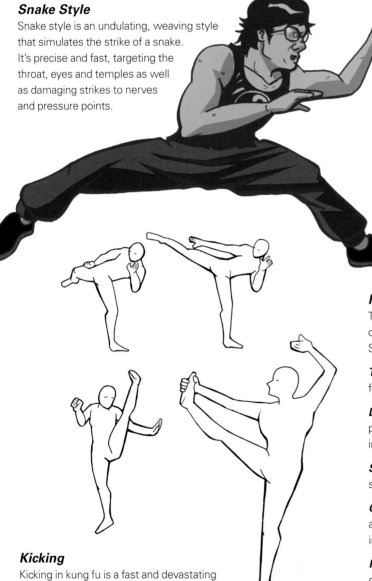

Sticky Legs

Sticky legs is similar to sticky hands, but focuses on kicks and footwork. Low kicks like this are designed to break the opponent out of their stance and upset their center of gravity.

Tiger

Hand Strikes

These striking techniques are representative of the traditional five animal styles found in Shaolin kung fu.

Tiger: low, powerful stances and hand forms used for grappling and clawing.

Dragon

Dragon: straight fingers for striking vital points on the body. In some traditions, the index finger is raised and used for thrusting.

Snake: fast and flowing strikes relying on swiftness, timing and accuracy.

Snake

Crane: like the beak of a crane, the strikes are powerful and accurate with focused impact.

Panther: like a paw, relying on powerfully conditioned knuckles. This form relies on flat and piecing strikes using the flat edge of the knuckles for various effects.

Crane

Panther

Kicking

Kicking in kung fu is a fast and devastating attack. It is often associated with "northern styles" of kung fu such as Shaolin "long fist." These techniques were designed to keep great distance between the combatants.

Kung Fu
Tiger Claw Strike

Shaolin tiger movements simulate the tearing motion of tiger claws. It is a rigid, open-hand technique that uses downward arcing swings as well as palm and forearm blocks in a downward sweeping motion. The wrist twists the fist as the blow strikes and produces amazing power. As the name suggests, this form was based on the characteristic movements and attacks of the tiger.

1 Block In the Figure
Block in the basic forms paying close attention to the stance and arm placement, making sure the figure is posed properly. Keep things simple at the start. Don't be afraid to "draw through" to help keep the elements of the figure in proper proportion.

2 Add Details
Add details such as the clothing, hair and face to give the character personality and individuality. Confusing structure lines can be drawn over or erased. Even though the facial expression is exaggerated, the image doesn't seem overly cartoony because of the accuracy of the figure's pose.

3 Color and Shade
Add color and shade to breathe life into the final drawing. Notice that even though the yin-yang symbol on the shirt is a simple black and white image, the white on the shirt has been knocked down to a gray in order to reinforce the light source and develop the figure as a three-dimensional form.

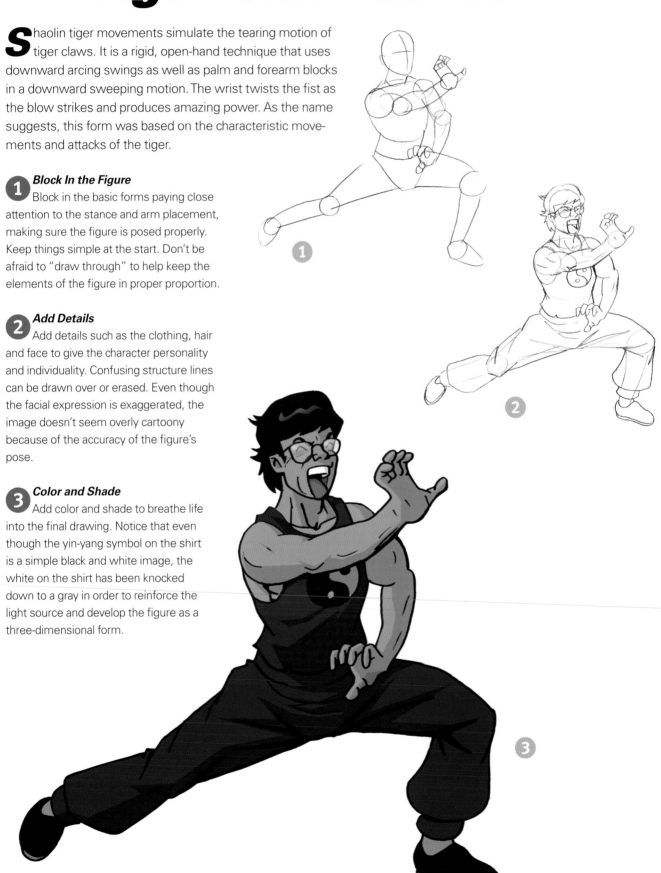

Kung Fu
Monkey Style Strike

Monkey style is steeped in history and legend. The movements imitate those of monkeys or apes. It is a flamboyant and humorous style, using colorful acrobatics and unpredictable and random movements to confuse and surprise opponents. It is a style that uses rolls and squats as well as long reaches, grabs and arm swings.

① *Block In the Figure*
Block in the pose using construction lines. Remember that the angle of the hip and the angle of the shoulders will complement each other and point in opposite directions. "Draw through" the forms to get a better sense of where anatomy is located. Imagine that the tubes, circles and shapes used to construct the figure are made of glass or clear plastic.

② *Add Details*
Block in the details carefully, considering the flow of material on this classic Mandarin-style outfit and the monkey-like hands, ready to block and grasp any attacks. Be careful with the proportions so that the head, hands and feet are in proper proportion with each other and the rest of the figure.

③ *Color and Shade*
Finish the image and create depth of form. Keep the light source consistent as you shade your image. Be aware of what parts of the figure are shadowed because of the three-dimensional form of the figure and what parts are shaded using external shadow sources. The final image uses highlights and gray to indicate that this is a black uniform. The thin lines act as a convenient way to differentiate distinct elements from the basic body shape.

A Style Steeped in Legend

It is said that monkey style originated with the legendary hero Monkey who helped Hsuan Tsang, a Buddhist monk on his sixteen-year quest to find the Buddhist scriptures. Modern Monkey style originated in the nineteenth century by a jailed warrior named Kou Sze who watched a group of monkeys from his jail cell and studied their actions and characteristics. The style was identified in a document dating to the third century B.C.

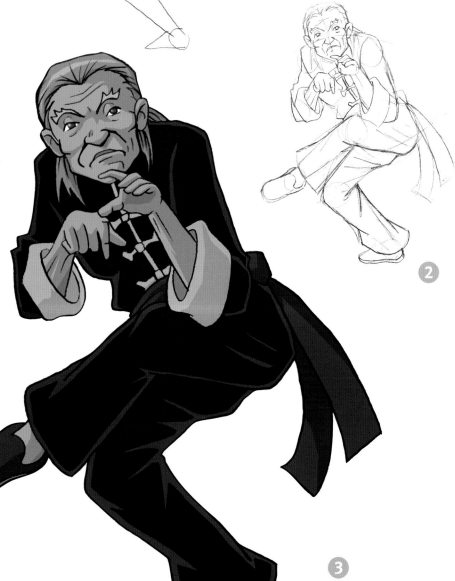

White Crane Style Strike

Practitioners of this style keep out of range of their opponents, dodging and blocking and then, at the right moment, counterattacking with brutal and tenacious energy. The white crane style then continues a relentless attack, from which there seems no escape, until the enemy is defeated. Stances and movements mimic the motions of actual white cranes using focused strikes with the fingers in a beaklike shape.

The Story of White Crane Style

A Tibetan monk was disturbed from his meditation by an ape attempting to steal eggs out of a crane's nest. The monk observed the crane and ape and was impressed with the crane's ability to ferociously defend its nest and launch a fearsome attack of its own on the ape. Hence, the movements of white crane style are grand and all encompassing, swinging the arms like wings and twisting the body for maximum power.

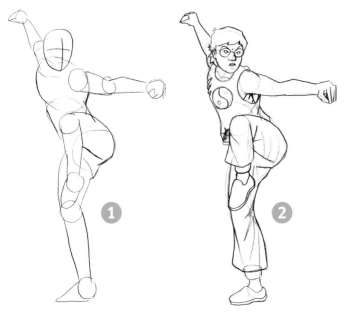

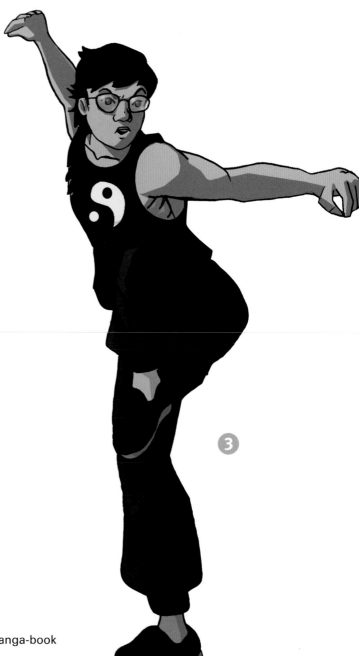

1 Block in the basic shapes of the crane stance. Be very aware of the three-dimensional shapes of the body parts. Notice how parts of the body overlap each other and therefore appear to be closer. The left thigh is also foreshortened to appear to come forward in space. The right arm is partially covered by the shoulder and head but also uses foreshortening to appear to move back in space. Attention to space and forms makes the figure more realistic and convincing.

2 Carefully add details over the initial drawing to define elements such as clothing, hair and accessories. Make stylistic elements, such as the hand forms, easy to identify. Make sure the initial blocking-in lines are light enough to erase easily after this stage.

3 Make sure the light source is consistent in all your shading. Pick a light source and stick to it in the shading as well as highlighting. First and foremost, create a convincing pose, focusing on the defensive strength of crane style. Attacks are evaded or blocked and finally a flurry of precise strikes are unleashed upon the opponent.

Download FREE bonus demos at impact-books.com/monster-manga-book

Kung Fu
Dragon Style

Dragon style uses the coiling of the mythic serpentine Chinese dragon. The martial artist uses loose, circular hip movements and does not have many kicks or jumps, focusing on palm strikes and clawing techniques. Dragon style movement is a zigzag motion, designed to emulate the slithering motions of the dragon.

1 Start with the basics. Drop the figure down into a low bow stance as the figure zigs to the right. This position will set up an attack, allowing the figure to zag into a new strike. The arms are up to protect the torso and head. Keep the figure strong and confident, ready to strike.

2 Dragon style is all about zigzagging and avoiding attacks, and looking for an opportunity to strike vital points with powerful thrusts of the fingers. The fingers are curved so that when they strike the target, they can spring with the impact and will not break easily. Slight indications of movement on the figure include the stray strand of hair and the flowing pant cuffs that indicate the direction and force of the move.

3 Clean up the construction lines and focus on coloring and shading. The black uniform has a blue-gray highlight that helps define the basic forms of the figure and convince the viewer that the outfit is indeed black. The highlights avoid the danger of having the arm disappear into the mass of the body.

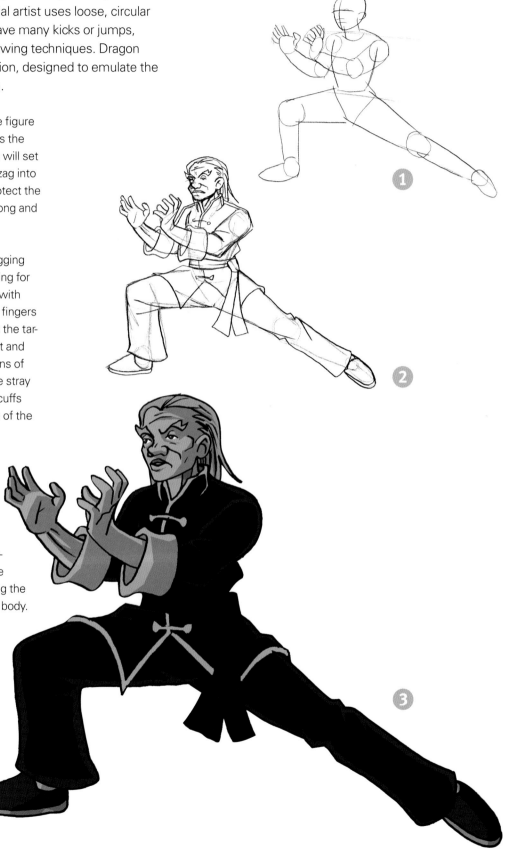

Ninjitsu: the Art of Deception

Ninja have had a powerful impact on popular culture all over the world and have been the subject of many successful manga comics, anime and live action movies.

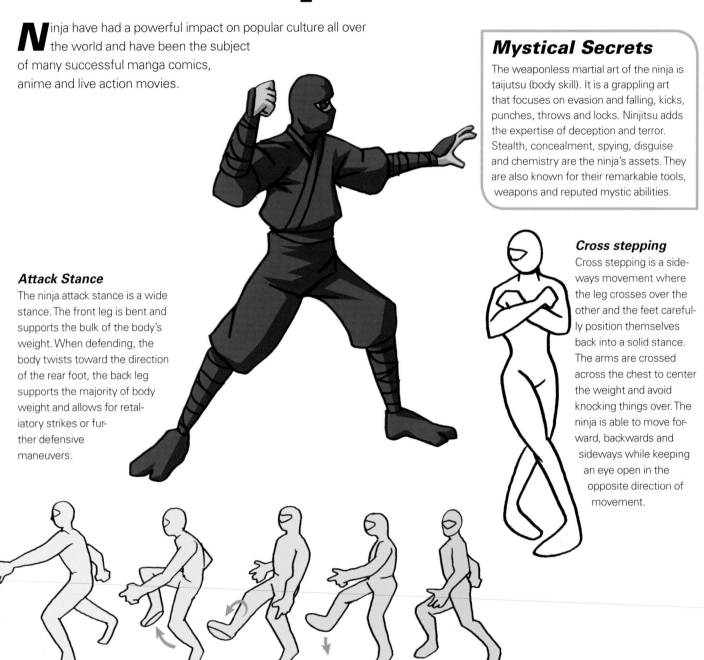

Mystical Secrets

The weaponless martial art of the ninja is taijutsu (body skill). It is a grappling art that focuses on evasion and falling, kicks, punches, throws and locks. Ninjitsu adds the expertise of deception and terror. Stealth, concealment, spying, disguise and chemistry are the ninja's assets. They are also known for their remarkable tools, weapons and reputed mystic abilities.

Attack Stance

The ninja attack stance is a wide stance. The front leg is bent and supports the bulk of the body's weight. When defending, the body twists toward the direction of the rear foot, the back leg supports the majority of body weight and allows for retaliatory strikes or further defensive maneuvers.

Cross stepping

Cross stepping is a sideways movement where the leg crosses over the other and the feet carefully position themselves back into a solid stance. The arms are crossed across the chest to center the weight and avoid knocking things over. The ninja is able to move forward, backwards and sideways while keeping an eye open in the opposite direction of movement.

Stealth Walk

This is an unusual way to walk, but it's effective for avoiding traps and trip-wires and clearing the path. This is also a very quiet way to get around. With this method of walking, objects obscured by darkness can be avoided.

Endurance, Strength and Flexibility

These are the ninja's physical abilities. This low stance provides a smaller target and allows the ninja to remain hidden. The concept of triangle, circle and square is used in all actions, as in aikido. Defensive maneuvers are triangular. Attack techniques are circular. Solid stances are indicative of the square.

Movement

The ninja had to have a powerful set of core muscles to pull themselves up on rooftops quickly and possess the agility to perform acrobatic stunts in order to escape or launch a surprise attack.

Stealthy Lookout

The ninja crouches to maintain a small profile and uses a crossing side step to keep an eye out behind. Were they followed? Also, the ninja is using a concealed sword technique to reduce his weapon's reflection and glare.

Legendary Wall Climbers

Ninja scale impossible heights with limited outside support. "Ninja claws" on hands and feet were used to get a better grip. The ninja hugs close to the wall to avoid detection and limit the tendency to fall backwards. The limbs are outstretched and rarely tightly bent to avoid wearing them out too soon.

All-Terrain Ninjas

Ninja must learn to cross all kinds of terrain stealthily. Crawling this close to the ground requires practice and dedication. Three limbs should be used to support the body's weight at all times during movement for stability and an even spread of mass.

Rin

Kyo

Toh

Sha

Kai

Jin

Retsu

Zai

Zen

Kuji-Kiri

The legendary kuji-kiri finger-knitting techniques are used to focus attention and energy. These secret hand positions were passed on through ninja families to help draw on inner forces of willpower and resolve in order to overcome adversity or maintain calm. Fictional ninja use these techniques to control elemental or mystic forces.

Rin: strength of mind and body, an inner strength designed to get the job done.

Kyo: direction of energy within the body used for healing and calming.

Toh: harmony or an awareness of one's place in the universe.

Sha: healing of the self and of others.

Kai: premonition of danger.

Jin: knowing the thoughts of others.

Retsu: mastery of time and space.

Zai: control of the elements of the natural world, useful in appearing to disappear into the background.

Zen: enlightenment, a deep understanding of the self.

Defensive Posture

The stance is low and the weight is shifted to anchor the defender to the ground and avoid being knocked over. The sword is kept at eye level, almost disappearing from the point of view of the attacker. It is a subtle, hidden-weapon technique. The body weight will shift forward when the character strikes, using the weight of the character and the forward momentum to launch a devastating attack.

1 Focus on the solid posture and structure of the figure. Make sure the legs and arms are considered three-dimensional cylinders. Don't be afraid to "draw through" the figure so that every part of the body is considered and not "fudged." Notice that the leg closest to the viewer appears lower on the page, increasing the illusion of depth.

2 Define the form of the figure. The wrappings around the wrist and shins reinforce the three-dimensional structure. Indicate areas of black clothing by leaving a white highlight outline. While not particularly realistic, it simplifies the problem and allows you to define the structure without turning the character into an amorphous blob.

3 Color and shade using a consistent light source. Each element of the figure is a three-dimensional form and should be shaded as such. Not shading flattens the drawing and destroys the illusion of a structural form. The blue highlights are a standard convention on a black surface. If the color doesn't suit the character, use gray instead.

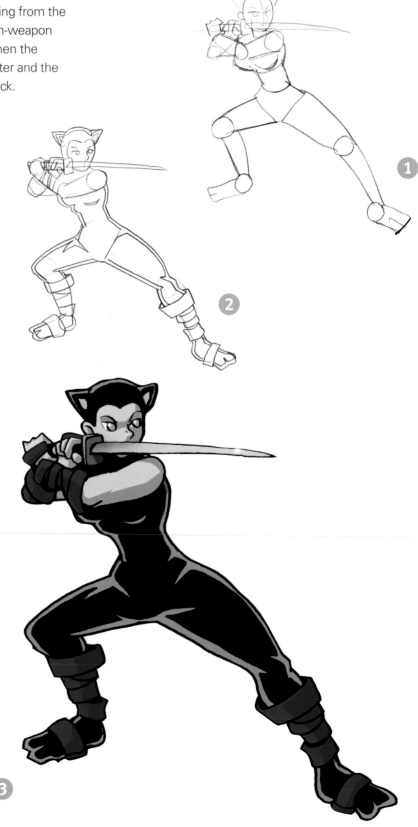

Ninjitsu
Shuriken Throw

*T*he shuriken or "throwing star" is one of the most famous or infamous weapons associated with the ninja. Throwing stars were traditionally thrown individually, but in the fictional world of cinema, manga and anime, handfuls of shuriken may be launched at a target inflicting a devastating autofire attack.

1 It's difficult to throw things when you are leaping because you can't brace yourself against anything. The arm is shown at the farthest extent after the throw. Speed lines indicate the velocity and direction of the thrown objects.

2 Set up the details of the clothing making sure you respect the three-dimensional forms by wrapping them around the figure, not just placing them on a flat drawing. Make sure proportions and anatomical details are respected. Even though the character is stylized you should endeavor to maintain the basics of anatomical logic unless you specifically exaggerate a feature such as the eyes or the mouth.

3 Color and shade the final image to appear as three-dimensional as possible. Shading and coloring can indicate characteristics of the materials you are depicting. The metallic shuriken are shaded smoothly with clearly defined areas of light and shadow. One way to show movement is blurring objects in motion either digitally or as you are drawing.

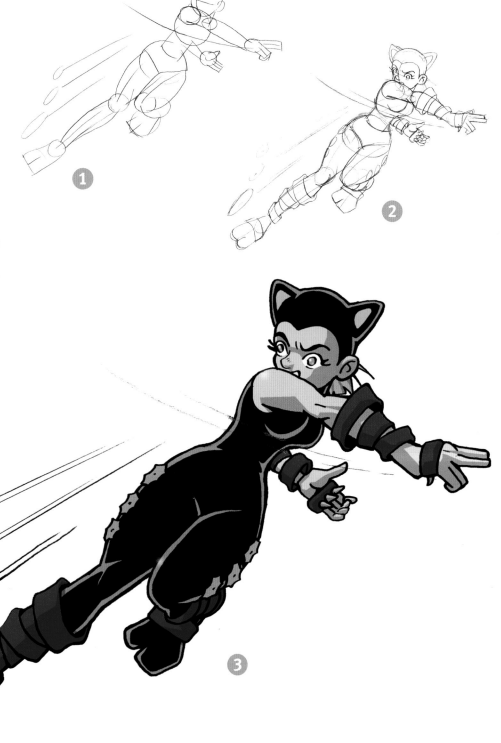

Sneak Attack Take Down

The traditional role of the ninja was a spy or assassin, stealthily sneaking into guarded compounds using the cover of darkness. From time to time, guards would be in the way and need to be removed. This is a dangerous maneuver that could result in the death of the guard. Simply sneaking up and pulling them down could result in a loud crash and an angry guard lying on the ground. In this attack the knee is driven into the spine and will support the unconscious guard, controlling the fall. The necklock could seriously damage the neck and cut off the supply of oxygen. This is a wonderful example of "don't try this at home."

Smooth Finish

The final move would be knocking out the guard or breaking the neck. Denying someone oxygen for a limited amount of time can do severe damage to the brain and injury to the spine. Again, don't try this at home, kids. These manga characters are trained professionals.

1 Be careful with the placement of the feet in the picture plane. Make sure the feet that are lower are the feet closest to the viewer. This is a key stage to make sure perspective works and anatomy makes sense. Fix things at this stage so you don't waste your time drawing the details only to have to correct them later.

2 Lots of small details convince the viewer that the characters exist in a space with its own internal logic. References should be used for some specific details such as the gun and the suit.

3 Work to make the characters appear three-dimensional. Make them look different from each other so that you know where one starts and the other ends. Make sure the light source is consistent for both characters and that they appear to exist in the same place.

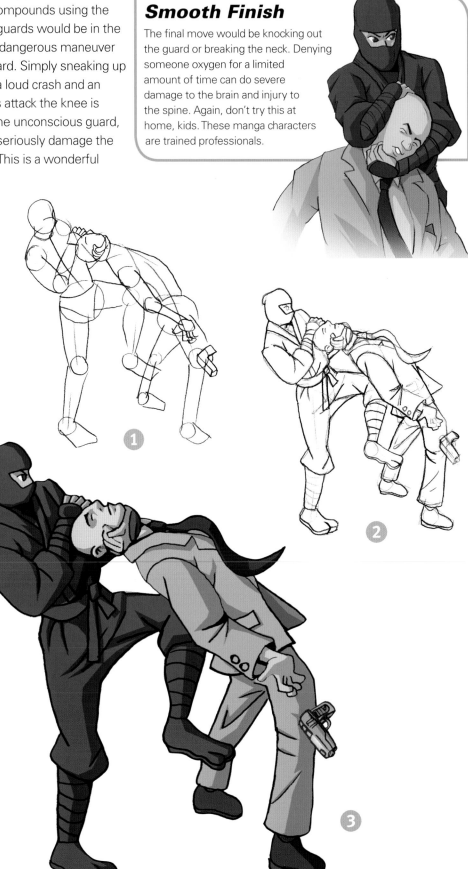

Ninjitsu
Armbar Lock and Strike

Much of Taijutsu involves sudden shifts of weight and angling the body to avoid attacks. The other side of it is trapping the opponent and striking. This maneuver is a typical result of years of intense training and a total awareness and understanding of the environment and the opponent.

1 Establish the relationship of the two figures early on. It's difficult to tell here, but the ninja has stepped aside to avoid the punch, has trapped the forearm with his right arm and created an armbar with his body. He then strikes the back of the attacker's head. It's important to indicate the direction of movement of the attacker and to show the strong, stable stance of the defender.

2 Draw details to reinforce the action. The clothing of the attacker indicates his forward momentum. Showing the results of the action provides the viewer with details that indicate movement without relying on speed lines or other indicators. You can see how vulnerable the attacker has become by over-extending his strike.

3 Show creases and folds that help define the shape of the clothing and body as well as the twist and movement of the figure. Avoid making the colors and values too similar. Make sure that each figure stands out.

Keep Multiple Forms Simple

Drawing a combat situation often requires the artist to block in two or more characters interacting with each other. Don't be intimidated. Keep the forms simple and separate from each other.

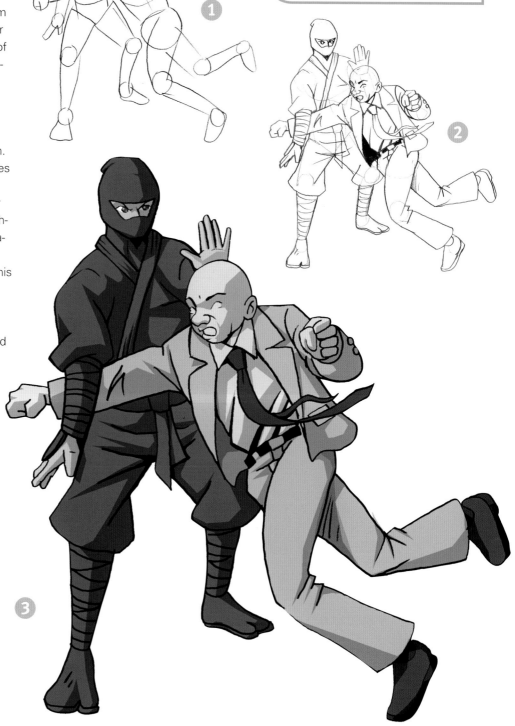

Tae Kwon Do: *Way of the Fist and Foot*

Tae kwon do is known for devastating kicking techniques and powerful strikes. Practitioners of tae kwon do attempt to increase the power of their techniques through physical training, concentration of force to a small target area, balance and stability, breath control and speed. Downward movement is used to increase the energy of the strike. Scientific application of these concepts allows people of all sizes to dish out impressive amounts of destructive power.

The Five Tenets of Tae Kwon Do

1. Courtesy: selfless acts of treating others with respect and compassion. These acts are done with nothing expected in return.

2. Integrity: strict observance to a strong personal morality or code of ethics.

3. Perseverance: sticking with a difficult task and getting back on that horse leads to ultimate success.

4. Self-Control: this tenet is useful to avoid injury when training or sparring.

5. Indomitable Spirit: inner courage and the ability to overcome personal doubts and fears.

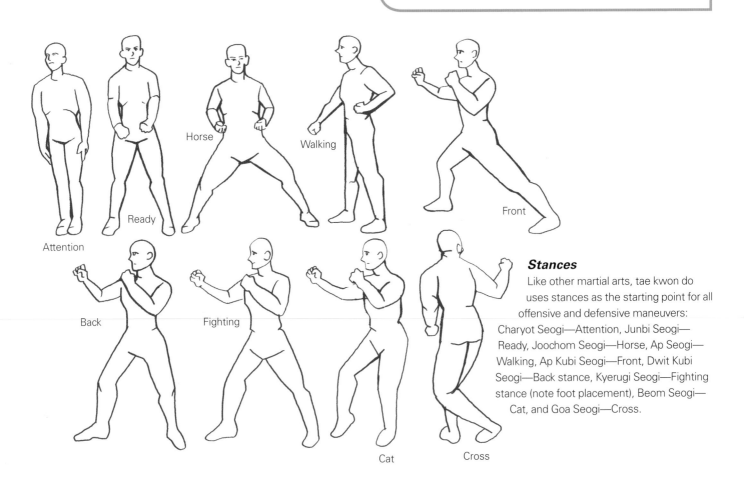

Attention Ready Horse Walking Front

Back Fighting Cat Cross

Stances

Like other martial arts, tae kwon do uses stances as the starting point for all offensive and defensive maneuvers: Charyot Seogi—Attention, Junbi Seogi—Ready, Joochom Seogi—Horse, Ap Seogi—Walking, Ap Kubi Seogi—Front, Dwit Kubi Seogi—Back stance, Kyerugi Seogi—Fighting stance (note foot placement), Beom Seogi—Cat, and Goa Seogi—Cross.

Movement

Tae kwon do kicks include kicks found in other martial arts such as the front kick and the side kick. Despite the predominance of flexible and creative kicking, basic punches or chirugi are also an essential element in tae kwon do. Kwon, after all, is Korean for "fist."

The Versatile Foot

Tae kwon do has flexible and creative kicking attacks that use many parts of the foot as a striking surface.

Breaking Things

Tae kwon do is known for its impressive breaking demon-strations where boards, bricks and other hard-to-break objects are destroyed. This takes more skill and confidence than physical strength. In martial arts manga, breaking things is often depicted to show the power and danger of the opponent in order to build the sus-pense and sense of urgency in the story.

Draw a Balanced Kick

When depicting a kick, make sure to balance the attacker so they don't appear as if they are falling over. We naturally tilt the torso forward in a kick to avoid falling backwards. Don't for-get that the kick is first drawn up towards the body "in chamber" and then snaps out. The higher the leg is raised in chamber, the higher it goes as a kick.

Front Kick Back Kick Jumping Back Kick Axe Kick

Roundhouse Kick Jumping Front Kick

The Famous Kicks

The roundhouse kick or dollyo chagi is drawn up into chamber and rotates to strike. The back kick or dui chagi is used to strike targets behind the attacker. The jumping back kick or dwee a hoo reu chagi is a difficult kick, but can deliver with the element of surprise. The jumping front kick or the yi dan ap chaki adds height and momentum to a standard front kick. It can be a very difficult kick to master as the kicker is vulnerable when he lands. The axe kick or nero chagi strikes the target from above, usually aiming for the head or the col-larbone.

Tae Kwon Do
Flying Side Kick

The flying side kick is a demonstration of agility, power and acrobatics. The kick would need a running start to execute properly. It takes relentless training to achieve a kick high enough to strike an opponent's face.

1 The forms should correspond to the anatomy, but notice how the body is twisted and overlaps some of the bent leg. Make sure that the "knife-edge" of the foot is the part that appears to strike the target. Taken out of context this guy seems to be sitting on the floor. Make sure he is drawn in relation to another character or a setting to show how high he has jumped.

2 Add details such as hair and clothing. Don't forget to use them as clues to help describe the action. The hair flying back indicates the direction of movement and the billowing clothing helps complete the effect.

3 Color and shade to fill in some details of the folds and creases of the clothing. It looks like he's really flying!

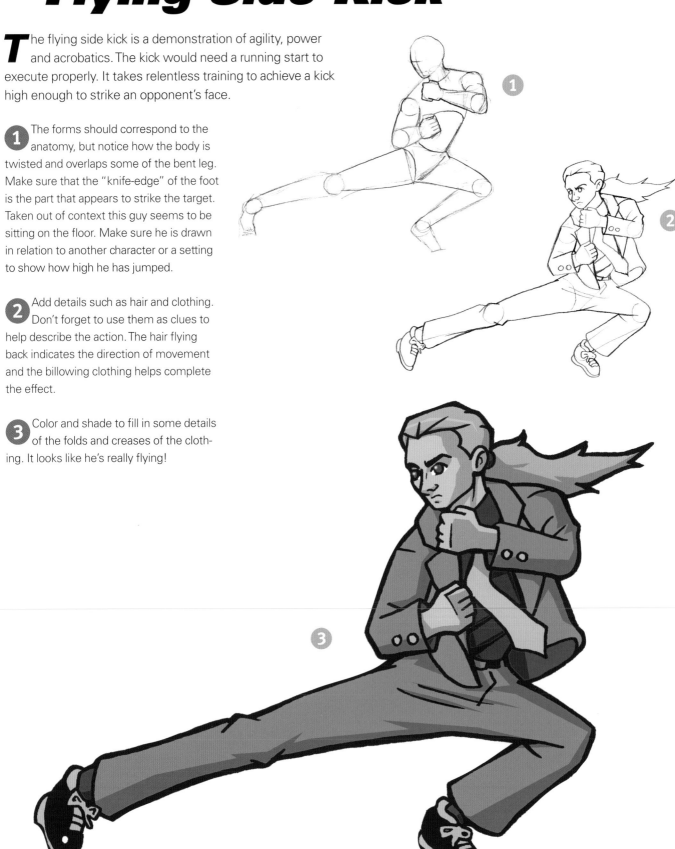

Tae Kwon Do
High Kick

To kick this high it is important to chamber the knee as high as possible before kicking. Kicks like this are the cornerstone of tae kwon do.

1 Ensure the anatomy is correct by "drawing through" the figure. This lets you draw the figure correctly even though other parts will cover elements of the figure. Some indication of details at this early stage of a drawing can really pay off in the end. Notice how the toes are curled back so they don't break when you kick.

2 Make the character identifiable through details. Clothing will crease and billow according to the direction of the movement. Notice how the hair is shown peeking up over the left shoulder. It looks like it's really swinging with the momentum of the kick.

3 Use the shading to detail the creases and folds in the clothing. This kick is aimed at the opponent's temple. The figure is depicted leaning back and off to one side to counteract the movement of the leg. The kick uses the ball of the foot as the point of impact. It is important not to turn away from the opponent and to maintain a defensive posture with arms up. With the proper training the legs can be a powerful weapon.

Keep the Guard Up

It is important when raising the leg up into chamber that the hands are raised to defend the body and face. During sparring and fighting it is difficult to maintain this posture when one is tired, injured or distracted. Lowering one's guard at the wrong moment can be disastrous.

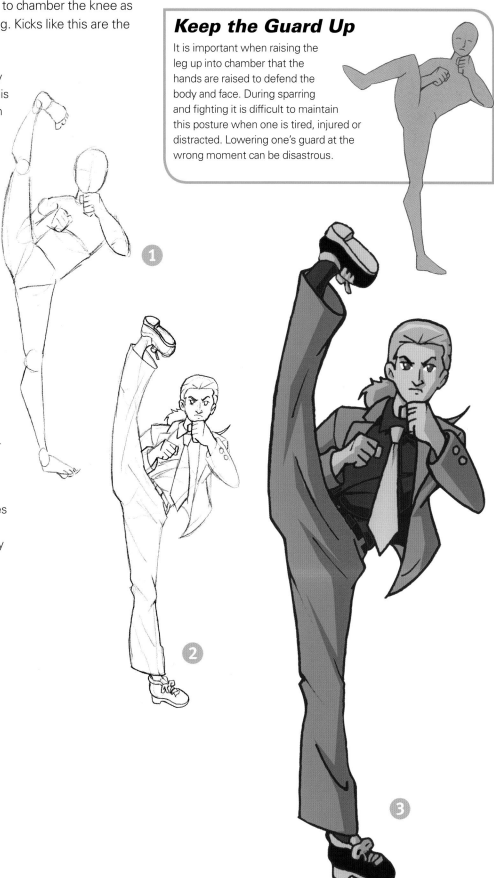

Tae Kwon Do
Kick Off!

It's all well and good to draw people kicking at the air. Showing two fighters squaring off against each other makes a lot of sense, especially if you are telling a martial arts story. The trickiest thing about depicting two combatants fighting each other is showing enough details to make them unique and recognizable. Try to show both characters' expressions. This draws the reader deeper into the conflict.

1 When you are blocking in the figures it's sometimes difficult to figure out which character is which. Although it may look confusing at first, "drawing through" helps you understand where every part of the character's anatomy should go in relation to the action. This avoids the rookie mistake of having an arm float into frame that doesn't seem attached to any characters.

2 Add details and erase extra lines. A clearer picture of the characters' identities and actions emerges. Overlapping characters is a good way to create a sense of depth. During the character design phase it's a good idea to make sure that each individual has a distinct outline that sets him or her apart from others.

3 Clean up the remaining lines and add color and shading to finish the drawing. Choose opposing colors for clothing—warm or cold, dark or light—to make characters that are easily distinguished from each other.

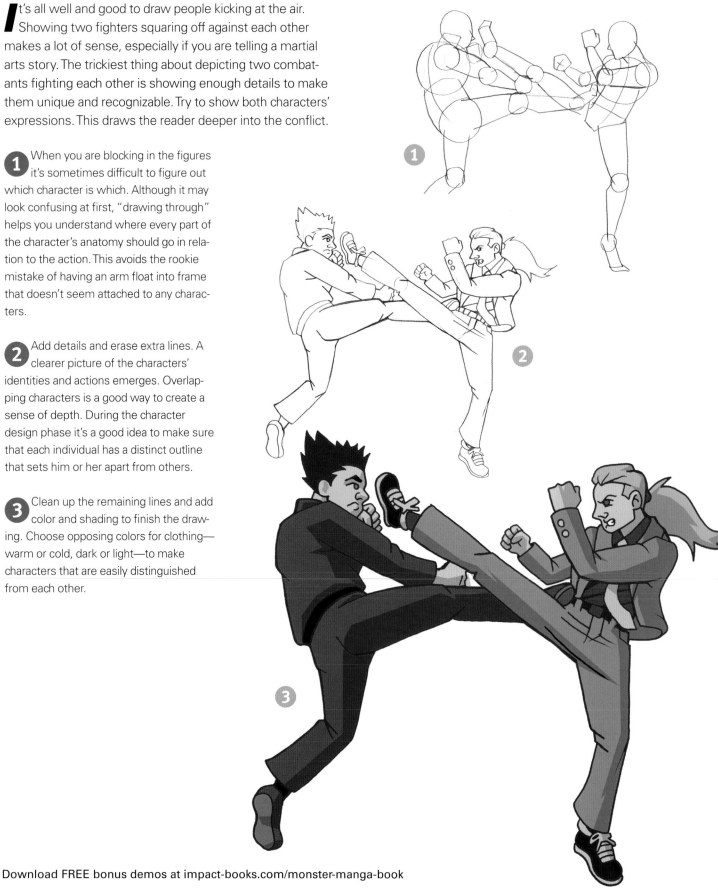

Tae Kwon Do
Breaking Things

Unfazed by the breaking of mere wooden boards, some martial artists like to prove their worth by breaking concrete paving stones or bricks. The approach is basically the same no matter what material is being broken. The key is in the velocity of the strike, not the physical strength of the martial artist. Breaking is a form of conditioning the body to build up resistance against physical damage, but it can cause long-term injury.

1 Don't forget how helpful "drawing through" can be when you block in your figure. Even though the slabs of granite are in front of the back leg, the back leg is drawn so that we can understand the character's relation to the blocks and the ground at his feet. Notice that the heel of the palm is the point of impact to break the slabs.

2 Draw the hair and clothing trailing after the figure to indicate the speed of the strike. Much of the break depends on speed, but striking down like this also makes use of gravity and the weight of the slabs to achieve a break. Pointing the feet inward toward the center of the figure uses back muscles, not just the arm, in the strike.

3 Know where the light source is in relation to the figure and props. The face is in shadow and the shadow of the slabs and blocks is also cast on the ground, indicating depth. Different materials break in different ways. Wood tends to splinter as it breaks. Stone and brick disintegrate into smaller pieces and sometimes a cloud of dust.

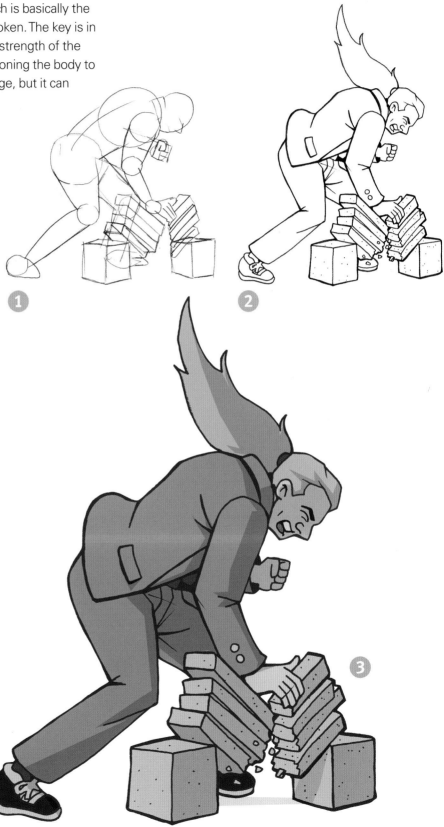

David Okum has worked as a freelance artist and illustrator since 1984 and has had comic book work published since 1992 when he had a story published in a *Ninja High School* anthology published by Antarctic Press. He has since been included in two other Antarctic Press anthologies and several small-press comic books. His writing and artwork have appeared in six books by Guardians of Order. He is also the author and illustrator of *Manga Madness, Superhero Madness, Manga Monster Madness, Manga Fantasy Madness* and *Manga Martial Arts* from IMPACT/North Light Books. David has also illustrated two graphic novels for Scholastic's Timelines series. David studied fine art and history in university and works as a high school art teacher.

Other fine IMPACT Books are available from your favorite bookstore, art supply store or online supplier. Visit our website at fwmedia.com.

17 16 15 14 13 5 4 3 2 1

DISTRIBUTED IN CANADA BY FRASER DIRECT
100 Armstrong Ave.
Georgetown, ON, Canada L7G 5S4
Tel: (905) 877-4411

DISTRIBUTED IN THE U.K. AND EUROPE
BY F&W MEDIA INTERNATIONAL, LTD
Brunel House, Forde Close, Newton Abbot, TQ12 4PU, UK
Tel: (+44) 1626 323200, Fax: (+44) 1626 323319
E-mail: enquiries@fwmedia.com

DISTRIBUTED IN AUSTRALIA BY CAPRICORN LINK
P.O. Box 704, S. Windsor NSW, 2756 Australia
Tel: 02 4560 1600 Fax: 02 4577 5288
E-mail: books@capricornlink.com.au

ISBN-13: 978-1-4403-3209-8
ISBN-10: 1-4403-3209-6
SRN: U6497

Metric Conversion Chart

To convert	to	multiply by
Inches	Centimeters	2.54
Centimeters	Inches	0.4
Feet	Centimeters	30.5
Centimeters	Feet	0.03
Yards	Meters	0.9
Meters	Yards	1.1

The material in this book appeared in the following previously published IMPACT Books:
Okum, David. Manga Madness © 2005.
Okum, David. Manga Monster Madness © 2005.
Okum, David. Superhero Madness © 2005.
Okum, David. Manga Fantasy Madness © 2006.
Okum, David. Manga Martial Arts © 2008.

Edited by Stefanie Laufersweiler and Mary Burzlaff Bostic
Designed by Angela Wilcox
Production coordinated by Mark Griffin

Ideas. Instruction. Inspiration.

Download FREE bonus demonstrations at
impact-books.com/monster-manga-book.

IMPACT-BOOKS.COM

- ▶ Connect with your favorite artists
- ▶ Get the latest in comic, fantasy and sci-fi art instruction, tips and techniques
- ▶ Be the first to get special deals on the products you need to improve your art